American Visual Culture

American Visual Culture

Mark Rawlinson

BERG

Oxford • New York

First published in 2009 by
Berg
Editorial offices:
1st Floor, Angel Court, 81 St Clements Street, Oxford, OX4 1AW, UK
175 Fifth Avenue, New York, NY 10010, USA

Berg is the imprint of Oxford International Publishers Ltd.

Library of Congress Cataloging-in-Publication Data

Rawlinson, Mark (Mark S.)
 American visual culture / Mark Rawlinson.
 p. cm.
 Includes bibliographical references and index.
 ISBN-13: 978-1-84520-217-0 (pbk.)
 ISBN-10: 1-84520-217-1 (pbk.)
 ISBN-13: 978-1-84520-216-3 (cloth)
 ISBN-10: 1-84520-216-3 (cloth)
 1. Arts, American. 2. Arts and society—United States. 3. Visual
communication. 4. National characteristics, American, in
art. I. Title.
 NX503.R38 2009
 700.973—dc22

 2009017555

British Library Cataloguing-in-Publication Data

A catalogue record for this book is available from the British Library.

ISBN 978 184520 216 3 (Cloth)
ISBN 978 184520 217 0 (Paper)

Typeset by JS Typesetting Ltd, Porthcawl, Mid Glamorgan
Printed in Great Britain by the MPG Books Group, Bodmin and King's Lynn

www.bergpublishers.com

For Lisa and Seth

Contents

Illustrations

Acknowledgments

Overlong acknowledgments are worse than long goodbyes and often more embarrassing to witness, so I will be as brief as possible without, I hope, leaving out or offending anyone.

Firstly, books like *American Visual Culture* rely on images: what is the point of talking about visual culture if the audience cannot see the object under discussion (or something very similar)? Gathering all this stuff together for the well-organized person might be easy, but I am not as organized as I might be, so for all those images that appear here, I would like to thank the many individuals behind the permissions process. In particular, I would like to thank several individuals/organizations: Mark Michaelson for providing many images from his *Least Wanted!* Collection; the staff at National Geographic for finding photographs I thought lost forever; artists Emory Douglas and Richard Prince; Susan Sutton at the Indiana Historical Society; Lisa Spurgeon at the Art & Archives Collection, John Deere & Company, Victoria Jones at PA Photos; Darcy Marlow at The Philbrook Museum of Art; Robert Blackman at Fototeka Gallery. Images and permissions cost money and this book would be poorly illustrated without financial support from the School of Humanities at the University of Nottingham, so thank you. Secondly, a thank you and an apology to Tristan Palmer at Berg because writing this book whenever time allowed has meant I have tested his patience and good humor for quite some time. To all the students who dared choose *American Visual Culture* as part of their degree at Nottingham, thank you: the discussions inside and outside the classroom have proven a rich source of ideas and opinion that have shaped the content and focus of this book. Thanks to my colleagues in the Department of Art History and the School of American and Canadian Studies for suggestions and support. I would also like to thank Jeff Brouws not only for the photograph on the cover of this book, but also for the conversations about photography that have since followed; long may they continue.

Finally, a huge thank you to Lisa, to whom I made a promise: that I would finish this book before the birth of our first child. I failed to finish but I *really* tried. As a small peace offering, and because Lisa met her deadline, I dedicate this book to her and our son, Seth Luka.

Introduction

A book with the title *American Visual Culture* has a lot of ground to cover, most of it difficult to navigate, none of it straightforward. The process of researching and writing *American Visual Culture* has been, to a large degree, a lesson in inadequacy, haunted by an ever-present feeling that, by choosing one example from one theorist of visual culture over another, the book was biased or incomplete. And of course it is. Reflecting on what aspects of American visual culture are most worthy of attention—film, television, art, advertising, design, architecture, illustration, photography, etc.—and then envisaging the means by which one could properly discuss each, drawing on specific examples, all contextualized and analyzed, then cross-referenced with other examples from its own and then all other disciplines, is maddening in its complexity (and note I have not even mentioned the historical dimension). It would also be impossible. So, I think it best to set out a series of realistic expectations.

American Visual Culture is certainly not able to offer an all-inclusive, complete reading of all aspects of American visual culture. Instead, and, I hope, without sounding too pretentious, this book aims to encourage and inspire readers to think about the issues raised in each chapter and then research, explore, and discover for themselves aspects of American visual culture not included here, whether it be theories of the visual and/or other forms of visual ephemera. I suspect, and hope, that readers will complain to themselves, make mental notes, and/or annotate the margins of the text with alternative and more relevant examples than the ones provided: to my mind, this is exactly what a text like this should do. The underlying principle of *American Visual Culture* is simple: to stimulate new and original thinking in its readers and certainly not present itself as the beginning and end of its subject; in essence, *American Visual Culture* is a suggestive rather than exhaustive survey of its topic. This is not an apology for inconclusiveness or a tactic to defer criticism; I see it as an intellectual openness to an academic field of inquiry still finding its subject/object; as such, the study of visual culture remains an exciting arena of possibility for students and scholars alike.

What is American Visual Culture?

Realistic expectations aside, three questions require our attention: the first of these is why *American* Visual Culture, as opposed to British, Japanese, or Australian, etc.?

Secondly, what, exactly, do we mean by "American"? And finally, what do we mean by "visual culture"?

The question of "why American visual culture?" relates to a central theme running through this book: the critical examination of "American exceptionalism." But what is American exceptionalism and why does it require a critical examination? The phrase was coined by Alexis de Tocqueville (1805–59), a French historian, political scientist, and politician who visited America in 1831, compiling his observations on the country in *Democracy in America Volume One* (1835). For Tocqueville, the society and social order of America was unique and distinctive from all others, hence American exceptionalism. The problem since Tocqueville is that the idea/ observation has taken on a life of its own. Rather than exceptionalism being seen or identified as what it is, ideology or myth, the institutions of America from the government down have emphasized the so-called exceptional qualities of America, especially for nation building, and by so doing made them appear real or natural. As such it appears counterproductive or even hypocritical to present the visual culture of America as more worthy of analysis than other forms of visual culture because this in itself is a form of American exceptionalism. But the logic for doing so is straightforward. Rather than stress the uniqueness of American visual culture in order to valorize it, it is timely to reconsider the objects of American visual culture.

By chance, the connotations of the name "American" and "visual culture" were subject to widespread but separate criticism during the mid 1990s.[1] Art historians, in particular, expressed varying degrees of excitement and consternation toward the emergence of visual culture, a reaction underscored by a simple question: "friend or foe?" Was it an academic discipline in its own right, a kind of trans-discipline, or even an anti-discipline? Would visual culture subsume art history (and other subjects like cultural studies) or was it a new critical tool—a form of inter-discipline—to be taken up by what might be described as more established disciplines? Likewise, (mainly US-based) American studies scholars in the mid 1990s openly expressed dissatisfaction with the associative meanings, as well as meaninglessness, of the nationalistic terms "America" (as in the nation state) and "American" (as in "American studies").[2] As a consequence of the impact of globalization, combined with the mobilization of postcolonial studies, the idea of studying America—as an actual territory, with definite borders and exceptional cultural, social, and individual characteristics—suddenly appeared redundant, anachronistic, and, to a degree, imperialist.[3] Out of this self-reflexive questioning of the discipline emerged the New American Studies. However, as I write this introduction in 2008, these disciplinary spats may have evolved but neither has reached consensus.

What's in a Name?

> I think that there is but a single specialty with us, only one thing that can be called by the wide name "American." That is the national devotion to ice-water.

> Mark Twain (1897)[4]

Twain's humorous incredulity at the existence of an identifiable and singular American character shared with his fellow citizens seems only to have occurred to scholars of American culture in the last decade of the twentieth century. Since its inception as an academic discipline in the 1930s, American studies—the study of American history and culture—has ignored Twain's perceptive rebuke of American "specialness" in favor of articulating not difference but similarity. In fact, American studies seems to have busied itself with writing, as much studying, a *mythology* of the United States of America, one in which the U.S.A. in all its cultural, political, and social institutions is historically distinct and exceptional.

Although somewhat pared down, the critique of American studies described above emerged from within the discipline itself during the 1990s, and what follows is a short account of the ongoing debate regarding the usefulness of the name "America" among those who study American culture and history. Again, what follows relates to a particular perspective—American studies—it is nevertheless revealing. After all, it is important for us to grasp the connection between studying the culture of the United States and American exceptionalism.

Under the banner of the "New American Studies," scholars working from "postnational" or "transnational" critical perspectives openly criticized a bias in traditional American studies scholarship toward American exceptionalism. John Carlos Rowe, a central figure in the new American studies, explains that, "The criticism of ... 'American Exceptionalism' has focused on both its contributions to U.S. cultural imperialism and its exclusions of the different cultures historically crucial to U.S. social, political, and economic development."[5] To put it simply, Rowe argues that in its effort to find the exceptional qualities of America, American studies has not only ignored the diversity of those contributing to the cultural heritage of America but the variety of those contributions; and this despite the interdisciplinary foundations of the discipline. For Rowe, to describe the diaspora that constitutes the citizenry of the United States of America as a homogeneous and consensus-based group named "Americans" strips each cultural group of their own specificity as well their own sense of what being an "American" means to them.

Moreover, Rowe's first point—the relationship between American exceptionalism and U.S. cultural imperialism—highlights the fact that American studies is an internationally recognized academic subject, studied and researched outside of the U.S. The long-standing problem with American studies is, according to George Lipsitz, its complicity with American imperialism. As Lipsitz sees it: "American Studies itself has been implicated in this project because of its inattention to the role of imperialism in U.S. history and because its core questions about 'what is an American' have assumed the existence of an unproblematized, undifferentiated, and distinctly national 'American' identity that differs from the identities open to individuals from other national contexts."[6]

In essence, both Rowe and Lipsitz suggest the export of traditional American studies is as much a form of cultural imperialism as the sight of McDonald's Golden

Arches on the city streets of Berlin or Beijing and, importantly, that scholars have failed to address the most fundamental questions relating to American national identity. It is not "cultural influence" but a form of cultural imperialism that inculcates foreign nationals into the exceptionalist myths that underpin the idea of "America."[7]

Leaving aside any conspiratorial notions of ideological brainwashing taking place across the globe under the guise of American studies, Rowe's essay exhibits a common complaint or, perhaps, anxiety found in the work of transnational/postnational American studies practitioners: the name, "America." There is no clearer example of this anxiety than Janice Radway's presidential address to the American Studies Association (ASA) in 1998, "What's in a Name?" Radway's address argues that the organization seriously consider renaming itself:

> Does the perpetuation of the particular name, "American," in the title of the field and in the name of the association continue surreptitiously to support the notion that such a whole exists even in the face of powerful work that tends to question its presumed coherence? Does the field need to be reconfigured conceptually in response? Should the association consider renaming itself in order to prevent this imaginary unity from asserting itself in the end, again and again, as a form of containment?[8]

To say "What's in a Name?" polarized opinion is an understatement. There is no time here to analyze differing reactions, but Radway's essay exemplifies a shift in emphasis not only in American studies but also more widely in academia. While respectfully paying homage to the founding principles of the ASA (and, by extension, American studies), Radway asks uncomfortable questions of many entrenched and "naturalized" biases that inform the study of American history and culture.[9] Like Rowe, Radway's criticisms are informed by theories of globalization and postcolonial studies; how can "America" exist as a coherent geographical, political, cultural, or social entity in a world now shaped by global capital and digital information technologies, such as the Internet, which have not only corroded national borders, questioned the possibility of consensus politics, fixed identities, and displaced traditional notions of time and space.[10]

As Shelley Fisher Fishkin identifies, one of the key driving forces behind American exceptionalist discourse in contemporary culture is the U.S. government itself.[11] For Fishkin, the proper corrective for governmentally driven American exceptionalism—one that continues to peddle a vision of America that is oversimplified and mythological—is a more critical American studies. For example, George W. Bush's speech to Congress and the American People on September 20, 2001 in which he provocatively declared, "Either you are with us, or you are with the terrorists,"[12] is a non-statement if there is no sense of an "us" to stand with or against. Moreover, Bush's speech categorically splits the debate into two discernible halves: America and Americans on the one side, the terrorists on the other; to suggest that

this logic is flawed necessarily places the dissenting voice with the negative group: the terrorists. To speak out against the "War on Terror" becomes un-American. One could add that a non-American individual or nation state who chooses to side with Bush automatically becomes an American by default, wherever and whoever they might be. What is more, the so-called terrorist *and* the dissenting voices of international individuals and nations are also by default un-American.

To conclude this brief discussion on the new American studies, its critique of and impact on traditional American studies, it is helpful to set out how these developments relate to this book. The transnational turn in American studies has a predominant U.S.-centric bias, and, in fact, only Fishkin's ASA address makes any substantive call for a more sustained engagement with non-US scholars. Fishkin asks:

> If the citations in the books and articles we publish refer to nothing published outside the United States, if our syllabi include no article or book by a non–U.S.-based scholar, if the circle of colleagues with whom we regularly share our work all live in the United States, if we assume that the subject of our study is by definition what transpires within U.S. borders, and if all are comfortable reading or speaking no language but English, many of us see nothing amiss.[13]

As a European academic based in Europe, Fishkin's impassioned plea to ASA members to broaden their church makes for uncomfortable reading. Despite the apparent openness of Fishkin's call to internationalize American studies in an American context, one cannot ignore, as Ali Fisher notes, that, "While Fishkin, Kaplan, and Rowe particularly highlight the importance of engagement, they also identify, to varying degrees, a purpose to American Studies; to interpret and project 'America' in a certain way."[14]

With this in mind, *American Visual Culture*, the origin of which is a module of the same name taught in the Art History Department at the University of Nottingham in the UK, appears situated well outside the critical context central to new American studies: this book was written outside the U.S.A. and by a non-U.S. scholar. However, as Paul Giles argues, "one of the historical problems about the construction of American Studies within a British context, in particular, is that it has tended simply to replicate the formation of ... traditional [literary and philosophical] canons from another perspective."[15] Therefore, with the "imaginary coherence of a national tradition" revealed as such, American studies outside the U.S.A. has necessarily reassessed what, exactly, it means to do American studies in a globalized world.[16] In terms of the European academic community's reaction to the U.S. led transnational challenge, Giles offers the most coherent response. Giles argues that,

> It is important to emphasize this point: transnational American Studies, as I understand it, involves not a filling up of partitioned spaces, but rather an emptying them out; not so much a recuperation of buried material, but rather the deformation or dematerialization of cultural hierarchies and systems of authority that already obtain. Transnationalism in

this sense is more of a Foucauldian exercise involving the renegotiation and redescription of power, not just the supplementation of power by parallel but fundamentally equivalent discourses of race, gender and ethnicity.[17]

This book, then, has one obvious but complex aim and that is to analyze American visual culture—from maps to advertisements, from photographs of national parks to the covers of men's adventure magazines—and then articulate the ways in which each is in some way a reflection of American national identity. This is not to say the book supports an American exceptionalist agenda of the sort transnational American studies finds so reductive, far from it; *American Visual Culture* is highly critical of such an agenda. Following Amy Kaplan's argument that "American studies must … contest the universalism of American exceptionalism,"[18] *American Visual Culture* examines the ways in which visual culture is, on the one hand, complicit in the formation, circulation, and manifestation of the exceptionalist agenda; on the other hand, the book analyzes the ways in which images, even exceptionalist propaganda, are riddled with contradictory narratives, which in turn problematize the existence of a distinct national "American" identity. This book then does not so much "recuperate buried material" as look anew at the more commonplace aspects of American visual culture.

What is Visual Culture?

Nicholas Mirzoeff begins his book, *An Introduction to Visual Culture*, with one assertion, "Modern life takes place on screen," and ends his first paragraph with another: visual culture "is not just part of your everyday life, it *is* everyday life."[19] Clearly, visual culture amounts to more than simply the things we can "see" and extends to include the ways in which we "see," known as "visuality." As such, the study of visual culture is as much about the way vision is and has been "constructed" as it is about what we see, be it billboard advertisements, the window displays of department stores, works of art, magazines, or movies. In fact, visuality—the construction of seeing—is intimately related to not only how we make sense of the world of visual objects, but also how those visual objects were conceived in the first place. But what does visual culture mean in this book?

In an effort to get to the point and avoid an overlong, overcomplicated assessment of the present field of literature on visual culture—nowadays the work of volumes rather than monographs or articles—let me start with an explanation of what this book takes to mean by visual culture with brief reference to the wider definition of visual culture studies.[20] Still, a preference for brevity does not preclude some background, so I advise readers with limited knowledge about the emergence of visual culture studies to undertake some background research.

Let us begin with a lengthy quote from W. J. T. Mitchell:

So what is "visual culture," this new hybrid interdiscipline that links art history with literature, philosophy, studies in film and mass culture, sociology, and anthropology? Is it the "visual front" of the cultural studies movement? Is it a new scientism that hopes to construct a linguistics or semiotics of the visual field? A new aestheticism that moves cultural studies away from signs and meaning, and toward sensation, perception, feeling, and affect? Could it be a response to the brute fact (or is it just a received idea?) that the visual dominates our world as never before, the popular formulation of the "pictorial turn"? Is it an academic collusion with or critical resistance to a society of "spectacle" and "surveillance"? What are the limits of a politics of the visual? Should art history expand its horizon, not just beyond the sphere of the "work of art," but also beyond images and visual objects to the visual practices, the ways of seeing and being seen, that make up the world of human visuality?[21]

Mitchell is writing in *The Art Bulletin* and addressing (a concerned) audience of art historians, many of whom might well perceive visual culture studies as a threat to the discipline of art history/the history of art. Putting aside the concerns of art historians, Mitchell's description of what visual culture studies "is" has quite a bit to do with what distinguishes it from what is generally seen as its "partner": cultural studies.

Visual culture studies, though, is *not*, as Mitchell categorically states, the "visual front" of cultural studies because "visual cultural studies is too interested in the question of what vision is, too 'aesthetic' in its fascination with the senses, perception, and imagination."[22] Cultural studies is to a large degree uninterested in these aspects due to a Marxist inheritance, one that binds it to linguistic and discursive models of analysis; not so, the analyses of visual culture studies, unencumbered by a similar legacy—visual culture "names a problematic rather than a well-defined theoretical object."[23] As such, and quite unlike cultural studies, visual culture studies is "grounded in a fascination with visual images" that are "attentive to the full range of visual experience from humble vernacular images, to everyday visual practices, to objects of both aesthetic delight and horror."[24] It is this approach to American visual culture that this book will take; so throughout this book we will examine a range of visual material drawn from familiar and unfamiliar sources, including pin-up imagery, lynching photography, and maps.

Although Mitchell's summary of visual culture studies differs somewhat from Mirzoeff's, it is prudent to highlight similarities. For Mirzoeff, the study of visual culture is rather more contemporary in its historical focus, more concerned with what he discerns as "the growing tendency to visualize things that are not in themselves visual," as well as "the growing technological capacity to make visible things that our eyes could not see unaided … In other words," he concludes, "visual culture does not depend on the pictures themselves but the *modern tendency* to picture or to visualize existence."[25] Written earlier than Mirzoeff's text, Mitchell's *Picture Theory* identifies the historical bases of this desire to visualize in the adoption of a pictorial rather than textual view of world in certain fields of Western philosophy and science since the eighteenth century. Mitchell's work is cited by Mirzoeff in an effort to

validate his argument vis-à-vis the twofold acceleration in the desire to visualize existence and the technological means to do so. As such, Mirzoeff's model for visual culture studies relates more readily to a world captivated by media technologies; Mitchell, on the other hand, seems more willing to concede a much longer history for visual culture studies to explore, one that began long before the invention of television and subsequent "screen-based" technologies. Mitchell's work, as well as that of Jonathan Crary, Martin Jay, James Elkins, and Barbara Maria Stafford,[26] highlights the fact that historical periods have distinct visual regimes "that are both born of and create ways of viewing the world, visual skills and literacies, notions of vision, historically located ways of seeing, image-making devices, modes of perception and ways of understanding visual evidence …'[27] *American Visual Culture* is not in complete dispute with Mirzoeff's theorizing of visual culture studies, but does break from his periodizing framework and aligns itself more readily with the work of Mitchell, in particular.

In saying this, the commentary above fails to address head-on another important question: "why privilege sight over all other senses'; or, in keeping with a developing theme, "why extrapolate sight from all the senses and treat it as somehow exceptional?" The experience of our everyday life obviously consists of a sedimentation of sense data; sight/vision, touch, hearing, smell, taste, as well as proprioception ('knowing" where your hand is—for example, close your eyes and touch the end of your nose), equilibrioception (balance), thermoception (temperature), and nociception (physiological pain).[28] It is these senses working in concert with one another (not forgetting our internal senses, the ones that let us know when we need to eat or go to the bathroom, among others) that truly constitute the framework through which we engage with physical world around us. However, concentrating our attention on vision, the visual, and visuality—or, on seeing, what it is we see, and how we make sense of what we see—is not an effort to place the visual at the top of a hierarchy of senses. It is, instead, recognition of the pivotal place the visual and visuality play in culture. Again, Mitchell offers a pertinent insight in this regard, namely the notion of what he has called the "pictorial turn."

'My idea," Mitchell writes, "(hardly an original one) was that the image had become a conspicuous problem (where 'image is everything' was the mantra of the day), and in the study of the arts, the media, cultural theory and philosophy, where a turn from language to the image seemed to be occurring."[29] Dating Mitchell's observation to the early 1990s should not lead us to the conclusion that images became a "conspicuous problem" only at and from that historical moment. The conspicuousness of the image is what demarcates the pictorial turn; from this moment our knowledge of the image—its making, its distribution, its audience, its reception, its *life*—interrupts or makes it impossible for us not see the image as more than just a problem. I say this because human beings for centuries have continually recycled a fear of the image. Historically, images have consistently been considered problematic and their power to seduce, corrupt, manipulate is readily "known." In

the twenty-first century, forms and degrees of censorship are regularly exercised across media, for example, in the classification of movies and video games, but each forms part of a very long chain with links stretching back to the ban on the graven image invoked in Genesis and Plato's suspicious philosophizing on the work of the artist.[30]

The pictorial turn can be defined can be defined as an awareness of the complex role of the image in societies and cultures, not only in the present but throughout history. It might sound odd but, arguably, the "pictorial turn" is the point at which the invisible aspects of the image become visible. For example, the work of both Sigmund Freud on scopophilia (pleasure in looking) or the "dream-work" and Roland Barthes on the language of advertising as myth, as denotation and connotation, highlight the complex nature of visual representation, its multiple layering of meaning and sense. Let me explain what I mean. Mitchell connects, or better, relates the "pictorial turn" to the earlier "linguistic turn," most closely associated with American philosopher, Richard Rorty (1931–2007).[31] The linguistic turn—the premise of which is that language is *not* transparent; there is no natural link between a word and its object— along with the pictorial turn belong to an earlier turn: the "cultural turn." So many turns in so few sentences is, admittedly, dizzying but the wider "cultural turn" is an important principle to grasp.

As Margaret Dikovitskaya explains, the cultural turn of the 1980s is founded upon the realization that culture, "a representational, symbolic and linguistic system … [was] an instigator of social, economic and political forces and processes rather than a mere reflection of them."[32] In the past, a more scientific model had dominated studies of societies and cultures, one that relied more upon the analysis of social categories than on individual motivations expressed within those social categories.[33] Before the cultural turn, then, categories were presumed as stable and unchanging entities, so not much attention was paid to either "meaning or operation" of a social category or the "individual motivations within social formations."[34] Dikovitskaya notes that this approach fails to address "the issue of subjectivity and the subjective side of social relations"; that is, how individuals react and interact with their world, a point we shall address later in the book in relation Michel Foucault. When "culture" becomes the object of study, new ways of studying this object must necessarily be found. As a "representational, symbolic and linguistic system," then, it follows that, from the cultural turn, we move to a linguistic and then to the visual turn: the study of images "as a reflection on the complex interrelationships between power and knowledge."[35] And, in this spirit, here is this book: an examination of American visual culture.

Beginning American Visual Culture

As an example of how this book "works," I want to end the theoretical part of the Introduction with an analysis of the quintessential symbol or icon of the United States

of America: the Stars and Stripes, or Old Glory. Framing this short debate is what Mitchell refers to as an "interdisciplinary practice called 'iconology' (the general study of images across the media) or more broadly 'visual culture' (the study of the social construction of visual experience)."[36] The American flag, like other icons of American culture, such as the skyscraper (the Chrysler Building and the Empire State Building, especially) or the Statue of Liberty, is a highly recognizable symbol.[37] But what does this mean? How has the American flag become so recognizable, how do we know what the flag is supposed to symbolize? Moreover, does the flag elicit the same feelings in non-American individuals, and if not, why not? And what are flags for, why do people fly flags from their homes, have it tattooed on their bodies, sprayed onto the fuel tank of a Harley-Davidson? Why do manufacturers of all kinds of goods, from cookies to tractors, incorporate the flag into their brand logos? Why do people salute and swear allegiance to the flag? Why did the first astronauts to land on the moon plant a flag on its surface? Flags have very particular connotations such as to patriotism and belonging; to wear a flag, as winning athletes often do on their honorary lap, or to have the flag draped over the coffin of a fallen soldier, are all very different contexts for the Stars and Stripes and yet these gestures would mean nothing without an underlying coherence or shared sense of meaning.

The genesis of "Old Glory" is, like all complex, cultural symbols, as much myth as it is fact, as mundane as it is fantastic: the "flag is mythical, and a little mysterious … but it is also cloth, thread, and colors, arranged according to federal law."[38] The mythical origins are found in the story of George Washington and Betsy Ross; Washington sketched a flag, with a six-pointed star, which he then handed to Betsy Ross, the seamstress who made his ruffled shirts; she in turn, "took a scrap of cloth, folded it, and with a single snip produced a more distinctive five pointed star rarely used in heraldry because of the supposed difficulty of making one." Thus was born the Betsy Ross Flag, with its thirteen alternating stripes of red and white, "adorned with a circle of thirteen five-pointed stars."[39] All myth, of course, but a wonderful one. What is less mythical are the ways in which the developing flag, due to its mass production throughout the nineteenth and twentieth centuries, was governed by law. For example, the colors were standardized in 1934. As Karal Ann Marling informs us: "White is white. The Blue is a common shade. But," adds Marling, "OG Red ('Old Glory Red') is a distinctive hue, the experts say, with the merest touch of heavenly blue." Finally, Marling also notes that "a Flag code, formulated in the 1920s and endorsed by Congress at the end of World War II, mandates how soiled and worn flags are to be disposed of with due reverence."[40] This latter point is intriguing as it elevates the flag from a mere object—made of dyed cloth, then stitched together in a particular way—to something "revered"; as such, the flag is more than just cloth, more than the sum of its parts, something that you do not simply throw away. But what are the parts that make up the sum?

Of all the images of the American flag, it is Jasper Johns's *Flag* (Plate 1) that most strikingly reveals the complexity of the flag and its iconology. What makes

Flag such a distinctive example is not only its physical resemblance to an American flag but also the way in which the work of art came into being, both in terms of its construction (out of bits of wood, newspaper, and wax) and its original conception (Johns claims he dreamt of "painting a large flag" and awoke and made *Flag*[41]). As such, *Flag*—unlike the flag planted on the moon by Neil Armstrong or the poignant gesture of a flag draped over the tangled remains of the World Trade Center—actively encourages the viewer to experience the flag not as a secure or stable colored rectangle of readily available and digested meaning—we know what the Stars and Stripes means—but as an object that is always in a state of flux, whose meaning is constantly changing, whose "construction" is not hidden by ideology but writ large in the roughness of *Flag*'s finish, and in the torn newspaper clippings that lie half obscured beneath red, white, and blue melted wax.

In *What is Abstraction?* Andrew Benjamin describes *Flag* in these terms: "it is not abstract, since it does not refer to the history of abstraction, it depends upon certain principles in that it maintains as central to its work the necessary impossibility of absolute identification."[42] Benjamin's argument is that *Flag* is not an abstract work of art in the same way we might say of abstract expressionist Jackson Pollock's *Autumn Rhythm*. For one thing, *Flag* actually looks like a real flag; *Autumn Rhythm* looks

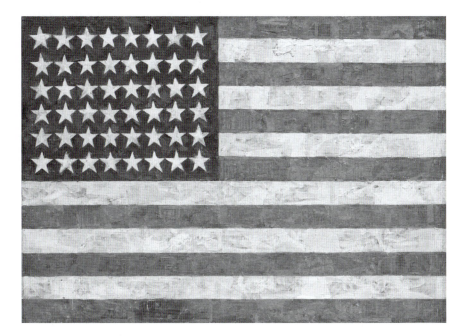

Plate 1 Jasper Johns (*b*.1934), *Flag*, 1954 (dated on reverse). New York, Museum of Modern Art (MoMA). Encaustic, oil and collage on fabric mounted on plywood, 42¼ × 60 ⅝″ 107.3 × 153.8 cm). Gift of Philip Johnson in honour of Alfred H. Barr, Jr. 106.1973. © 2008. Digital image, The Museum of Modern Art, New York/Scala, Florence. © Jasper Johns. VAGA, New York / DACS, London 2008.

quite unlike anything else except itself, and it certainly does not look like a flag. But, crucially, despite appearances as a work of art *Flag* is not a flag either. It just looks like a flag (*Flag* is always a flag, and yet it is not a flag). *Flag* is then a work of art that foregrounds the work of the work. (By the work of the work we mean it is a made of object but what kind of made object is *Flag*? A painting? A collage? Both?) Moreover, it is a work that offers no finality of interpretation because "the flag does not designate an automatically singular meaning."[43]

For Benjamin, the literality (it looks like a flag) and complexity (is it or isn't it a flag?) of *Flag* is betrayed by its historical relation to, not only the Stars and Stripes, but to any flag and the consequent interpretative ambivalence that must arise out of assumptions derived from and about flags. The power of *Flag* is that it belongs to a complex relational structure which resists any finality: *Flag* is constructed literally in much the same manner as a "real" Stars and Stripes,[44] suggesting its literal role of being a flag. However, while *not* being constructed in the normal manner—out of fabric—this literal function, its appearance of being a Stars and Stripes, and hence, a flag, is problematized (it does not billow in the wind, you cannot attach it to a flag pole, etc.).

The ambiguousness of the experience ingrained in and generated by *Flag* is to a large extent deliberate (however, as will be discussed later, the deliberate nature of the act of construction is not so clear cut). Fred Orton explains that "It was important for [Johns] that the history of the creative process should be part of the finished object, a conventional avant-garde strategy … He wanted the process and history of the making of *Flag* to be part of its meaning and effect."[45] The work of Jasper Johns in this respect echoes the mythic creation of America itself: the American exceptionalist ideal of one nation, under one flag. To add another layer of echoing and complexity, just as the Stars and Stripes itself evolved as states were added, Johns "continually returns to" to the Stars and Stripes and "retrieves it … to make another *Flag*."[46] Orton argues that the "affixed material," the stuff hidden under the colored wax—newspaper cuttings, advertisements, etc.—must be viewed as not as important as the manner in *which* they are fixed. Orton says:

> The affixed material that helps make *Flag* intervenes between representation and illusion (the depicted flatness of the Stars and Stripes) and literal flatness (the actual flatness of the fabric ground and prevents factitiousness coinciding with flagness) … the affixed stuff on *Flag* is neither obviously different from nor extraneous to literal flatness or depicted flatness. Rather, it functions as another literal surface.[47]

In other words, *Flag* makes obvious the layers of meaning that make up a genuine flag. Orton adds, "With this in mind we can see how it is the marks that make *Flag* come to mean more than what they are as material or texture; they imply something about how they got to be what and where they are, and more than that they imply 'experiences.'"[48] In this way, the affixed material—the newspaper's

tales of everyday horror and joy, the advertisement's desire to sell, sell, sell, and the snippets of "funnies" whose aim is to make us laugh—are all subsumed within *Flag*. The surface of *Flag* necessarily invites continual reinterpretation and actually reveals, somewhat discreetly, the myriad of social and cultural forces that make up any flag; and as the flag sums up the nation, so those same social and cultural forces are constantly struggling to be seen through the patriotic colors of the OG red, white, and blue. Flags at once bind together and divide, speak *for* while working to exclude. Johns's *Flag* can therefore be and become anything from an ambivalent gesture toward patriotism, a piece of cold-war propaganda, or anything else we desire, but crucially, it can be or become one or all (or more) of these things at any one given moment of time. What *Flag* reveals is the ideological work of the Stars and Stripes (or any flag); to pledge allegiance to the American flag is to suppress difference and dissent; it is to ignore the historical making of the United States and all that entails. A flag, one might argue, is what binds peoples together while it blinds them to their past. In the end, the flag and all it stands for—as the beginnings of Johns's own *Flag* reminds us—is just a dream: an American dream.

In the following chapters, we shall look at objects like Johns's *Flag* but mostly our focus will not be on art but on the products and objects of popular culture. To help us "read" these visual objects, each chapter will also introduce a theorist and theory of visual culture. First up is one of the preeminent visual symbols of America, its landscape; in "Visualizing Various American Landscapes," we examine the ways in which "manifest destiny" and "American exceptionalism" have been visualized through representations of the landscape. From John Gast's *American Progress* (1872) to the regionalist paintings of Grant Wood and Alexandre Hogue and the photography of America's national parks in National Geographic publications, landscape is a powerful symbol of American-ness. To help unpack this urge to visualize the landscape, we look at the work of W. J. T. Mitchell and D. W. Meinig. In Chapter 2, we turn to the first of two chapters on what I call American anxieties; the first, "All Consuming Culture," considers broadly what Elaine Tyler May calls "domestic containment" in post-World War II America; or, how the creation of the perfect housewife and the rise of suburbia served to reinstate a less agitated, class-aware social order in 1950s' American culture and society. The "pill" to "inoculate" the American public against the threat of revolutionary communism was consumption, a flood of labor-saving devices, large automobiles, and suburban housing: all bound up as the freedom to choose. As the most persuasive method of conveyance, we consider the role of advertisements and advertising of the period, with particular emphasis on the implicit gender inequalities "hidden" within the image. Helping us in this task will be French theorist, Roland Barthes and his work on myth. The second of our "Anxiety" chapters, Chapter 3, "A Case of Black and White," focuses on the "color line" in America. The theoretical dimension of this chapter is drawn from W. E. B. Du Bois and considers the distinctly visual emphasis in his work on black identity; concepts such as "double consciousness," "the color

line," "the veil," "second sight," and "two-ness" are powerful interrogative tools. Du Bois in his journal *The Crisis* was strident in his opposition to the lynching of black Americans and the chapter considers the role of photography in lynching. Where *The Crisis* deploys lynching photographs as a means to deconstruct them, we look at the work Black Panther, Emory Douglas, whose work forms part of a more strident and confrontational visual resistance to white cultural and racial dominance. Chapter 4, "From a Comfortable Distance: Visual Culture and War," discusses the challenging criticism of Martha Rosler and Abigail Solomon-Godeau in relation to documentary photography. Their thorough critique of documentary is explored through images of America at war, including Joe Rosenthal's iconic photograph of soldiers raising a flag on Mt. Suribachi, Don McCullin's *Shell Shocked Marine* (1968), and the terrible photographs of prisoner abuse at Abu Ghraib. In Chapter 5, "Crime and Punishment," we explore the work of Michel Foucault on the prison and his concept of power/knowledge, with a lengthy consideration of mug shot and crime scene photography. How did the mug shot come into existence, what does it tell us about crime and criminality? And what about crime scene photography—either the voyeuristic photographs of Weegee or those images made by photographers working for the LAPD—how do photographs operate as evidence in visual culture? The (imagined?) conservatism of America is reconsidered in Chapter 6, "Visualizing Sex in America." As the first Kinsey report on male sexuality and desire showed in 1948, American attitudes to sex were not as chaste as thought, and a brief look at the imagery related to these twin themes, especially pin-up images, reveals a clear fault line in American culture. We approach these images through Sigmund Freud's theories on dream-work and scopophilia as well as Laura Mulvey's theory of the male gaze. In the final chapter, "The Trouble with Kitsch: Highs and Lows in American Art and Visual Culture," we find ourselves once again considering questions of manifest destiny and American exceptionalism. The aim of the chapter is to make us think again about the history of American modern art; rather than "seeing" American art through the eyes of Clement Greenberg, whose ideas about great art and modernism have instigated the "Greenberg effect." What about the many artworks and artists who have, contrary to Greenberg, plundered popular culture as inspiration for their art? This chapter introduces the theories of Theodor Adorno and Max Horkheimer on the culture industry and reconsiders their negative assessment of low culture. To do this, Stuart Davis's "Tobacco-series" from the early twentieth century and Richard Prince's appropriated photographs of Marlboro-men from the late twentieth offer two distinct yet similar connections to low culture and the culture industry; a connection which should lead us to rethink American modernism and ask: what does it mean when artists explore and exploit the objects of everyday visual culture of America in their art? Does it make their work more or less "American"? And what does it matter either way?

Finally: a note on the images in this book. I have tried whenever possible to include images in the text but there are occasions where images are not present.

There are several reasons for these omissions. First, several requests for permission to reproduce images were declined (a few organizations were uncomfortable with the critical aspect of the book and hence about being seen in a negative light). Second, requests were made in good time for publication but replies were either too late to be included or, in the case of one large advertising firm, nothing was heard at all despite multiple requests. Third, some images and/or their illustrators were impossible to track down, although I try to direct readers to locations where the missing pictures are available.

<h1 style="text-align:center">–1–</h1>

Visualizing Various American Landscapes

... while I know the standard claim is that Yosemite, Niagara Falls, the upper Yellowstone and the like, afford the greatest natural shows, I am not so sure but the prairies and plains, whiles less stunning at first sight, last longer, fill the aesthetic sense fuller, precede all the rest, and make North America's characteristic landscape... Even their simplest statistics are sublime.

Walt Whitman, from "America's Characteristic Landscape" in Graham Clarke (ed.), *The American Landscape*

Introduction

In this chapter, we consider the ways in which the American landscape has been visualized in various media, as well as addressing *why* the process of picturing the landscape—*re*-presenting what can already be seen—has been and continues to be central to American national identity. In doing so we will touch upon what constitutes landscape itself—what *is* landscape?—but also how various representations of the American landscape performed and perform an ideological function, one that helped support and sustain a notion of American-ness. Of these the most obvious and historically significant are "manifest destiny" and "American exceptionalism'; and though the westward expansion of America long ago reached its physical goal, the so-called "frontier" mentality has arguably always been more important in defining the exceptional qualities of the emergent American nation and its people. And although streamlined and given a new spin in the late twentieth and early twenty-first centuries, the restless attitude of the early pioneer remains critical for national self-definition.

Reading the images of the American landscape will introduce and draw upon the work of what might appear an unlikely pairing of 1970s' geographer, D. W. Meinig, and a name familiar from the Introduction, W. J. T. Mitchell. I say "unlikely" but both highlight the ambiguities of meaning relating landscape and as such reveal the landscape, in a physical as well as intellectual sense, as a site of conflict. That is, the meaning of landscape is continually contested; indeed, it is possible (and this is a good thing) to see conflict between the theses of Mitchell and Meinig presented here. This in turn reveals how the representation of landscape in visual culture is subject not only to historical change across media—painting, photography, travelogue,

literature, etc.—but also criticism and theory. Crucially, the critiques of Mitchell and Meinig both emphasize another historical necessity or desire: *to visualize the landscape*. First up are maps, and ideological functions of mapping, followed by images relating to the frontier and manifest destiny, and concluding with a look at regionalist painting and photographs of America's national parks.

To put the American landscape in a critical context, I want to begin with Walt Whitman. In the preface to the first issue of *Leaves of Grass* (1855), the nineteenth-century American poet proclaims, "The United States themselves are essentially the greatest poem";[49] a poem written by the shared "poetical nature" of all ordinary American citizens and their relationship to the landscape around them: whether the urban or the rural. For Whitman, "The largeness of the nation, however, were monstrous, without a corresponding largeness and generosity of the spirit of the citizen."[50] Faced with the sheer *scale* of the American landscape, the new peoples of America tamed and ordered the vast expanse; hence, Whitman pictures a "oneness" or a special type of dialogue between the individual and their physical environment. To both underline and contradict Whitman's eulogizing, Whitman himself suggests an altogether harsher reality in "On to Denver—A Frontier Incident."

> The jaunt of five or six hundred miles from Topeka to Denver took me through a variety of country, but all unmistakably prolific, western, American, and on the largest scale. For a long distance we follow the line of the Kansas river, (I like better the old name, Kaw) a stretch of very rich, dark soil, famed for its wheat, and call'd the Golden Belt—then plains and plains, hour after hour—Ellsworth county, the center of the State—where I must stop a moment to tell a characteristic story of early days—scene the very spot where I am passing—time 1868. In a scrimmage at some public gathering in the town, A. had shot B. quite badly, but had not kill'd him. The sober men of Ellsworth conferr'd with one another and decided that A. deserv'd punishment. As they wished to set a good example and establish their reputation the reverse of a Lynching town, they open an informal court and bring both men before them for deliberate trial. Soon as this trial begins the wounded man is led forward to give his testimony. Seeing his enemy in durance and unarm'd, B. walks suddenly up in a fury and shoots A. through the head—shoots him dead. The court is instantly adjourn'd, and its unanimous members, without a word of debate, walk the murderer B. out, wounded as he is, and hang him.
>
> In due time we reach Denver, which city I fall in love with from the first, and have that feeling confirm'd, the longer I stay there. One of my pleasantest days was a jaunt, via Platte cañon, to Leadville.[51]

A "jaunt" in the hundreds of miles hardly seems pleasurable or a short trip, and so Whitman's memoir apparently disturbs the regular definition of a "jaunt." But then again, *this is* a jaunt in the context of the size of the physical environment. Whitman's short travelogue can hardly contain his pleasure, either; not only does he "fall in love" but, as we shall see, the language used to describe the landscape— "unmistakably prolific, western, American, and on the largest scale"—becomes

typical from the nineteenth century onwards. While Whitman does not use the word "sublime" to describe this landscape, the passage's reflection on the landscape is imbued with notions of sublimity. The landscape is not just called "America," it *is* America.

Whitman also reminds us most clearly of the relationship between history and the landscape; namely, the way in which the landscape shapes history and history shapes the physical landscape. Of these the most obvious is the westward expansion of the United States and the motif of the Frontier. Moreover, Whitman's writings reveal a darker side to the large and generous spirit of the American people, one evident in frontier rhetoric: a harsh and determined desire to control and maintain the social order, a desire that echoes the control and order required to tame the largeness of the American landscape. Finally, "On to Denver—A Frontier Incident" reminds us of the importance of representation; that is, the ways in which words and images are used in the understanding of what constitutes landscape, what it means and why it is so important to wider social, cultural, and political issues relating to American national identity. So, what is landscape?

What is Landscape?

As Rachel Ziady DeLue notes, "it is difficult to overestimate the importance of understanding what and how landscape is and does ..."; as such, she adds, "'landscape' is difficult to see and, consequently, to theorize... ."[52] Of course, this difficulty is what motivates and encourages the continuing debates surrounding the question, "what is landscape?"[53] In 1975, Jay Appleton described landscape as "a kind of backcloth to the whole stage of human activity," and to some degree this idea was an attempt to encapsulate the all-encompassing nature of "landscape."[54] In 2008, though, while DeLue concedes "landscape is part and parcel of human activity, experience and discourse," it is more accurate to describe landscape as "neither foreground, nor background, center nor periphery, etc."[55] In this vein, W. J. T. Mitchell, in his "Theses on Landscape," proposes the following: "landscape is not a genre of art but a medium" because, as DeLue summarizes, it is able to evoke "the manner in which humans use landscapes of all sorts (natural, pictorial, symbolic, mythic, imagined, built and so forth, if such distinctions can be drawn) as a means to artistic, social economic, and political ends (some nefarious, some not), as well as the manner in which landscapes of all sorts act on and shape *us*, as if agents in their own right."[56] Mitchell's "theses on landscape" are explored in more detail later, but here is his summary:

1. Landscape is not a genre of art but a medium.
2. Landscape is a medium of exchange between the human and the natural, the self and other. As such, it's like money: good for nothing in itself, but expressive of potentially limitless reserve of value.

3. Like money, landscape is a social hieroglyph that conceals the actual basis of its value. It does so by naturalizing its conventions and conventionalizing its nature.
4. Landscape is a natural scene mediated by culture. It is both represented, both a signifier and a signified, both a frame and what a frame contains, both a real place and its simulacrum, both a package and the commodity inside the package.
5. Landscape is a medium found in all cultures.
6. Landscape is a particular historical formation associated with European imperialism.
7. Theses 5 and 6 do not contradict one another.
8. Landscape is an exhausted medium, no longer viable as a mode of artistic expression. Like life, landscape is boring; we must not say so.
9. The landscape referred to in Thesis 8 is the same as that of Thesis 6.[57]

The upshot? For those looking for a definitive answer to the question, "what is landscape?" only disappointment awaits because no two textbooks seem ever to agree.[58] One reason for this is exemplified when Stephen Mills asks: "Is [landscape] what's out there, an empirical reality, or a representation, a framed image of some aspect of reality?"[59] Each question forms the basis of "two divergent schools of thought"; on the one side, the environmental sciences, such as geography and, on the other, the humanities, especially art history. Mills notes that only recently have efforts been made to bridge or "integrate" these opposing views. W. J. T. Mitchell's "Theses on Landscape" is perhaps clear evidence of this interdisciplinary effort and a comprehensive attempt to elucidate what we mean by the word "landscape."[60] Mitchell's list offers no easy or straightforward answers; as such I would advise a slow and thoughtful reading of each thesis.

Mitchell explains that, "[a] landscape just is a space, or the view of a place."[61] Buried within these formulations is a complex account of the creation of what we refer to as landscape, but I do not think we should be scared or put off by this apparent complexity. In essence, Mitchell's theses also convey a simpler argument: that images of landscape, so common to us all, are never neutral. There is, in other words, nothing "natural" about the landscape.

Although I do not intend to unpick each thesis in turn, one can identify an underlying set of assumptions that inform the theses on landscape. Of these, the notion of looking or gazing—viewing the landscape—is crucial, and Mitchell identifies a feature particular to this type or form of looking, which one can paraphrase as a question: what, exactly, do we look at when asked to look at a particular landscape? Referring to everyday parlance, Mitchell draws attention to the fact that, more often than not, if we are in the position to see a landscape—from the window of an automobile, bus, or train, for example—there is a tendency to exclaim, "look at the view!" The point being that rarely do we identify a specific "thing" in the landscape—a mountain, say, or "the ocean, the sky, the plains, the forest, the city, the river"—instead we ignore the particular in favor of the general vista or scene.[62] What this means, suggests Mitchell, is that our appreciation of landscape might "be dominated by some specific feature, but it is not simply reducible to that feature."[63]

Mitchell follows this observation with the example of the painter being asked to paint or depict a landscape.

The American geographer, D. W. Meinig, argues that, "[l]andscape *is an attractive, important, and ambiguous term*."[64] Attractive because it might bring to mind "some pleasant prospect … or the depiction and interpretation of interesting scenes … it may even be regarded as a way of viewing man as well as of admiring nature." Important because, more than the connotations stated above, landscape is a "technical term used by artists and earth scientists, architects and planners, geographers and historians." And now, we can add, those interested in visual culture. Landscape remains ambiguous though because "it is used by so many different people for such a variety of purposes."[65] It is worth staying with Meinig for a while longer because of the attempt to offer a more concrete idea of what landscape *is* through his descriptions of what landscape is *not*.

According to Meinig, landscape is related to but not identical with:

- *Nature*: "[t]he idea of landscape runs counter to recognition of any simple binary relationship between man [*sic*] and nature."[66] As such, the term landscape is a conceptual bridge that unifies what Meinig calls the "the impressions of our senses rather than the logic of sciences"; this makes it similar in outlook to Mitchell's "look at the view" analysis.
- *Scenery*: the problem here is that the idea of scenery is "limited, a conscious selection of certain prospects, locales or kinds of country."[67] Therefore it is a discriminating gaze, one underscored by some kind of desire or interest to examine a particular object. Consequently, when we choose to look at the mountain, the sky, the ocean, the city, the road, we are no longer looking at the landscape (again, we can see the similarity to Mitchell's "look at the view" point).
- *Environment*: although "landscape is all around us," environment "surrounds and sustains"; landscape is "less inclusive, more detached," it is defined by "our vision and interpreted by our minds."[68]
- *Place(s)*: a difficult term in itself because of its own ambiguous nature. When butted up against landscape, one idea of a "place" or "places" relies on the idea of fixed location. That is, we can visit a place—Las Vegas, the Lower East Side of Manhattan, the store at the corner of Mason and Powell Streets in San Francisco—but not a landscape because we are always already "in" landscape. Meinig draws on another kind of place, the notion of "a sense of place," which is a subjective and personal response and remains therefore "unique to each of us in content and in the way it relates to general social definitions of places" (the "home" for example or the memories one might have of their grandparent's house). In the end, "landscape tends to be something more external and objective than our personal sense of place; and something less individual, less discrete, than the usual named place; it is a continuous surface rather than a point, focus, locality, or defined area."[69]

- *Region, area, geography*: in his final "related to but not identical with" section, Meinig distinguishes between the map as a "symbolic abstraction of spatial relationships ... applied by geographers to the study of many phenomena which are not directly part of the visible landscape." For Meinig, such mappings, while "useful," are insufficient because, he argues, "the landscape must be visualized and if not directly by our own eyes then by means of the best substitutes."[70]

The Landscape Must Be Visualized

Mitchell and Meinig cannot over-emphasize that we only know landscape through representation. Something Meinig says above is worth considering in greater detail: for Meinig, "the landscape must be visualized and if not directly by our own eyes then by means of the best substitutes." Meinig's insistent "must" aims to convey a human imperative and is convincing, particularly when we consider the long history of human beings' attempts to visualize our world. Importantly, the process of visualizing landscape is not simply a case of using one's eyes but also of employing "the best substitutes." What does he mean by "substitutes"? For one thing, he might mean painting or travel writing, like Whitman's, but it might equally apply to maps and cartography, and of course to photography. All these and others are forms of representation used to visualize landscape. What we need to specify though is the implication that there are certain forms of representation whose ability to visualize the landscape exceeds that of others. Or, to put it simply, the impetus to represent landscape is firmly rooted in history and culture.

German phenomenologist, Martin Heidegger (1889–1976), famously discusses the desire to visualize landscape in his essay, "The Age of the World Picture." Heidegger's investigation leads him to ask, "[d]oes every period of history have its world picture, and indeed in such a way as to concern itself from time to time about that world picture? Or is this, after all, only a modern kind of representing, this asking concerning a world picture?"[71] Heidegger answers his own question: every period of history does have its world picture, *but* it is how this world picture is produced that differentiates. But Heidegger's point is more subtle and worth thinking through with care. He continues:

> Where the world becomes picture, what is, in its entirety, is juxtaposed as that for which man is prepared and which, correspondingly, he therefore intends to bring before himself and have before himself, and consequently intends in a decisive sense to set in place before himself.... Hence world picture, when understood essentially, does not mean a picture of the world but the world conceived and grasped as picture. What is, in its entirety, is now taken in such a way that it first is in being and only is in being to the extent that it is set up by man, who represents and sets forth.[72]

Heidegger adds: "The fact that the world becomes picture at all is what distinguishes the essence of the new age. *The world appears as re-presentation 'for man.'* In the classical age, to the contrary man is the one who is looked upon by that which is. Put simply: the gods or God used to look upon us and we had a perception that they he watched us; now we look at the world and we understand the world as that which we can see."[73] In these lines, Heidegger articulates a massive shift in human understanding, especially with regards to our "place" in the world. No longer subject to the gaze of the classical gods or God, human beings now subject the world to our gaze and thus we make the world appear as if for us and us alone. "On this account human beings explain and evaluate whatever is, in its entirety from the standpoint of human beings and in relation to human beings. Everything else is elided."[74] All knowledge, every form of evaluation and explanation for the world around us appears as it does because we make it so, an argument also implicit in Mitchell's first thesis: "Landscape is not a genre of art but a medium."

Mitchell's first thesis reveals that the very idea of landscape as genre seems unable to contain this broader notion of landscape; art, like cartography, fails to represent landscape because we cannot make sense of or fully apprehend landscape. Philosopher Edward S. Casey refers to this as "a quandary of containment":

> How is the artist to contain something as overflowing as landscape within the very particular confines of a painting? The issue here is not one of how objects of three-dimensions are to be represented in a two-dimensional surface: that problem is common to all painting and is by no means limited to landscape.... . Instead, the issue is how something that, by its very nature, overflows ordinary perception can be represented by something else that, by *its* very nature, can only represent itself to the viewer as a discrete object with definite dimensions and often within a delimited frame.[75]

Casey references the importance of the picture frame but also the act of framing, of identifying, and depicting only an aspect of the visible landscape (see Mitchell's fourth thesis). Moreover, there is the issue of scale, the actual dimensions of the painting, for example, which, as we shall see below, becomes a crucial aspect in nineteenth-century painting of the American landscape. For now though I want to return to another point made by Casey, ably supported by art historian, Kenneth Clark. Casey quotes from Clark's *Landscape in Art* to help underscore a rather surprising observation which, given Meinig's earlier insistence upon the issue, must be considered.

Apparently, the human desire to visualize the landscape as conceived by Meinig is—in terms of millennia of human history—a recent phenomenon. Casey argues that one would be hard pushed to find "the broad vistas, the commodious scenes that we consider to be the sine qua non of landscape painting ..." in the images of the ancient world of the West; when it appeared, landscape was "place-setting" whose role was as "a literal background only."[76] The relentless human effort to visualize landscape

through text and image, as Mitchell, Casey, and Clark all concur, truly emerges in the work of artists of the seventeenth century, becoming "the dominant art" through the creation of "a new aesthetic of its own" during the nineteenth century.[77] And this is where it gets interesting for the study of American landscape. Let us go back and reconsider Mitchell's sixth thesis: "Landscape is a particular historical formation associated with European imperialism." It so happens that the high point of European imperialism coincides exactly with the ascension of landscape painting; or does it? Mitchell's sixth thesis 6 does not refer specifically to painting or any other medium of representation; in fact, instead it goes much further: "Landscape is a particular historical formation." This means that the idea of landscape emerges at a specific historical moment as a solution to a specific historical and cultural set of circumstances. In this instance, and in the simplest terms, the logic of European imperialism—to bring civilization to uncivilized nations/peoples—required new ways of representing the world; forms of representation were broad—maps, charts, diagrams, painting, sketching, diaries, travelogue, and (later) photography, etc.—but when combined would amount to more than the sum of their parts: they form what French philosopher Michel Foucault would call "discourse."

During the nineteenth century, the discourses of power and knowledge converged on several issues in America, one being the "Indian problem," and I would encourage you to research this area in greater detail for there is limited space here to do the subject justice. The "Indian problem" can be seen as part of a bigger picture, namely the westward expansion and the rhetoric of the frontier. Martha Sandweiss alerts us to the fact that long before the introduction of photography, "[t]he West loomed large in the American imagination... ."[78] Sandweiss continues: "Known through paintings and prints, maps and drawings, through the voluminous words penned by travelers and explorers, [the West] was for many nineteenth-century Americans a fabled place of fantastic topography, exotic peoples, the place where the nation's future would unfold."[79] Photography might have made "this imagined place more real" but the imaginary West, in all its glorious potential, remained a potent charm.[80] Intimately bound up in the perpetuation of the imaginary West was Frederick Jackson Turner.

Published in 1894, as part of the *Annual Report of the American Historical Association for the Year 1893*, Turner articulated his "frontier thesis" in "The Significance of the Frontier in American History."[81] Turner describes the American frontier as "the outer edge of the wave—where civilization meets savagery"; and this is what makes the American experience of the frontier exceptional: "the American frontier," Turner argues, "is sharply distinguished from the European frontier—a fortified boundary line running through dense populations. The most significant thing about the American frontier is, that it lies at the hither edge of free land."[82] Besides the obvious inference of American exceptionalist thinking underscoring the thesis, Turner's essay presents the physical American landscape as not only available to immigrant settlers—beyond the frontier lies "free land"—but also a

logical rationale to legitimize the progressive expansion of the frontier: to replace savagery with civilization.

One might and should ask, "where exactly was the frontier at any given time?" There were no lines carved into the landscape to demarcate a front line as it were; what we might infer from this is that the frontier was a particular way of thinking about the physical landscape as well as the relation between the white settlers and the idea of landscape. Importantly, this thinking is "spatial." As Turner argues, the frontier actually produces both America and Americans: the frontier "promoted the formation of a composite nationality for the American people."[83] A sense of belonging to a country—America—and a wider populace—of Americans—was socially produced as progressive waves of people headed out into the wilderness and, through farming, then trade, then manufacture and industrialization to some degree, helped create and sustain the nation and a people with a shared vision. We now turn to the role of visual culture in the production of national identity and landscape.

Mapping America

I would ask you to consider the following: if a map is, as Meinig insists, a "symbolic abstraction of spatial relationships," is it not possible to describe a painting of the same landscape in much the same way? If landscape is the medium then surely all forms of representation engage in the abstraction of spatial relationships? Obviously, a map is not the only "symbolic abstraction of spatial relationships": one would argue that a painting, photograph, or literary description of a landscape might well be described in the same way but for different reasons. Nonetheless what should hold our attention here is the fact that a map, like any form of representation, not only represents a particular landscape (a mountain range, the prairie, a specific place, like the Grand Canyon) but also a particular "point of view" (where, exactly, is the Grand Canyon?). Quite simply to understand the power of landscape imagery (in all its forms) we have to consider not only what is viewed but *who* is doing the viewing on our behalf, as it were: what agencies, institutions, individuals are holding the pen, the brush, or the camera, actively editing what is taking "place" within the scene of the landscape; and, how do these views of landscape relate to the dominant ideologies governing in this case the USA? (One could think back also to who originally published Turner's essay on the frontier and why?)

In his fourth thesis, Mitchell describes the process like this: "Landscape is a natural scene mediated by culture. It is both represented, both a signifier and a signified, both a frame and what a frame contains, both a real place and its simulacrum, both a package and the commodity inside the package." Now this is quite complicated, so let us concentrate on maps to help elucidate Mitchell's point. I want us to consider the different ways in which mapping has helped *visualize* America. A short reflection on the kinds of maps with which we are all familiar reveals the complexity not only

of the systems of mapping—landscape, population, geological features, subway systems, etc.—but the simultaneous complexity inherent in our understanding of them. All maps are abstractions; that is, they are a form of representation of selected features, which offers the viewer a certain perspective or series of meanings—a map can answer the question, "where am I?" or, "how do I get from this place to that place?"—therefore, maps are a form of knowledge.

But maps in themselves are incomplete; they offer a specialized perspective. Their "abstract" quality relates quite obviously to their representation of three-dimensional space in two-dimensional form; exactly the same problem facing landscape artists identified earlier by Edward S. Casey. But maps differ considerably from landscape images. A map of geographical features requires reference to an agreed cartographical "language." That is, in order to understand a map we must be able to read it; we must be able to understand its symbols, its construction, its design, and, critically, its conventions. But before all of this, before we begin to read and interpret a map, we have to *recognize* an object *as* a map. Admittedly, this seems a somewhat obvious thing to point out: surely the difference between a map and other forms of landscape representation are self-evident? To consider this point, let us look at several cartographical representations of the Grand Canyon, Arizona (Plates 2–4).

In each of the above, we can identify similarities: for one, naming plays a key role; places, geographical features, roads are all named. And all but one attempts to represent the dramatic features of this landscape—the elevations, undulations, etc. that define this region. On the one hand, these maps help us respond to the basic question, "How do you represent the scale of the Grand Canyon in two-dimensional form?" But in terms of an analysis of landscape in American visual culture there is a much more interesting set of questions which go far beyond the pragmatics of how maps accurately portray their object, in this case, the Grand Canyon.

The fact that I have started with the question, "How do you represent the Grand Canyon [or any other geographical landscape] in two-dimensional form?" is not, one could argue, necessarily the first question one should ask. But the fact that it is reveals something about maps and culture; namely, the way in which the map and mapping appear completely normal. To begin with, "how" is to ignore "why" and by skipping "why" in favor of "how" we reveal what is essentially a culturally constructed and therefore learned act has become a neutral and "natural" way for us organize and understand space. Maps are not realistic (think, for example, of the subway maps of New York City, where the lines are made to conform to a logic not governed by the actual terrain of the city above), they are spatial abstractions, and yet we accept them often without question (until we get lost—then we blame the map). Maps do not, for example, tell us anything about the struggle faced by those early settlers who headed into the imaginary West or about the suffering of the indigenous "savage" peoples displaced as white settlers went about their mission to "civilize" the space. As such we must consider not only the various types of maps and mapping relating

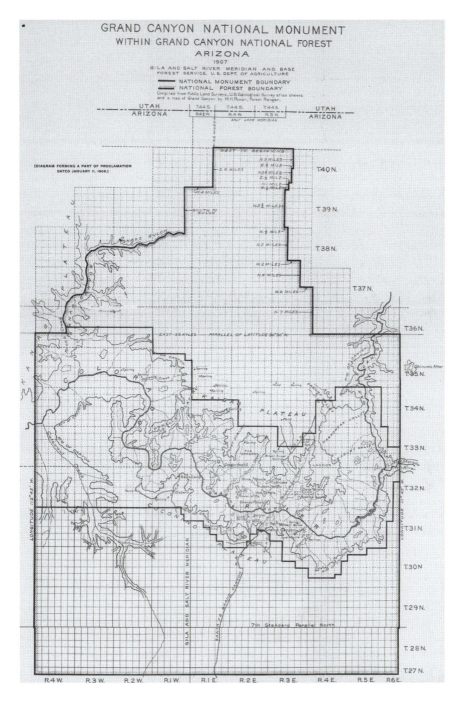

Plate 2 Grand Canyon National Monument within Grand Canyon National Forest Arizona, 1908. Courtesy of Library of Congress, Geography and Map Division.

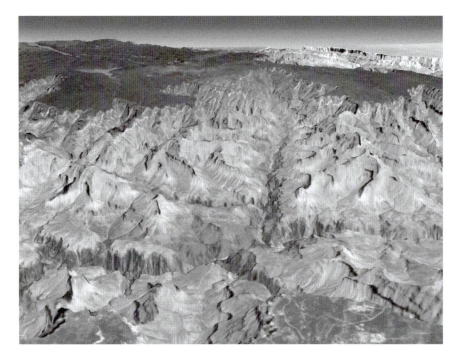

Plate 3 The Grand Canyon, courtesy NASA/GSFC/LaRC/JPL, MISR Team.[84]

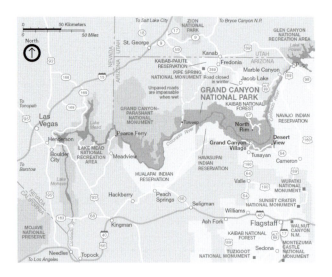

Plate 4 Grand Canyon Area Map, courtesy of the National Park Service, U.S. Department of the Interior.

to America but also the institutions that facilitated their creation. The geographer David Harvey rightly notes that maps "have always been, and continue to be, created and used in an extraordinarily wide range of institutional and disciplinary settings and for a variety of purposes."[85] It is worth quoting Harvey at length:

> In the bourgeois era, for example, concern for accuracy of navigation and the definition of territorial rights (both private and collective) meant that mapping and cadastral survey became basic tools for conjoining the geographer's art with the exercise of political and economic power. The exercise of military power and mapping went hand in hand. In the Imperialist era, the cartographic basis was laid for the imposition of capitalist forms of territorial rights in areas of the world (Africa, the Americas, Australasia, and much of Asia) that had previously lacked them. Cartographic definitions of sovereignty (state formation), aided state formation and the exercise of state powers. Cartography laid the legal basis for class-based privileges of land ownership and the right to appropriation of the fruits of both nature and labor within well-defined spaces. It also opened up the possibility for the "rational" organization of space for capital accumulation, the partition of space for purposes of efficient administration or for the pursuit of improvements in the health and welfare of populations (the Enlightenment dream incorporated into rational planning for human welfare).[86]

In essence, cartography is able to create what Harvey refers to as a "spatial frame."[87] The defining a particular space—for example, the West or the United States of America—allows for the situating and unfolding of "events, processes and things" within its ordered and known boundaries or limits. Historically, this has meant the strategic and deliberate use of maps as forms of propaganda and hence "tools of governance, power and domination."[88] In addition to this, Harvey notes another kind or level of mapping: mental or cognitive mapping.

For now, let us return to the fundamental issue: Harvey's far-reaching conclusion that cartography is first and foremost "a major structural pillar of all forms of geographical knowledge," one that plays a vital role in the "formation of personal and political subjectivities."[89] In other words, cartography becomes an enabling factor or process in the self-definition of individuals and societies/communities. In other words, the two-dimensional representation of "their" place in the space of a particular landscape actively creates and sustains identity: personal, local, regional, and national. We can draw several significant conclusions about mapping and identity based on Harvey's observations: a map is not simply an aid to locating oneself in the landscape, nor does it merely facilitate movement from one place to another; neither is a map just the visualization of geographical terrain. One could go on and on because maps and mapping might share consistencies but what is mapped reveals a much broader set of interests relating to many different institutions and disciplines. There are maps that trace the westward historical movement of people across the North American continent, the growth and decline of farming or industry; maps that show the shifting state lines and national boundaries of America; maps

that reveal patterns of American behavior, from voting in presidential elections to America's most visited tourist attractions. Go out and find as many different kinds of maps as you can, what do they show—ask why? When were they produced and for whom—the general public or a specialized audience? How would the maps you find have been used or kept? What do they look like? What about interactive maps on the Internet, how do they differ, if at all? And, where did you find them and, as such, why were they there?

For example, a few years ago I bought several road maps of the northeastern states of America, all published in the late 1950s and 1960s. I remember opening the package when they arrived to see that each map was clearly emblazoned with a sponsor: a large gasoline/petroleum company. Opening out the folded maps of each state, its highways and byways, cities, and towns highlighted in various fonts, colors, symbols, and I could easily understand how to get from point A to point B. On closer inspection, though, it became clear that other icons existed on the map, ones placed so as to draw attention to the locations of said map-sponsors' gas stations throughout the state. Also included are lists of "tourist attractions" and directions on how to get there from all the big cities and, of course, the convenient location of the sponsors' gas stations along the way to help fuel the journeys to and from. Moreover, the map provided more information on the attractions themselves, short paragraphs briefing the prospective traveler on their destination, complete with a reminder of the sponsors' key locations en route. In essence, a map *and* an advertisement; an invitation to explore the new American landscape of the late twentieth century without the worry of not knowing where you were heading and whether you would be able to find your way there and back; all underscored by the comfort of knowing that a gas station was never too far away. These maps trade on ideals and promises whose roots are traceable back to the frontier and imaginary West; tourism and travel, especially to geographical wonders like Niagara Falls, the Grand Canyon, or America's national parks, becomes a contemporary form of adventure. The automobile and the map afford benefits and luxuries unknown to the earliest pioneers, but the essence of travel, mobility, freedom, and becoming acquainted with the American landscape (well, certain aspects of it) can be framed as the continuation Turner's frontier thesis. The frontier was not only a site of conflict but also the place where American national identity was forged, now transmogrified into a place to visit—a point we shall pick up again in the final section of this chapter.

Manifest Destiny

Of course a map is a singular example of visual culture and in itself lacks the necessary power to substantiate identity of any kind without forming part of a bigger picture. David Harvey argues that "it is important to recognise that regions are

'made' or 'constructed' as much in the imagination as in material form and that though entity-like, regions crystallize out as a distinctive form from some mix of material, social and mental processes."[90] Maps are part of this process. But westward expansion and the frontier thesis required, as I noted earlier, a legitimate reason as well as region to go out into and appropriate the "free land" beyond the frontier.

Taking up Harvey's argument on the power inherent in mapping territory, America is "made up"; moreover, there is nothing exceptional about the character of those who went out in pursuit of their fortune in the West. For Meinig, the expansion of the United States is not simply the "Westward Movement"—which he says is "so famous in our national history and mythology"—but a "powerful Outward Movement that ramified deeply into every neighboring society."[91] Of these "neighboring" societies, the remainder of this chapter will focus on the white settler's representations of their Native American "neighbors," or more accurately, the ways in which the myths of the American landscape and the place and fate of the Native American population within it were intertwined. Under the heading, "Shoving the Indians out of the Way," Meinig flatly reminds us that at heart of the republic was "a vexing national problem"; namely, the difficulty of formulating an "effective Indian policy."[92] Meinig describes this problem as a "deep dilemma" because American leaders were motivated by a desire to have "expansion with honor"—"that is to dispossess the Indians of their lands with a clear conscience"; this in turn generated a new problem: "how to get such people out of the way without affronting the moral opinion of mankind."[93] From this we can "see" two things: (i) that the actual act of dispossession was not the cause of vexation, in fact, there was little dissent in government or among white settlers that, in its simplest terms, expansion was justified and proper whatever the consequences for the Native American population. And, (ii) a social, cultural, and biological hierarchy that placed "mankind" (white, civilized, moral) in a position of absolute authority over both Native American "savage" and the landscape itself. Meinig puts it like this: "Americans came to the same conclusion: one could not leave the continent to a band of wandering savages."[94]

Meinig's summary neatly conveys the logic behind the expansionist rationale. The gathering of two distinct populations under the monographic labels "American" or "savage" is further advanced by the sense that "expansion" has purpose, while "wandering" does not. "Purpose" relies upon logic and forethought and, hence, intelligence, while "wandering" appears as its opposite, invoking notions such as aimlessness and directionlessness. How can these people be of any usefulness to the Republic, a republic whose logical coherence is drawn from the Bible, history, and, whether they would have liked it or not, a European conception of rationality? And so it came to pass that westward expansion or outward movement became associated with the phrase, "manifest destiny." The phrase "manifest destiny" was originally coined by journalist John L. O'Sullivan in 1845,[95] and one can find reference to it as early as 1846 when, in a speech to the House of Representatives on January 3, Representative Robert C. Winthrop of Massachusetts referred to the "right of our

manifest destiny to spread over this whole continent."[96] Now is the time to look carefully at the ways in which the expansionist rhetoric reproduced itself in the visual culture of the nineteenth century and beyond.

Perhaps the best-known example of manifest destiny visualized is John Gast's *American Progress* (1872) (Plate 5), an image that is compelling in that it is, to borrow a phrase from Angela Miller, "everywhere and nowhere."[97] Miller notes that American artists of the nineteenth century adopted "conventions associated with the older European tradition of the heroic landscape" but "transformed their place-specific materials into nature scenes that carried national associations."[98] Rather than relating to a specific location or place, Gast's painting is a "synthetic" image of landscape; it is at once all of the American landscape while not making reference to any specific feature, land mass, town, or city. The landscape here is, according to Miller, an invention; one that echoes to a large degree Jay Appleton's earlier observation on landscape as the backcloth to human activity. The landscape in Gast's image also performs the important task of supporting the exceptionalist myth that, "the republic was more than the sum of its parts."[99] As such, Gast's image served an important function beyond its status as an artwork; but how and why?

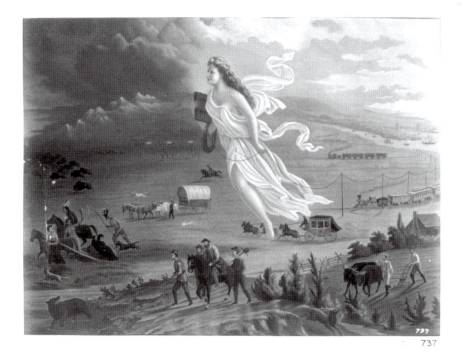

737

Plate 5 *American Progress*. George A. Crofutt chromolithograph, *c*.1873, after an 1872 painting of the same title by John Gast. Library of Congress, Popular Graphic Arts Collection. Prints and Photographs Division [USZ62-737].

Gast's original image and the lithograph reproduced by George Croffut, were, as Barbara Groseclose says, "[c]omposed for commercial use": that is, to sell the idea of expansion as progress; and by extension, that more expansion meant more progress and vice versa. This virtuous circle is grounded on a "masterful philosophical confusion."[100] To the modern observer, *American Progress* appears a somewhat naive, crude and, dare I add, bizarre evocation of expansionism. But why? Well, before we can even begin to consider this question we need to examine carefully the image itself. Throughout this book will appear plenty of examples of what will be called American visual culture, and for us to comprehend and then make sense of why these images might be referred to as American visual culture relies upon the way in which we analyze such images. Moreover, perhaps you might already be asking or maybe even expressing concern about the choice of image: why this one image and not another? And, if you have already skipped a few pages and looked ahead, why in the next section are there works of art by regionalist artists followed by photographs from a National Geographic publication of the 1960s? What have these got to do with maps of the Grand Canyon, or the "everywhere and nowhere" landscape of John Gast? I will be up front here and say that the reason is simple: comparative readings often produce insightful and exciting interpretations. So, let's look closely at the scene as played out in Gast's *American Progress*.

Now this is the first sustained examination of an image and what I suggest here is a basic means of approaching every other image in this book (but why stop with the images in this book?). Rather than begin with naming what is in the image, let's start with questions. What is most striking about this image? Can we identify any of the objects caught within the frame? Who is the floating figure in the center of image? Are those figures on the left "Indians"? Where in America is this "place"—can we recognize the mountain range/river/prairie/railroad, etc? What types of boats/ships are on the river? Which bridge is that? Is the light in the image significant? Notice how to the right or "east" the sky is bright and clear, whereas on the left side of the image, the "west," the sky appears dark, brooding and unforgiving: what might this mean or signify? Furthermore, what size is the original image? Who made it? What is it called? What is a lithograph? Who was George A. Croffut and what has he to do with John Gast, the image, and its production? When was it made? Where is it now? How many versions are there in existence?

There are many other questions, too. Such as, are we to connect the idea of American progress with the floating woman in the white drapery? And, if so, why is progress represented as a woman? What is the book she has clasped under one arm and why is she carrying telegraph wires? And then there are the anomalies. Why is Progress the only white woman shown in the image? Who put the telegraph poles in the ground to which Progress attaches the wires? Moreover, in terms of scale and perspective, how big or small is she—consider the distance between Progress, the ground below her, and the last telegraph pole? Can the people on the ground see her; and, if not, why can we? Finally, what will happen to the train when it runs out of track …?

Let us try to address a few of these questions. Art historian Barbara Groseclose argues that Gast's picture clearly depicts "a would-be western population [that] is a straight textbook demonstration of class uniformity."[101] Observe the vanguard of settlers farming the new land, pioneers heading westward with the railroads following in their wake, the already settled and civilized lands to the east evidenced in the bridges, ports, and ships signifying trade and progress. The sheer force of progress pushes the Native Americans towards the outer edge of the picture frame; and thus metaphorically and literally out of this visualization of American landscape and progress (to eradicate the Native Americans' presence in the landscape therefore becomes a form of progress for the collective good). However, we should pause and ask: why is the dominant figure of "American progress" represented as a white woman? Or, more accurately, why is progress gendered?

Clearly, what connects the protagonists in this image is their obvious movement through or across space—the dynamic notion of space Harvey described earlier—from right to left: or east to west. Other than Progress herself, the white settlers in this image are all male. Moreover, these male figures are engaged in typically masculine traits of labor (farming, driving horses), a less than subtle exposition that links masculinity with activity and being out of doors, and the feminine with passivity and the role of the woman indoors. (Where are the women in this image: lodged in the back of the covered wagon, or seated comfortably in the carriages pulled by steam locomotives? Certainly not breaking ground with plows or pushing back the frontier on horseback.) For Groseclose, if we are to see uniformity of purpose in this image we must think of the image in terms of exclusion. Groseclose's argument to a degree relates to and with Miller's notion of the American landscape in these nineteenth-century representations as "everywhere and nowhere." Here is every American individual but no individual specifically: a kind of homogenized body politic, but one whose body is distinctly male and its attributes masculine, all bound up in the depiction of a landscape that is everywhere and nowhere. However, as Amy S. Greenberg notes, while the "gold-rush migrant, the US-Mexico War soldier, the fur trapper and the frontiersman were all exemplars of masculinity in he middle decades of the century ... it [was] difficult to envision 'American Progress' in any of these forms, indeed in any male form at all."[102] A feminized "American progress" operates as a "benevolent domestic presence," distracting the eye and the imagination from the more distressing truth behind the violent nature of expansion in the name of progress.[103]

Going further, this class uniformity based on gender is also linked to racial uniformity. The whiteness of these bodies, elegantly reflected in the white robes of Progress, stands in distinct opposition to the Native Indians. Look closely at the image. Besides whiteness, in what other ways are the settlers distinguished from the Native Americans fleeing the scene? I can think of two striking differences: technology and dress. Where the Native Americans possess only basic means of shelter and transportation, the settlers have set forth from places with permanent

structures, road systems, railway stations, and thus powered travel; their horses pull wagons on wheels, they cultivate the land with tools, they communicate not with smoke but through the telegraph. In terms of dress, it is almost impossible to ignore the very different dress codes of the settlers and the Native Americans; where the settlers are covered head-to-toe in the style of the day, the Native Americans appear naked from the waist up, reinforcing their savagery and backwardness in the eyes of the settlers. A point made only too clear when we compare the only other non-male figures in this image, other than Progress: Native American women, one running and two others wrapped in blankets being pulled along behind a horse. However, unlike Progress who floats freely and whose breasts remain covered despite the clear possibility of an imminent "wardrobe malfunction," one of these women "shamelessly" reveals her breasts.

Gendered Landscape

In this final section, I want to turn to a series of images that link back to the previous discussions on landscape, mapping, and gender. The aim here is not to offer some kind of comprehensive account of any of the images but to encourage the reader to research other images from American visual culture which they might add to those discussed in the following section. Although quite different from the work of Gast, the examples under discussion below are arguably as ideological in their depiction of another ideologically motivated version of the American landscape. Firstly, two paintings by artists associated directly and indirectly with what is known as regionalism: Grant Wood and Alexander Hogue. The artists' images of the American landscape appear very different to Gast's, as well as from each other, but both were made at a time a great upheaval and hardship in America: the Depression and the effects of the Dust Bowl on America's farmers and farmland. These images themselves seem a world away from the final images in this chapter, a series of photographs taken from the book, *America's Wonderlands*, which, depending on your point of view is either a visual history of or a lengthy advertisement for America's national parks, published by National Geographic in the 1960s.

A few questions to bear in mind: why is it that in times of national hardship—for example during the Depression of the 1930s—the representation of landscape becomes a preeminent symbol for (or site of) that struggle? Conversely, are there any differences in the representation of landscape in less turbulent periods? Are the landscapes of America subject to a different or exceptionalist order of representation? Are we to believe that landscape or more properly the representation of landscape is the glue that binds peoples together or reveals a true sense of national identity? Or, does the representation of landscape present us not with a cohesive or shared sense of national identity but a stage or Appleton-related "backcloth" on or against which conflicting ideas of landscape and identity are contested without proper resolution?

To discuss these questions, we turn our attention to a series of landscape images produced under the auspices of regionalism in the 1930s, before moving on to the photographic paean to America's national parks in *America's Wonderlands.*

As Wanda Corn notes, regionalism came into being during the late 1920s and early 1930s, and "flourished in the Midwest."[104] Considered as "narrow in focus, descriptive and story-telling, conservative and nationalistic" by the art establishment—a group certainly not located in the Midwest—regionalism has in recent times been viewed with somewhat less suspicion and judged rather less harshly.[105] From the early 1980s onward, art historians, like Wanda Corn, Erika Doss, and James M. Dennis to name three, have readdressed those criticisms leveled at the art and artists who made up the regionalist movement. The off-hand rejection of regionalism says more about the inherent and unquestioning prejudices of the art establishment since the 1930s than it does about the work of Grant Wood, Thomas Hart Benton, and John Steuart Curry. Whether or not you find regionalist artworks avant-garde, as a specific artistic and political response to the devastating effects of the Depression following the stock market crash of 1929, such a parallel movement in American art deserves our attention.

Unlike the other major school of politically motivated American painting of the 1930s' period, social realism, the regionalists did not concentrate on the city, on urban decay, or on highlighting the aims of the political Left.[106] Instead, regionalist subject matter was the rural landscape, especially small-town America; its formal interests were figurative and traditional, and the statements of the artists themselves were often unequivocal about their motivations. The core regionalists—Grant Wood, Thomas Hart Benton, and John Steuart Curry—expressed dissatisfaction with European modern art's avant-gardism and the foothold it was gaining in America. Wood argued that "abstract art was divorced from reality, [and] that it had no contact with the people";[107] Benton, too, was scornful of what he called the "modernist dirt" he had to work out of his system and in his descriptions of American cities, especially New York as, "coffins for living and thinking."[108] Benton's vociferousness was in part an effort to divorce himself and his regionalist work from his earlier abstract experiments, under the tutelage of the synchromists, Stanton Macdonald-Wright and Morgan Russell.

Regionalism has long been regarded as conservative, nostalgic, and nationalistic, if not xenophobic, in its political attitude. Underscoring all these criticisms is the charge that regionalism was "anti-modern"; for example, in a review of Benton's autobiography, *An Artist in America*, Marxist art historian, Meyer Schapiro complained about the artist's "hatred of the foreign, his masculine emphasis, his antagonism to the cities," as well as "his uncritical and unhistorical elevation of the folk."[109] In a none too subtle manner, Schapiro here aligns regionalism with a form of fascism, one that offers an unproblematic realism, where the art of regionalism can be defined as escapism, providing "entertaining distractions from the realities facing oppressed people."[110] In this vein, Martha Sandweiss develops a connection

between Turner's frontier thesis as an echo of the "old myth of the West as garden" and artists like Thomas Hart Benton. Summarizing this period, Sandweiss says "nature presented a formidable challenge, but it was simultaneously a source of spiritual renewal and regeneration, a place and a force somehow capable of drawing out the very best of the American character."[111]

Paintings such as Grant Wood's *Stone City, Iowa* (1930) or the most famous of his works, *American Gothic* (1930), confirm Sandweiss's reading; here each image employs an emotive and romanticized agrarian American historical landscape, one filled with abundance, prosperity, and order.[112] In their efforts to reimagine a mythological American landscape, the regionalists, despite their advocacy of veracity of realist art over the elitist and nonsensical abstract art, all but fail to picture the true effects of the Depression on the landscape itself, best exemplified by the Dust Bowl landscapes of the southwestern states of America throughout the 1930s. (But look at the work of any of the regionalists and see the ways in which abstraction plays an important role.) One can reason that their avoidance of the awful truth relates to the powerful and persuasive force of the imaginary landscape as a means of moral and spiritual sustenance when the landscape in reality offered neither.

The fecund landscapes of Grant Wood, for example, as seen in works like *Stone City, Iowa* (1930), *Spring Turning* (1936), *Young Corn* (1931) (Plate 6), and *Fall Plowing* (1931) are completely absent in the 1930s' works of Wood's contemporary

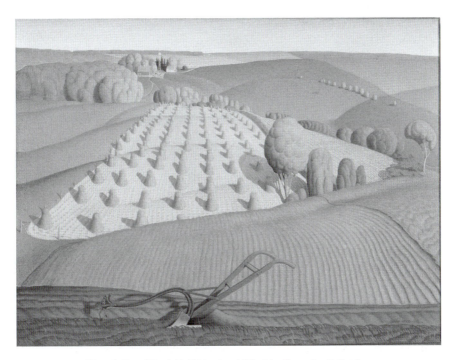

Plate 6 Grant Wood, *Fall Plowing*, 1931, John Deere Art Collection.

and regionalist with a small "r": Alexandre Hogue. Here we see the projection of an American landscape of an altogether different order. Hogue was not an "official" regionalist painter but his images of Texas and Oklahoma share many visual and political similarities with the work of Benton, Curry, and Wood, particularly an interest in the specificity and importance of the regional landscape.

Hogue's *Mother Earth Laid Bare* (1936) (Plate 7) manages to express these concerns, but with a twist. *Mother Earth Laid Bare* is an interesting foil to Grant Wood's *Fall Plowing* (Plate 6), a regionalist work par excellence. Both works are compositionally similar; notice the way each painting locates the horizon at the very top of the frame, leaving only enough space for the artist for a limited depiction of the sky. By doing so the majority of the framed space of the canvas is taken up by the rural landscape and focuses the attention of the viewer on the expanse of land running from the "front" of the picture to the "back." Before saying more about this, notice also the objects each artist includes within the image: buildings, fences, trees, hedges, and, of course, a plow. The significance of the plow is doubled because of the perspective employed by Wood and Hogue; each stands closest to us and each appears larger than the objects off in the middle and far-distance. The obvious symbolism of the plow and its resonances distinguishes Wood's painting from Hogue's.

In *Fall Plowing* the unmanned plow sits *in* the ground, its blades buried in a welcoming earth, a fertile bed waiting to sustain crops. We might ask, where is the

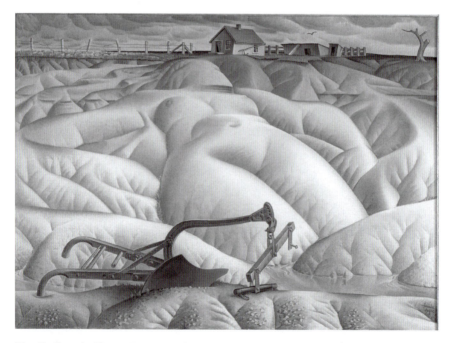

Plate 7 Alexandre Hogue, *Erosion No. 2—Mother Earth Laid Bare*, 1936, © 2008 Alexandre Hogue Estate, The Philbrook Museum of Art, Inc. Tulsa, Oklahoma.

absent farmer supposed to be plowing this field? I imagine him sitting comfortably under a tree, taking a break, and taking in the beautiful view of a fall landscape, considering what needs to be done during that day and the shortening days to come through winter, looking forwards to spring. Consider the plow in *Mother Earth Laid Bare*; it too sits in the landscape but through neglect rather than use. This plow has been exposed to the elements, resolutely sitting outside, embedded, abandoned, and forgotten. The ground beneath it is arid, hard, and resistant to cultivation or "land*scaping*": the manipulation of the earth by agriculture. Where is the absentee farmer? Well, there no trees to shelter under, no autumnal landscapes to take in, and, one could argue, no future to ponder. An abandoned farmhouse broken down and in disrepair, just like the fencing around it, suggests the occupants upped sticks and left some time ago. The uselessness of the plow in the foreground is echoed in the desolate farm buildings in the background; in the middle-ground, not the soft, feminine, undulations of Wood's lush valley in *Fall Plowing* but a dead landscape, molded from the hardened lifeless earth is the shape of a woman's corpse.

As discussed earlier in relation to John Gast's *American Progress*, progress was not only personified but also *gendered* as feminine. In Wood, we see clearly a connection between the landscape and the feminine, from the inferences of fecundity, of planting seed and the harvest, to the undulating and curvaceous shapes that make up landscape. Wanda Corn goes further, for her: "Wood's farm landscapes, are without doubt, the most sensuous and passionate works he painted. Mingling eroticism with ecstasy … he turned the landscape into a gigantic reclining goddess, anthropomorphizing the contours of fields and hills so that they look like rounded thighs, bulging breasts, and pregnant bellies, all of them swelling and breathing with sexual fullness."[113] In *Fall Plowing*, just as in works like *Spring Turning* (1936) and *Young Corn* (1931), Wood presents us with an eroticized landscape; perhaps "presents" is too obvious, the image *connotes* fecundity and eroticism, the painting turns the "relationship between farmer and mother earth into a Wagnerian love duet."[114]

By contrast, Hogue's image of mother earth dispenses almost entirely with connotation and presents us with the landscape *as* woman, as feminine. But what kind of woman is this? On the one hand, the land is bare, hence so is she; naked, exposed, and vulnerable. But on the other, the plow as a symbol of technology and masculinity lies impotent and unable to fertilize the land/woman. Here the American landscape, which means American-ness, personal, local, and national identity, has been betrayed or worse, slain, as in matricide. Technology, "man's" artificial union with mother earth, has reduced her fecund contours, the "rounded thighs" and "bulging breasts" to dust: no pregnant bellies here, only death. How quickly the positive attitude toward technology expressed in Gast has been turned on its head in Hogue. In the bottom right of Gast's image, of course, two farmers plow the land as Progress continues Westward Ho! planting new forms of technology, the telegraph, as she goes, closely followed by the railroad. Hogue's image presents a much darker

picture, one that asks us to consider for a moment what happens in the sole pursuit of the frontier, what is left behind?

In terms of the visual culture of landscape, Hogue's image when set against the images of Wood and Gast offers up an alarming and at times contradictory set of notions, knowledges, truths, and inclinations that exist in relation to the meaning of American landscape. Hogue's arid landscape is not as dry as it first appears. To the right of the plow, notice the silvery pool of water among the contours of the land, and in the background the grass surrounding the old farm buildings is vibrant green. The sky too appears full of rain as bulging steel-gray storm clouds gather on the low horizon. What might this mean? Does it represent the end of the drought? Is Hogue's image, despite first appearances, an image of hope, potential, and renewal, like Wood's imagined glorious small town reveries? Or does it remain a portentous picture, where the coming rains will not saturate and then reinvigorate but wash away that which remains? And what will be washed away, just some dried, powdery earth or something of much greater significance? You decide.

Conclusion

I want to conclude with a brief look at a series of images produced to illustrate a fascinating book called *America's Wonderlands: The Scenic National Parks and Monuments of the United States*.[115] In many ways, *America's Wonderlands* expresses, through text and image, similar anxieties and impulses toward the American landscape identified in Gast, Turner, maps, and the regionalist artists. Each example in turn played their part in specific social and historical moments and contexts, and *America's Wonderlands* is no different. Originally published by the National Geographic Society in 1959, and then enlarged in 1966, *America's Wonderlands'* objectives are clear: to continue the work of "courageous men of vision," "men like John Muir, Stephen T. Mather, Horace M. Albright, and John D. Rockefeller" in order to "carry on the crusade for an unspoiled America."[116] Melville Bell Grosvenor, then president and editor of the National Geographic Society, speaks in his "Foreword" of the importance in Congress of "conservation-minded patriots" and the role of *America's Wonderlands* to educate and further public knowledge of the national parks of America.[117]

Do you find this stirring rhetoric familiar? I expect you are able to pick out aspects of Turner's frontier thesis or ideas of manifest destiny in Grosvenor's words. Adding to Grosvenor's opening "Foreword," George B. Hartzog, Jr. writes on the continuing program of finding and then securing national park status for areas in Alaska, Hawaii, California, and Washington's North Cascades. For Hartzog,

Our Nation commemorates historic battles and birthplaces; how about the landmarks of such important movements as our industrial revolution, advances in medicine, progress

in the arts? These too are part of America's great heritage—and part of Parkscape's planning for the future. And the appalling speed of the steel and concrete across our land means we had best get all the parks we need—including more of the scenic parks—before it is too late.[118]

From these brief gobbets of Hartzog and Grosvenor's writings, what can we ascertain? What is the importance of commemoration and how is landscape a part of this process? What about the reference to America's "great heritage," for example, what *is* this heritage? Moreover, what is ignored or hidden behind this statement? What is not said, what is excluded, and what is overlooked?

Mitchell's second thesis on landscape is useful here. ("Landscape is a medium of exchange between the human and the natural, the self and other. As such, it's like money: good for nothing in itself, but expressive of potentially limitless reserve of value.") Whether Turner's frontier thesis, or paintings such as Gast's or Wood's, landscape is, in Mitchell's words, "a medium of exchange." So when Hartzog describes the need to create national parks in order to save the American wildernesses before it's "too late," he is actually equating their presumed disappearance with the decline of America and the American people. The fear of losing landscape is associated directly with the proliferation of road building, the intrusion of the contemporary world into an ancient and pristine one. Perhaps this is the final irony; remember Gast's vision of American progress? The westward march was as much one based on laying down steel rails and erecting wooden poles for the telegraph—the technological westward expansion—as it was a clearing of the land for agriculture. And yet, by the 1950s, this advance is phrased in terms of devastation not progress. Sticking with irony, look at Plate 8 taken from *America's Wonderlands*. How does this picture fit with the concerns outlined above? Two people stare down from a rocky perch onto a winding road below, a snaking pass cut into the Rocky Mountains. The photograph has a substantial depth of field; the vastness of the landscape is easily translated. But why do the viewers in the scene—a married couple, perhaps—seem to be more concerned with the parade of cars headed up by a large bus reimagined as what looks like a New York yellow cab? As an image of the wilderness, what is its function? How does it operate? I would ask you to compare and contrast the image with the meaningful "crusade" outlined above. How is it possible to balance the need for preservation while encouraging the American people to explore the wilderness. How will they get there and what facilities will be there to greet them? And how do roads, highways, gas stations, and car parks fit into the vision of *America's Wonderlands*?

In another image, we see a family sitting down to dinner "amid Giant Forest in Sequoia National Park."[119] Perched on small stools, family members tend to the fire, cook food, and prepare the dinner table as though not outdoors at all; the domestication of the forest appears here as incongruous as the family's large blue car, parked in stark relief among the sequoia. We should ask a few questions. Did

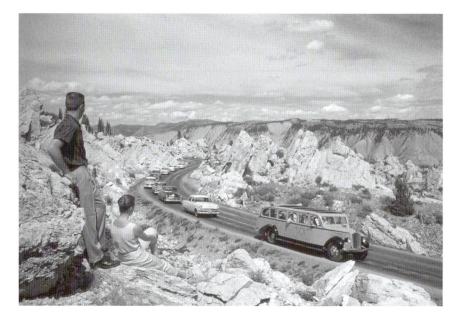

Plate 8 Sightseers in a yellow bus drive through Yellowstone's Hoodoos area. These aren't actual hoodoos geologically, as they are blocks of ancient travertine rock that tumbled from Terrace Mountain and rest in odd formations. *America's Wonderlands* National Parks Book 1966, pp. 86–7 Andrew H. Brown/National Geographic Image Collection.

the photographer stumble across this scene or was it planned out beforehand? Were several photographs of this scene made and if so why was this one chosen above the others? And how would such knowledge affect our understanding of the image and its relation to *America's Wonderlands'* quite open and specific goals and aims? And what about the image taken at Edwards Park of "Newspaper Rock" (Plate 9)? In this scene the photographer sets up a comparison between the children, their father, and the "Newspaper Rock." The side panel explains: "Indian petroglyphs on Newspaper Rock might recount news of eight centuries ago—if we could decode them. The myriad symbols challenge youngsters in Petrified Forest, Arizona. Father prefers a paper he can read."[120] Here the landscape is presented to us a text but one in a language we cannot read. In fact, there is no evidence that this rock is any kind of "newspaper" at all; the only true newspaper is the one held by the father. As such, the children are merely playing a game with the petroglyphs of a now absent civilization. Could we argue that this image enforces a view of progress where the white settler survives because of technological ingenuity and manifest destiny, while the "Indian," who apparently lack such ingenuity, disappears as a matter of course? And why does an emblem of a deceased culture seem only to reinforce the values (and the success of them) of the white settler rather than alert us to the significant

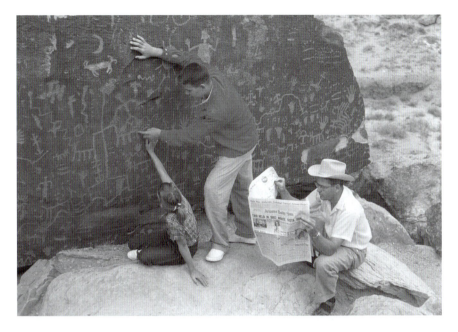

Plate 9 Young visitors try to decipher 800-year-old Indian petroglyphs on Newspaper Rock in Petrified Forest National Monument. NGM May 1958, Edwards Park/National Geographic Image Collection.

loss of a race of people and their culture, instigated and carried out under such terrible circumstances?

Finally, an image in *America's Wonderlands* that goes by the name of "Tracking a Fugitive Flower" (Plate 10).[121] What I have not mentioned so far is gender or, more properly, the way in which the family each with their own specific roles are mobilized in these images. As discussed briefly, the physical landscape tends to be considered in feminine terms, but these images of American families in the 1950s should strike us as interesting for other reasons. Look back over the previous images taken from *America's Wonderlands* and consider the roles of family members in each. What are men and women doing, and what do boys and girls do? Simple. Do you see how men and boys tend to be more active; often leading or helping women and girls? Or that woman and girls are in some sense offering support for the activities of men and boys? So while Dad is working at the fire, Mom is preparing the tables, arranging cutlery; while Dad is reading about the world's news, the brother— standing higher—seems to be instructing his sister. And here, in this final image, we find a partnership of an active male and a supportive female. It goes without saying that the man is holding the camera, he has spotted the "fugitive" flower, he has clambered the precarious outcropping in order to get a better shot. Conversely, the woman in this picture appears as the able assistant in the guise of a well but

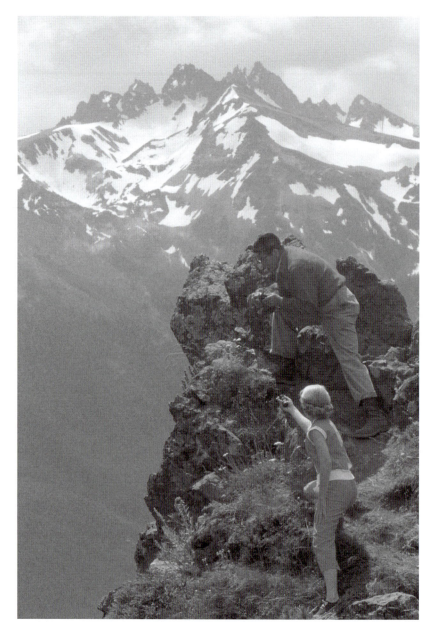

Plate 10 Paul Zahl and his wife photograph piper bellflower (*Campanula piperi*) blooms on a cliff. This hardy perennial is unique to the Olympics. In the background loom the 7,000-foot Needles. NGM July 1955, Paul Zahl/National Geographic Image Collection.

inappropriately dressed woman; she seems dressed more for evening cocktails rather than the hiking trail, and her role is less active and more concerned with positioning herself to help the action man perched on a cliff top. Unlike Progress in Gast, whose outstretched arm dispenses technological wonder, here the feminine presence holds in her hand some photographic equipment—a lens?—but it is an unacknowledged gesture. However, like Progress, she appears, despite the brightness of her outfit, invisible to all but us.

To end, I want to make clear that the critique of images in *America's Wonderlands* does not detract from the legitimate and important aims of the National Geographic Society's determination to preserve American wildernesses. What this brief critique does show us, however, is the complicated relationship that exists between America, national identity, and landscape. For example, the aims to open the wilderness to as many people as possible, for them to learn about their national heritage through an active engagement with the landscape requires road building and the use of steel and concrete so hated by the conservationists themselves. And then there's the difficulty in presenting the meaning of landscape and just how it is related to national identity; how do you "hide" the history of the eradication of the native peoples of America while drawing attention to their great culture and the impact this culture left in certain parts of the American landscape?

I have offered here a very slight and brief selection of landscape imagery and theory; the aim now is for you to go out and find more images of landscapes and to think about them anew.

–2–

Cultural Anxieties I

All Consuming Culture

Post-World War II America became embroiled in the "Cold War" and, as this chapter shows, the visual culture of the American nation becomes charged with explicit and implicit references to emergent cold war, as well as older cultural anxieties. Besides the fear of nuclear Armageddon and the invasion of communism, particularly through insidious means, such as movies made by communist sympathizers intent on brainwashing the American public, America was gripped by a more domestic drama. This chapter focuses upon the tandem developments of suburbia, advertising, and consumerism and the changing status of women in America after World War II. We shall look closely at the 1950s' visualization in advertising and popular media of the perfect home, equipped with the most modern conveniences, and managed by the perfect housewife. The 1950s mark a major shift in attitudes toward the role of women in American society; to some degree World War II freed women, albeit temporarily, from the social bonds that had tethered them to the home and to domesticity. But after the war ended we see what Elaine Tyler May has called "Domestic containment." However, despite the implicit overtones of imprisonment suggested by "containment," May reports that, surprisingly, the new found freedoms enjoyed during the war were given up with not much of a fight at all. But how and why? To help understand how this transition was managed, we shall look closely at several advertisements, and read them through "semiotics," in particular Roland Barthes' theory of myth expanded in his book, *Mythologies*.

From the late 1940s onwards, America—from the "man" on Main Street to the man in the White House—was preoccupied more than ever with the threat posed to the United States by communism and its proselytizers. The war against "Red propaganda" is best exemplified by the witch-hunts of Senator Joe McCarthy and the investigations of the House Committee of Un-American Activities (HUAC). In what might be described as a "purge," HUAC investigated a "blacklist" of alleged communist sympathizers working in the film industry, all suspected of secreting propaganda in films. Concern over surreptitious "brainwashing" says much about the contemporary attitude toward the power of the cinematic medium, so it goes without saying that in response to films with perceived hidden or implicit messages, many movies were made with explicit anti-communist messages.

Of these, Warner Brothers' *Big Jim McLain* has now achieved something approaching cult status. The plot is straightforward to say the least: A HUAC investigator, "Big" Jim McLain, played by John Wayne, is sent on a mission to Hawaii, his objective to root out and then boot out communists. Formulaic and lacking any character-related nuance, it is clear that Big Jim is the force for good, the embodiment of the American way; his communist enemies' paper-thin baddies with no redeeming features. Similarly and often as bluntly, many movies from the 1950s' science fiction genre allegorized the "red threat," casting "Martians" from the red planet in the barely disguised role of communist invaders.[122] Not every science fiction movie adhered to this simplistic template, though. For example, *Invasion of the Body Snatchers* (1956) offered a sharp critique of the "mindless" scare-mongering at the heart of Hollywood anti-communist film-making; the rather straightforward depiction of mind-control is not what it first seems and one can quickly see in *Invasion of the Body Snatchers* not a critique of the threat of communism but of American anti-communist anxiety pushed to its extreme. What remains most striking about *Invasion of the Body Snatchers* for our analysis is its setting: suburbia.

As rich and as entertaining as the films of the 1950s are in the context of cold war anxieties, this chapter examines how competing ideas of "Americanism" and "un-Americanism" were visualized outside of the movie theater. There are several reasons for this decision—scale and scope for one thing—but for me the most persuasive reason is that their absence will encourage readers to research the diverse history of the medium for themselves. Another reason is simply that limiting our focus on communism and the cold war in America distracts attention from two other crucial cultural anxieties: gender, in this chapter, and race, in the next. The last chapter explored the ways in which the landscape has been gendered, but a wider anxiety about gender or, more accurately, the problem posed by women can be seen in the subsequent rearticulation of post-World War II gender roles.

The "backcloth" against which this rearticulation takes place is the new arch-itecture of the suburb; onto this backcloth were projected the defining notions of 1950s' American culture: "social exclusivity, female domesticity, and a lust for things."[123] As such, it is important that we consider the role of women within the spaces and places of the suburb, and the ideal of the home within the suburb as a site (sight) of conspicuous consumption; or, the coming of the all-consuming form of American culture. Imagery of the home, especially the kitchen, and the multitude of other significant objects of consumption of the 1950s, like the television set and the automobile, appears repeatedly in advertising. In order to interrogate these advertisements, we shall adopt a critical approach known as "semiotics," especially the work of French theorist, Roland Barthes (1915–80) and his work on what he called "myth." Barthes' work is important for our understanding of consumption as ideological domination, what I referred to earlier as an all-consuming consumer ideology; as Barthes notes, when we buy the products of capitalism, from toothbrushes

to automobiles, we must also consume its "codes": as such, a toothbrush is no longer *just* an object for ensuring oral hygiene but the route to the perfect smile, which leads to a charmed social life, better promotion prospects, or perhaps greater respect from peers; so, a car is more than just a mechanical means of getting from A to B, as we shall see.

The Saturday Evening Post cover (August, 1959) (Plate 11) spells out, in a constellation of consumer goods, the aspirations befitting a young couple who gaze up to the "stars" and see the "secrets of long life" twinkling in the night sky: a ranch-style house with swimming pool; a son, playing baseball, and a daughter, learning piano;

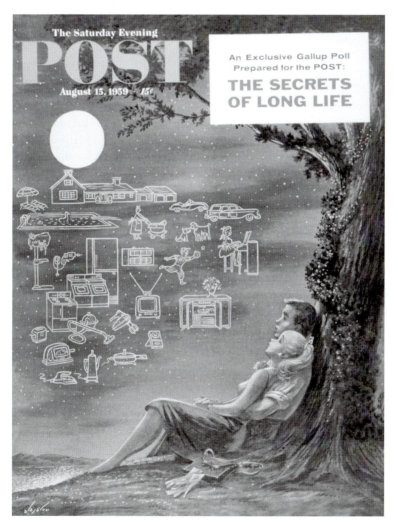

Plate 11 Constantin Alajalov, *Moonlit Future*, *Saturday Evening Post*, August, 1959, © 1959 SEPS; Licensed by Curtis Publishing Company, IN. All rights reserved. http://www.curtispublishing.com.

a nursemaid to tend a new-born; two cars—his and hers; a television and all the labor-saving aids one could wish for (if you were a woman in the 1950s). I want to stress that what is at stake here is not idle fantasy; these are not pipedreams. Floating above the future married couple is more than simply the American Dream, these consumer goods represent not just the desirable but an achievable American way of life; a way of life that distinguishes Americans from communists. And at the heart of this way of life is freedom, not just in the form of political democracy, but the freedom to consume from a cornucopia of consumer products.

Only a month before the publication of *The Saturday Evening Post*, on July 24, 1959, Vice-President Richard Nixon and Soviet Premier Nikita Khrushchev debated the relative merits of capitalist and communist ideologies in the so-called "Kitchen Debate." The occasion was the "American Exhibition," which took place in Sokolniki Park, Moscow. Nixon directed the Soviet Premier toward a kitchen exhibit, saying, "I want to show you this kitchen. It is like those of our houses in California." Everything on display could be produced in the thousands and installed directly into American homes, Nixon went on; the modern American kitchen and consumerism more generally exemplified the American way of life, one based upon the principles of freedom and choice. Ultimately, according to Nixon, the kitchen before the two men exemplified "Freedom from drudgery for the housewife." Unsurprisingly, Khrushchev saw it as "a display of wretched excess and bourgeois trivia."[124]

As Karal Ann Marling notes, these expositions of "science, technology, and culture" with their displays of modern homes and supermarkets were "important Cold War propaganda devices, offering compelling, tangible evidence of the economic system that so casually spewed forth labor-saving marvels, frozen dinners (steak and French fries) and tasteful living furnished by *House Beautiful*."[125] Marling adds that, "The items on display in Moscow—the houses, the groceries, the fancy cars, the pretty clothes—came from the everyday experience of individual Americans. They were somebody's, everybody's, definition of the good-life in the affluent 1950s. As such, they were the decade's most powerful icons...."[126]

The summation of all the rhetoric and posturing situated the kitchen as iconographic center of the new American home, an American home rooted in a newly emerging form of suburbia.

Domesticating America: Consumption and the Cold War

During the war American women had answered the call of the government and successfully made the transition from homemakers and housewives to skilled manual laborer and factory worker, jobs traditionally associated with men. Many women were stirred by the idea of taking up the tools of industry, following in the imaginary footsteps of "Rosie the Riveter," first seen in Norman Rockwell's *Saturday Evening*

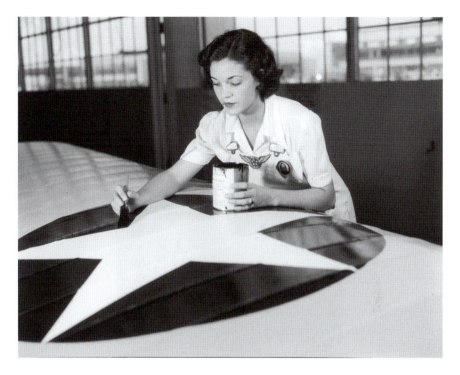

Plate 12 Painting the American insignia on airplane wings is a job that Mrs. Irma Lee McElroy, a former office worker, does with precision and patriotic zeal. Mrs. McElroy is a civil service employee at the Naval Air Base, Corpus Christi, Texas. Her husband is a flight instructor (August, 1942). Library of Congress, Prints & Photographs Division, FSA-OWI Collection [LC-USW36-387].

Post cover (May 1943).[127] Encouraged by the government to fulfill their patriotic duty, many women responded to posters with headlines proclaiming: *Women in the War, We Can't Win Without Them* (1942) and *Women, There's Work to be Done and a War to be Won ... Now!* (1944).[128] Each of these posters in turn quite clearly attempts to portray the image of the ideal woman to help fight the war on the home front; after all, the war cannot be won "without them," there is "work to be done," and this work can be done by women. But this is more than just a case of putting on some cover-alls and picking up a wrench. To enter the working environment of the skilled laborer required training, application, and self-belief; Packer's *Good work, sister: we never figured you could do a man-size job! America's women have met the test!* (Plate 13) shows a resolute Rosie-type eating lunch with an older male colleague (note the white hair above his ears). It is interesting to consider why an image such as this would encourage women into the workplace; after all, the male co-worker is expressing his surprise that a woman could perform "a man-size job" with such skill. What, I wonder, constitutes a woman-size job: making the sandwiches they're both eating? The irony here is that this woman worked alongside men *and* made

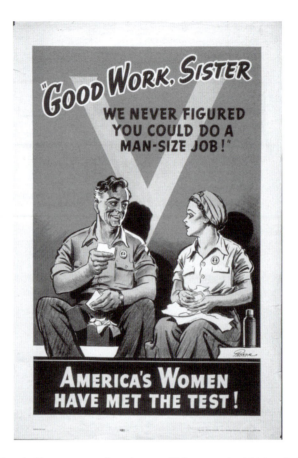

Plate 13 "Good work, Sister: we never figured you could do a man-size job! America's women have met the test!" CREATOR: Packer. Library of Congress, Prints & Photographs Division [LC-USZC4-5597].

the sandwiches. But maybe I am being too presumptuous and "seeing" this poster through contemporary eyes? Rather than demeaning his female co-worker, maybe his surprise is genuine; this is probably the only occasion that long-held, deep-seated prejudices about women and the work they were capable of had been properly and publicly put to the test. As the poster intimates, encouraging women into the workplace and monitoring their performance *had* been a test, one that they passed with flying colors. As such, the poster is not simply a call to arms; here is modern womanhood working to cement consensus—the American war effort—by displaying a clear sense of shared female, and worker experience. Now, this is all well and good during a period of conflict where immense personal sacrifice (waving off loved ones off to fight but who may never return; doing her bit for the war effort on the home front) on the part of all Americans, but when the war ended, this social and cultural

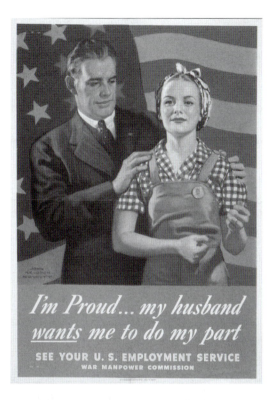

Plate 14 "I'm proud . . . my husband wants me to do my part: see your U.S. Employment Service War Manpower Commission." CREATOR: Howitt, John Newton (1885–58) Library of Congress, Prints & Photographs Division [LC-USZC4-5603].

shift in gender roles, what Mikhail Bakhtin called the carnivalesque—the world turned upside down—had to end and somehow be reversed. Things had to return to their "place": a process Elaine Taylor May calls "Domestic Containment."

For May, the response to the perceived postwar threat to the American way of life was to seek security: Americans, in particular the expanding middle-class, "wanted secure jobs, secure homes, and secure marriages in a secure country. The reason was straightforward enough: "Security," May writes, "would enable them to take advantage of the fruits of prosperity and peace that were, at long last, available. And so they adhered to the overarching principle that would guide them in their personal and political lives: containment."[129] Containment operated on several levels in 1950s' America. The concept was originally used in a foreign policy context by the American chargé d'affaires in Moscow, George F. Kennan; so, in 1946, it was the threat to security by the Soviet Union that needed to be contained. But by the 1950s containment was more malleable and its uses extended to cover the containment of the nuclear bomb, domestic anti-communism had to be contained, and of course,

the home became refuge for domestic containment.[130] Within the walls of the home, "potentially dangerous social forces of the new age might be tamed, where they could contribute to the secure and fulfilling life to which postwar women and men aspired"; women and men like those on the cover the *Saturday Evening Post* gazing at their Moonlit Future.[131]

Here the suburban home becomes the hub and the automobile the extension of the domesticated, private space of the suburban home. Going back to the Kitchen Debate, Nixon saw the ameliorative benefits of home ownership and of filling these new homes with labor-saving devices and appliances; for him, "home ownership would diffuse two potentially disruptive forces: women and workers." As May notes,

> In appliance-laden houses across the country, working-class as well as business-class breadwinners could fulfil the new American work-to-consume ethic. Home ownership would lessen class consciousness among workers, who would set their sights toward the middle-class ideal. The family home would be the place where a man could display his success through the accumulation of consumer goods. Women, in turn, would reap rewards for domesticity by surrounding themselves with commodities. Presumably, they would remain content as housewives because appliances would ease their burdens. For both men and women, homeownership would reinforce aspirations for upward mobility and diffuse the potential for social unrest.[132]

Suburbia and the suburban home, then, become the new "front line" in the battle to reconfigure America to middle-class ideals, a pressure point, if you will, where often conflicting values of American culture intersect. Beatriz Colomina argues that the early cold war period was a "hothouse," one that bred "new species of space" and instituted a "new organizational matrix." "Everything in the postwar age," Colomina argues, "was domestic."[133] For example, the "drive-in" cinema was "promoted as a living room, bedroom and kitchen, where you could take the kids, dress as you wish, have a conversation, make noise, seduce, and perhaps watch a film."[134] America's national parks were domesticated along similar lines; think back to the National Geographic *America's Wonderlands* imagery discussed in Chapter 1, with their road systems, walking trails designed for women to enjoy in high heels, and camp-sites designed to look like suburban cul-de-sacs, the "great outdoors was transformed into a comforting domestic interior . . ."[135]

Home, then, with its associated comforts and behaviors, can be seen to extend *beyond* the limits of the individual's property. On saying this, the domestication of the drive-in cinema or drive-through restaurant, or of the landscapes of the national park, not only extends the notion of private space but connects it ever more closely with pleasure derived from consumption. This is not to say that prior to the postwar period consumption was not pleasurable. Rather, the postwar period represents the democratization of consumption, or, less grandly, a shift in American cultural values

that encouraged rather than chastised what sociologist and economist Thorstein Veblen (1857–1929) called "conspicuous consumption."

To understand the relationship between consumption and the visual culture of the postwar period, we must consider the epochal cultural and societal shift that took place in America at the end of the nineteenth century, the shift from entrepreneurial to monopoly capitalism: a new phase in the development of modernity. Veblen's *The Theory of the Leisure Class* (1899), a book that chides the cultural elite of America for making a virtue of wasteful behavior, is important because it was written in this transitional phase. Conspicuous consumption (and its necessary adjunct, conspicuous waste) for Veblen mean the "utility of consumption as an evidence of wealth ...'; simply put, extravagant expenditure on goods which satisfy no justifiable need other than to display spending power.[136] Veblen attacks capitalism's self-perception as the most advanced form of culture and society, arguing the reverse: calling it barbaric. More than just an issue with conspicuous consumption, then, Veblen is distressed at the elevation of mere trivia—learning long-dead languages, engaging in pointless leisure activities, building ostentatious houses, or having architectural structures built in your name—as the pinnacle of American culture and society. To be able to do nothing and then to display how little you do as a mark of social status and cultural superiority is barbarism. As Theodor Adorno notes, "Under Veblen's gloomy gaze, lawn and walking-stick, umpire and domestic animal become revealing allegories of the barbarism of culture."[137]

At the heart of Veblen's critique are, of course, his own prejudices, namely his own objection to the leisure class itself, which is "not so much the pressure it exerts on the others as the fact that there is not enough pressure on it to satisfy his puritanical work ethos."[138] Puritanical work ethos or not, we tend to forget the outrage most Americans felt at the end of the nineteenth century when the wealth of the few far exceeded anything previously imagined. The power these figures held both psychologically and financially led to many strikes, battles, etc. where the rich could always invoke the power of the police and military to protect their plants and produce. The ostentatious and glamorous lifestyles of the rich both thrilled and sickened ordinary Americans and, as John Diggins argues, "it must be asked whether lower-class Americans actually desired to bring down the higher classes or merely to climb up with them."[139] On the cusp of an aspirational or revolutionary culture, the former, despite the protestations of the latter, won out as capitalism shifted gears and America embraced the technological promise of early twentieth-century modernity.

In *Making the Modern: Industry, Art, and Design in America*, Terry Smith traces exactly how this technological promise of American modernity was "sold" at the turn of the twentieth century, focusing on Henry Ford and the Ford Motor Company. Clearly, what is significant about the Ford Motor Company was "mass production," the installation of "new methods of production on an unprecedented scale," methods which quickly became "not only striking examples of innovative manufacture but also symbolic models of a desirable kind of modernization."[140] Modern America

or America-as-modernized was envisioned through images of industrial progress: in essence, "Mass production reproduced images of itself on a massive scale for mass consumption."[141] For Smith, images of progress actively produce not only a corresponding image of modernity but modernity itself, as such; it is controlled and organized and resembles the process of iconology we discussed with reference to W. J. T. Mitchell in the Introduction. What we have then is "the split between an iconography—a repetition of images—to an iconology—the active production of meaning and knowledge through its social reception."[142] One of the most interesting aspects of this process is the production of myth, specifically what Smith refers to as the "myths of Henry Ford." We shall discuss myth in greater detail below but it is worth pausing to consider the "myths of Henry Ford." According to Smith, Ford was able to project a complex and some might say contradictory "image" of himself, his company, and his cars through iconology; Smith identifies the following myths relating to Ford: "the successful plain man, the engineering genius, the farmer-mechanic who worked hard and got lucky, the social prophet and philanthropist, the conservative visionary, the man whose doctrine of high wages and low prices makes capitalism work for all (that is, achieves socialism) ..."[143]

Smith refers to these "myths" relating to Ford as "wish-projections of people in a variety of political and ideological positions," all of which formed part of the "carefully cultivated imagery of the Ford Company."[144] Even from this brief exegesis we can see that the general public's relationship with the Ford Motor Company extends beyond the simple purchase of an automobile; to buy a Ford car associates and embroils the consumer in a much deeper, more nuanced cultural relationship with the mass-produced object; people buy more than a car, they buy and, in the process, help reproduce a set of cultural relations which come to be seen as "normal."

In "Confessions of a Commodity Fetishist," the Preface to the twenty-fifth anniversary edition of *Captains of Consciousness: Advertising and the Social Roots of Consumer Culture*, Stuart Ewen argues that before the 1970s the institutions of consumerism, mass media, and commercial culture—despite "leaving tractor marks across the American social landscape"—were rarely acknowledged as a subject for serious academic study. Rather, the ability to ignore the products of mass culture was the "litmus-test of intelligence." [145] While this might be true in an American academic context, the "shadowy arts of persuasion," or advertising as we should call it, had been explored during the 1950s in France by Roland Barthes. Most famously, Barthes' *Mythologies* was an attempt to use semiotics and semiology to unpick the meaning of key French cultural products of the era, from the Citroën DS automobile to steak and chips, from the face of Greta Garbo to the world of wrestling.

For Barthes, these "objects" have a mythological status; by this he means that each possesses a prosaic or literal meaning (the car is the epitome of modern engineering, the contemporary equivalent of "great Gothic cathedrals"[146]) while partially concealing a more suggestive meaning; here the car is more than engineering, it is a

tactile, sexualized object, where doors are "caressed," cushions "fondled," the car is "totally prostituted, appropriated" to the extent that "one pretends to drive with one's whole body": car and car lover become one in what appears to be a new but natural form of union. Barthes' commentary on the Citroën DS is particularly pertinent for thinking about Ford and mass production because it is a revelatory form of address; Barthes shows us that industrial production is able to present itself to consumers as a benign and natural process: as Ewen notes, "It is a benign Nature because it floats or appears to float by virtue of itself. It is nature apart from the experience of what is natural."[147]

Barthes, Myth, and Mystification

Barthes argues, in "The Rhetoric of the Image" (1964), that there has been a historical tendency to consider the image as a form of meaning as "a rudimentary system in comparison to language"; in other words, pictures cannot convey the same complexity and richness of meaning one finds in written and spoken language.[148] As such, Barthes' semiotics of the image, if you will, is a rejoinder or at least an attempt to understand meaning and images as a particular type of language. In this respect, Barthes' work builds on the pioneering studies of Swiss linguist, Ferdinand de Saussure (1857–1913); therefore, it is helpful to briefly consider Saussure's groundbreaking conception of language.

Published posthumously in 1916, Saussure's *General Course in Linguistics* challenged the view that language was an organic system, a naturally occurring phenomenon, one that understands the relationship between words and things to be reflective. Such a "common-sense" view of language is based upon the idea that words are simply "naming devices which allocate to each object a discrete word."[149] Following this, we can say that the reflective model believes language to be a neutral system of communication and description. Saussure argues the opposite: language is a social and not a natural construction; far from being neutral—language is not a reflection of the world—it is language itself. Saussure divides language into *langue*, the rules and organizing principles of language, and *parole*, the everyday utterances of speech, and his analysis concentrates on the former rather than the latter. This is because Saussure is less interested in the heterogeneous qualities of *parole*, the way in which words are used in speech, and much more interested in the task of revealing the homogeneous "structure" of *langue*. Saussure's emphasis on structure and of revelation makes him the earliest "structuralist" thinker.

Saussure's examination of *langue* is focused upon the investigation of the linguistic unit or *sign*. The sign is made up of a signifier (an image, a sound) and a signified (concept or meaning) (see Figure 1 bottom left) and the relationship between signifier and signified is, crucially, *arbitrary*. Saussure argues that the internal connection within the sign between the signified "tree," and its signifiers (an

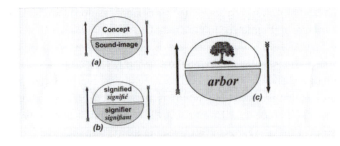

Figure 1 Saussure's model of semiotics (from Ferdinand de Saussure, *Course in General Linguistics*, orig. 1910–11).

image, the written word, an utterance) is not fixed but rather arbitrary; there is no reason for a tree to be called a tree, in fact, historically the English language could well have settled on any number of alternative signifieds, such as "eert." Saussure defends his thesis of the arbitrary nature of the sign further by arguing that if words only reflected preexisting concepts, examples of exact equivalents would be found in all languages, which is patently not the case.

Langue operates not through similarity, then, but through difference; it is a negative system of meaning: a tree is a tree because it is not a cat, etc. As a system of difference, signs work or operate in opposition to one another, producing meaning "though the selection and combination of signs along the syntagmatic and paradigmatic axis."[150] In keeping with our interest in Barthes, his explanation of syntagmatic and paradigmatic is particularly informative.

In *Elements of Semiology*, Barthes describes the paradigmatic and syntagmatic elements of the "garment system," thus drawing on singular items of clothing rather than singular words; he notes that the paradigmatic elements are as those items which cannot be worn at the same time (you cannot wear several pairs of shoes at once, for example), while the syntagmatic dimension is "the juxtaposition of different elements at the same time in a complete ensemble from hat to shoes."[151] Paradigmatic elements can be substituted—so a bowler hat can be substituted by a baseball cap, which can be changed for a top hat, etc.; the syntagmatic axis, in terms of dress, is therefore the combination of those singular paradigmatic elements: bowler hat, white shirt, black tie, black jacket and trousers, black brogues. Clearly, it would be impossible to combine garments like this—bowler hat, fedora, white shirt, black tie, black jacket and trousers, black brogues—because one type of hat must be substituted for another (the same applies to any aspect of clothing). Importantly, meaning accumulates along the syntagmatic axis, through the combinations of paradigms (signs), but this meaning is dependent on which signs are chosen and then placed in various syntagmatic combinations.

Now, what influences the choice of sign is convention. For example, wearing the following combination of garments—bowler hat, white shirt, black tie, black

jacket and trousers, black brogues—at different periods in history, say 1959 and 2008, generates very different meanings; as would substituting a baseball cap for the bowler hat or running shoes for brogues. All combinations would be meaningful and to a degree acceptable but such substitutions substantially alter meaning and remind us therefore that meaning is not universal but fluid and changing because it is historically and culturally specific. More simply, a businessman wearing a baseball cap with a suit in 2008 is culturally and historically more acceptable than in 1959, which is not to say that wearing this combination was impossible in 1959. Moreover, the wearing of a bowler hat in 2008 is possible but the connotations of wearing such a formal item of dress are very different to those of 1959; I would ask you to consider why. The mention of connotation suggests the time is right to move from Saussure to Barthes and what the latter calls "myth."

As Michael Moriarty notes, it is not necessarily the topics of Barthes' myths that matter—the Citroën DS, "Steak and Chips," the face of Greta Garbo or the world of wrestling—more the means by which he regards them as "messages circulating within 'mass-culture.'"[152] Throughout *Mythologies*, "Barthes' task is twofold: to decode the messages, and to evaluate their links to mass culture."[153] To "decode" is an active and interpretative process and underscoring Barthes' task is reading the messages of mass culture and then decoding them. Barthes' study is dedicated to connotation, or the "secondary systems of meaning from language," which Moriarty argues is "vital to a culture's self-understanding—since society is constantly (overtly and covertly) generating secondary systems of meaning from language as such—and difficult in that the units of these secondary systems do not necessarily correspond to those of the primary system."[154]

Barthes says that "Myth is not defined by the object of its message, but by the way in which it utters this message."[155] In other words, myth is a second-order semiological system. As Annette Lavers notes, acknowledging the dual aspect of myth—"the presumed structure of myth and the ... purpose of myth and its use"—cannot be over-stressed.[156] As a final, second-order signification, each of the passages utter their message in a literal or denotative manner or, as Barthes puts it, "It is a *statement of fact*."[157]

Barthes explains that the concept (or second-order signified) deforms the signifier, which is itself split into two halves: the full signifier and the empty signifier. For

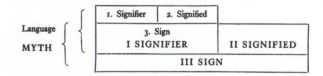

Figure 2 Barthes' theory of myth (from R. Barthes, *Mythologies*, trans. Annette Laver, Vintage, 1993, p. 115).

myth to take hold of the whole signifier it must first deprive the full signifier of its "meaning." For Barthes, the meaning contains "a whole system of values: a history, a geography, a morality, a zoology, a Literature,"[158] and it is this history that the concept alienates and deforms. The empty signifier, or form, allows the concept to fill it and suppress the full signifier or meaning. This process motivates the equivalence between the signified and signifier, or meaning/form and the concept. Barthes asserts that there exists a "turnstile" between the empty and full signifier, the meaning and the form, which the mythologist (s/he who deciphers myth) can use to decipher the myth. Barthes explains the role of the turnstile in these terms:

> If I am in a car and I look at the scenery through the window, I can at will focus on the scenery or on the window-pane. At one moment I grasp the presence of the glass and the distance of the landscape; at another, on the contrary, the transparence of the glass and the depth of the landscape; but the result of this alternation is constant: the glass is at once present and empty to me, and the landscape unreal and full. The same thing occurs in the mythical signifier: its form is empty but present, its meaning absent but full. To wonder at this contradiction, I must voluntarily interrupt this turnstile of form and meaning, I must focus on each separately, and apply to myth a static method of deciphering, in short, I must go against its own dynamics: to sum up, I must pass from the state of the reader to that of mythologist.[159]

The concept requires meaning to contextualize moments in myth like the breaking down the dichotomy of "inside" and "outside."

Why Barthes' interpretation of "myth" is so important for this chapter is outlined in the following: Barthes says, "It is through their rhetoric that bourgeois myths outline ... pseudo-physis which defines the dream of the contemporary bourgeois world."[160] One can roughly translate pseudo-physis as meaning an attempt to be like nature or to give the appearance of being "natural"; the upshot being that the "contemporary bourgeois world" presents its ideals, politics, attitudes, and, of course, the desire or need for its consumer products as "natural" (in that it is only natural to want the latest version of Apple's iPod or Microsoft's Windows). To help understand the thrust of Barthes' categories of "pseudo-physis," listed below, think back to the cover of the *Saturday Evening Post* (Plate 11).

1. *The inoculation*: "One immunizes the contents of the collective imagination by means of a small inoculation of acknowledged evil; one thus protects it against the risk of a generalized subversion."
2. *The privation of History*: "Myth deprives the object of which it speaks of all History ... it has been made for bourgeois man, the Spain of the Blue Guide has been made for the tourist, and 'primitives' have prepared their dances with a view to an exotic festivity."
3. *Identification*: "The petit-bourgeois is a man unable to imagine the Other ... How can one assimilate the Negro [*sic*], the Russian?"

4. *Tautology*: "Tautology is this verbal device which consists in defining like by like ('Drama is drama') ... Tautology creates a dead, a motionless world."
5. *The quantification of quality*: "By reducing any quality to quantity, myth economizes intelligence: it understands reality more cheaply."
6. *The statement of fact*: "The foundation of the bourgeois statement of fact is common sense, that is, truth when it stops on the arbitrary order of him who speaks it."

Moving through each of the six chosen categories in turn, we might see the *inoculation* as the threat of communism, which would destroy the dream; the *privation of history* in the depiction of an idealized future with no mention of the past; *identification* works to exclude the Other while underscoring the unquestionable "natural" right of the WASP couple to have exactly a life laid out in the stars; *tautological* because the secrets of a long life are what floats before the gaze of the couple; the *quantification of quality* ("a long life") becomes necessarily reliant upon more and more "stuff"; and, finally, the *statement of fact* extends the tautological function by declaring its message on the cover of a national magazine and thus earning legitimacy in the mind of the magazine-buying public (this of course should encourage us to consider the age, residential location, class, race, and gender of the average *Saturday Evening Post* reader).

Barthes' interrogation of cultural myths is ultimately an exploration or *critique* of *ideology*. At its most basic, the concept of ideology can be understood as the written and unwritten rules, ideas, and conventions that bind together social groups. In the context of this chapter, American ideology is firmly underscored by capitalism, their Soviet adversaries underscored by another, different form of ideology: communism. On saying this, all ideologies present their core values not as historically contingent but as the opposite: as universal truths. As Barthes argues in relation to myth, what is concealed by ideology is the way in which the most powerful groups in society enforce and maintain their power over others. The study of ideology, then, since Karl Marx in the nineteenth century, has more or less considered ideology as "false consciousness"; that is, as an inauthentic or untrue way of thinking about and experiencing the world. The catalyst for the study of ideology began with Marx's questioning of working-class (or proletariat) compliance with rather than rebellion against the exploitative regime of capitalism; how did the processes of capitalism "blind" the working classes to their exploitation? Marx's answer to his own question, that an individual's "attitudes and beliefs are held to be systematically and structurally related to the material conditions of existence" is at best partial and leaves many other questions unanswered.[161]

Since Marx, thinkers like those associated with the Frankfurt School, Theodor Adorno and Max Horkheimer especially, and others like Louis Althusser, Antonio Gramsci, Guy Debord, Jean Baudrillard, and Slavoj Žižek have all tussled with the concept of ideology as false consciousness and queried the grounds of Marx's

perspective. The fact that the argument over ideology as false consciousness remains unresolved only goes to show the complexity of the ideological structures of society, which map out social meanings and help define attitudes toward race, gender, and sexuality, for example. Before moving on, I want to conclude this section with David Hawkes's definition of ideology. According to Hawkes, "[o]ne of the most venerable conceptions of ideology is as a system of thought which propagates systematic falsehood in the selfish interest of the powerful and malign forces dominating a particular historical era."[162] With this in mind, let us turn out attention to advertising and 1950s' America.

Freedom from Drudgery for the Housewife

While American capitalism took the ideological war with Soviet communism to Moscow, the weapons of choice were not missiles but, as we have seen, washing machines and food mixers. But this was a war on two fronts. Back home, as it were, the Federal Housing Administration introduced policies that encouraged urban dispersal and the Veterans Society Administration provided over 11 million mortgages for new homes. As the authors of *Suburban Nation: The Rise of Sprawl and the Decline of the American Dream* note, monthly mortgage repayments were typically cheaper than paying rent and were aimed at "single-family suburban construction."[163] As a consequence, perhaps unforeseen, FHA and VA programs actively "discouraged the renovation of existing housing stock"; moreover, "a 41,000-mile interstate highway program, coupled with federal and local subsidies for road improvement and the neglect of mass transit, helped make commuting affordable and convenient for the average citizen."[164] In conclusion, Duany et al. point out, young American families in the early 1950s made the most sensible and rational choice open to them: moving to out-of-town housing developments epitomized by Levittown.

Recalling the "Kitchen Debate," if Nixon was keen to convey to Khrushchev the freedom from drudgery for the American housewife, one afforded by American labor-saving devices and kitchen-design, then his argument was clearly predicated on the assumption that a woman's place was, unlike Rosie the Riveter, in the kitchen and more generally the home. It makes sense, then, that feminist Betty Friedan's book, *The Feminine Mystique* (1963), supports Nixon's prejudice but only in order to critique it. Friedan's book is a classic feminist text and one that draws on a questionnaire she distributed to her Smith College classmates in 1957. *The Feminine Mystique* questions "the myth of natural domesticity"[165] peddled throughout the postwar period in America and describes in detail what Friedan describes as "a strange stirring, a sense of dissatisfaction, a yearning that woman suffered in the middle of the twentieth century in the United States." For Friedan, a silent question affected millions of American women: "Is this all?"[166] As Friedan notes,

The suburban housewife—she was the dream image of the young American women and the envy, it was said, of women all over the world. The American housewife—freed by science and labor-saving appliances from the drudgery, the dangers of childbirth and the illnesses of her grandmother. She was healthy, beautiful, educated, concerned only about her husband, her children, her home. She had found true feminine fulfillment. As a housewife and mother, she was respected as a full and equal partner to man in his world. She was free to choose automobiles, clothes, appliances, supermarkets; she had everything that women ever dreamed of.[167]

Friedan adds that in the fifteen years following the end of World War II, "the mystique of feminine fulfillment became the cherished and self-perpetuating core of American culture."[168] For Friedan, the images of domestic harmony, replete with smiling, competent housewife pictured conducting the note-perfect orchestra of her home—fetching, carrying, providing, restocking, baking, entertaining, educating—meant that the only dream of millions of American women was "to be the perfect wives and mothers; their highest ambition to have five children and the perfect house, their only fight to get and keep their husbands."[169] The kinds of imagery Friedan credits with projecting this view of the contemporary, postwar woman is evident throughout the kinds of advertisements discussed below.

Barthes reminds us that it is not the object of the advertiser's message that should concern us as mythologists but the way in which the message is uttered. With this in mind, what can we say about an advertisement for the wonderfully named, "Take-it-easy" Kitchen, produced by *Republic Steel Kitchens* (Plate 15)? How is the second order of signification structured? Moreover, what can Barthes' articles of pseudo-physis tell us about the way this message is uttered? On the one hand, the advertisement inviting "us" to "step into my Take-it-easy Kitchen" is delivered by a talking-head next to the tag-line and then underscored by the rendering of the kitchen space using three-dimensional perspective in the main image; moreover, the invitation to join our hostess is further enhanced by her pouring a drink in advance of our acceptance. Look again and the rounded-edged kitchen counter to the right has two place settings and two stools, one for her and one for us, the viewer. The eye is then led downwards from the stools in the main image toward the four smaller images, which simply display in a didactic manner what helps define this as the "Take-it-easy Kitchen": advances in storage and space-saving, the ease with which one can reach stored items, the way everything is to hand at all times. In each instance, the well-dressed hostess actively presents the kitchen's features and advantages.

Complementing the visuals, a series of text boxes urgently inform us that planning is absolutely crucial—planning can tame "awkward" and "misbehaving" kitchens and can help "organize your energy." Elsewhere we are told that that kitchen is not what it seems because it is *more* than it appears: hidden drawers that run on silent nylon glides, shelves that appear and disappear with the flick of an

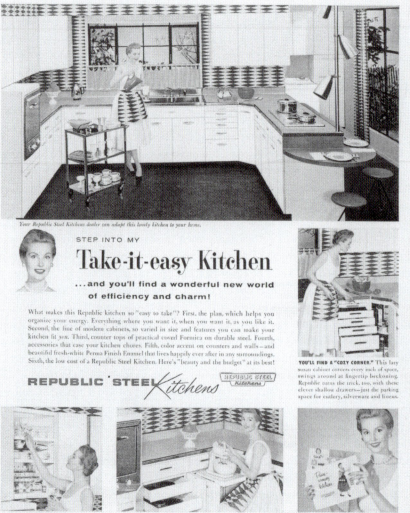

Republic Steel Kitchens, 1955

Plate 15 Take-it-easy Kitchen Advertisement, Republic Steel Kitchens.

under-counter switch: "supernatural? Nope—just *super!*" runs the advertising copy. Finally, the kitchen is made in the latest materials, Formica, combined with steel and decorated in accent-colors on walls and worktops. In a rather heavy-handed way, the advertisement blends text and image to present the efficient and charming features of this modern and desirable kitchen. But how does myth operate with regards the "Take-it-easy" Kitchen and similar imagery more widely?

There are several places where we might begin our analysis of the advertisement's mythological qualities, but let us begin with the "fact" that this kitchen saves energy (that is, everything is where you want it, you need never over-exert yourself in the search for that piece of cutlery or cheese). If this is true, then it follows that all other kitchens must waste energy, and clearly this is a negative property; therefore, a battle of waste versus efficiency is played out across the Formica work-surfaces of America. The drive to eradicate waste in American culture can, as highlighted earlier, be traced back to Thorstein Veblen and his observations conveyed throughout *The Theory of the Leisure Class*. Cecelia Tichi argues that *The Theory of the Leisure Class* was misinterpreted for "a satire on the lives of the idle rich and the bourgeois who attempted to imitate them," when it was "a scathing indictment of waste measured against a functionalist standard of value."[170] But what is a "functionalist standard of value"?

For example, although most often thought of in architectural terms, the functionalist building is designed for its purpose alone, with no extraneous details such as ornament or other forms of useless embellishment; if it has no function, then it has no place in the design. Most readily associated with architect Ludwig Mies van der Rohe's (1886–1969) dictum, "form follows function," one can see a rabid hatred of ornament in Adolf Loos' (1870–1933) "Ornament and Crime" (1908; translated into English 1913) and, in an American context, in the writings of Louis H. Sullivan (1856–1924) and his most famous protégé, Frank Lloyd Wright (1867–1959).[171] In essence, then, the "Take-it-easy" kitchen is the most advanced and most culturally progressive around; it is, as Nixon bragged to Khrushchev, the embodiment of American cultural superiority driven by the desire to save the suburban housewife from a life of drudgery.

The "Take-it-easy" kitchen, then, with its eradication of the wasteful, cluttered kitchen in favor of smooth, streamlined, and energy-saving surfaces and spaces, on one level clearly refers to the long-running cultural concern with waste. On another level, the connection between waste, the kitchen, and preservation or saving had particular resonance after World War II as prosperity spread; the effect of 1950s' middle-class prosperity reveals a transformation in the understanding and cultural significance of waste in America. Freed from the association of wartime shortages, the prevention of waste underscores for the most part the predominant new role for the suburban housewife as domestic micro-economist. To some degree, the running of the home, with responsibility for the household budget, preparation of meals, childcare, etc. places the woman at the center of the home. With this in mind,

explore archives, texts, and the Web for examples of other advertisements, whether from the same period or others; what do you notice about the positioning of the female protagonists in these advertisements? Are there noticeable differences in the representation of women across different periods in advertising?

Firstly, in the "Take-it-easy" advertisement the kitchen's features are demonstrated to the viewer by the housewife who is clearly the home "expert"; and one can identify in similar advertisements images of the period the housewife as instructor—often teaching her daughter how to cook, or allowing her daughter to act as "hostess" to the, often seated, father. In all cases, the housewives and their daughters are playing out very different roles to the males; I would add that the where the "men of the house" appear, they are not in the kitchen—the kitchen appears the sole domain of the American female. Women are thoroughly embedded in the architecture and spaces of the home: the home is therefore a gendered space, especially the kitchen. If we recall the images of women in the national park landscapes featured in Chapter 1, women—unlike the male protagonists, who were active—were definitely "not at home" in American landscape. A woman's "natural" place is in the home"; it is the environment they were born to occupy and maintain.

Matching masculinity with activity and the great outdoors is underscored by matching femininity with the indoors and domesticity; moreover, these advertisements suggest that the housewife, whether in the kitchen or running the home, must "operate" with the same kind of ruthless efficiency as the labor-saving devices and energy-saving rooms which surround her. One could argue that the role of housewife is underpinned by a strict ideology of a machine-like rationality whose sole aim is efficiency. Therefore, the second-order of meaning—the mythological meaning—in these advertisements offers a parallel between the efficiency of the kitchen and the housewife, setting out a clear benchmark for efficiency against which not just modern kitchens but all modern, suburban housewives should be judged. From the "energy saving devices" (the housewife needed to save her energy for countless other tasks) to the matching color schemes (look at the way the women in these advertisements are dressed), everything in the scene colludes to condition the role of housewife. And when, as these advertisements "prove" the role is played perfectly, "feminine fulfillment" becomes self-evident (see the smiling faces)—pleasure brought about by and through domestic containment.

Although it is rather clumsy and Barthes integrates the "pseudo-physis" lists with a good deal more elegance than I have here, using this list is useful for grounding your mythological analyses. So far I have argued that in essence kitchen advertisements with their emphasis on saving (space, time, energy) were very much part of a wider debate in American culture about waste. Moreover, I have suggested that the constant and consistent textual and visual reiteration of efficiency articulates the "modern-ness" of the new kitchen; crucially, though, I have argued that such an emphasis on kitchen efficiency is actually a means by which to define and judge the role of the new "modern" housewife. In other words, the rearticulation

of American postwar women from the de-feminized "Rosie the Riveter" type into a more traditional, feminine but, importantly, contemporary housewife role. Installed in their new homes with husbands and children, the aim here is to create a role of cultural and social importance, one with tangible responsibilities and benefits for all. It would be useful for the reader to take Barthes' pseudo-physis and apply the list to the advertisements here but also to advertisements from the same and other periods.

But how do these advertisements relate to the broader theme of anxiety? Well, the correlation between women, the domestic environment, and feminine fulfillment suggests that a woman who does not feel this ecstatic sense of fulfillment is clearly doing something wrong; a kind of going against nature. Friedan's articulation of the "mystique of feminine fulfillment" therefore is exactly the second order of meaning evident in the advertisements discussed here; as Friedan notes, "What kind of woman was she if she did not feel this mysterious fulfillment waxing the kitchen floor?"[172] Friedan adds that the woman affected by such doubts "was ashamed to admit her dissatisfaction," nor was she aware that many other women felt exactly the same way. If we turn again to the advertisement with this in mind, what do we see? Women whose roles actively divorce them from other women, each "trapped" by the clean lines of the modern kitchen in the Levittown style house. Everything here in these spaces, these homes has been designed to alleviate her life of drudgery, even the Vice President of the United States of America has said so, so surely she should be happy? Friedan calls this the "problem that has no name," defined by the housewife's inability to ask herself the question, "Is this all?"[173]

But Then Again …

We should, of course, ask "Is Friedan correct?" There is after all a neat alliance between Friedan's own identification of the source of the "problem with no name" and "the model of the marketing brainwash … the insidious manipulation of advertising …" we have extrapolated above.[174] Moreover, the harmful affects of the "feminine mystique" were, as Rachel Bowlby notes, "summed up by the repeated reference to 'waste,'" another key concept also outlined above. Bowlby adds that in Friedan's analysis:

> Waste is what happens when the mystique takes over. The avoidance of waste represents the kind of emotional parsimony and efficient use of available human resources that fits with the paradigm of goal-setting and deferred gratification. The "waste" is first of female "human" potential that is going unused or untapped, owing to its deflection on to feminine channels falsely and misleadingly imaged as leading to authentic fulfillment.

Underpinning Friedan's work then is, for the contemporary theorist, based on what might best be described as outmoded conceptions of the self and sexual identity.[175]

Friedan has a very clear sense of what "woman" means and it is underscored by an unquestioning "conception of natural sexual difference." The housewife is thus heterosexual, white, middle class, and controlled, like all Americans, by advertising media. Such a view offers, on the one hand, a rather uncomplicated model of identity formation; consequently, argues Jessamyn Neuhaus, too many historians have been able to characterize "the postwar era as uniformly repressive, oppressive, and miserable."[176] Neuhaus argues that in reality many white middle-class women actively resisted these "advertising" norms through affiliations with political and religious groups, an argument that somewhat disturbs Friedan's view of legions of "repressed, oppressed, and miserable" brainwashed housewives. But of real interest is Neuhaus's quite obvious but historically overlooked insight that not all women in 1950s' America were heterosexual, white, and middle class (WASPs); as such, "the political and social experiences of women of color and lesbians during the 1950s were, of course, quite different from white women …"[177]

Advertising Other Anxieties

To conclude this chapter and preface issues arising in the next, I want to highlight the existence of advertisements aimed solely at women of color: skin-bleaching ads. Writing in the *Journal of Marketing* in 1959, Irving S. White notes that, "It is that the function of advertising is to help to organize and modify the basic perceptual processes of the consumer, so that he is guided toward seeing and feeling a product in a given predictable way."[178] White is categorical in his assertion that advertising is simply "modifying" a consumer's already settled sense of self, hence the consumer is "guided" rather than directed or manipulated into purchasing a product. With this in mind, what are we to make of advertisements for skin-bleaching creams? What does the consumer "see" in these advertisements and how do they elicit a predictable "feeling" in the consumer?

Following Barthes, on the level of denotation—their literal quality—skin-bleaching advertisements depict a "beauty" product (again, a loaded idea because it appears that lighter skin means more beautiful) with the ability to soften and lighten skin color for *all* women, regardless of race (one can never be too white?). They do so because they possess more active ingredients than other creams and therefore offer an expedient route to the promised softer and lighter skin. Many advertisements traded on this power to transform, claiming advances in science as specific to the product, a method that applies even in today's advertisements for beauty products; for example, an advertisement for *Black and White Bleaching Cream* makes clear it is "safe" with a scientific formula "that is not Not 1 Not 2 BUT NOW 3 TIMES STRONGER THAN BEFORE" adding that the "Famous double strength bleach [is] now in a marvelous new formula."

The words "formula" and "scientific" suggest laboratories, people in white coats, the weight of scientific intelligence which literally spells safety and reliability, guaranteed performance, and, arguably, truth: the power of science actually reversing or altering "nature." I say this because each advertisement categorically states that you can change the color of your skin. On offer is "Fairer Loveliness" (as opposed to "Darker Ugliness"?), softer skin, and lighter skin tone. But why would any person want to alter their skin color?

Advertisements for skin bleaching products are quite direct in targeting their perceived audience of people they assume would want to change their skin color: not only women, but more often than not, African American women. On the one hand, these advertisements fudge the issue of race or temper any overt address to women with black or brown skin; generally these creams go by the double assertion of softer *as well as* lighter skin; a brand name such as "Black and White" might also be seen as an effort to widen the product's market. However, looking back on 1950s' America and the anxieties surrounding issues of race, anxieties with a long history, these advertisements rather coyly appeal to the cultural phenomenon of "racial passing."[179] I quote at length from "Racial Passing" by Randall Kennedy:

> Passing is a deception that enables a person to adopt certain roles or identities from which he would be barred by prevailing social standards in the absence of his misleading conduct. The classic racial passer in the United States has been the "white Negro": the individual whose physical appearance allows him to present himself as "white" but whose "black" lineage (typically only a very partial black lineage) makes him a Negro according to dominant racial rules. A passer is distinguishable from the person who is merely mistaken—the person who, having been told that he is white, thinks of himself as white, and holds himself out to be white (though he and everyone else in the locale would deem him to be "black" were the facts of his ancestry known). Gregory Howard Williams was, for a period, such a person. The child of a white mother and a light-skinned Negro man who pretended to be white, Williams assumed that he, too, was white. Not until he was ten years old, when his parents divorced, did Williams and his brother learn that they were "black" according to the custom by which any known Negro ancestry makes a person a Negro. Williams recalls vividly the moment at which he was told of his "new" racial identity:
>
> > I never had heard anything crazier in my life! How could Dad tell us such a mean lie? I glanced across the aisle to where he sat grim-faced and erect, staring straight ahead. I saw my father as I had never seen him before. The veil dropped from his face and features. Before my eyes he was transformed from a swarthy Italian to his true self—a high-yellow mulatto. My father was a Negro! We were colored! After ten years in Virginia on the white side of the color line, I knew what that meant.
>
> When he held himself out as white *before* learning of his father's secret, Williams was simply mistaken. When he occasionally held himself out as white *after* learning the "true" racial identity of his father, Williams was passing. In other words, as I define the term, passing requires that a person be self-consciously engaged in concealment.[180]

Overlooking on this occasion Kennedy's overt politics, the distinction between "knowing" and "unknowing" passing and the mention of the "color line"—especially Gregory Howard Williams's realization about what it meant to be on the "wrong" side of said line, the black side—is particularly revealing about white America's anxiety in relation to black people. It also echoes the childhood experience that shaped W. E. B. Du Bois, which is discussed in the following chapter. The fear that black people, like communists or aliens from outer space, might well be able to insinuate themselves unnoticed into the midst of white society, that is, drink from "whites only" fountains, eat in the "whites only" section of restaurants, or wait for the bus in "whites only" waiting rooms, is both fascinating and horrifying. Of course, at the root of this fear was another, greater anxiety: interracial liaisons and miscegenation.

With regard to those who might desire to pass as white, what do the advertisements for skin bleach connote rather than denote, what is their second-order of meaning? What do they tell us about the color line, and about the anxieties of black American citizens? To begin with, the desire for lighter skin is underscored by an implicit suggestion that darker skin is socially unacceptable ("Fairer loveliness can be yours!"); the lighter the skin, the more beautiful the woman, the more beautiful the woman, the more likely they are to find happiness with their personal appearance and as a result achieve success in (heterosexual) relationships. The "before and after" images in advertisements for *Nadinola Deluxe Greaseless Bleach Crème*, for example, present a woman unable to contemplate her own reflection in a mirror until a period of using "crème" has taken effect; while an advertisement for *Black and White Bleaching Cream* shows how lighter skin can help any woman find a white partner for life (and then pursue the American Dream as laid out in the stars on the cover of *The Saturday Evening Post*). However, in both instances, there exist further layers of anxiety: first, these woman are knowingly "passing" and, second, if their white partner were to find out they had been duped, one can only imagine what might happen.

As deceivers of the white American race, their consumer behavior, as marketing man White suggests, will certainly become predictable but not in the benign way he argues. Obviously, they must continue to bleach their skin in order to maintain their new status but, as Du Bois points out in the next chapter, even with lighter skin, these women could never escape the feeling of "two-ness," of being black *and* American. What is on offer in advertisements for bleaching cream is a kind of social and cultural camouflage, the ability to bleach out the color from one's skin and eradicate the most obvious marker of difference; what is on offer is yet another form of concealment, a surreptitious and risky pathway into a world generally denied people of color in America. The terrible irony about this situation, of course, being the twofold deception (of the self and of others) needed to attain the norm; a norm that is itself a kind of deceit and one that, even after bleaching, the "darker" skinned person can never truly attain: they only ever *appear* white, they can never *feel* white.

Despite the promise of the bleaching creams, black Americans, even those who might be able to pass as white, are arguably and forever barred from what white-skinned Americans, and all white people in general, take for granted; in short, they could never sit under the tree and stare at the night sky and imagine a moonlit future in the same way as the young white couple on the cover of the *Saturday Evening Post.*

Conclusion

All the advertisements discussed in this chapter make several presumptions about race (white), class (middle-class), and sexuality (heterosexual); and white, middle-class, and heterosexual becomes the "norm." Advertisements, despite what Irving White might have argued in 1959, are aspirational; they seek to outline a promise and the means of achieving that promise through the consumption of certain goods and services. Using Barthes' notion of myth, it has been possible to uncover and describe the underlying ideologies and anxieties that, in this case, have shaped notions of the feminine. And yet, we must end on a cautionary note. Many of the criticisms leveled at Friedan are applicable to Barthes; for one thing, Barthes' writing on myth shares the underlying notion of the concrete or universal subject. This means Barthes assumes that there is a knowing and knowable subject who is able to speak from a position of authority; that is, a person, like Barthes himself, who can "read" cultural texts in ways that ordinary people cannot. Barthes' mythological approach is therefore what is known as a "meta-language." In effect, the criticisms of Barthes noted here are meant to encourage us to think more productively about the complexity of the relationship between representation and ideology; so, while an advertisement for a kitchen or for skin bleach might not affect every person in the same predictable way, it should not prevent us from undertaking an ideological analysis of the advertisement itself. In fact, the opposite is true. For example, how might the advertisement for the "take-it-easy kitchen" tell us more about the color line and racial anxieties in the 1950s; or, what do the skin bleach advertisements reveal about the ideological fear of "racial passing"?

–3–

Cultural Anxieties II

A Case of Black and White

On November 4, 2008, the presidential election between Senator Barack Obama and Senator John McCain ended with America choosing to elect not a Vietnam War veteran but his African American opponent. In his acceptance speech to a crowd of over 240,000 people in Grant Park, Chicago,[181] President-elect Obama opened with: "If there is anyone out there who still doubts that America is a place where all things are possible; who still wonders if the dream of our founders is alive in our time; who still questions the power of our democracy, tonight is your answer."[182] Obama's speech itself speaks to the abiding ideal of America as a land where anything is possible, an ideal set out by the founders of the nation, as well as to more contemporary concerns regarding the credibility of American democracy;[183] these assertions themselves bookend a rather different American dream, one most readily associated with the civil rights activism of Dr. Martin Luther King Jr. (1929– 68). "It's been a long time coming," said Obama, "but tonight, because of what we did on this day, in this election, at this defining moment, change has come to America."[184] The significance of this change—the election to the office of President and Commander-in-Chief of an African American man, the son of a white woman from Kansas and a black man from Kenya—appears in stark relief with the issues raised in this chapter.

As this chapter shows, the tensions and anxieties played out along the "color line" in America throughout the twentieth century hint at a gradual shift in attitudes of the white majority toward the black minority. The idea that by the early twenty-first century America would elect an African American president when less than 100 years ago black men and women feared for their lives at the hands of lynch mobs is remarkable. Tracing this astonishing history, it is clear that the 1950s represent a watershed in the relations between black and white American citizens. Firstly, the *Brown versus Board of Education* case (1952) on which the Supreme Court ruled (1954) that racial segregation in schools was in violation of the Fourteenth Amendment led to the Little Rock School crisis in September 1957. Secondly, these two events are "interrupted" by another, equally pivotal moment: Mrs. Rosa Parks's refusal to give up her seat for a white passenger on a bus in Montgomery, Alabama in 1955 and the subsequent Montgomery Bus Boycott of 1956. Documentary imagery plays a crucial role in drawing attention to the psychological and physical subjugation

of black Americans but, as discussed elsewhere in this book, documentary is most often produced and disseminated by the system that actually subjugates. With this in mind, two very different kinds of imagery form the focus of our discussion; firstly, the visual culture of lynching—photography, postcards, other ephemera. It is difficult not be shocked and outraged by photographs of lynching and yet as we shall see, white people of all ages and classes gathered together at public lynchings, allowing themselves to be photographed openly participating in the murder of a black person. Moreover, the photographs themselves were mementoes and keepsakes; people collected, even displayed these images in their homes or more privately in photograph albums. As such we shall simply ask, what was the purpose of lynching photography? In direct opposition to the silenced black voices of the lynched black person, we turn to the highly political work of Black Panther activist and graphic artist, Emory Douglas. Douglas's confrontational imagery with its depiction of authority figures—the police, the national guard, the army—as pigs with guns and tear gas canisters at their hips, engaged in the terrorizing of the black population of America's inner cities, is a form of oppositional image making.

To help us theorize these images—the ways in which they visualize race—I want to offer a reading of the work of W. E. B. Du Bois, "the towering intellectual leader of African-Americans in the early twentieth century."[185] As a founder member of the National Association for the Advancement of Colored people (NAACP), Du Bois was involved in the struggle against racism, discrimination, and lynching; and *The Crisis* became the space or "venue" in which the "inequitable society in which blacks lived"—"a land plagued by white terror"—would be opened out to a national audience. Although distinctly visual in tenor Du Bois's concepts of "double consciousness," "the color line," "the veil," and "second sight" have not properly been explored for their usefulness in the analysis of visual culture, something I hope this chapter addresses in some way. Perhaps this has to do with the fact that Du Bois himself rarely acknowledged the importance of visual culture despite its prominent use in his journal, *The Crisis*. Amy Kirschke notes that art, cartoons, and illustration were a crucial weapon in the armory of *The Crisis* and yet Du Bois never mentioned either the "visuals or the importance of the art for the magazine …"[186]

W. E. B. Du Bois: Visualizing Race

To understand "blackness" it is useful to begin with what it is not: whiteness. What is striking about discussions of race is that whiteness is rarely if ever used as a racial category, especially among whites; when white people talk to each other about other whites, people are people until conversation turns to people who are not white, then they are "the black guy" or "the Hispanic woman."[187] Richard Dyer, in *White*, qualifies this by adding: "Whites must be seen to be white, yet whiteness as a race resides in invisible properties and whiteness as power is maintained by being

unseen.... . Whiteness is the sign that makes white people visible as white, while simultaneously signifying the true character of white people, which is invisible."[188]

Whiteness is a privilege, a privilege that remains invisible to white people. In other words, white people rarely "feel" white. There are several reasons for this. For example, whiteness is considered the cultural norm and also most of the time white people are surrounded by other white people. Peggy McIntosh compiled a list of assumptions white people are able to make about the world:

> I can turn on the television or open to the front page of the newspaper and see people of my race widely represented.
>
> Whether I use cheques, credit cards or cash, I can count on my skin colour not to work against the appearance of financial reliability.
>
> I can swear, or dress in second-hand clothes, or not answer letters, without having people attribute these choices to bad morals, poverty or the illiteracy of my race.
>
> I am never asked to speak for all the people of my racial group. [189]

McIntosh's list makes visible the invisible privileges of being white; of these, not experiencing a sense of alienation or distance from the world around you, where any transaction—whether social, cultural, personal, or financial—is not first viewed through a racial lens or that most obvious marker of difference: skin color.

One of the most perspicacious thinkers on the insidious side effects of the construction and naturalization of whiteness, racism, was William Edward Burghardt [W. E. B.] Du Bois (1868–1963). Du Bois grew up poor and black in the predominantly white Great Barrington, Massachusetts, although it was his poverty rather than his color that affected his youth. It was only an encounter with out-of-towners to Great Barrington that made Du Bois feel the effect of racism. Du Bois recounts this terrible epiphany in "Our Spiritual Strivings," which appears in *The Souls of Black Folk*:

> It was in the early days of rollicking boyhood the revelation first bursts upon one, all in a day, as it were. I remember well when the shadow swept across me. I was a little thing, away up in the hills of New England, where the dark Housatonic winds between Hoosac and Taghkanic to the sea. In a wee wooden schoolhouse, something put it into the boys' and girls' heads to buy gorgeous visiting-cards—ten cents a package—and exchange. The exchange was merry, till one girl, a tall newcomer, refused my card,—refused it peremptorily, with a glance. Then it dawned on me with a certain suddenness that I was different from others.[190]

Poor, black but academically gifted, Du Bois was encouraged in his studies. The culmination of Du Bois's intellectual labors was the award of a Ph.D. from Harvard in 1895, the first ever awarded to an African American.

The importance of Du Bois in this chapter relates to the ways in which he articulates the experience of being black in what is ostensibly a white world, that

is, a world made for white people, through the concepts of "double consciousness," the "color line," "the veil," and "second sight." For Du Bois, double consciousness can be explained as, "the sense of always looking at one's self through the eyes of others." Shawn Michelle Smith recognizes in Du Bois's work on race and racism an effort to "draw on a *visual* paradigm to articulate African-American identity in the Jim Crow United States."[191] As such, Du Bois can rightly be said to be one of the first visual culture theorists.

But what were the Jim Crow laws? Between 1876 and 1965 local and state laws across America enacted racial segregation on public transport, in public schools as well as in public spaces, such as waiting rooms or restaurants. Jim Crow effectively created a two-tier system, in which black people were classed as second-class citizens, intellectually and culturally inferior to their white betters. So, black children could not be taught with white children, buses had separate seating for white and black passengers, and in Alabama, "No person or corporation shall require any White female nurse to nurse in wards or rooms in hospitals, either public or private, in which negro men are placed."[192] It is important to note that although Jim Crow states, mainly southern and border states, enacted laws that enforced segregation at all levels of society, there was a secondary level of enforcement of "Jim Crow etiquette"; the unwritten rules of racial behavior. Breaking etiquette, such as a black couple showing each other public affection, a black man offering to light a white woman's cigarette, or a black person referring to a white person by their first name, would often be punished.

Jim Crow institutes something akin to the Foucauldian panoptic gaze, which will be discussed in the chapter on crime and criminality; to put it simply, the black body is disciplined psychologically to police itself—that is, in the company or vicinity of white people, no thought or action of the black person can ever be spontaneous but must always be considered, edited, refined before being acted upon for fear of breaking either Jim Crow laws or etiquette. What makes Du Bois's work so crucial for this chapter is not only that he utilized images "to describe racial constructs" but he also "conceptualized the racial dynamics of the Jim Crow color line *as* visual culture."[193] The color line in Du Bois's work addresses more than just the "systematic inequities of racialized labor but also a visual field in which racial identities are inscribed and experienced through the lens of a 'white supremacist gaze.'"[194] What Du Bois proposes is that the "experiences of *racialization* and *racial identification* are focused through a gaze and founded in visual misrecognition."[195] This is quite a complicated point and needs a more careful explanation.

What Du Bois is describing here when using the terms "racialization" and "racial identification" is a process most commonly associated with imperialism. As Dyer notes, "all concepts of *race*, emerging out of eighteenth century materialism, are concepts of bodies,"[196] ably supported by the new "sciences" of the nineteenth century, such as craniology (measuring human skull size to categorize the "races") and social Darwinism.[197] The white Western body—the body of imperialism and imperialist

power—becomes the norm, the pinnacle of evolutionary development against which all other racial differences are judged and ordered accordingly: "Imperialism," argues Dyer, "displays both the character of enterprise in the white person, and its exhilaratingly expansive relationship to the environment."[198] The white body takes on the role of the surveyor, the non-white body that of the surveyed. The visibility of whiteness becomes a crucial way of informing non-white peoples of the power behind whiteness; to be white is to have power, to be non-white is to recognize that not only are you subject to that power but you are not white. The non-white body is racialized and learns its racial identity though the white supremacist gaze; just as Du Bois suddenly felt at once the same as those other children but realized "with a peremptory glance" that he was *seen* as different.[199] The shock of being seen as different disturbs the ego's idealized version of the self because Du Bois realizes he is not who he thought he was. As Smith says, "in the white girl's eyes he sees an image that he does not, and cannot recognize in relation to himself, an image that fractures the illusion of an ideal and complete ego."[200]

Double consciousness, therefore, works on the level of experience and of being seen-ness, which Du Bois calls "two-ness." "One ever feels his two-ness," says Du Bois, "—an American, a Negro; two souls, two thoughts, two unreconciled strivings; two warring ideals in one dark body, whose dogged strength alone keeps it from being torn asunder."[201] The black person is conscious of this double consciousness, especially when trying to resolve or reconcile these two distinct perceptions of self: here, Du Bois identifies "the condition of being African-American in white supremacist America."[202] As Smith notes, double consciousness, the state of two-ness, is an effect of the color line (seeing your blackness through the eyes of the white supremacist); it is the "struggle of a healthy mind to confront and inhabit a perverse world."[203]

Du Bois's identification of a "perverse world" requires the introduction of two key concepts: the veil and second sight. If double consciousness is the black subject's recognition of "seeing one's self through the eyes of others," a splitting of the ego, then the veil "denotes such a split writ large culturally."[204] "[S]hut out from their world by a vast veil," Du Bois alerts us to the peculiar interaction of gazes between black and white. For Smith, we should imagine the veil as a "kind of cultural screen on which the collective weight of white misconceptions is fortified and made manifest. The veil is the sight at which white fantasies of a negative blackness, as well as fantasies of an idealized whiteness, are projected and maintained."[205] In this sense, the veil or screen works to enforce and naturalize the (negative) image of blackness as perceived by whites, while reinforcing the visible/invisible power of whiteness; on the other side of the screen, blackness and all it stands for (according to the whites) traps and captures the African American in the shadows of the "prison-house." The perversity of this world—the color line—is best expressed when Du Bois asks, "Why did God make me an outcast and a stranger in mine own house?"[206] On saying this, once one sees the veil, "consciously recognizes

that to which he has been blind … it produces a vision that pierces the structures of racism construed as the natural order of things."[207] This new way of seeing, or "second sight," enables African Americans to see what white Americans cannot see, the cultural and psychological construction of racial difference.

Visual Culture and Lynching

The lynching of black people by whites had a profound effect on Du Bois, and under his care, *The Crisis* "published accounts of lynchings, eyewitness descriptions, and photographs of lynchings."[208] For Du Bois, lynching operated as a means for "whites to control the black population and reaffirm values of the southern traditional order," but the threat of lynching also communicated in no uncertain terms that "American identity was reserved for white males …"[209] As Kirschke notes, the lynching of Sam Hose in April, 1899 had a "powerful impact on Du Bois."[210] Hose had approached his employer, the planter, Alfred Cranford to ask for an advance of pay and for permission to visit his sick mother, to which his employer had said "no." The next day, Cranford approached Hose who was chopping wood to resume the argument; Cranford drew his pistol on Hose who threw his axe in self-defense, killing Cranford instantly. Within two short days, the news of Cranford's murder had traveled far but with newspapers reporting a very different account of the events of that day. Hose had instead killed Cranford while his employer was eating dinner, and after robbing the house, then "dragged Mrs Cranford into the room where her husband lay dying and raped her."[211] The stories of Cranford's demise varied, according to Litwack, unlike that of Hose. Stripped and chained to a tree,

> the self-appointed executioners stacked Kerosene-soaked wood high around him. Before saturating Hose with oil and applying the torch, they cut off his ears, fingers and genitals, and skinned his face. While some in the crowd plunged knives into the victim's flesh, others watched "*with unfeigning satisfaction*" (as one reporter noted) the contortions of Sam Hose's body as the flames rose, distorting his features, causing his eyes to bulge out of their sockets, and rupturing his veins. The only sounds that came from the victim's lips, even as his blood sizzled in the fire, were, "*Oh, my God! Oh, Jesus.*" Before Hose's body had even cooled, his heart and liver were removed and cut into several pieces and his bones were crushed into small particles. The crowd fought over these souvenirs.[212]

The gruesomeness of this spectacle does not end here, though. Not only had "one special and two regular trains carried nearly '4000 people'"[213] to witness the lynching and burning of Hose but placed on a tree near the site of the lynching was a placard, which read: "*We must protect our Southern Women.*" This sign had a double function: as a warning to black men of the consequences of "rape" and as a legitimation of the brutal action of the lynch mob's *modus operandi*. As was often the case, Cranford's wife recalled the events of the day of her husband's death in a later investigation

and exonerated Hose of murder (he *had* reacted in self-defense) and rape (Hose had never entered the house, nor had he assaulted her). News of this kind, that the black man was not the beast he had been portrayed but the true victim of the outrage, was of no interest to either the white press or the public at the time.

Hose's murder at the hands of a white mob acting as judge, jury, and executioner is just one example among thousands; black men and women, tortured and executed, their lynching reported in the white press in lurid and graphic detail, where the public burning of black people became known as a "Negro Barbecue" (Plate 16).[214] It is helpful here to draw on Du Bois's concept of the veil, which Smith notes is "a kind of cultural screen" on which white racist discourse is "fortified and made manifest."[215] Newspaper media, as McIntosh alluded to earlier, is in the control of whites, and so enables the shameless depiction of black people as animals. Victims of lynch mobs were powerless to defend themselves against white accusations not only because of Jim Crow laws but also etiquette: black people had no recourse to debate, to counter negative representation, and no way to represent themselves. The veil—the newspaper—becomes the screen as Smith describes it: a place for whites to project the supremacist fantasy of white power winning over base and immoral blackness.

The notion of the "Negro Barbecue" alerts us to another aspect that makes up Du Bois's "perverse world": lynching as spectacle. Without fear or embarrassment,

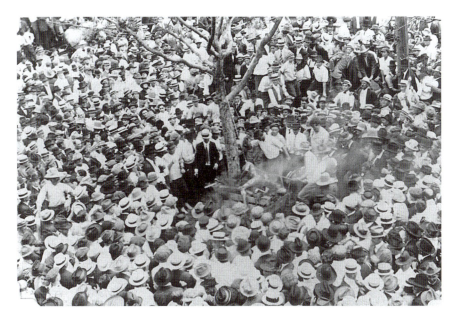

Plate 16 Waco Lynching photo provided by The Texas Collection, Baylor University in Waco, Texas. Thousands of people gather in Waco, Texas in 1916 to watch the lynching of a black teenager. AP/PA Photos.

newspapers openly printed incendiary editorials about the alleged crimes of black people and about the need for lynching to protect the white Southerners from a black menace. But, as Litwack adds, it is the "use of the camera to memorialize lynchings [that truly testifies] to their openness and to the self-righteousness that animated the participants."[216] Photography and the production of picture-postcards of the lynching, the crowds, the carnival-like atmosphere, along with the collection of souvenirs from the body of the victim attest to the brutality of such a spectacle. Lynchings in the early twentieth century were accompanied by the sound of "hundreds of kodaks" clicking, the sight of picture-card photographers installing "portable printing" plants "selling postcards showing a photograph of the lynched negro." Moreover, "Women and children were there by the score" and at several country schools "the day's routine was delayed until the boy and girl pupils could get back from viewing the lynched man."[217]

Let us consider for a moment not the hideous sight of the hanged man but the ways in which the crowds of onlookers react to the presence of the camera. Plates 17 and 18 depict the lynching of Rubin Stacy, which took place in Fort Lauderdale, Florida on July 19, 1935, "for the crime of 'threatening and frightening a white woman.'"[218] Dora Apel tells us that while being escorted back to Dade County jail

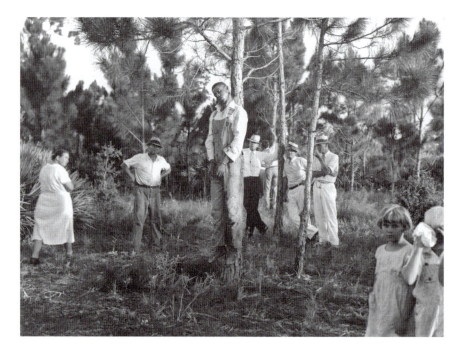

Plate 17 Lynching Rubin Stacy. The body of 32-year-old Rubin Stacy hangs from a tree in Fort Lauderdale, FL, as neighbors visit the site. Stacy was lynched by a mob of masked men who seized him from the custody of sheriff's deputies for allegedly attacking a white woman. AP/PA Photos.

in Miami, the car in which Stacy was traveling was run off the road by 100 masked men, who then overpowered the six deputies transporting Stacy and kidnapped him. Stacy was then hung from a tree "within sight of the home of the woman who had identified him as her 'assailant.'" [219] For Apel, this image of Stacy's body is, "even among lynching photos ... remarkable for the large number of girls standing about and ogling the corpse."[220] In the version printed here we see only two, but the fact that others exist with the ebb and flow of a variety of white people of all ages, men and women, and children. Here, we see the indoctrination of two children—a boy who covers his face and a girl who stares blankly at the photographer—into what Du Bois calls "the southern traditional order"; Apel adds that we are witnessing the normalization and domestication of racial terror. The death of this black man under such sordid and horrific circumstances is, on the one hand, extreme in its brutality and yet, on the other, simultaneously treated as a mundane everyday occurrence.

Finally, probably the most recognizable photograph of a lynching, Lawrence Beitler's *Lynching of Thomas Shipp and Abram Smith, August 7, 1930* (Plate 19). As Kirschke notes, the Great Depression "brought an upsurge in lynching" and further

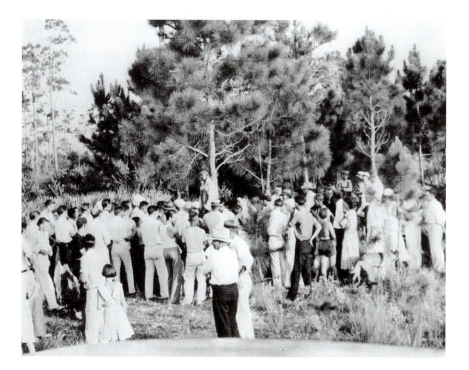

Plate 18 Rubin Stacy Lynching. A crowd gathers to view the body of 32-year-old Rubin Stacy as he hangs from a tree in Fort Lauderdale, FL, on July 19, 1935. Stacy was lynched by a mob of masked men who seized him from the custody of sheriff's deputies for allegedly attacking a white woman. AP/PA Photos.

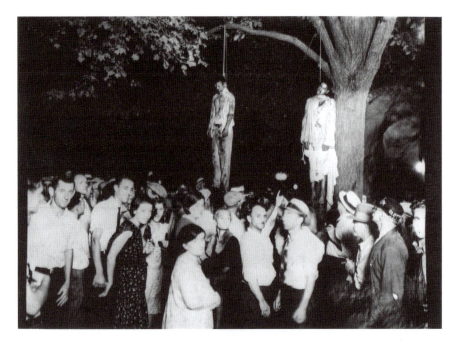

Plate 19 Lynching of Thomas Shipp and Abram Smith, August 7, 1930, courtesy of Indiana Historical Society.

convinced Du Bois of the economic roots of the practice. As part of Du Bois's efforts to reveal the true horror of lynching, Beitler's photograph was printed in the October 30 edition of *The Crisis* with the caption, *Civilization in the United States, 1930.*[221] The murder of Shipp and Smith is as ever a tale of false accusation and the failure of the police and the legal system to protect the accused from the mob. Shipp, Smith, and James Cameron, who survived the lynch mob, were accused of raping a white woman and murdering the white man accompanying her in Marion, Indiana. An investigation after the fact by Walter White discovered that Mary Ball, the "victim" of rape, was in fact associated with the accused and was quite likely "working in collusion with them to help rob her white 'dates' on lovers' lane."[222] Despite Beitler's photograph, made readily available for 50 cents and for sale as a postcard, which captures within the frame the clearly visible faces of the spectators and perpetrators of this outrage, all members of the lynch mob were acquitted. "Lynching," as Smith points out, "has always been illegal" and yet the "cultural forces of racism (and sexism) have historically been strong enough to allow these crimes to pass unprosecuted."[223]

Almost without exception lynchings were adjudged to have been carried out by "persons unknown" and yet as is plain to see no one in Beitler's photograph is masked or, in fact, appears intimidated by the presence of the camera. Moreover,

many people in this crowd seem to have struck a pose, that is, are actively partaking in the shot, are aware of being seen and photographed; they are active figures caught in the middle-ground between the photographer and the lynched figures of Shipp and Smith hanging from branches of the tree in the background. To pour further scorn on the validity of the judgment "persons unknown," we can turn to recollections of the event offered by the surviving member of the trio, James Cameron. Rather than an anonymous collection of unknown persons, Cameron "recognized those in the mob that lynched Smith and Shipp as neighbors, customers, onetime friends."[224] Perhaps it was a neighbor, customer, or onetime friend who bought a photograph from Beitler for 50 cents, framed it, pushed under the framed picture's glass pieces of the victims' hair, and wrote a note identifying a key protagonist, "Bo pointing to his niga," and "Klan 4th, Joplin, Mo, 33."[225] One can find this image in James Allen et al., *Without Sanctuary*, which contains the following commentary on the framed image:

> A man with a short Hitler moustache points to the body of Abram Smith. On his inner arm is tattooed the bust of an Indian woman. Indiana historians and researchers are interviewing reluctant Marion citizens old enough to remember the lynching of Thomas Shipp and Abram Smith. One of their goals is to identify the individuals in this photo, not to demonize them, but to better understand such a violent and tyrannical era. Nobody knows who Bo was.[226]

Nobody might remember Bo, but Cynthia Carr has identified several of the faces in the crowd.[227]

In the instance of the framed Shipp and Smith image, with its macabre memento of victims' hair—the complete opposite of a locket with a photograph and lock of hair of a loved one—the spectacle extends beyond the event of the lynching and moves into domestic space. A framed image, to be hung on the wall of a white person's home, a white person who might well have employed black people, black men, women, or children who might well have seen this image, along with images in newspapers, and all the stories that circulated in communities filled with threat and the reality of being lynched, knowing that there was no defense open to you, no true recourse to justice; "emancipated" and free in word only.

To a degree, we see here another aspect of the domestic containment discussed in the previous chapter; for the whites, the home is sanctuary, offering security from the threat of black violence, the image a reminder not only of white power but of black inferiority; an inferiority naturalized in the minds of the white population in many ways but here, situated in the home, it speaks to other white visitors, reinforces white solidarity, what Du Bois called "Southern traditional order." As the title of James Allen et al.'s *Without Sanctuary* brings to light, the black men, women, and children of the South (and border states) could rely on no such sanctuary; the circumstances of their containment were peculiarly visual. As Smith notes in her analysis of Cameron's self-commentary on the events leading up to his eventual

escape from the lynch mob, he perceived "his actual experience of lynching through the lens of the images that have shaped his imagination of lynching."[228] For obvious reasons southern black people did not attend public lynchings, in effect, then, their knowledge of lynching was "paradoxically distant and perhaps fantastic": a radically different form of domestic containment than that chosen by the white population.[229]

Writing in 1931 under the office of chairman of the National Committee for the Defense of Political Prisoners, Theodore Dreiser concludes his "Speech on the Scottsboro Case" thus: "Negro-lynching has become not only an age-old national menace, but almost a legitimate practice in the South which must be averted and stopped."[230] Underpinning lynching and the racialization and racial identity identified by Du Bois are the exceptional obstacles faced by black people in America, which were shaped by the experience of slavery. Lynching, therefore, forms part of the visuality of the South and is the more brutal and barbaric extension of the Jim Crow ratified visual regime of segregation operating in the South.

Plates 20 and 21 visualize the "perverse world" of Jim Crow America and help split black consciousness into Du Bois double consciousness. Every wall, sign, water cooler, window, etc. becomes the veil onto which "blackness" is projected, racializing the black community and enforcing their sense of psychological and physiological difference from white culture and society; the city, the architecture, the streets, the buses, for example, are all recognizably the same for black and white people and yet for the African American person these objects reflect their difference.

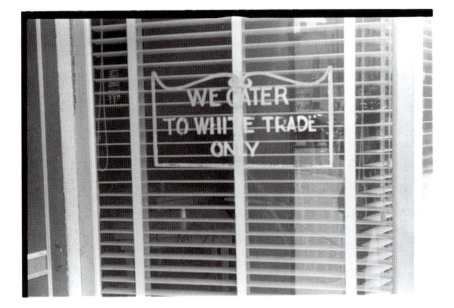

Plate 20 Ben Shahn, Lancaster, Ohio, August 1938. Library of Congress, Prints & Photographs Division [LC-USF33-6392-M4].

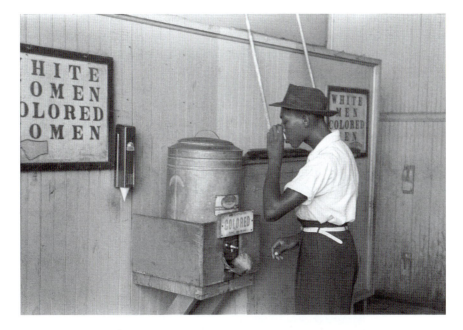

Plate 21 Russell Lee. Man drinking at a water cooler in the street car terminal, Oklahoma City, 1939. Library of Congress, Prints & Photographs Division [LC-USZ62-80126]

Entering buildings, waiting for buses, watching a movie all must be negotiated as though being seen through the eyes of another. What Shahn and Lee show us is the signage which tells one group of people that they are not fit to drink from the same tap, eat at the same table, ride in the same part of the bus; and if they do not like this then there are other ways of reminding black people of their "place."

Gordon Parks: *American Gothic*

The "place" of black people is as we have seen as "other" and "different," so different that separate waiting halls, bus sections, and neighborhoods were required to "remind" them of their difference. Gordon Parks's (1912–2006) *American Gothic* (1942), a photograph of Ella Watson, a charwoman at the Farm Security Administration Offices in Washington D.C., is a particularly damning photograph. The FSA, discussed in the chapter on war and documentary photography, was principally involved in documenting the hardships faced by Americans during the 1930s. Photographers including Walker Evans and Dorothea Lange were tasked with capturing on photographic film the facts of poverty and its effects on American life; Parks was recruited by FSA Director Roy Stryker and it was while visiting the FSA's offices in Washington D.C. that his eyes were opened up to the prejudices of white

America. Parks's first impressions of 1942 Washington, D.C. were hardly auspicious and he was dumbfounded by the bigotry and discrimination evident in the city. "White restaurants made me enter through the back," Parks says, "white theatres wouldn't even let me in the door . . ."[231]

Returning to the FSA offices, Parks met Ella Watson, who mopped the floors of the building as part of a cleaning team. He spoke to her about her life, asked to photograph her and she agreed. *American Gothic*, named after Grant Wood's famous regionalist painting of 1930, places Watson bolt upright, staring into the lens of Parks's camera, her mop behind her, a sweeping bush (rather than Wood's pitchfork) in front, the Stars and Stripes filling the background. One could (and

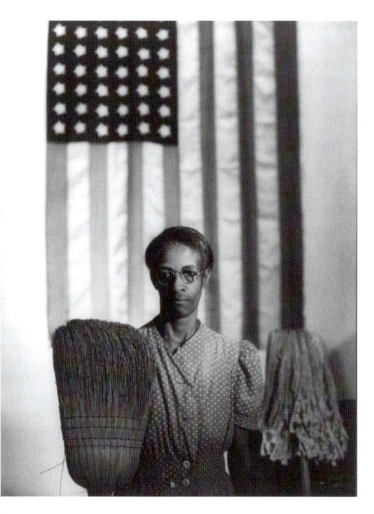

Plate 22 Gordon Parks, *American Gothic*, 1942. Library of Congress, Prints & Photographs Division, FSA-OWI Collection [LC-DIG-fsa-8b14845].

should) compare this picture to Lange's FSA photograph, *Migrant Mother* as well as Wood's painting of the same name, but in keeping with our interest in Du Bois and double consciousness, let us consider it in Du Boisean terms. Parks's photograph is confrontational, so much so that Stryker, while encouraging the photographer to continue to find subjects like this and photograph them, was sure that *American Gothic* would get "all the FSA photographers fired …"[232] This photograph is an indictment of white America's treatment of the post-emancipation African American and it was taken in the offices of a building that was supposed to expose social injustice in America.

Ella Watson is the face of those who inhabit the lowest level of the American social hierarchy, a system founded on racist principles, who for most part, like Watson and the teams of cleaners who work in the twilight hours, remain invisible to the white oppressor. Here is the "other" looking back in a way that makes it impossible for the viewer to refuse Watson's gaze as the little girl refused to exchange Du Bois's visiting card. As Du Bois notes, the white population might not see themselves as "white" or that their actions, social codes, and beliefs are as culturally and psychologically constructed as "blackness" but Watson's gaze appears to tell us that she, with second sight, recognizes it all too well. After reading the section on documentary photography later in the book, I would encourage the reader to return to Parks's *American Gothic* and reconsider it in light of criticisms leveled at documentary photography. For the moment though, Parks's image makes manifest the latent racism at the heart of America's legislature, Washington D.C., and hence across America. When the FSA was closed, Parks went on to join the photographers at the Office of War Information, resigning in 1944, again in response to endemic racism; his career as a freelance photographer saw him working at Vogue and producing many iconic portraits of the likes of Muhammad Ali, Malcolm X, and the Prime Minister of the Black Panther Party, Stokely Carmichael. A final note, and another area of visual culture to explore at another time, Parks's became Hollywood's first high-profile black director (directing *The Learning Tree* [1969] based on his autobiographical novel; he also composed the musical score and wrote the screenplay). More famously, Parks's helped invent the "blaxploitation" movie genre, with his films, *Shaft* (1971) and the sequel, *Shaft's Big Score* (1972).

Emory Douglas and the Black Panthers

In this final section, we turn to the story of a more radical, revolutionary-minded group, the Black Panthers. The imagery or visuality of the Black Panther Party is best exemplified by the activist illustrations of Emory Douglas. Douglas's art is without compromise, without fear, and, for many, without due recognition. As John Sinclair writes, Douglas's work for "the *Black Panther* newspaper and the party's other propaganda media—posters, banners, buttons, record covers, bumper-stickers and

broadsides—brought the Panthers' revolutionary analysis and grass roots political action program to vivid life for millions of oppressed African Americans and their white sympathizers."[233] Formed by Huey P. Newton and Bobby Searle in Oakland, California in 1966, the Black Panther Party for Self-Defense initially promoted a radical agenda, one that rejected Dr. King's integrationist agenda, in favor of a revolutionary politics. The writings of Karl Marx, Vladimir Lenin, and Mao, revised and interpreted accordingly, were crucial in the Party's professed intention to bring about a socialist revolution.

The Panthers, though, were not the first African Americans to find hope in the work of Marx and the Communist Party. In an anthology of writings, simply called *Negro*, Nancy Cunard collected and published (originally in 1934) writings by African Americans, with a large selection of writers espousing the benefits of a Socialist/Communist/Marxist political revolution for "the Negro." Will Herberg argues, in "Marxism and the American Negro," there is an "organic link between the democratic emancipation of the Negro people and the Socialist revolution of the proletariat" and that the "racial emancipation of the Negro cannot come as the result of a purely 'racial' movement …"[234] In "Blacks turn Red," Eugene Gordon offers a feisty rebuttal of "entrenched black leadership" and calls for more African Americans to stand with the Communist Party; abused since "emancipation" and let down by successive black leaders, Booker T. Washington and Frederick Douglass among them, only the Communist Party can truly emancipate the black worker.[235] Both Herberg and Gordon express a lack of faith not only in the present political system that has made them "free" but in the capacity of black leaders in the 1920s and 1930s to do anything about the plight of "the Negro." However, this should not distract from fact that, as reported in the New York *Daily Worker*, on May 31, 1932, James W. Ford was named nominee for Vice-President on the Communist ticket. In his speech accepting the nomination, Ford said: "Negroes exist as a nation of social outcasts in this country. This is their status after 70 years of so-called 'Emancipation'."[236] The significance of this event is relayed in a short piece in *The Negro Worker* (June 15, 1932), entitled: "Sketch of the Life of James W. Ford, Negro Worker Nominated for Vice-President of the U.S."; and contains the following information:

> Today the grandson of a man who was lynched to "show niggers their place," the son of a laborer whose name was changed because "it don't matter about a nigger's name nohow," has been brought by a wave of working-class solidarity, or working-class resentment against jim-crow [*sic*] and lynching, to the position of candidate for the vice-president of the United States.[237]

It was a continuing wave of violence and brutality by the police, and the authorities they served, against black communities in the 1960s, that galvanized the Black Panthers, in much the same way as lynching, poverty, and inequality galvanized the

likes of Herberg, Gordon, and Ford before them. Riots in Detroit, New York, New Jersey, Watts, Harlem, Rochester, and Philadelphia in 1964 and 1965, which saw mostly black people killed, resulted in the police occupation of black ghettos across America. The *Black Panther* newspaper became a crucial tool in the dissemination of the Party's ideas, its work in communities and to "prepare oppressed people for violent revolution, if necessary, in pursuit of psychological and economic liberation."[238] Douglas's posters, which appeared sometimes in color on the back of the newspaper, and his black and white cover images, display the Panthers armed militancy with great frequency.

Armed and confrontational (Plate 23), Douglas portrayed the revolutionary consciousness as one willing to bear arms when necessary. Perhaps more controversial was the repeated motif in Douglas's work of the police (or any armed government agency working to defend capitalism) as pigs (see below) and fascists. The "pig" was the signature image of Douglas's work; the term "The Pig" was the Black Panther's description for "the killer police force 'occupying' the black ghettoes of America."[239] Amiri Baraka says that "Emory's 'pig' was a nasty filthy creature with the projected sensibility that was mostly slime lover and animal slacker, if you will."[240] Douglas thought the purpose of revolutionary art was "to expose the lies and oppression of the enemy, and in doing so win the minds of the people."[241]

Is it possible to think of Douglas's pig imagery (Plate 24) as more than simply a shock tactic, designed to incense white authorities and humor those "occupied" black communities in 1960s' America? There seems to be in Douglas's work some sense of what Du Bois called "second sight," when African Americans come to see what white Americans cannot see, the cultural and psychological construction of racial difference. In essence, racial difference and all the connotations that go along with it have been naturalized to the extent that the white oppressor is totally blind to their own cultural and psychological construction as "white"; Douglas's pigs project a picture of whiteness that white people do not recognize, a visualization of whiteness that is a translation and transplanting of Du Bois's "sense of always looking at one's self through the eyes of others," a white introduction to the double consciousness of being seen as different, as a "race." As such, Douglas's art is more than mere agitprop but a complex critique of the construction of black and white racial identity—a reminder to the white oppressor of the vulnerable nature of their own sense of self and identity as well as a reminder of black intellectual, social, and, if need be, militant power.

The *Black Panther* newspaper was a budget, two-color, highly illustrated publication, and these technological limits are important when we consider Douglas's work. One of the most significant solutions Douglas found to counter his limited resources was his use of collaging and recollaging photographs and drawings. In the work, *Alabama, Georgia, Louisiana, Mississippi, California, Chicago, New York, America! Freedom is a Constant Struggle* (November 23, 1972) (Plate 25), Douglas incorporates an image we were confronted with earlier, Lawrence Beitler's,

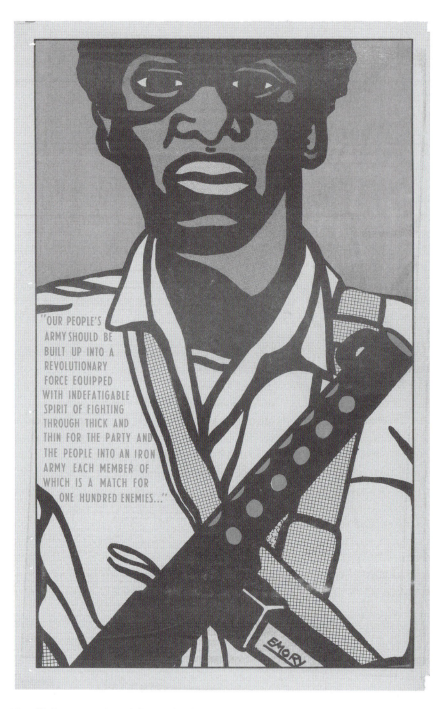

Plate 23 Emory Douglas, April 18, 1970 with the quote "Our people's army should be built up into a revolutionary force . . ." © Emory Douglas. ARS, NY and DACS, London 2008.

IT'S ALL THE SAME

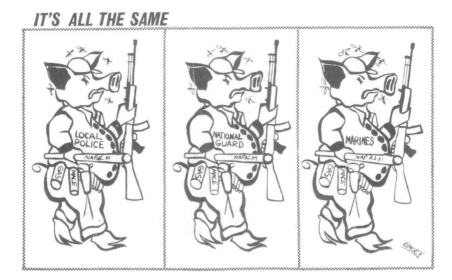

Plate 24 Emory Douglas, September 28, 1968. "It's All the Same." © Emory Douglas. ARS, NY and DACS, London 2008.

Lynching of Thomas Shipp and Abram Smith, August 7, 1930. Here the context is very different, no longer framed, annotated, and containing mementos taken from the victims' bodies or displayed in a white Southern home; this time, the image is on the back of a radical political magazine espousing violent revolution and the end of white imperialist power, not just in America but across the world. Douglas colorizes the original photograph, while masking out one of the lynching victims who remains black and white. Pasted onto this backdrop is the figure of an old black man, seated, holding crutches and a hat, wearing an expression of defeat; at his knee is another image, of two small black boys, and to the upper left an advertisement for the "Labor Supply of Maryland and Virginia Negroes." The white figure in the crowd who seems to stare us in the eye, was previously identified as "Bo pointin at his niga"; on that occasion, we described the latent threat of this image as a warning, which acted as a means of containment—the white man pointing at the hanged black man, staring from the page at the (presumed) black reader of the *Black Panther* newspaper—this image seems to register as a reminder that the black man is different and does not belong in white society. However, the fact that the *Black Panther* newspaper, which is aimed at a specific readership, has published the image and that the image itself was produced by a black activist, alters considerably our understanding of this picture.

If we recall Du Bois's veil as the screen onto which white fantasies of black inferiority/white superiority are projected, then what can we make of Douglas's collage? Is this veil showing blackness through the eyes of another, that is, is this image capable of producing the Du Boisean double consciousness or does it render

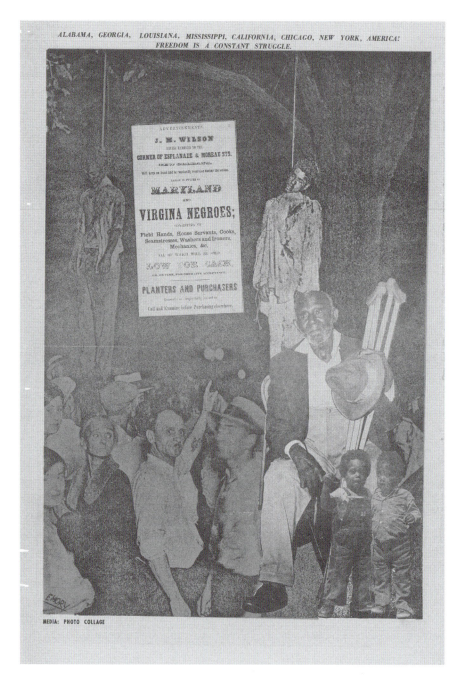

Plate 25 Emory Douglas, *Alabama, Georgia, Louisiana, California, Chicago, New York, America! Freedom is a constant struggle* (November 23, 1972). © Emory Douglas. ARS, NY and DACS, London 2008.

the psychological split redundant? Arguably, Douglas trades on the concept of double consciousness here, but then seeks to enlighten the viewer through provocation and the provocateur in this image emerges out of several gazes. What do we see: the slavery advertisement which labels black workers as though they were types of vegetable and appears to auction them off for little more than the price of vegetables; the murder of two black men by a mob of white people, one of whom looks directly at us, pointing; the old man and young boys, poorly clothed but contemporary, not historical figures: emancipation and desegregation and still no change. Still poor, still considered second-class citizens, still lucky to make it into old age, born into a very long and ongoing nightmare of disadvantage, hardship, and systematic, government sponsored disenfranchisement. Douglas's image wants to make us angry, to make us aware of the racialization of the black community and to mobilize an active and participatory audience who will fight back; to enthuse and enable people who refuse to be bought and sold, or to live under the threat of white supremacist lynching and violence.

Evidence for the anxiety the Black Panther Party generated during its relatively short lifespan is easily found in literature produced to discredit the organization, to name but one source. The long-standing fear in America of communism taking root, leading to revolution and the overthrowing of the ruling classes, was given new edge by the Black Panther's militant message of "Black Power!" As a reaction, conservative America mobilized to extinguish the movement, as exemplified by Kent Courtney's, *Are These Cats Red? The Black Panthers* (1969).[242]

Courtney's "exposé" outlines the Black Panthers as a ruthless guerrilla outfit, bent on killing police officers, arming black communities so that they may wage war on America to secure their goal of a socialist state. Courtney's America is "white" America and it is under attack or at least the threat of attack; the Panthers are envisioned as traitors, agitators for foreign (communist) powers in the heart of America. Courtney notes that "FBI Director, J. Edgar Hoover testified before the House Appropriations committee, February 16, 1967, that Stokely Carmichael, Black Panther Prime Minister, 'has been in frequent contact with Max Stanford, field Chairman of the Revolutionary Action Movement,' which is 'dedicated to the overthrow of the capitalist system in the United States, by violence if necessary, and its replacement by a Socialist system oriented toward the Chinese-Communist interpretation of Marxism-Leninism.'"[243]

Obviously, the history of the Black Panther Party is contentious for reasons I have not covered here—the illustrations of Douglas were the most important focus of our analysis—therefore, I would encourage the reader to explore this history in more detail. Courtney's "exposé" makes several startling claims but the basis of them all seem to speak through those twin anxieties of race (blackness) and communism, both viewed as threats to white, capitalist power, a power which remains invisible because it has been naturalized and hence seen as "normal." The work of Du Bois on the visualization of race in America and his concepts of double consciousness,

the veil, and second sight are an extremely useful and insightful critical framework for the analysis of white images of "blackness" and vice versa. Du Bois's insight allows for a complex examination of troubling material, lynching photography and ephemera particularly, but also the seemingly more neutral "documents" of Jim Crow, which show window signs denying access to black people or directing them to an allotted "colored section." The revolutionary artwork and illustration of Emory Douglas, uncompromising in its analysis of white prejudice and racism, might appear straightforward, even crude, but the language of Douglas's collages following Du Bois opens up a series of critical gazes that reveal the work to be far from didactic but complex and nuanced. Du Bois's use of the color line to understand that "sense of always looking at one's self through the eyes of others," the adoption of a visual paradigm as a means of comprehending "racialization" and racial identification, is fundamental in helping the visual culture theorist understand the complicated meanings associated with the images that are of or about racism in America.

–4–

From a Comfortable Distance

Documentary and the Visual Culture of War

If the last chapter alerted us to the ways in which photographs of lynching in America operated within economies of racial "containment" and consumption (purchasing photographic prints, postcards, even parts of the victim's body), it only hinted at another crucial visual economy: documentary. The determination of Du Bois to use actual photographic imagery of lynching itself in *The Crisis* is, in effect, the assertion that photographic meaning is unstable. Where Emory Douglas embellished the photograph of Shipp and Smith's lynching through collage, Du Bois's use of the caption, for example, retains the original visual image but reveals another dimension to the still picture. Here lynching photography is not a means to reinforce traditional Southern order, that is the naturalization of white racism and brutality against the black population, but its opposite—lynching photography as evidence whose aim is to denaturalize the Southern traditional order, and reveal it as inherently racist and overtly brutal. In this chapter, we will look more closely at the instability of photographic meaning and how this in fact complicates Du Bois's notion of documentary photography. The important difference here will be that the photographs discussed hereafter were produced under very different circumstances: war. For obvious reasons, the visualization of war has played an important and defining role in American history (a point that can be made about nations, war, and the role of photography). Whether as propaganda (deliberate or not) to bolster a war effort or as exposé of horror or injustice, photographs that document war say an awful lot not only about the conflict and the subject they depict, but also about the photographer him/herself. This chapter asks "what is documentary photography?" and examines several iconic images of America at war.

A day after the terrorist attacks of September 11, 2001, where four commercial jet airliners were hijacked in a coordinated suicide attack on American soil, President George W. Bush, in a meeting with his National Security Team, said, "The deliberate and deadly attacks which were carried out yesterday against our country were more than acts of terror. They were acts of war." Consequently, President Bush and his administration announced and then embarked upon a "war on terror."[244] The continuing war on terror might easily become a continual war on terror—as the meaning and perpetrators (Bush's "evil doers") of terror are constantly revised and "revisualized," resulting in what W. J. T. Mitchell calls "cloning terror" and the

"biopicture"[245]—but these debates, just like the arguments surrounding the validity of the war on terror or the conspiracy theories surrounding the attacks on the World Trade Center and the Pentagon, are not the prime interest of this chapter.[246] What is of interest is the visualization of war through documentary photography and related imagery: from the American Civil War, through World War II and Vietnam, up to the present "war on terror."

To understand how war is—and has been—visualized, the first port of call is documentary photography and photojournalism. Our investigations here will cover familiar ground—the authenticity and veracity of photography as a medium, one able to scientifically and therefore objectively "capture" the real world—but are framed somewhat differently. The terms "documentary" and "war" are spectacularly amorphous and made more so when they carry the burden of representation; that is, what *is* documentary and how does its imagery *represent* war? This latter point is intriguing because, as we shall see, historically the representation of war has altered dramatically. In other words, what can and cannot be shown oscillates throughout the nineteenth, twentieth, and twenty-first centuries: what remains unchanged is the desire and urge to visualize all aspects of war. But who "censors" images of war and why? And how do modes of dissemination (newspapers, magazine, television, cinema newsreels), authorial intention (the "investigative" photojournalist), or institutional allegiances (the US Military Photographic Service, for example) affect, manipulate, or "control" the meaning of a war image?

Addressing each of these questions, and others that arise, this chapter will examine a variety of war images, mainly photographs, taken by different image-makers during several conflicts. We begin with a question, "What is Documentary?" and examine the historical development of documentary photography. Variously described as "a form, a genre, a tradition, a style, a movement and a practice," documentary photography has been used as a tool to draw wider attention to issues other than war.[247] In fact, documentary imagery has been employed in "wars" against poverty and social injustice, and the opening discussion on documentary is grounded in the complementary critiques of Abigail Solomon-Godeau and Martha Rosler.[248] Picking out the fundamental criticisms of Solomon-Godeau and Rosler—the imperialist gaze, the structural limitations of documentary imagery—we then turn our attention to a series of documentary images relating to war: Matthew Brady and American Civil War imagery, Joe Rosenthal's photographs of the raising the flag on Iwo Jima, a selection of images taken from the American National Archives, Don McCullin's image from Vietnam, *Shell Shocked Marine* (1968), and ending with a series of questions relating to images of the so-called war on terror.

What is Documentary?

Abigail Solomon-Godeau begins at the beginning, as it were, by asking: "What is a documentary photograph?" Her initial answer is an even-handed "'just about

everything' or alternatively, 'just about nothing.'"[249] By "everything," Solomon-Godeau refers to the indexical quality of photography; the photograph is a trace of what appeared in front of the camera lens: just as a footprint in sand is evidence of the now absent foot that made the original mark or impression. Therefore the photograph "is a document of *something*. From this expansive position, no photograph is more or less documentary than any other."[250] In essence, every photograph documents something; hence, *all* photographs are documentary. Documentary, though, was not a phrase applied directly to photography with any regularity before the 1920s. The phrase came into being in 1926 after British film producer John Grierson used the term to describe a type of factual film or form of cinema able "to replace what he saw as the dream factory of Hollywood."[251] The emphasis here is on the employment of lens-based media, film or photography, to tell the truth and not to deceive the audience. Grierson's reaction to the films of the Hollywood "dream factory"—and the wedding of photography to this idea of documentary—reveal how historically photography has been understood "as innately and inescapably performing a documentary function."[252] The next chapter, on crime and the invention of the mug shot, shows that such a perspective is predicated on the belief in photography's veracity, its capacity to simultaneously be *and* show the "Truth."

To make sense of documentary photography, Solomon-Godeau argues that, firstly, we must look at it as a historical construction. So, how do we differentiate contemporary documentary photography from that of the nineteenth century? As a "plural-field"—documentary is every photograph—"Is the avatar of documentary photography the police mug shot possessing evidentiary status, the horse race's photo finish, or photography animated by social concern?"[253] Or is it all of these and more? Secondly, we must consider documentary photography semiotically or, in other words, as part of a larger system of meaning and visual communication. And, thirdly, we must examine "the position of documentary photography within the discursive spaces of the mass media ... in order to better grasp the role it plays, the assumptions and attitudes its fosters, the belief systems it confirms."[254] For the sake of this chapter, it is the third of Solomon-Godeau's points that will engage us; the impetus behind our examination of war imagery is not just a visual analysis of a particular image but the way in which that image, in terms of its form and content, operates within the wider nexus of cultural relations across a variety of media.

The arguments above all converge around the concept of realism. This is because "it is pre-eminently photography's ostensible purchase on the real that materially determines both its instrumentality and its persuasive capacities."[255] Documentary photography, therefore, appears as a kind of gatekeeper to the truth; it offers the promise of unmediated access to the reality of whatever fills its lens—whether it is the suffering of poverty, the horror of war, or the devastating effect on the human body of starvation—the photograph is an authentic and accurate recording of that suffering: it persuades us because it is, in the end, undeniable. All the horror, happiness, distress, relief, terror, or joy captured in film, drawn in through the

camera lens, caught in a split-second as the shutter blinked; and all this, whatever the subject might be—a wounded soldier, a dying child, a destroyed building, a flooded village—engages with us directly as we see what the photographer/camera saw but as a photograph. More often than not this powerful intersection of gazes between the viewer and the subject of the photographic image, notes Martha Rosler, has been utilized by documentary images with a moralizing, rather than revolutionary politics. Rosler says documentary photography can generally be described as the "social conscience of liberal sensibility presented in visual imagery."[256]

Two issues distinguish themselves here. One, that documentary photography and its practitioners work with a goal in mind; they take photographs of certain subjects, at certain historical moments in order to draw attention to a perceived problem, whether poverty, child-labor, or the treatment of the mentally ill. As such, documentary photographs are neither unmediated, nor unintentional: they are motivated by and saturated with intention, be it political, moral, ethical, philosophical. For Rosler, the power of photography and, by extension, the photographer, lies in their ability to elevate forms of reality simply by *photographing* it: by "*being photographed* and thus exemplified and made concrete," reality is not just pictured but actually made more real.[257] I would ask you to pause and think about this before reading on.

The photograph becomes a form of indisputable evidence; more than hearsay, anecdote, or journal entry of the social anthropologist or progressive reformer: it is the real. As we shall see, the late nineteenth-century documentary photographer and reformist Jacob Riis (1849–1914) deliberately combined text *and* image to highlight the plight of immigrants on Manhattan's Lower East Side. Secondly, Rosler makes the case that the form of the documentary is bound or restrained by the larger social discourses of their era. In other words, how the image is composed: which elements receive attention, which are overlooked, what the subject is, how it was captured (by surprise, with consent, etc.). Solomon-Godeau, too, confirms that the reformist documentary photography of a man like Jacob Riis and his most famous work, *How the Other Half Lives* (1890), necessarily operates "within larger systems that function to limit, contain, and ultimately neutralize them." What Rosler and Solomon-Godeau pursue here is the idea that documentary photography does not have a privileged status; it is not an "outsider" looking in on the world. The outsider status of documentary photography is a kind of myth because, fundamentally, photography is not able to take up a critical position outside society and comment upon all its ills since documentary photography itself only exists *because* of the society that generates the ills it seeks to criticize. As such, Rosler and Solomon-Godeau highlight "the structural limitations of conventional documentary imagery," limitations that cannot "disrupt the textual, epistemological, and ideological systems that inscribe and contain it."[258] To fully comprehend these rather depressing and pointed criticisms, it is helpful to contextualize them in light of Riis's work.

Arguably, the documentary tradition we recognize as such today begins with Riis. In Riis's hands the genre is "defined within the framework of reformist or ameliorative

intent, encompassing issues such as public address, reception, dissemination, the notion of project or narrative rather than single image, etc."[259] *How the Other Half Lives* quite simply blends photographic half-tone reproductions combined with "muckraking prose," the aim of which was to prick the social consciences of American polite society.[260] At the heart of Riis's project was the use of the recently developed flash-powder photography, an advance that allowed him to capture life as it was lived in the dark tenements of the Lower East Side. Having worked as a police reporter/journalist for the *New York Evening Sun*, *Brooklyn News*, and *New York Tribune* covering stories in the city's poorest neighborhoods, Riis was inspired to tell their story, to inform one half of the population how the other half lived. The "Introduction" to *How the Other Half Lives* is filled with emotive rhetoric, all of it aimed at a specific reader. For example, Riis says:

> 4. What the tenements are and how they grow to what they are, we shall see hereafter. The story is dark enough, drawn from the plain public records, to send a chill to any heart. If it shall appear that the sufferings and the sins of the "other half," and the evil they breed, are but as a just punishment upon the community that gave it no other choice, it will be because that is the truth. The boundary line lies there because, while the forces for good on one side vastly outweigh the bad—it were not well otherwise—in the tenements all the influences make for evil; because they are the hot-beds of the epidemics that carry death to rich and poor alike; the nurseries of pauperism and crime that fill our jails and police courts; that throw off a scum of forty thousand human wrecks to the island asylums and workhouses year by year; that turned out in the last eight years a round half million beggars to prey upon our charities; that maintain a standing army of ten thousand tramps with all that that implies; because, above all, they touch the family life with deadly moral contagion.[261]

Riis's follows up the imploring section above with a simple question: "What are you going to do about it? …"

Riis is appealing directly to a reader with whom he is familiar, familiar enough to ask such a pointed question, and quite convinced his reader not only wants, but also has the means, to actually do something about the tenements and terrible lives of those trapped therein. Arguably, Riis takes on the task of challenging apathy and provoking those with power to make the necessary social changes required to alleviate squalor and end poverty, and hence crime, sickness, and disease, not only among the poor but all city dwellers. Riis's warning is simple: if this problem is not soon ameliorated it will spread and no one will be spared the terrible consequences. Inaction is not an option, implore Riis's photography and accompanying prose, it is irresponsible and not in any individual's self-interest.

Sally Stein's essay, "Making Connections with the Camera: Photography and Social Mobility in the Career of Jacob Riis," disputes much of the above. Under Stein's critical gaze, Riis's reformist zeal is underscored by personal ambition and his "assumption of the mantle of crusader."[262] What Riis's images of tenement squalor

(and the accompanying text) reveal instead is a "matrix of bourgeois anxieties and the need to assuage them." Notice how Riis constantly raises the troubling specter of epidemics, disease, and death, of how the poor and the cities' beggars clutter the legal system and bleed charities dry; all of these affect his "concerned" readers and if they are not worried about such things, then they *should* be. As Solomon-Godeau summarizes, the "matrix was constituted by the threat posed by large numbers of poor, unassimilated recent immigrants, the specter of social unrest, the use of photography as a part of the larger enterprise of surveillance, containment, and social control."[263] These are stiff criticisms. We should remember that photographs are able to put "a face on fear" and to "transform threat into fantasy, into imagery" because "[o]ne can handle imagery by leaving it behind (*It is them not us*)."[264] The photographic "transformation" regulates and ratifies social containment, which is exactly how the lynching photography discussed in the last chapter operated.

For Solomon-Godeau, Stein's analysis neatly draws out the "too easy conflation of 'victim photography' (a phrase from Rosler's essay) with progressivism and reform": or, simply giving poverty a face is only half the story.[265] In turn, this alerts Solomon-Godeau to a series of other interconnected but unresolved issues. For one thing, the already given *place* of the documentary subject and their status as "to be looked at" by the viewer (the "more powerful spectator") is problematic. In short, the relationship between the viewer and the subject of the photograph is one of convention, a kind of conformism, just as school pupils "know" that when they enter the classroom they make their way to their desks and face the front, so the class teacher knows to make his/her way to the front of the room and face the class; it is learned and therefore naturalized behavior. The result is that the documentary image performs "a double act of subjugation: first in the social world that has produced its victims; and second, in the regime of the image produced within and for the same system that engenders the conditions it then re-presents."[266] An example from Walter Benjamin is helpful here.

In his essay, "The Author as Producer," written in 1934, Benjamin castigates the new photography of the time—not documentary but *Neue Sachlichkeit* or The New Objectivity—for a mode of image making where "poverty is made an object of consumption."[267] More specifically, Benjamin argues that photographer, Albert Renger-Patsch, "succeeded in making even abject poverty, by recording it in a fashionably perfected manner, into an object of enjoyment."[268] What Benjamin expresses here chimes with Solomon-Godeau's concerns over documentary; first, photography as a practice is totally embedded within the institutional make-up of society; in fact, as we shall see in the next chapter, photography is fundamental to the development of the system of law and order which governs us all; the arguments that photography is somehow "outside" society becomes questionable. Second, the conventions of looking, the role of the viewer, and the conventions of making photographic images, which seem unable to resist aestheticizing its subject ("making poverty an object of enjoyment") seem resistant to the stated aims of documentary.

Do you think Solomon-Godeau's criticisms are valid? Or do you think otherwise? Whatever your position, consider the reasons why you agree/disagree: is this a debate in which it is possible to take definite position?

America and Documentary in the 1930s and Beyond

Moving on. In America, at least, the 1930s was "a period in which documentary forms in film, photography, and letters were most privileged …"[269] The genre of politicized documentary is ultimately about subject matter and the "real," and not formal experimentation. For Solomon-Godeau, "cubism, dada, surrealism, constructivism, and of course, photomontage, cannot be said to have had much influence on either the theory or the practice of documentary."[270] Documentary, it seems, is wedded forever to realism, or, more accurately, depicting the world realistically. So, if Riis was more concerned about assuaging the fears of polite society rather than actually overturning the system that created the poverty he felt compelled to picture and describe, then what about the photographic program of the federally funded Farm Security Administration (FSA), which ran as part of Roosevelt's New Deal? How different, if at all, was its approach?

The FSA, overseen by director, Roy Stryker, used documentary photography "to foster support for New Deal relief programs" through a concerted effort to show through images the effects of the Depression and Dust Bowl on American agriculture and the farmer. If Solomon-Godeau highlighted the zero effect of advanced image making (cubism, photomontage, etc.) on documentary photography, her criticism of the founding principles of FSA photographic practice is not surprising; the FSA, she argues, "took for granted that a photograph of advocacy or reform should effectively concentrate on subject matter."[271] The reason for this is because of Stryker's approach to the project. All assignments were carefully orchestrated and photographers, like Walker Evans and Dorothea Lange, went out into the field with specific directions on more than just where and whom to photograph, but also on what mood or attitudes to capture, the types of expression and certain kinds of "feeling," etc. Solomon-Godeau argues that Riis and FSA photographers, such as Lange, might well have produced radically different images but there remain "unchanging tropes." The most of important of these being "the depiction of the subject—the subject's circumstances—as a pictorial spectacle usually targeted for a different audience and a different class."[272]

Dorothea Lange comes in for criticism on the basis that her images portray "worthy" rather than "unworthy" subjects of poverty. If, as Solomon-Godeau claims, the individual victim in these images is in fact "a metonym for the invisible conditions that produced it," then documentary surely cannot effect real, lasting social change because the truth of the subject's lived experience was absent from the picture itself.[273] A face of suffering only reveals the intention of the documentary

photographer to "build pathos or sympathy into the image, to invest the subject with an emblematic or an archetypal importance, to visually dignify labor or poverty …" Solomon-Godeau concludes that "such strategies eclipse or obscure the political sphere whose determinations, actions, and instrumentalities are not in themselves visual."[274] The source of Stryker's eulogy is Lange's *Migrant Mother* (Plate 26), the

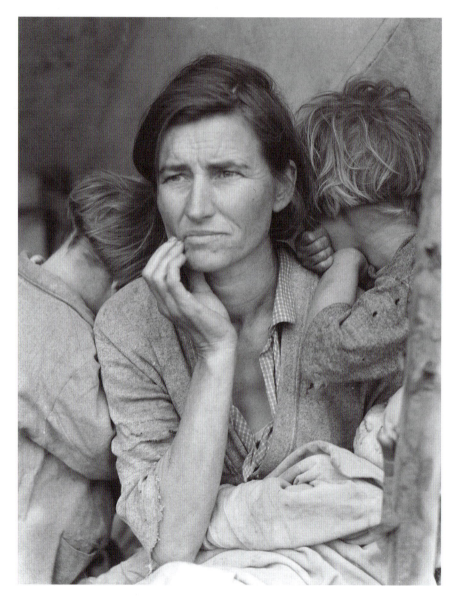

Plate 26 Dorothea Lange, *Migrant Mother*, Nipomo, CA, February 1936. Library of Congress, Prints & Photographs Division [LC-USF34-9058-C].

photograph most often referred to as the most reproduced in the world. Stryker said of the image in 1972, "When Dorothea took that picture, that was the ultimate. She never surpassed it. To me, it was *the* picture of Farm Security ... So many times I've asked myself what is she thinking? She has all the suffering of mankind in her but all of the perseverance too ... You can see anything you want in her. She is immortal."[275] But Florence Thompson, the woman in the picture, is not immortal; it is the image of her and the meanings it connotes that are considered ageless, universal. Does this single photograph explain why Florence Thompson was a migrant? Or what social and political reasons lie behind the events that led to the moment Lange snapped Thompson and her children? Can this photograph explain any of these details? The answer is "no." Stryker's eulogy never names Florence Thompson, only Lange; and yet he considers Florence Thompson to personify all human suffering and endurance; therefore, who she is and how she came to be withers away. Lange's photograph defines the aims of a governmental institution rather than questions and interrogates them; the photograph underscores Lange's greatness as a photographer. Did this photograph actually change Florence Thompson's life? Well, considering is might well be the most reproduced photograph in the world, I don't think she ever received royalties.[276]

Just to underline this point, Rosler also discusses the example of Gamma photographer David Burnett, and the photographs he made of new prisoners arriving at the infamous Chilean football stadium where many people were detained and shot after the brutal putsch of 1973. Burnett's coverage of the coup won him the Press Club's Robert Capa Award "for exceptional courage and enterprise," an event covered by the magazine, *American Photographer* (1979). As in the case of *Migrant Mother*, Rosler asks what happened to the men, the prisoners, in Burnett's photographs? But this is not a question that can be answered because the article is not about the coup, the prisoners, or anything else relating to the political turmoil in Chile; it is solely about Burnett, his photographs, and a magazine called *American Photographer*.

What is Documentary? Conclusion

To wrap up this (lengthy) introduction, I want to summarize the criticisms leveled at documentary by Abigail Solomon-Godeau and Martha Rosler because they form the critical framework for the rest of this chapter. Broadly, it is clear that both Solomon-Godeau and Rosler express several concerns; firstly, about the validity of documentary's claim to truth; and, secondly, regarding the underlying assertions that ratify documentary's motivations. Documentary seeks to rectify wrongs, to prick society's conscience (which presumes that it has one), and/or to draw attention to suffering; therefore, the invasive or voyeuristic practices of the documentary image-maker (think of Riis bursting into slum houses, catching his subjects unawares with

his photographic flash powder!) are excused or mollified on the grounds of good intentions. It is for the greater good; hence, the ends justify the means. However, as we have seen, the critiques of Solomon-Godeau and Rosler question the belief in the realism or transparency of the photographic medium—its inherent ability to show the truth—because, as they point out, this has long since been undermined; on the end/means point, documentary's best intentions can only mirror and not change the social system it purports to challenge. As Rosler says, "Imperialism breeds an imperialist sensibility in all phases of cultural life."[277]

Following Rosler, documentarians like Riis, Lange, Burnett, and others occupy the position of imperialist overseers, adventuring into "forbidden" or "dangerous" places, photographing the "natives" in order to report back on their findings to "civilization" under the auspices of raising awareness and challenging perception. At the end of the day it is not the victims' names we remember but the name of the photographer who made the photograph. Beneath the outward rhetoric of reform, in say Riis, it is possible to divine another level of motive, one that has little to do with the alleged gaze of the photographer's lens and more to do with policing the borders between a "them" (the subject of documentary) and an "us" (those who look at the products of documentary). It is the documentary photographer who holds the power, their role is to "capture" those considered without power, voiceless individuals and peoples, unable to represent themselves: the documentarian as imperialist speaks for the subject of the image because the subject cannot speak for themselves. And this is the problem at the heart of documentary for Rosler and Solomon-Godeau ("Who is Speaking Thus?").

One might well concede a misguided effort on the part of the reformist or progressive drive but when even this evaporates, we are left, Rosler argues, with an altogether different kind of documentary: "The exposé, the compassion and outrage fuelled by the dedication to reform has shaded over into combinations of exoticism, tourism, voyeurism, psychologism, and metaphysics, trophy hunting—and careerism."[278] In the end, for Rosler, the documentary work of reformists and progressives like Riis, "did not perceive of those wrongs as fundamental to the social system that tolerated them—the assumption that they were tolerated rather than *bred* marks a fallacy of social work."[279] On the decline of progressive or liberal documentary, complete with its appeals to outdated ideals such as pity or the "rescue of the oppressed," Rosler describes documentary's evolving forms as merely testifying "to the bravery or (dare we name it?) the manipulativeness and savvy of the photographer, who entered a situation of physical danger, social restrictedness, human decay, or combinations of these and saved us the trouble."[280]

The highly critical work of Rosler and Solomon-Godeau on documentary is provocative and challenging; and, in what follows, we will draw on their ideas to reconsider a variety of images of war but also to query the grounds of their critique.

Photographing War

Although I begin with the photography of the American Civil War, the aim here is simply to outline the earliest emergent themes in American photographs of war. By doing so, it helps set in stark relief a series of images from World War II; these include Joe Rosenthal's image of the raising the Stars and Stripes on Iwo Jima, photographs of war in the National Archives, as well as the effect of war on American soil, particularly Dorothea Lange's documentary photographs of the internment of American-Japanese citizens in California. The closing sections of this chapter move on to Vietnam and Don McCullin's *Shell Shocked Marine* (1968), ending with photographs of different register, taken by soldiers at Abu Ghraib prison.

As Joel Snyder notes, the "American Civil War was the first war to be photographed systematically from beginning to end."[281] On the whole, these photographers, commercially successful before the war, went to take photographs that they could sell to the public and popular press. Snyder admits that "[b]y contemporary standards, most photographs of the Civil War seem static, remote, and often dull."[282] This is because the war photography with which most of us are familiar belongs to a "tradition" that emerged in the 1930s with the development of the extremely portable 35mm Leica roll-film camera. Portability allows the photographer access to the action itself; the nineteenth-century Civil War photographer was not quite so mobile, with a huge camera, portable darkroom, and glass-slides, etc. Still, Snyder argues that neither technological advances, nor the attitude of the photographers can explain the radical difference in the images. Civil War photographs do not contain images of the maimed, dead and dying or "ground-shaking explosions lifting soldiers and debris into the air." Instead, the dominant trope is landscape photography, with an emphasis on the pastoral: churches, old farmhouses, and empty fields.[283]

As such, the photographs of the Civil War appear quite unlike the documentary imagery Rosler and Solomon-Godeau criticize with such ferocity. The photographer and the photographs of this earlier war are of a completely different order; here is a different kind of documentary. Snyder argues that what constituted the war photograph during the Civil War was carefully constituted and determined by an agreed set of principles. Describing these principles as "crude," Snyder continues:

> the operating principle for depicting the field of battle was something like this: if the territory to be photographed was the ground upon which the battle had been fought, or if it was reasonably close to such ground, it was a fit subject for depiction. The interest of the picture was not to be generated from the manner of representation, but was to grow out of a clear and precise rendering of the geographic location which itself had *intrinsic significance*.[284]

At best, these images attend to the circumstances of war. However, the landscape and those places within it touched by the war are more significant than the

representation of the actual conflict itself. What fascinates the photographer about these landscapes (and one presumes the contemporary audience of the day) are "the unoccupied houses in which generals planned battles … and the scenes of devastation caused by the war."[285] Here are perfectly still images which bear witness to the traces or inferences of terrible events, the staging of counterattacks, and strategizing under the pressures of war. These are images of the aftermath, the smoldering calm after, not before, the storm.

At the heart of this story is Matthew B. Brady (1822–96). When the Civil War began, Brady was a successful, award winning portrait photographer with studios in New York and Washington, D.C. Blessed (or cursed) with an opportunistic eye, Brady decided to photograph the war. Along with a large Corps of artist-photographers, Brady and his "unit," each with a mobile dark room, produced over 10,000 photographic plates.[286] Brady petitioned the Congress of the United States in 1869 with the hope that the U.S. government would purchase his archive, but they refused. Consequently, Brady was bankrupted; although he was later offered (and accepted) $25,000 for the collection, he died penniless and forgotten. History portrays Brady's as a tragic tale of a great photographer whose vision and accomplishment was ahead of its time, but is this truly the case?

With Rosler's condemnation of the "superstar" documentary photographer still ringing in our ears, is it worth thinking again about the significance of Brady? Can we identify a contemporary tendency to read the history of the Civil War and the thousands of photographs relating to the conflict through a solitary figure named "Brady"? Writing roughly a decade later than Snyder, Alan Trachtenberg notes,

> Much of the hard archival scholarship seems to have gone in pursuit of one particular red herring: the role of Mathew B. Brady, with whose name the entire Civil War project has long been unshakably identified. As everyone knew at the time, Brady was more an entrepreneur than a photographer, the proprietor of fashionable galleries in Washington and New York. It seemed to trouble no one that he was not himself the cameraman who made the pictures he signed "Brady."[287]

Perhaps the genius of Brady was not his technical skill as a photographer but that, some time before artists Marcel Duchamp and Andy Warhol, he realized the power of the authorial signature as a sign or guarantee of meaning. As such, "It can be said that whoever may have authored Brady's images, 'Brady' authorized them, gave them imprimatur…. Most important, he placed the images in a distinct context, a structured discourse that has sealed them indelibly as 'Civil War photographs.'" Trachtenberg argues further that "Brady does seem to have been the earliest to conceive of a form for the presentation of the pictures, a structure to contain and articulate them as a whole entity, a totality—and to enunciate them one by one as parts of that totality."[288] In essence, the stamp of "Brady" readily recalls "Civil War" just as, since the 1940s, the moniker "Weegee" evokes "crime"; each individual

image, whether made by Brady or not becomes subsumed, forming part of a larger structure of meaning. *Brady's Photographic Views of the War* (1862) is the product of this process, what Trachtenberg calls "the earliest effort to organize a rapidly accumulating mass of war and war-related images, to present, even as the war progressed and images piled up, the entire mass as a single whole, an emergent totality."[289] Each photograph is captioned, organized, and categorized, the result being that the individual image is no longer a picture as such but "datum, an item of sequential regularity."[290]

We should not forget, however, that Brady's desire to categorize the war was underscored by a commercial motive. Looking again at Brady's petition to Congress, it not only lists the kinds of legitimate views of "the Rebellion" but also offers a rationale and a subtle request that his financial outgoings be recompensed. Brady's marketing skills come to the fore in his pleadings to Congress; of his own volition, the petition makes clear, on commencement of the Rebellion he took it upon himself to record what would no doubt become a crucial part of American history. Brady subtly references himself as being the sole organizer of the project, overseeing "an efficient corps of Artists for the production of photographic views, illustrating prominent incidents of the war." All of which, he adds, at great (personal) expense.[291] It is a fantastic appeal—the artist photographers are a fighting unit, a corps; this is the recording of American history, so this collection must be preserved for the nation; and it was extremely expensive for a private, concerned citizen, therefore financial compensation was only fair. Do you think Congress was initially wrong not to purchase Brady's collection of war images? And what of Brady's motives, does it matter that his prime motivation might have been money and glory, when we are left with such a rich archive of Civil War images?

Joe Rosenthal and the Raising of Two Flags

Like Lange's *Migrant Mother*, Associated Press (AP) photographer, Joe Rosenthal's Pulitzer Prize winning *Marines Raising Flag: Mount Suribachi, Iwo Jima* (1945) (Plate 27) is also referred to as the most reproduced photograph of all time. This dubious distinction aside, Rosenthal's photograph of Marines raising the Stars and Stripes seemingly owes little to either Matthew B. Brady or the principles of Civil War photography. Of course, Rosenthal's photographic equipment was more portable (he used a "Speed Graphic" camera, just like Arthur "Weegee the Famous" Fellig), he had no need to carry with him a mobile darkroom, and he moved alongside the soldiers rather than appearing after they had left the scene. Hence, this image is one of action, where the viewer is in the moment, watching as the Marines haul into prominent sight the symbol of American power, the national flag. Having said this, Rosenthal's image has quite a lot in common with Brady and Civil War photography; as Rosenthal admitted, we are not in the moment *the* flag

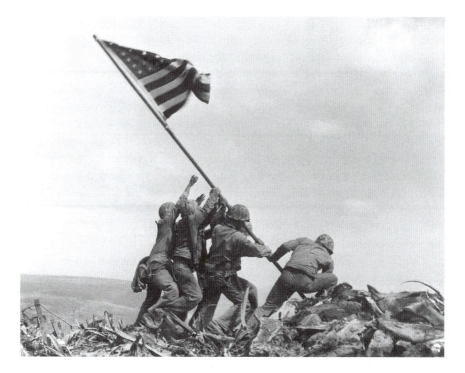

Plate 27 Joe Rosenthal, *Marine Raising Flag: Mount Suribachi, Iwo Jima*, 1945. Taken at 13.00, February 23, 1945. Men raising flag: the front four are (left to right) Ira Hayes, Franklin Sousley, John Bradley, and Harlon Block. The back two are Michael Strank (behind Sousley) and Rene Gagnon (behind Bradley). AP/PA Photos.

was raised at around 10.35 a.m. on February 23, 1945 because this is a picture of the raising of a second flag, a larger, more visible replacement for the original, a flag "scrounged from the Navy."[292] Just like Civil War photography, then, this image *illustrates* a prominent incident of war, in much the same way Brady articulates in his Petition to Congress.

This does not mean, though, as some have claimed, that Rosenthal's picture is staged, a carefully orchestrated rendition of how one might imagine this dramatic ritual against a portentous sky: something akin to a "Hollywood version." But Rosenthal's image has nothing to do with Hollywood and everything to do with simply being a more arresting image than that of the raising of the first flag over Iwo Jima. Lou Lowery took the less famous and far less striking photograph of the first flag raising on Mt. Suribachi (Plate 28). As a Marine Corps photographer, Lowery was on hand to document the event of the first flag raising a full three hours before Rosenthal who arrived for the second—as we imagine all documentary photographers do—"unofficially" paid a visit to the summit after hearing about the Marines' success.

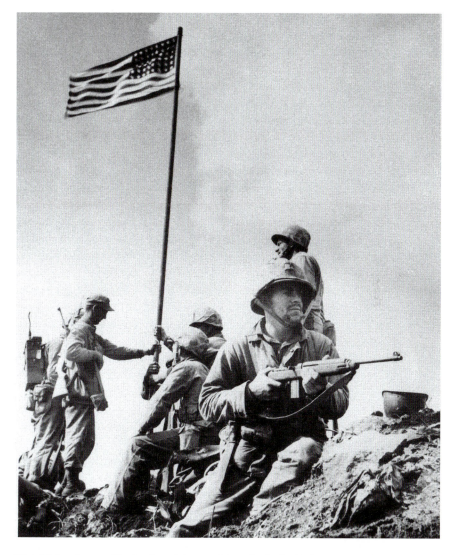

Plate 28 Lou Lowery, *The first flag raising atop Mount Suribachi, 23rd February*, 1945. Hank Hansen (without helmet), Boots Thomas (seated), John Bradley (behind Thomas) Phil Ward (hand visible grasping pole), Jim Michaels (with carbine), and Chuck Lindberg (behind Michaels); 10 a.m., Feb. 23, 1945. AP/PA Photos.

Lt. Colonel Chandler decided the first ensign in Lowery's photograph was too small to be seen by troops elsewhere on the island, so a larger flag was raised in place of the original.[293] Rosenthal arrived to witness the change: thought about photographing the switch with both flags but decided against it, concentrating instead on the raising of the new flag.

Rosenthal ignored the two flag photograph, with famous consequences. (Pity Bob Campbell, then, who captured the taking down of one and the raising of the other flag; a significant moment in the war and a great photograph in itself (not reproduced here).) Lowery's photograph is by the standards of Rosenthal and Campbell's photographs, quite dull. The momentousness of the victory hardly registers in Lowery's picture at all; in Campbell's shot, at least there is a sense of precariousness, of care, of solemnity and pride not to drop the flag, matched in the background by the efforts to secure and raise the new ensign. Neither, however, has the dramatic compositional and visual power Rosenthal's photograph: but what makes this particular photograph so special?

For the sake of argument, there are two, interconnected points to be made in this regard: firstly, the aesthetics of the photograph and, secondly, as we discussed earlier, Solomon-Godeau's observation that documentary is metonymic. Metonymy is a figure of speech and, like metaphor, works by replacing one word with another. The word "Hollywood" is a good example; Hollywood is a district of Los Angeles, California, but is more often than not used to signify the film industry as a whole rather than the district. The same is true of "The White House," which is an architectural structure and official residence of the President of the United States of America, but it is also a metonym for the President and his staff; next time you watch the news, listen for the use of "The White House" in reports. So, how is Rosenthal's image metonymic? Or what is it a metonym for? To answer these questions, we must consider the way in which Rosenthal's photograph entered the wider public consciousness—surely the aim of documentary?

Other than the raising of the flag, Rosenthal also photographed the subsequent steadying of the flag and then organized a group shot in order to ensure he had several worthy pictures to wire to the Associated Press offices. However, as Karal Ann Marling and John Wetenhall point out, taking the photographs is the easy part, getting the undeveloped film off the island was much more difficult.[294] Rosenthal sent his film to Guam where it was developed and printed (and probably scrutinized for censorship reasons); it caught the eye of John Bodkin, an AP photo-editor, who reportedly announced, "Here's one for all time!" before radiophotoing the image to AP offices in New York. Within less than twenty-four hours of being taken, Rosenthal's photograph had been picked up "off the wire" by countless newspapers, the majority of which ran it on the front page. Already Rosenthal's picture is entering a rather different cultural arena than the military sanctioned imagery of Marine Corps photographer, Lou Lowery. Exposure for photographer, photograph, and the men photographed grew exponentially, especially after President Franklin D. Roosevelt decided to use the photograph (and the men in it) to head up the Seventh War Bond drive. Roosevelt's decision to bring back the Marines has its own story, one which began with a problem: correctly identifying the men in the frame.[295]

We will touch on Roosevelt's demand to bring back those particular Marines from the picture below, but for now we must examine what *Marines Raising Flag:*

Mount Suribachi, Iwo Jima (1945) means as a documentary image. This requires a consideration of the ways in which the photograph was subsequently reproduced and the effects on the photograph's meaning. Circuitous though this route appears it will lead us back to Roosevelt, issues of photographic truth, and the perpetuation of myth. Looking back on *Brady's Photographic Views of the War* (1862) as a portable archive of Civil War imagery, where each photograph belongs to and is subsumed by a larger structuring ethic, *Marines Raising Flag* is burdened with carrying such a weight not as part of a series but as an individual photograph. Just as Florence Thompson is all humanity's suffering and its ability to endure, this image—the soldiers and the flag trapped forever within the frame, immortal—possesses a metonymic message, which is, arguably, as mobile as the modern documentary photographer her/himself. Might it be more accurate to say messages plural? *Migrant Mother* was of course part of an absolutely enormous "machine," the FSA and the New Deal, but it seems to have broken free of the archive but only by virtue of its ability to speak on behalf of all the images in that archive. In this sense, *Marines Raising Flag* belongs in one small part of war-related image production documenting World War II while simultaneously acting as a unique focal point through which all war imagery speaks: the photographic image as conduit, or the medium as medium.

But what is being channeled, what message does the photograph deliver? Let us look again at *Marines Raising Flag* and identify what exactly we can see, or what made Bodkin (and the world's press) react as they did on seeing the photograph for the first time? Is this a beautiful picture? Perhaps not. What about a powerful picture? If we agree that it is a powerful picture, what does that imply? Where does it gain its power and how is this power conveyed? Initially, this is a striking photograph. The composition is strong; see the way the flagpole diagonally bisects the picture frame; how the picture is classically divided into horizontal thirds—"the golden mean"; notice too the tonal qualities of the soldiers' bodies and the demolished landscape, as well as the way the white-gray smoke in the distance acts as a kind of halo around the men and the flag. The ground and the bodies, too, somehow seem connected, as though each man is struggling not just to erect the 100-pound flagpole but to escape the war-torn earth, which seems resolved to absorb them into its spiky terrain. Alternatively, we might see the men as emerging from the war-torn earth, breaking free of its horrors, the guiding light of Old Glory to help them out of the filth and the fury of war. It is little wonder then that *Marines Raising Flag* had such an impact.

But what does it tell us about war? What does this image document? Metonymically, this picture is about victory, heroism, patriotism, valor, endeavor, sacrifice, and the American way. These are the reasons newspaper editors ran the photograph on their front pages (a war-weary America needed a boost, as did Roosevelt's war chest), why Roosevelt demanded these men be brought home, and why the memorial to fallen Marines in Washington, D.C. is a huge scale recreation of Rosenthal's photograph. And yet Rosenthal's photograph is not what people believe it to be, even though the facts are known, more widely since Clint Eastwood's movie, *Flags of Our Fathers*.

For some reason, the myth is more powerful than the truth, so powerful that it has become the unassailable, unquestionable truth.

As Karal Ann Marling and John Wetenhall found to their cost, drawing attention to the contradictions surrounding both the photograph and its subsequent employment caused a degree of outrage and disgust.[296] Marling and Wetenhall's *Iwo Jima: Monuments, Memories and the America Hero* (1991) traces the myths surrounding Rosenthal's image and the wider history of Iwo Jima since the end of the war, from John Wayne's movie *Sands of Iwo Jima* to the Marines Corps Memorial mentioned above.[297] To summarize, one of the book's most contentious points is not to argue that Rosenthal's image is a fake or that the raising of the flag was staged—it is a genuine, spontaneous photographing of the moment one flag was taken down, while another was raised in its place—rather their aim was to ask how did Rosenthal's image become the root of a national myth. What Marling and Wetenhall conclude is that while the American public want to know the true story of Iwo Jima, that story is based on an inconvenient fact: the men raising the second flag, except one, John "Doc" Bradley, did not raise the first. But the "fantasy" as well as the reality offered by Rosenthal's image is preferable to the straight, factuality of Lou Lowery's Marine Corps photograph. In part, the reluctance to address this inconvenient fact stems from the Hollywood-version of war but also the mass circulation of Rosenthal's picture.

The Seventh Bond drive poster, "All Together Now," which Marling and Wetenhall say "made Rosenthal's image look so real that it had to be true," along with the nationwide tour fronted by the "heroes" themselves added another layer of meaning or mythologizing. Of course, one wonders, knowing what we do, why (or how) a documentary image could be made "more real," but the myth relies on the inherent realism of the photograph, which, despite facts to the contrary, sediments in popular consciousness and becomes practically impossible to dislodge and/or dispute.

Of course, Roosevelt's request that each of the six men be identified and honored as war heroes is the ultimate recommendation. The endless replication of the six figures raising Old Glory on posters, stamps, and in the countless reproductions of Rosenthal's photograph over-determines the image; if the image is used so widely, across a variety of media, by all kinds of institutions then surely there is good reason for this? Why would anybody lie? The startling effect of naming the six heroes does not diminish their ability to symbolize the American war effort, or patriotism, or valor; just as knowing Florence Thompson is the migrant mother is only a brief distraction from the greater themes the photograph metonymically addresses. Iwo Jima, and Rosenthal's photograph especially, taps deeply into what Marling and Wetenhall call the American people's "preservation of a passionate faith in the hero, a belief in the individual's ability to change the course of history."[298] Reflecting on the flak their work received, they concede Iwo Jima is "a holy place in our civil religion," one apparently subject to the same kinds of reactions as blasphemy or desecration of holy ground.

Documentary and Japanese-Americans

The battle for Iwo Jima was just one consequence of Japan's attack on Pearl Harbor on December 7, 1941. Within two months of the Japanese attack on the American base, Franklin D. Roosevelt responded to growing fears for national security by issuing "Executive Order 9066."[299] Roosevelt's order resulted in the evacuation and relocation of about 117,000 persons of Japanese ancestry, citizens and aliens, from California, Oregon, Washington, Arizona, Alaska, and Hawaii.[300] Evacuation and internment was rationalized on two grounds: (i) to prevent espionage, (ii) to protect Japanese-Americans and their families from possible attack by Americans with anti-Japanese attitudes. Referred to as "permanent relocation centers," the camps were located in remote, even desolate places, far inland and a long way from home for most internees.[301] Rounding up a group of a nation's own citizens and interning them in guarded camps seems implausible and against civil liberties, but war is fought on the home front, too. But with the USA Patriot Act (an acronym for Uniting and Strengthening America by Providing Appropriate Tools Required to Intercept and Obstruct Terrorism Act of 2001) passing into law this episode is a sober warning.

WESTERN DEFENSE COMMAND AND FOURTH
ARMY WARTIME CIVIL CONTROL
ADMINISTRATION

Presidio of San Francisco, California
April 1, 1942

INSTRUCTIONS
TO ALL PERSONS OF
JAPANESE
ANCESTRY

Living in the Following Area:

All that portion of the City and County of San Francisco, lying generally west of the of the north-south line established by Junipero Serra Boulevard, Worchester Avenue, and Nineteenth Avenue, and lying generally north of the east-west line established by California Street, to the intersection of Market Street, and thence on Market Street to San Francisco Bay.

All Japanese persons, both alien and non-alien, will be evacuated from the above designated area by 12:00 o'clock noon Tuesday, April 7, 1942.

No Japanese person will be permitted to enter or leave the above described area after 8:00 a.m., Thursday, April 2, 1942, without obtaining special permission from the Provost Marshal at the Civil Control Station located at:

1701 Van Ness Avenue
San Francisco, California

The Civil Control Station is equipped to assist the Japanese population affected by this evacuation in the following ways:

1. Give advice and instructions on the evacuation.

2. Provide services with respect to the management, leasing, sale, storage or other disposition of most kinds of property including real estate, business and professional equipment, household goods, boats, automobiles, livestock, etc.

3. Provide temporary residence elsewhere for all Japanese in family groups.

4. Transport persons and a limited amount of clothing and equipment to their new residence as specified below.

The Following Instructions Must Be Observed:

1. A responsible member of each family, preferably the head of the family, or the person in whose name most of the property is held, and each individual living alone must report to the Civil Control Station to receive further instructions. This must be done between 8:00 a.m. and 5:00 p.m., Thursday, April 2, 1942, or between 8:00 a.m. and 5 p.m., Friday, April 3, 1942.

2. Evacuees must carry with them on departure for the Reception Center, the following property:

 a. Bedding and linens (no mattress) for each member of the family.
 b. Toilet articles for each member of the family.
 c. Extra clothing for each member of the family.
 d. Sufficient knives, forks, spoons, plates, bowls and cups for each member of the family.
 e. Essential personal effects for each member of the family.

All items carried will be securely packaged, tied and plainly marked with the name of the owner and numbered in accordance with instructions received at the Civil Control Station.

The size and number of packages is limited to that which can be carried by the individual or family group.

No contraband items as described in paragraph 6, Public Proclamation No. 3, Headquarters Western Defense Command and Fourth Army, dated March 24, 1942, will be carried.

3. The United States Government through its agencies will provide for the storage at the sole risk of the owner of the more substantial household items, such as iceboxes, washing machines, pianos and other heavy furniture. Cooking utensils and other small items will be accepted if crated, packed and plainly marked with the name and address of the owner. Only one name and address will be used by a given family.

4. Each family, and individual living alone, will be furnished transportation to the Reception Center. Private means of transportation will not be utilized. All instructions pertaining to the movement will be obtained at the Civil Control Station.

> Go to the Civil Control Station at 1701 Van Ness Avenue, San Francisco, California, between 8:00 a.m. and 5:00 p.m., Thursday, April 2, 1942, or between 8:00 a.m. and 5:00 p.m., Friday, April 3, 1942, to receive further instructions.

<div align="center">

J. L. DeWITT
Lieutenant General, U. S. Army
Commanding

</div>

Source: http://www.sfmuseum.org/hist9/evacorder.html

If Roosevelt's "Executive Order 9066" was meant to protect the Japanese-Americans from intimidation and violence on American soil, then what are we to make of James Montgomery Flagg's provocative war poster from 1944? In this image, a powerful and muscular *Uncle Sam* performs an expressive display of aggression, rolling up his sleeves as if ready not just to confront but to finish off the Japanese adversary: "Jap ... You're Next!" the poster screams.

The Japanese internment camps were governed by the War Relocation Authority (WRA), which was instituted by Roosevelt in March 1942.[302] In that year, Dorothea Lange, along with the likes of Ansel Adams, joined the WRA and began photographing the mass internment of Japanese-American citizens. Lange's work on this subject matter is worth considering in light of several of Solomon-Godeau and Rosler's observations on documentary. For one thing, Lange is working *for* the government; hence, she is the imperialist presence in the midst of a government program of mass internment. As a consequence, we should ask what function does Lange's photography serve? Is it merely to record the movement of people from their home to the camp? If so, then the images lack the reformist zeal of Riis or Lewis Hine's images of child labor. And what is documentary without a political motivation as opposed to a political obligation? Without a critical agenda of some kind, what does documentary become? Are Lange's WRA-sponsored images a form of surveillance, a gathering of data on "undesirables" and those judged as threats to national security?

It is not difficult to second-guess why Lange chose to work for the WRA, even when much of her work clearly has aspirations beyond a recording of the literal. The reality of the period was that it was paid work when paid work as a photographer, no matter what your standing, was in short supply. In one photograph, Lange captures a store in Oakland, California, and it presents a sorry, desperate state of affairs. The Japanese-American grocery owner's direct appeal to his fellow American citizens appears not worth the cost of the board "I Am An American" is written on. His fellow citizens, though, are prepared to buy the business, sold to the highest bidder by White and Pollard, the only board on the building front that seems to matter.

Lange's WRA images from this period depict sad-faced, uprooted families standing in long lines, talking to officials, making the best of the terrible conditions in the remote relocation centers and in the end her work was censored by the WRA. So where does this leave Lange in light of the Solomon-Godeau/Rosler critique? What was the point of Lange's project? What did she think it might achieve and in the longer term what has it achieved? One final question, do you think Solomon-Godeau/Rosler are justified in their skepticism about motives, aims, and outcomes in documentary? If so, then what is the point of documentary if it can never properly succeed?

McCullin and *Shell Shocked Marine*

In 1997, British-born documentary photographer Don McCullin (1935–) admitted, "I don't do photojournalism any more because, frankly, nobody really wants it."[303] Still, Martha Rosler identifies him among a set of "luminous documentarian stars" and his reputation for stark, startling images remains undimmed.[304] Susan Sontag more generously and genuinely says of the photographer: "no one has surpassed in

breadth, directness, in intimacy, in unforgettability—the exemplary, gut-wrenching work produced by Don McCullin."[305] Although McCullin's documentary work covers more than conflict, unforgettable and now iconic images like *Shell-Shocked Marine, Hue, Vietnam* (1968) are in part the reason he was not allowed to photograph the Falklands War by the British government of the time.[306] This might encourage us to think differently about three things. Firstly, Rosler's earlier identification of a slide toward, in this instance, the voyeuristic in documentary, especially when we consider the power relationship between spectator and photographic subject. Secondly, the wariness with which we should approach an image that might arguably share a great deal with Lange's *Migrant Mother*. In this regard, it is difficult not to return to Stryker's commentary on Lange's photograph of Florence Thompson, the migrant mother. And, thirdly, can *Shell-Shocked Marine* escape the institutional containment of the photograph identified by Solomon-Godeau?

In McCullin's photograph we see the hunched figure of a seated soldier, his jacket fastened up, helmet on, his fingers gripping the barrel of his gun. Tense and obviously in shock, the soldier appears frozen, his eyes fixed in what became known as the "2,000 yard stare." Earlier we mentioned photography's ability to put "a face on fear" and to "transform threat into fantasy, into imagery"; in relation to poverty and the threat of the poor rising in revolt, to give the poor a face is to know your enemy, perhaps; with this in mind, is McCullin's photograph of a different order? Although we as viewers did not witness the events that led to this soldier's mortification, is our empathy with his situation lessened to any degree? Does the fact that this photograph tells us nothing of the machinations behind the war in Vietnam distract us from recognizing human suffering? And are we, as viewers, not empowered as we stare at the soldier but left helpless and unable to help this man in this non-exchange of gazes? I wonder how easy it is to forget this image, to leave it behind and console ourselves with the thought, "(*It is them not us*)."[307] As Sontag notes:

> There are questions to be asked. Who caused what the picture shows? Who is responsible? Is it excusable? Was it inevitable? Is there some state of affairs which we've accepted up to now which ought to be challenged?
>
> A photograph can't coerce. It won't do the moral work for us. But it can start us on the way.[308]

I would ask you to consider Sontag's comments and compare them to the critiques of Rosler and Solomon-Godeau; who do you think is "right"?

Of course, there are many precursors to McCullin's composition, the most striking and the origin of the phrase, Tom Lea's *Marines Call It That 2,000-Yard Stare* (1944) (Plate 29). Lea (1907–2001) was an artist and correspondent for *Life* magazine from 1941 to 1945, and in 1944 he accompanied the 1st Marine Division during the invasion of the tiny island of Peleliu in the Western Pacific.[309] His painting *2,000-Yard Stare* precedes McCullin's work and while not a photograph, it captures the

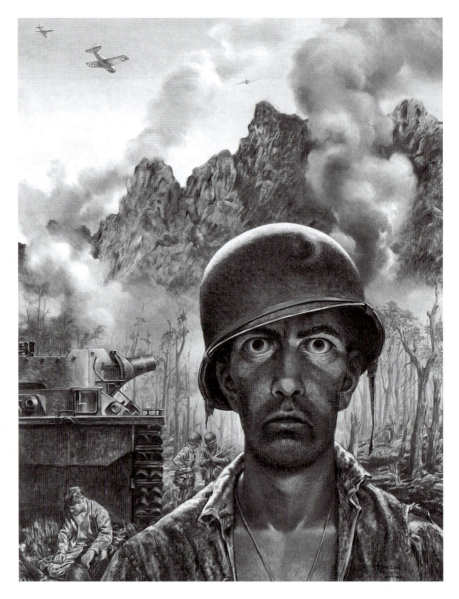

Plate 29 Tom Lea, *Marines Call It That 2,000-Yard Stare*, 1944. Courtesy of the Army Art Collection, U.S. Army Center of Military History.

soldier's presence-less presence; the fact that his physical body is located within the war zone but the effects of war have pushed his mind elsewhere. McCullin's updating of Lea articulates a similar sense of claustrophobia, of being trapped in a place with which you are unfamiliar, far away from home and divorced from reality and, most of all, your own sense of self: truly lost, then. In Lea, the smoking jungle,

artillery, and exhausted comrade form an overbearing backdrop; in McCullin, it is the cropping of the image that does this work. McCullin's Marine is locked in our gaze, boxed-in by the photographic frame, a compositional device that emphasizes the soldier's physical and mental state of being trapped, alone, and suffering. And what of the fact that the soldier does not stare back at us? Does the fact that we can stare at him lessen our understanding of his plight? Are we engaged as Solomon-Godeau suggests in an imperialist gaze? Or, is our reaction to McCullin's soldier of a different order because it—unlike Lea's picture, which is a painting—possesses a form of evidential truth? Here is a real soldier, captured on film, in a real state of distress and not a painterly interpretation of exactly the same state of distress produced after the fact.

Solomon-Godeau identified documentary's unchanging trope as the depiction of the subject's circumstances, produced as "a pictorial spectacle usually targeted for a different audience and a different class."[310] Now one can see how Lange's *Migrant Mother*, as well as the images of Riis, might partake in this liberal documentary tradition, but is it possible to read *Shell Shocked Marine* as a "pictorial spectacle," in keeping with Solomon-Godeau's argument? *Migrant Mother* remains problematical because of the nameless subject of the photograph, or, alternatively, the renaming of the subject to express suffering and to convey, as Stryker happily confirms, that Florence Thompson was all humanity's suffering as well as its perseverance. Is the same true of *Shell Shocked Marine*? Who is this man? What happened to him (remember Rosler's critique of Burnett and the Chilean football stadium prisoners)? Are we to see the Marine as a metonym for the conditions that produced him, a war which rages behind the soldier, who remains tightly bundled in his tightly cropped frame?

In stark contrast to *Migrant Mother*, *Shell Shocked Marine* holds close not a small child but an assault rifle. Shocked he might be, but is he also a migrant, with no clue about the world of circumstances and discourses that conspired to conscript and dump him in uniform in a country thousands of miles from home, just as Florence Thompson and her children found themselves homeless in the barren, dead landscape of the Dust Bowl in 1930s' America? Like Thompson's children, is the rifle all the Marine has? And if so what does this tell us about the experience of war? Should we assume that McCullin's photograph is anti-war, anti-Vietnam? On the one hand, this makes sense. Here is a young American man in 1968, fighting and now injured in Vietnam, his world shattered. How can this be justified? War equals suffering, and this man is suffering, like Thompson in *Migrant Mother*; this Marine is every soldier, airman, navy man; he is every parent's nightmare, every country's shame. See how quickly we slide into metonymy. How easy it is to elevate one specific reality to mean all realities.

As yet the question of intention remains unasked, but what was McCullin's intention in taking this photograph? A cynic might play on Rosler's criticisms of documentarians more interested in "trophy hunting" and "careerism": those who

trade on their "bravery" and enter no-go zones, risking their lives for the "shot."[311] Like Rosenthal and Lea, as well as countless others, the fact that McCullin put himself in mortal danger throughout his career (and has been seriously injured in the process) in order to shoot pictures is worthy of careful consideration. Does the knowledge or the obviousness of present danger alter the viewer's engagement with the image? Are we more likely to "believe" the photograph that trades on its perilous conception over that taken from a comfortable distance; after all, as an audience are we supposed to view these images from a comfortable distance? And like Rosenthal and Lea, *Shell Shocked Marine* has taken on iconic status, but how? Well, through the distribution of the image through print media: newspapers, magazines, books, and of course on posters and in art galleries. As such, *Shell Shocked Marine* is not outside the "system" but fully integrated within it. McCullin's intentions—whether of the highest moral order or not—soon become subsumed, smothered, rearranged as the image circulates in mass culture. Early documentary was sustained by the belief that a photograph had the power to "rectify wrongs," but as we have seen such an ameliorative view changes nothing: like the *Monty Python* sketch about the world's funniest joke (a joke so funny that everybody who reads or hears it dies laughing), it appears that the true documentary image must never be seen for the whole world would necessarily fall down upon sight of it.

Conclusion

The elephant in the room (or chapter) relates to the most recent wars in which America has been the driving force, the metonymic war on terror. The first and second ongoing wars in Iraq and the more amorphous "war on terror" are replete, like all wars, with their own imagery, imagery that is more often than not defined by new technologies. I suspect that Solomon-Godeau and Rosler could easily extend their critique of documentary in light of 24-hour news reporting, digital cameras, and cameras strapped to smart bombs, etc. French philosopher, Jean Baudrillard (1929–2007) touched upon these issues around the time of the first invasion of Iraq by coalition forces in 1991 in a short text with an incendiary title, "The Gulf War Did Not Take Place." For Baudrillard, the first Iraq war was to be defined by its reliance on visualizing machines to wage war and highly edited television coverage to disseminate an "image" of a conflict. In some respects, one can see the seeds of this kind of reliance on imagery in the dissemination of Rosenthal's *Marines Raising Flag*. Here is a photograph that we take to be the real when it is actually only an image of the real. When a photograph, like *Marines Raising Flag*, becomes the basis on which the truth of an event is secured, no matter that the photograph is not the truth (flags tend to be raised at the end of battle, however the battle for the island was ongoing) but a legitimate re-enactment of another, related event, then we are mistaking representation for reality. The modeling of a statue on the *Marines Raising Flag* only compounds this issue.

One final example before ending and moving on: This chapter opened with Solomon-Godeau's open answer to the question, "what is documentary?" On the whole, the reading of documentary throughout this chapter has related the standard idea of the committed and/or brave documentary photographer, putting themselves in places and situations that most of us would never consider. They do this, some argue, because of an inner urge to find and relate to the truth, to draw attention to forms of suffering, exploitation, scandal, etc. and they do so to help make the world a better place; on the other hand, some argue that this is no reason at all and that our fundamental understanding of documentary misses the point: these images can never change the world because they replicate the very foundations of the world they seek to criticize. Documentary photographs those suffering to remind us that we are not suffering. We congratulate the photographer and quickly forget the name of his subject; that is, if we ever knew their name(s) at all.

But what of those images, which can be considered documents, which are taken not by named photographers but by the people serving in the Military themselves? Not the official Military photographer but ordinary soldiers, sailors, and air personnel, perhaps working as prison guards; just like images of lynching taking by members of the crowd or local, professional photographers looking to profit from the spectacle. Photographs of all kinds of activities taking place within the prison walls, hidden from the public and, we hope, their superior officers; these images are shared on the Internet but soon these photographs find their way off base and onto the computers of non-military personnel; in turn, they make their way into the wider national and international media, are transmitted on television screens to the world's public. There are pictures of men, stripped naked, with what look like pillowcases over their heads, some cornered by guards with dogs, standing in pools of their own urine, others piled on top of one another or positioned in sexually humiliating poses, surrounded by American soldiers, who partake in the action, pointing and laughing, directing the camera-operator and vice-versa; images like Plate 30.

Does an image such as this (or any of the related Abu Ghraib photographs[312]) operate as documentary in the traditional sense? Solomon-Godeau noted earlier the importance of context; judging by joviality of the military personnel in these photographs, the Abu Ghraib photographs were photos of people having fun at someone else's painful expense. The photographer and their accomplices exert complete control over their subjects and the photographs in the context of their making appear like snaps taken on a particularly unpleasant vacation. One instantly thinks of two things: firstly, the longer history of collecting mementoes of war, often the most graphic and hideous photographic images, and also lynching photography. Secondly, the infamous "Stanford Prison Experiment" (August 1971) initiated and then quickly halted by Philip Zimbardo, in which students were divided up into prisoners and guards; within days each group had over-identified with their institutional roles, with the guards resorting to troubling and violent behaviors toward the "inmates." To a degree, the immersion of the individual within the

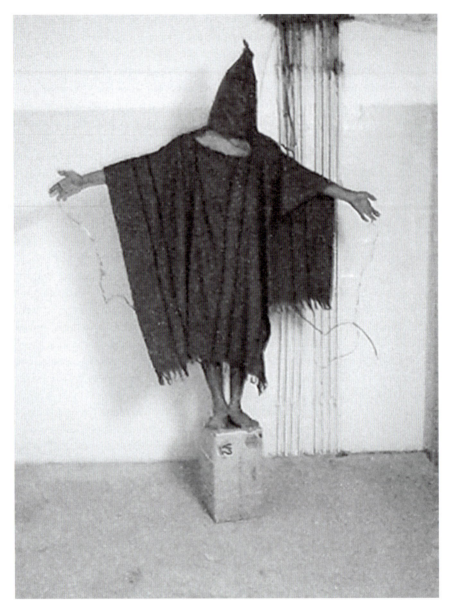

Plate 30 Abu Ghraib. AP/PA Photos.

institutional complex and the fact that Abu Ghraib was closed off to the outside world compounds an insularity that marks the faces of the McCullin and Lea's Marines. Outside of this personal and institutional context, though, the Abu Ghraib photographs take on a very different complexion; they are shocking—appalling, in fact—and deeply affecting; a point that can also be made of lynching photography.

Like lynching photography, and in a return to Mitchell's point in the Introduction, images such as this have the effect of reproducing what they hope to extinguish; they clone terror. At the beginning of this chapter, Abigail Solomon-Godeau asked, "what is documentary?" and answered "just about everything." Do you agree? Are the Abu Ghraib photographs documentary? If so, what do they document?

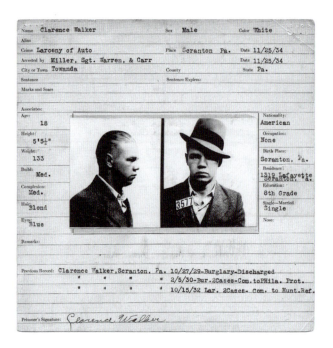

Plate 31 Clarence Walker, Scranton, PA, Larceny of Auto, 11/25/34. Courtesy of Mark Michaelson.

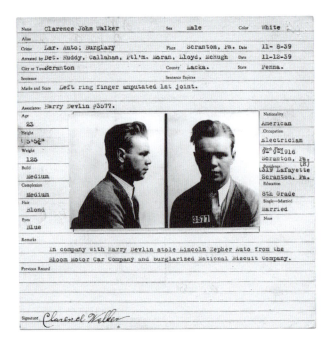

Plate 32 Clarence Walker, Scranton, PA, Lar. Auto; Burglary, 11/12/39. Courtesy of Mark Michaelson.

–5–

Crime and Punishment; or, Mug Shots and Crime Scenes

Our society is not one of spectacle, but of surveillance … We are neither in the amphitheatre, nor on the stage, but in the panoptic machine, invested by its effects of power, which we bring to ourselves since we are parts of its mechanism.

Michel Foucault, *Discipline and Punish*, p. 217.

Photographs furnish evidence.

Susan Sontag, *On Photography*, p. 5.

The mug shot, the scene of the crime, photographic evidence—all of these are predicated on the belief that the photograph shows the truth, unvarnished and indisputable.

Back cover of Sandra S. Phillips et al., *Police Pictures: The Photograph as Evidence*

This chapter's focus is to survey the visual culture of crime and criminality in America; how do we recognize the good guys from the bad guys? And more to the point, who came up with the idea that there are good guys and bad guys to be recognized? To understand this second question we turn to the work of French philosopher Michel Foucault and to American writer and critic Allan Sekula, both of whom have written on the use of photography in the creation and maintenance of a culture of surveillance. The aim here is to consider the continuing importance of the mug shot and other forms of photography, such as the crime scene photograph, in their role as visual "evidence." By evidence we mean truth, of course, and we are therefore concerned with debating why the photograph is still considered a truthful medium. Our visual examples include mug shots from the early twentieth century through to crime scene photographs held in the collections of the Los Angeles Police Department collections to the work of Arthur Fellig, better known as Weegee.

Introduction

In a twist on the regular and necessarily dramatic "Wanted!" posters, *Least Wanted: a Century of American Mugshots* presents the reader with "one anonymous face

after the other.... ."[313] These images show (alleged) criminals, captured and arrested, then photographed, fingerprinted, measured, and interviewed.[314] The introduction is emphatic: there are "no celebrity criminals here, no immediately recognizable names or faces, no one of any great notoriety."[315] However, a lack of the infamous or the notorious does not lessen or detract from this "rogues gallery," thus making it possible to argue that this collection of images is far from unremarkable. The anonymity of these faces and profiles, when paired with the accompanying description of the crime and fragmented personal histories, makes for endlessly fascinating and remarkable, if voyeuristic, reading and viewing. These images of the so-called least wanted, demand our attention.[316]

The people documented within the pages *literally* represent the *least* wanted of American society: pickpockets, the homeless, racketeers, hoodlums, bigamists, murderers, prostitutes, transsexuals, drifters, and more; all are individuals sanctioned as outside of or on the margins of decent, law-abiding society. As the least wanted they are *judged* as a negative force in society: at the very least disruptive, at the most highly dangerous. In this sense, these people "pose," in one way or another, a threat to society; they are a contagion or disease that must be stopped in its tracks before it infects society as a whole. In response to this threat, society protects itself by identifying those who pose the threat and, as *Least Wanted* reminds us, the means and processes of identification are thoroughly rooted in photography. What develops and remains, both in the hands of private collectors (for example, the collector behind *Least Wanted*) and law enforcement agencies is an ever-expanding archive of regulated poses—two upper-body shots placed side by side consisting of one full-face and one profile photograph—of those who pose this threat. But this is not altogether true. As the index card of Clarence Walker shows (Plates 31 and 32), the image has a textual supplement. All this demands we consider a series of questions. For example, who does the sanctioning and what grounds are categories such as deviant or criminal based; who decides for society what moral or immoral behavior is; and, specifically, what role does the mug shot or more generally photography and the photograph play in all this?

These questions form the central structure of this chapter and helpfully direct us toward the work of Michel Foucault, in particular his notions of power and knowledge, and the emergence of surveillance society. Another key figure here is Allan Sekula, whose essay "The Body and the Archive" identifies and analyzes just how the criminal and the criminal archive emerged in America during the nineteenth and twentieth centuries.

Picturing Crime and Criminals

I have already drawn attention to Clarence Walker's index cards (Plates 31 and 32) because they are typical of the way information on individuals was collected

and stored. The format changes slightly depending upon county and state but, as previously noted, for the most part they consist of two images—a head shot from the front and in profile—combined with details relating to the photographed individual. In both, Clarence Walker stares back at us, his photographic image resolutely stationed in the middle of the index card, his personal data—height, weight, address, previous convictions, present charge, arresting officer—all placed on the periphery: so no surprises here.

However, if we take to time to consider in greater detail Walker's index cards, several questions can be asked of this "normal" or "regular" police record. Firstly, why is the written information—height, age, weight, date of birth, date of arrest, place of arrest, etc.—relegated to the margins? Surely *all* of this material, the images, the personal details, is important: So why the emphasis on the photograph? How did this come about and, moreover, why and how did this familiar format emerge? The most obvious answer is that society has placed an enormous degree of faith in the power of photography, and bound up with this particular faith, society has also been beguiled by the criminal and their criminal activities. On one side of this equation, photography and the photograph are presumed to possess an inherent authority, an unsurpassable capacity to reveal the truth. Perhaps photography's objective qualities seem sensible when the camera itself appears a benign contraption: an unthinking box with a lens, supported by a tripod, a machine that "catches" light, faithfully and without prejudice recording what it "sees." Or maybe it is the photograph itself, an object that many today might consider almost mundane, even antiquated when compared to the growing preference for digital images in popular culture.

Such an attitude toward the photograph and photography as "commonplace," and therefore "obvious," is based upon the assumption that we "know" not only what a photograph is but what it actually "means." In the previous chapters on documentary and racial anxieties, we started to pick at the basis of these assumptions. Questions about intentionality, context and use, distribution and consumption disturbed any straightforward idea of photography as an objective medium, but what about in this context: law and order? Beyond the obvious—a photograph is a technological product made of special paper and produced in a photographic laboratory—I want us to consider more carefully the question, what, exactly, *is* a photograph? And then another, why do individual photographs seem to possess such power?

On Photography

"Few people in this society share the primitive dread of cameras" (the fear that part of your soul will be abducted as if by magic by the machine), says Susan Sontag in *On Photography*, but, rather surprisingly, there remains "some trace" of this magical relationship, borne out "in our reluctance to tear up or throwaway the photograph of a loved one, especially of someone dead or far away."[317] Deliberately destroying a

photograph—whether in anger or with controlled malice, from poking out the eyes of a rival or reducing a photograph to glossy confetti—is an action that goes beyond the rational. So, for example, puncturing the photographic surface, shredding it or burning the photograph of a cheating partner can be cathartic—"that'll show them"—as though the errant partner will "feel" prodded, torn, or burned and thus empathetically share the experience of your own emotional pain. Whatever the case, and whatever the emotional impulse of pleasure or regret, this depends upon a belief that a boundary has been crossed; that there exists a magical or supernatural connection between the subject in the photograph and the photograph itself. What you hold in your hand is a conduit between worlds, one that not only allows us access to a moment passed but connects us with those places and people captured in the photograph itself.

Sontag pointedly reminds us: that which compels us also prevents us from destroying, or merely throwing out, old photographs. If a photograph presents us the past in the present, it therefore plays a pivotal role in memory and remembering. The magic and the pragmatic, the superstitious and the rational, are all bound together. Once destroyed, can we rely on our memory to recall exactly what the camera recorded, with same level of detail and vitality? For this reason, photographs are magical and rational objects, transformative, even slightly terrifying, and, perhaps, sublime; because in your hand you hold an image of the past no matter how recent, a moment that has gone and will never come again, but a moment which survives as the object you hold in your hand and fix under your gaze. It should not surprise us, this infatuation with or fetishization of photography and the photograph.

That said, we are not too concerned at this moment with personal reflections on the status of photography, but the example serves to remind us of the continuing power of photography and the photograph. Historically, the investment in the veracity of camera-based media across American institutions of law and order during the nineteenth century has had significant consequences for wider American culture.[318] The institutional absorption of photography is far too cumbersome to discuss in this chapter, so our focus remains on those institutions with an interest in crime and criminals; these were and remain, the legal and justice system, and the entertainment industries.

Turn on the television, "surf" the channels and you will quickly find that a considerable portion of airtime programming is devoted to the depiction of fictional and non-fictional crime and criminal activity. There are documentaries on serial killers, shows presented by ex-police personnel which consist of video footage of dangerous car chases, difficult arrests and blurry CCTV imagery of foiled convenience store robberies; 24-hour news channels report "live" from the "scene of the crime," often combining on the ground images with those taken above from helicopters. Moreover, mobile phone technology now allows viewers to send digital imagery to news stations; "eye-witness" accounts of unfolding events, which in turn are broadcast alongside in-house reporting. Often of poor quality, these

"homemade" images are seen as more authentic and more real than footage with production values, but why? Moreover, this non-fictional material exists in tandem with contemporary fictional crime dramas, which, for the sake of argument, either present crime and criminality in as authentic a way as possible, such as *The Wire* (again, plenty of shaky camera work in evidence), or from a distinctly more playful or entertaining manner, the *CSI*-franchise is one example.[319]

Taking a look at the history of television reveals that the cop-show has been a staple for American television viewers since the earliest days of broadcasting. Early shows like *Dragnet*, *Highway Patrol*, and *Car 54, Where are You?* were succeeded by *Columbo*, *Perry Mason*, and *Starsky and Hutch* in the 1970s and 1980s. And alongside the more conventional cop-show there have been many other shows based around crime-fighting private detectives (*Magnum*, *The Six Million Dollar Man*), superheroes (*Batman*, *Wonderwoman*, *The Incredible Hulk*), and characters who might be best described as "concerned citizens" (*Murder, She Wrote*).[320] Not forgetting, of course, the world of animation's own interest in the genre; referencing Hanna-Barbera cartoons alone provides us with: *Scooby-Doo*, *Captain Caveman and the Teen Angels*; *The Amazing Chan and the Chan Clan*; *Inch High Private Eye*; *Clue Club*; and, a personal favorite, *Hong Kong Phooey*.

Television is a rich source but, of course, so is Hollywood. Without creating yet another long list of movies to echo and reinforce the above, the point I want to make here is a simple one: the crime genre, whether on television or celluloid, needs its villains as much as it needs its good guys. There is little need for cops without robbers, or for investigators with no crimes to solve. Essentially, "We need criminals because they are not us. Crimes are transgressive acts, committed not by "normal" people but by those we define as outside the norm."[321]

On one level, the visual signifiers of law, the uniformed officer, the agent wearing a coat emblazoned with FBI, SWAT, or DEA or the detective drawing an identity card with their rank, division, and number from their pocket, are easily identified. Criminals in television and film, too, often exhibit certain recognizable characteristics; whether the swag-bag carrying, unshaven lantern-jawed thief often seen in cartoons and silent movies to the twitching, unkempt junky-criminal-turned-informer, evident in series as diverse as *Starsky and Hutch* and *The Wire*, viewers' understand the coded language of "goodies" and "baddies." Arguably, audiences are so adept in this regard that many contemporary narratives deliberately seek to mislead the viewing public with a "twist" or an inversion in order to defy expectations (think Harvey Keitel in *Bad Lieutenant*, Gary Oldman in *Leon*, and Denzel Washington in *Training Day*).[322]

But how did we come to understand this visual language and so ably recognize the criminal (or even the cop gone bad)? And why has the "photograph as evidence" yet to be superseded by other technological advances, the types of which are endlessly revealed to us in programs like *Crime Scene Investigation*? For example, can you recall an instance in any of the *CSI*-related series where an agent was not seen

systematically photographing a crime scene with a digital camera? But before we get to the photograph and photography, we must consider the historical and cultural context in which photography emerged. Therefore, the next section of this chapter will introduce the work of Michel Foucault; Foucault's work on power and of the rise of societies of surveillance forms the backdrop for the analysis of the visual culture of crime.

Michel Foucault, Panopticism, and Surveillance Societies

The work of Michel Foucault has become a crucial tool in the formation of many critical frameworks used across many disciplines, and visual culture studies is no different. Foucault's work is foundational for the analysis of power in modern Western society and culture, how it circulates, how it works, etc. In this section, I want to outline in some detail the important features of Foucault's work on power and the type of surveillance society with which we are all familiar. Quite simply, it has become difficult to conceive of an analysis of power and the development of the modern subject without reference to Foucault. So, in light of the material under discussion here—the visualization of the criminal body and type—it is imperative to do more than simply name check Foucault.

Michel Foucault (1926–84) was a philosopher, historian, and sociologist whose work addresses the social relations of power and the way social order is maintained without means of a centralized power base, such as the monarch or the state. Foucault's understanding of power and how it operates challenges what we might call more traditional approaches to the formation of power structures and the dissemination of that power. Most obviously, Foucault argues against the idea of power being solely in the hands of dominant groups; this distances his work from Marxism, which sees power as controlled by capitalists who own the means of production, and to a large degree from feminism, which locates power in the hands of men. In both Marxism and feminism, the emphasis is on a "top-down" model of power where only those at the top are able to exercise power; those at the bottom remain *subject* to that power. As reductive as these descriptions are—some might argue, crude—they suffice to help elucidate the radical element in Foucault's thinking.

As David Gauntlett writes,

> These kinds of models would also have to rely on stable and clear-cut ideas of identities: no confusions as to whether people are ruling class or workers, male or female, straight or gay. Foucauldian work runs against all this, suggesting that it's silly to reckon that power will somehow be possessed by certain people and not at all held, in any way, by others. Instead, power is something which can be used and deployed by particular people in specific situations, which itself will produce other reactions and resistances; and isn't tied to specific groups or identities.[323]

This means that the study of power for Foucault is not a matter of examining where power is located and who exerts it, but how power affects and impacts upon the individual subject in society. A re-examination of power in these terms means a complete re-evaluation of what power is, how it circulates, and why we as individuals are *subjected* to and by power (that which makes us "subjects" as much as individuals). Foucault says: "Let us not, therefore, ask why certain people want to dominate, what they seek, what is their overall strategy. Let us ask, instead, how things work at the level of ongoing subjugation, at the level of those continuous and uninterrupted processes which subject our bodies, govern our gestures, dictate our behaviors."[324]

For Foucault, power is not a purely repressive force but is a social discourse in which we all participate. Participation in the social requires a set of rules that each citizen obeys, often without question, where we seem to know without thinking what is normal and abnormal, right and wrong, good and bad. At the center of Foucault's examination of order is his conjunction of power with knowledge and the rise of discourses, mainly scientific and medical, that arose with the Enlightenment and gave birth to what we recognize as the modern subject or individual.

The key text here is *Discipline and Punish*, originally published in 1975; in this text Foucault considers at length the cultural and social upheavals brought about by the Enlightenment, the eighteenth-century philosophical revolution, which advocated science and rationality over religious and superstitious belief systems. [325] Part of this shift in the dominant paradigm—in this case, from a belief in power of religion to organize the social and cultural spheres to one rooted in scientific study, for example—is the transition from feudalism to capitalism.[326] Many eighteenth- and nineteenth-century philosophers and thinkers[327] derided the feudal system as grossly unfair, and the most obvious example (and target) of criticism was the *Ancien Régime* and the French monarchy.

The decisive break from the impoverished ideologies of the feudal system quite clearly informed the Enlightenment's concern for social reform, especially in the realms of social order and punishment. The Enlightenment was a deliberate and conscious effort to eradicate barbaric forms of punishment and replace them with a justice system based upon principles of rationality and fairness. However, those in control of the feudal system—monarchies, aristocracies—were uninterested in fairness and justice and more concerned with maintaining their privileged position in wider society. The impetus behind the Enlightenment was to move toward a society that defined itself in opposition to feudal ideals, describing them as uncivilized and with no place in progressive and modernizing cultures and societies.

Replacing barbaric forms of punishment in turn required the creation of more humane forms. Now, Foucault, instead of celebrating the proliferation of progressive attitudes towards crime and punishment, is quick to highlight a new kind of bias at the heart of Enlightenment thinking. Resistance to public torture/execution and the abuse of power it involved was informed not only by the "knowledge" that, as forms

of punishment, torture and public execution were morally bankrupt but that they were, more to the point, unpredictable and inefficient. (Here we see the impingement of early capitalist ideals.) Arguably, the impetus underlying penal reform stems in Foucault's view not just from an enlightened form of rationality but from the necessity to ensure a more efficient and rationalized legal and social field. Why? Because the feudal/monarchical regime is based on an exorbitant and spectacular use of power whose effects on subjects are uneven and dysfunctional. Therefore, the object of penal reform was not only to establish a new right to punish based on more equitable principles but to set up a new economy of power, one better distributed, more efficient, and less costly in both economic and political terms. The discussion of forms of punishment necessarily invokes a number of issues because it raises many questions. For example, why is this person being punished? On what grounds can we identify their wrongdoing? What is to be done to prevent others from doing the same? What emerges here is a realization that we are not discussing the general population at large—the social body—but the individual subject, a person; which, for Foucault, means the body of the individual subject. Foucault argues

> Power must be analysed as something which circulates, or rather as something which only functions in the form of a chain. It is never localised here or there, never in any-body's hands, never appropriated as a commodity or piece of wealth. Power is employed and exercised through a net-like organisation. And not only do individuals circulate between its threads; they are always in a position of simultaneously undergoing and exercising this power. They are not only its inert or consenting target; they are also the elements of its articulation. In other words, individuals are the vehicles of power, not its points of application.[328]

To fully understand power/knowledge, Foucault reconsiders what actually constitutes the subject or individual and, hence, subjectivity. Since the emergence of philosophy, especially since Plato, notions of the subject and subjectivity have been pivotal for philosophical investigation; as a consequence of this foundational principle, philosophy and philosophers have tended to view the subject as the source of all meaning. It is exactly this emphasis Foucault tries to overturn.[329] In essence, philosophies that ground meaning and understanding in the subject do so based on a presumption that the human subject is in possession of a kind of accessible transcendental truth; a truth able to be understood through certain kinds of philosophical reflection. This argument, Foucault argues, misses the point because it is based on a fallacy. Namely, that any philosophy that privileges the idea of the individual as having deep interiority and innermost truths, expressed in concepts such as the soul, psyche, and subjectivity, is nothing more than a coercive illusion. The idea that we are in possession of an inner and essential depth is itself an effect of material processes of subjection; that is, it is a coercive illusion brought about by power relations. The individual is *never* free but always subjected to various regimes of power—caught within the panoptic machine of society—which operate not

through direct means of repression, but through less visible forms of normalization. Foucault says this: "One has to dispense with the constituent subject, to get rid of the subject itself, that's to say, to arrive at an analysis which can account for the constitution of the subject within the historical framework."[330] The subject, therefore, is not primary, but secondary. In fact, the subject or self is a secondary *effect* or *by-product* of discursive formations. Therefore, Marx, who places the working class or proletariat subject at the heart of his thesis on communism, is mistaken. The proletariat like the bourgeoisie (those who own the means of the production) are products of capitalism itself—they are not timeless or natural formations but the opposite. Foucault's response is to resist what is known as teleology and replace it with genealogy.

Foucault concludes that history is not teleological at all; there can be no *end* to antagonism because there exist only specific conflicts in history, all of which relate to the will to power. History in this sense is not unfolding and therefore not teleological; that is, it is not a series of connected events moving forward towards some goal or conclusion. The most influential teleological thinkers in modern history are Hegel, with his end of history thesis and the attainment of absolute knowledge, and Marx, whose version of the end of history involves the annulment of social antagonism (class-conflict) in absolute communism, the perfect society. Instead genealogy sees only the event, and there are millions of them, each waiting to be "read individually." At the center of these conflicts, the will to power, is the human body. Historical forces act upon and through the body in a manner which cannot be explained from a totalizing historical perspective. From this view of history and the subject, Foucault develops the notion that power relations permeate all levels of social existence. Repression, which still exists, is not the central force exercising power; rather it is one of many positive and negative effects generated through the interplay of power relations between subjects and institutions. As a result, Foucault is able to dismantle and dismiss the Marxist view of power as reductionist because it concentrates on those centered manifestations of power, the state, the economy, and class. Instead of studying the whole, we study where power leaves an indelible mark: the human body.

The Panopticon

To help contextualize the genealogy of "power/knowledge," Foucault turns to English philosopher and social reformer Jeremy Bentham's design for the Panopticon (Plate 33), a special kind of prison. The principle of the Panopticon is quite simply one of permanent visibility, a principle Foucault argues extends beyond the walls of the prison and into diffuse forms of social control. As Foucault notes,

> The principle was this. A perimeter building in the form of a ring. At the center of this, a tower, pierced by large windows opening onto the inner face of the ring. The outer

building is divided into cells each of which traverses the whole thickness of the building. These cells have two windows, one opening onto the inside, facing the windows of the central tower, the other, the outer one allowing daylight to pass through the whole cell. All that is then needed is to put an overseer in the tower and place in each of the cells a lunatic, a patient, a convict, a worker, a schoolboy. The back lighting enables one to pick out from the central tower the little captive silhouettes in the ring cells. In short, the principle of the dungeon is reversed; daylight and the overseer's gaze capture the inmate more effectively than darkness, which afforded after all a sort of protection.[331]

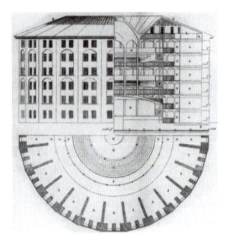

Plate 33 Jeremy Bentham's Blueprint for the Panopticon, 1791.

The Panopticon is an architectural "machine" allowing permanent visibility that in turn legitimizes or, more accurately, visualizes the assessment and judgment of the subject's body. To be held under and judged by "the gaze"—that is, subject to the gaze of authority—becomes a form of control through normalization. For Foucault, Bentham "invented a technology of power designed to solve the problems of surveillance."[332] The reason for this is simply that the Panopticon creates a field of visibility whose viewpoint is invisible; in other words, the building's design enables the viewer (prison guard) to watch the prisoner without the prisoner being able to see the viewer. This model of looking, of observation, of surveillance, is crucial.

But the so-called panoptic gaze alone is not responsible for this normalizing process. Modern penal regimes are further bolstered by the myriad of pathologies that accompany surveillance. Not only is the prisoner subject to surveillance but that surveillance is intimately tied into other discourses or categorizations; we are all familiar with labels or distinctions such as "delinquent," "felon" or slang terms like "perp" in relation to criminality, and each reinforces other discourses of power/ knowledge. What Foucault argues is that the notion of, say, the "delinquent" is not

formed in isolation but as a consequence of several forms of discourse converging: criminology, psychology, psychiatry, and medicine, for example. Categorization of this kind helps establish an important cultural and social distinction between normal and abnormal, the good person and the bad person: an "us" and a "them." It also forms the basis of legal and illegal, which implicates the subject within normalizing assumptions. Society is saturated with "judges of normality" from the teacher, to the doctor, to the judge, and the social worker. Such figures are installed everywhere in society, assessing and diagnosing each individual according to the normalizing set of assumptions, which Foucault eloquently phrases as the "carceral network of power-knowledge." Individuals are controlled by the power of the norm and this power is effective because it is relatively invisible.

The essential point to be made here is this: in modern society, the behavior of the individual is not regulated not through overt repression—violence (actual or threatened)—but through "a set of standards and values associated with normality which are set into play by a network of ostensibly beneficent and scientific forms of knowledge."[333]

As is clear, these discourses form the basis or categories for exclusion and norm-alization. But to what ends, seems the obvious question? Foucault's response relates to the social and cultural "order":

> The point, it seems to me, is that architecture begins at the end of eighteenth century to become involved in problems of population, health and the urban question. Previously, the art of building corresponded to the need to make power, divinity and might manifest. The palace and the church were the great architectural forms, along with the stronghold. Architecture manifested might, the Sovereign, God ... Then, late eighteenth century, new problems emerge: it becomes a question of using the disposition of space for economico-political ends.[334]

With the transition to capitalism we find a resultant shift in the cultural power base; previous power regimes with their ideologies that brought order and helped make sense of the world are swept aside leaving a vacuum or more sensibly creating the need for new regimes of power to replace those now considered uncivilized and defunct. With God *Deus Absconditus* and the massive social impact of the Industrial Revolution—for example, the movement of masses of people from the countryside into the new cities—the need for law and order becomes reliant on scientific/rational discourse. Foucault again: "Is it surprising that prisons resemble factories, schools, barracks, hospitals, which all resemble prisons."[335]

The Body and the Archive

To say at this point that no panoptic structure was ever built during Bentham's lifetime might undermine Foucault's relevance for what follows, especially so

quickly after making such a point of describing the importance of the Panopticon.[336] It would be a mistake to lose sight of the model of surveillance Foucault's theory articulates, especially those observations on its effects on the distribution of power. Moreover, Foucault's work also helps us recognize the role photography plays in the development of these institutions and the notions of power associated with them. The camera, as a mechanical apparatus for seeing and capturing reality—the representation of the real—fits neatly into the unwritten history of photography as a form of evidence.

Allan Sekula's work is particularly rich in exploring this assumption, especially the evolving presence of photography in society. Sekula notes that the widespread use of photography in relation to prisoners did not become commonplace until the 1860s, although "the potential for a new juridical photographic realism was widely recognized in the 1840s ..."[337] Photography's potential was viewed, as Sekula summarizes, as "a silence that silences."[338] What Sekula refers to here is "the presumed denotative univocality of the legal image and the multiplicity and presumed duplicity of the criminal voice"; a contest that "is played out during the remainder of the nineteenth century." What this debate helps define is a new kind of object—the criminal body—and, as Sekula adds, "a more extensive social body is invented."[339]

In short, the creation of the criminal body establishes and delimits what Sekula refers to as the "terrain of the other."[340] In its simplest terms, we are talking about the identification of difference—the criminal—based on physical appearance. The photographic portrait was at once a "wonder" which, on the one hand, elicited excitement and fascination but, on the other, was soon considered the perfect tool for the job of accurately classifying all members of society, especially those considered not normal (the insane, the deviant, the criminal). As such, "the photographic portrait ... was welcomed as a socially ameliorative as well as a socially repressive instrument."[341] What we find is a sense of the "moral economy of the image," that is, its ability to do good work, one underscored by a genuine belief in the power of photograph. This power could:

- work as an active deterrent (once criminals realized they were "recognizable" they would as a consequence cease to break the law);
- democratize access to the photographic portrait and hence offer the working classes a greater sense of responsibility to family.[342]

But what photography and the photograph in a more general, dispersed fashion served to do was "introduce the panoptic principle into daily life ..." In short, "photography welded the honorific and repressive functions together. Every portrait implicitly took its place within a social and moral hierarchy."[343] If your face appeared in a ledger like the ones in Plates 34 and 35, then you found yourself in a particularly uncomfortable place in that social and moral hierarchy.

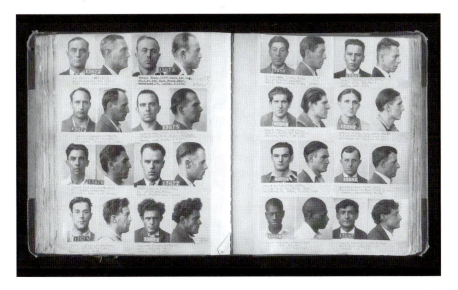

Plate 34 Ledger. Courtesy of Mark Michaelson.

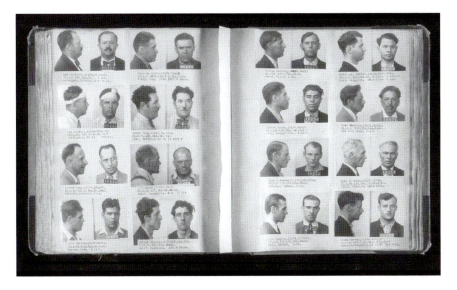

Plate 35 Ledger. Courtesy of Mark Michaelson.

Before moving on to Allan Sekula's work and the history of Alphonse Bertillon, a few questions: How do the ledgers printed in Plates 34 and 35 form part of a wider surveillance society? Who has access to this archive of images and what is it used for? What would it mean to be included in a ledger like this, how do you think your life might have been/would be affected and why? Can you think of forms of

surveillance—contemporary or otherwise—that confirm Foucault's theories? What about examples that resist Foucault's thesis?

To understand the significance of Sekula's argument, it is pertinent to consider the importance of Paris police clerk, Alphonse Bertillon who devised a system of criminal identification in 1879 called anthropometry (meaning "man measurement"). Bertillon calculated that there was a 268,435,454-to-1 chance that two people could have fourteen identical measurements (height, length and width of head, length of left forearm, etc.). The Paris clerk's system was deemed a success and was adopted by police departments throughout Europe and the United States. Each Bertillon card measures 3" × 5"; full-face and profile photographs appear on one side and the criminal's name, Bertillon measurements, and other information (nativity, age, crime) appear on the reverse. Keeping records of criminals makes perfect sense, of course. Identifying the perpetrators of crime quickly and efficiently ties in well with the predominant notions of scientific method and verifiability that the new institutions of power put together in the late nineteenth century. However, it is worth mentioning that the "anthropometrical system" devised by Bertillon was intimately linked with wider social Darwinist discourses of racial superiority. Identifying a criminal from his photographic likeness is one thing, but, the almost immediate efforts to employ these images or this type of image-making in order to diagnose the mental health, the criminal nature of individual, or the racial inferiority of the non-white person is different again.[344] Underpinning the derivation into "scientific" reasoning are a series of assumptions with regard to the status of the photograph.

As Sandra Phillips notes, "In America ... camera based images have both glorified violence and functioned as a tool to contain it."[345] This dualism at the heart of photography—the contradictory nature of the photograph—is what makes the visual culture of crime such a compulsive subject for study. On the one hand, the photograph of the "wanted" criminal might well help us identify the dangerous figure in our midst and encourage concern and connection with a community of law-abiding citizens; but, on the other, the use of imagery in this kind of media cannot help but romanticize and sensationalize the criminal act and the associated freedoms enjoyed by those who operate *outside* the law. The same is true of photographs of crime scenes; these pictures present themselves as objective evidence of a horrific or terrifying event too awful to look at, while simultaneously enticing us—the viewer—to look again and enjoy the voyeuristic spectacle of a hidden and secret world beyond our everyday lives. Again, is should not surprise us that the everyday horrors of crime and criminality proved such a rich resource for entertainment media.

This push-pull or "should I/shouldn't I" attraction to the forbidden or the unexpected is not exclusive to images of crime and criminals but plays a large part in explaining the enduring popularity of the crime genre in film and television. From the earliest so-called "Penny Dreadfuls" of the nineteenth century, the pulp novels and spicy stories of the 1920s and 1930s through to the hi-tech forensic dramas

offered on network television at the turn of the twenty-first century, the demand for and attraction to the various crime genres seems undiminished. Surveying the television schedules and upcoming movie theater releases as I write this chapter, the crime genre maintains a high profile in popular culture; the genre offers an apparently inexhaustible supply of narratives and characters to satisfy what must be an identifiable and, likewise, inexhaustible demand for variations on long established themes.[346]

Many of the most memorable mug shots—or, to be blunt, those "popularized" and now part of a shared cultural memory—are those of America gangsters of the 1920s, 1930s, and 1940s. In fact, our interest in mug shots of America's least wanted might not exist if not for those images of America's most wanted. From Al Capone to "Bugsy" Siegel and "Lucky Luciano," notoriety, snappy nickname, and standard mug shot composition converge to produce iconic images whose protagonists have taken on mythic status, their lives and deaths, crimes and misdemeanors both horrifying and terrible yet undeniably seductive and fascinating.

Salvatore Lucania, better known as Lucky Luciano, was the architect of the modern American Mafia or Cosa Nostra. In his 1936 New York Police Department mug shot, Luciano stares at us, impassive and upright. By this point, Luciano had transformed the Mafia into the organization we recognize today. Leading up to 1936, Luciano had embarked upon a life of criminality in childhood; born in Sicily in 1897, he came to the United States in 1907, his family moving to a Jewish neighborhood where he soon began "shaking down" the local school children for "protection" money. From then on, Luciano fell foul of the law with regularity, mainly for selling drugs. The making of Luciano was, like many early century "mobsters," the introduction of Prohibition in America on January 16, 1919. Luciano began racketeering, pushing drugs as well as bootlegging liquor, but soon crossed Giuseppe "Joe The Boss" Masseria, the head of the largest crime family in the country. Masseria had Luciano kidnapped, beaten, stabbed, and left for dead on a New York beach. Luciano survived the attack but was left a droopy eye and infamous scar: it also provided him with him moniker, "Lucky." The 1920s and 1930s saw Luciano's businesses expand nationwide and grow in power. At the same time, the inter-family Mafia wars grew more intense and violent (including the assassination of Giuseppe "Joe The Boss" Masseria in 1931; a scene reimagined in *The Godfather*). It is acknowledged that Luciano, along with many other senior Mafioso, avoided jail time through the systematic bribing of public officials, politicians, and the police, but Luciano was arrested in 1936 for running a prostitution ring and was sentenced to thirty to fifty years in prison.[347]

Of course, Luciano's biography is atypical, not every individual involved in organized crime becomes head of the "Family" and not every American individual can hope to be "America's most wanted" criminal mastermind. But as "Lucky" or his sidekick "Bugsy" Siegel stare back at us, we stare at them, knowing that they are long dead, knowing that each of these simple photographs presents us with what these men *actually* looked like—their facial features, their dress, and that

they were arrested for criminal behavior. In 1936, Luciano was in that place at that time, the little NYC plaque perched on his shoulder with the date of his arrest and arrest number. Here is an example of what Sekula means by the body and the archive—Luciano forever "caught" by the camera (as well as the police), the image catalogued, recorded, and then stored. Evidence.

Speaking of evidence, the catalogue produced to accompany the exhibition, *Protect and Serve: The LAPD Archives, 100 Years of Photography* is itself a mini-archive reprinted for public eyes. This is not to say archives are secret, though they often are, but institutional archives (hospital and medical records, police archives) generally allow privileged access only; that is, the archive works on the presumption that the layperson is unable to navigate and make sense of it. Tim B. Wride queries not just the role or institutional grounds of the LAPD archive but its actual organization and the production of meaning. "Photographs in an archive," Wride says, "are placed within a sequence that has little to do with the circumstances of their making or intrinsic characteristics."[348] One of these intrinsic characteristics is photographic composition. With mug shot imagery a kind of anti-aesthetic is at work—these photographs are not meant to capture "beauty"—one related to scientific and forensic attitudes toward fact, objectivity, and truth. The simplified form of these pictures does not, because it cannot, distract from the image's role as evidence: it is what it plainly is. But as Plates 36 and 37 reveal, the straightforward "scientific" standard mug shot of full-face and profile was not always the standard used; here are six examples of single-photo mug shots that use a mirror to produce the profile image; two images in one. Does the form of these mirror images disturb the notion of these photographs as objectivity and truth? Or is it the more standard two-shot images which now appear the more playful, less scientific. Now think back to those first index cards relating to Clarence Walker, which opened this chapter; the same man but on different dates, but photographed in the same manner, and yet are these images identical? I would argue that while there are clear similarities, it is obvious Walker has made little effort to disguise himself. Quite unlike the woman in the three sets of mug shots in Plates 36 and 37. Does this attempt to conceal or transform one's identity through disguise resist the effort on the part of the mug shot to control both the form and the content of the image, when the content (not only how the person looks or appears but how the photograph is subsequently read for meaning and recognition) is so much more malleable?

These questions lead us to the next section and crime scene photographs. As we have seen here with mug shots, while photography makes it possible (even sensible) to control the form of the image—the conventions of crime scene photography—surely what the image contains, that is, its subject, what the photograph is of—a dead body dumped in an alleyway, a car crash, the foyer of a bank after a robbery—is more suspect, less easy to decipher with any certainty. As we discussed previously in relation to the documentary image, the meaning of a photograph, no matter what its official or institutional status—as document or evidence—does not secure for the

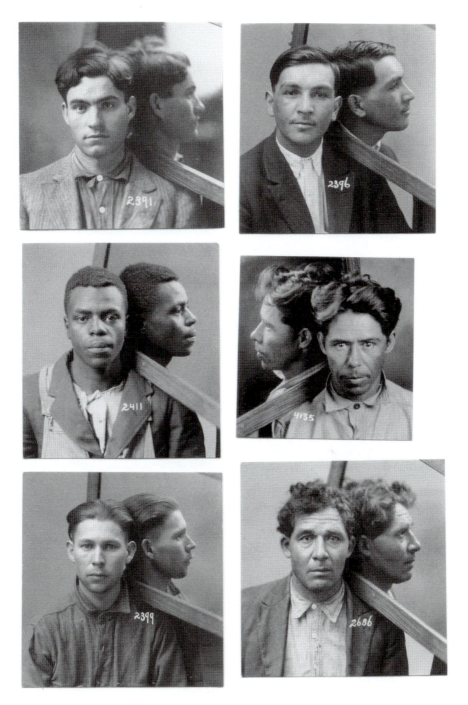

Plate 36. Mirror Mug Shots. Courtesy of Mark Michaelson.

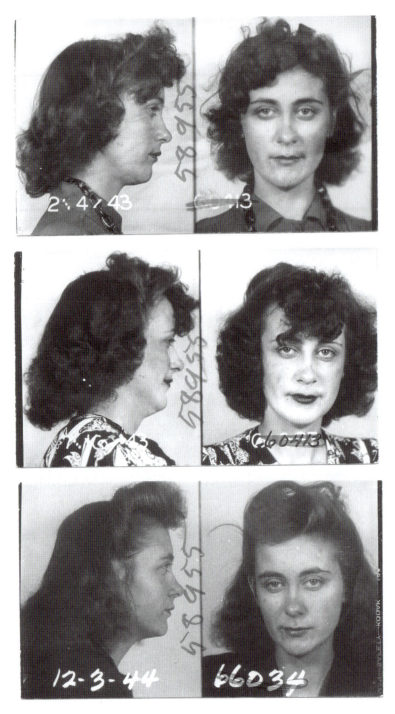

Plate 37 Different Mug Shots of Same Woman. Courtesy of Mark Michaelson.

photographic image a singular and unassailable meaning. Photographic meaning is process; it is not static and timeless, despite institutional assurance to the contrary.

Early crime scene or forensic photographers were "art" photographers first and their images retain a more personal approach to the "murder, mayhem, and perversion" captured in them; with the professionalization of the field, though, "today's specialized definition of forensic photography, the photographer has previous little latitude within which to express him- or herself."[349] Two early figures emerge as capturing a time when artistic license was acceptable: the first a photographer known only as Driver, the second, Weegee, or Arthur Fellig. Little biographical information about Driver is known,[350] and though we know more about "Weegee the Famous"—he stamped the back of photographic prints saying as much—his work is truly bound up in the crime mythology of New York City in the mid twentieth century. A brief examination of works by Driver and Weegee will help sharpen our focus on what might best be described as the problematic status of crime scene photography.

For Wride, Driver's photographs "identify him as a photographer with an exquisite sense of composition and occasion."[351] To give some idea of what Wride means, consider photograph DR #714-160 taken by Driver on August 31, 1932 (Plate 38).

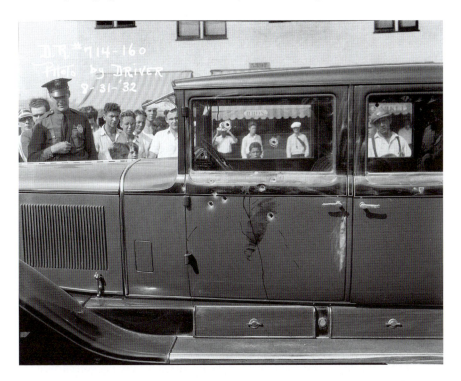

Plate 38 LAPD Driver DR #714-160, August 31, 1932. Copyright LAPD. Image courtesy of Fototeka Gallery, Los Angeles.

The composition is classical; the horizontal picture plane divided into thirds, the body of the bandit's bullet-holed automobile taking up two-thirds, the final third filled with expectant viewers, some framed by the windows of the car. The stolen car was used to escape from two robberies—first of a motorist and then a bank heist in Sierra Madre; a teller from the bank was kidnapped then released and police chased, cornered, and shot the bandit in Lincoln Heights. In the ensuing gun battle the bandit shot and mortally wounded a young patrolman, Frank E. Meredith. Probably injured himself, the bandit abandoned the car pictured here, on Poplar Street, and escaped in another stolen vehicle.[352]

Compare this image to earlier mug shots in this chapter. How does Driver's image partake in the categorization of knowledge? That is, how does this image work as evidence? And how much does this photograph play out the inherent contradictions of this kind of photography; namely, as both a tool to prevent crime and a glorification of it? As part of the LAPD archive—itself a body of knowledge—how does one make sense of this photograph? Without doubt the LAPD archive, like all archives, has organizational principles to aid storing and then finding evidence easily and efficiently; however, as Wride argues, "Archives can be organized, classified, and systematized, but try as one might, they cannot be sanitized."[353] Or, in other words, it appears impossible to reduce the photograph to pure fact; it is always possible to narrativize an image such as Driver's. Look at the crowd looking at the spectacle of mayhem. However, do you notice how many crowd members are attracted not only to the car and the horror it represents but to the photographer's lens? Driver's composition sets up a kind of social portrait—us looking at them—with a large black car between us. Although the driver's door and window are punctured by bullet holes, the audience cannot see what we can see; so what are they looking at? Are there bullet holes to that side of the car, too? What can we not see from our vantage point?

Unlike Driver, Weegee was not a police photographer. But, very much like Driver, Weegee also produced well-composed, thrilling images of everyday horror, such as *Their First Murder* (1941) (Plate 39).[354] You can find *Their First Murder* in Weegee's *The Naked City*, originally published in 1945, where he writes that: "A woman relative cried … but neighborhood dead-end kids enjoyed the show when a small-time racketeer was shot and killed."[355] In this picture, Weegee, as a photographer for the tabloid press, dispenses with the evidence of the act—the dead body, perhaps the discarded murder weapon—in favor of the evidence of the reaction. Unlike Driver, who was professionally compelled to include the admittedly photogenic bullet-ridden vehicle (but, I would argue, did so aesthetically), Weegee faces the crowd, as Driver had done, but with only the camera between himself and the craning necks and grinning faces of the neighborhood residents. The excitement bursting out of this image is incredible and somewhere in the middle is the crying woman Weegee mentions; around her, young children and adolescents fight for a better view, notice the girl front-right appears to have a hand pushing her head forwards, as though

Plate 39 Weegee, *Their First Murder*, 1941. J. Paul Getty Museum, © International Center for Photography.

forcing her closer to the gory climax of a "young racketeer's" life. Others just "mug" for the camera: the blond boy to the left grins wildly, below him a wry, confused smile from a dark-haired boy and behind another youth finding himself fighting to keep his place in the front row. How does this photograph make you feel? What does it tell us about the crowd's reaction to such a horrible spectacle? In what ways does this image differ from Driver's and in what ways are they similar? Which would you say is the more authentic and why? And, can either of these photographs truly be called evidence? If so, how do we interpret the evidence, how can we piece it together, and what do we learn? As a simple task, I would recommend discussing your responses with others.

While hardly mini-mug shots in the official sense, all these faces convey some form of emotion and it has been captured with the aid of a flash gun and printed on photographic paper for us to see. Many of these 1941 faces stare into the lens and hence at us, but over sixty years later; it is a candid photograph, taken quickly,

unposed, and unaltered. Driver's image, too, appears as much a spontaneous photograph as a forensic one, just with more care and attention paid to the framing and the composition of the subject matter. In both cases, a crowd, an event, and us the viewer, all bound up in a series of exchanged gazes; a frozen moment in time, staring back at us sort of whispering and imploring: "I am the truth, please believe me ...'

For many years, as we have seen, photography's request (or is it a demand?) to be believed as the truth has been upheld, and as we have seen has secured the status of institutional power and discourse. As Foucault and Sekula have shown, though, it is the use of photography to underpin these claims to truth that has come under critical pressure in recent decades. The distrust or, more politely, critical acceptance that, as a form of representation, the photograph and photography can lie is exacerbated by digital imagery. Perhaps no clearer example exists in American visual culture than the deliberate alteration of a mug shot of O.J. Simpson that appeared on the cover of *Time* magazine on June 27, 1994.[356]

Conclusion

As photography was taken up in nineteenth-century hospitals, schools, and asylums, the photograph became the locus of repression and surveillance and the source of scientific claims for social engineering. It also formed the basis for the humanist rhetoric of social reform, as can be seen in the photographic work of Jacob Riis and Lewis Hine at the end of the nineteenth and beginning of the twentieth century. The photograph was a mirror able to reflect the truth of social depravation and scientific discovery; the photograph was a portable medium more than equipped to carry its message far and wide but also able to be classified, organized, and systematized in archives. As such, the strange nature of photography is quite simply its double-life: a simultaneous existence as both an art form and form of evidence and proof, or documentary, its status on any given day reliant upon context in which the photograph is displayed.

The clipped phrase, "mug shot," manages to capture the rather demeaning and certainly socially leveling power of this particular type of image. From its beginnings in nineteenth-century American culture, photography and photographs performed an important role as *evidence*; photography was "seen to embody the new authority of empiricism.... . [And] many of the important scientific projects of the era exploited the photograph's perceived impartiality—as well as its speed, accuracy and fidelity—to record or constitute their findings."[357] With regard to the criminal, the photograph and photography offered the means of making an accurate visual record of an individual's facial features while simultaneously creating an archive of photographs. An archive is a body of knowledge, and the analogy extends to cover the growth, development, and ageing of the archive: a kind of social and cultural memory.

The aim of this chapter has been to draw attention to the ways in which certain ideas—with regards to criminality, especially—were founded upon and consequently legitimized by the photograph and photography. The perception of photography as authentic record of the reality helped insure the practice against criticism. The point here has been to show that photography's grounds for truth are rather shaky and that the nineteenth century drive for truth based on categorization persisted well into the twentieth century. I end with a question for you to ponder: have digital technologies the capacity to fundamentally change our understanding of the status of photography and the photograph in the twenty-first century?

–6–

Visualizing Sex in America

How do we make sense of an image like Art Frahm's (1907–81) *No Time to Lose*? (Plate 40) In this chapter, the short answer is: psychoanalysis. From this point on, our task is to consider the uses and, as some have complained, abuses of psychoanalysis or, more accurately, theories derived from psychoanalysis as a toolkit for understanding culture. The impact of psychoanalysis as a critical approach to those forms of cultural production studied by scholars of literature, art history, and film, to name but three, has been and continues to be extensive and in truth somewhat problematic. But before drawing attention to flaws, complaints, and disavowals, let us trace the ways in which the ideas of Sigmund Freud have proved (and, to many, remain) vital to the interpretation of culture, in particular visual culture. Freud's work on dreams, the unconscious, scopophilia (or pleasure in looking), and fetishism, continue to nourish critical interrogations of all forms of visual representation across many academic disciplines.

This chapter has two distinct aims: firstly, to introduce and outline Freudian ideas and the significant visual theories his work underpins, such as Laura Mulvey's notion of the "male gaze." Secondly, to work through several connected case studies that examine the representation of women in a variety of media, with the predominant focus on the first half of the twentieth century. During the early twentieth century, it is possible to detect a shift from Charles Dana Gibson's rather reserved pen-and-ink illustrations of the idealized American woman of the early 1900s, known as the "Gibson Girl" to the more graphic depictions of women on the covers of "dime" and "pulp fiction" novels, and the pin-up girls of George Petty, Gil Elvgren, and, of course, Art Frahm. Armed with the tools of psychoanalysis we will ask, *why* does the representation of women in popular culture so often portray them as objects to be looked at; and, moreover, *how* has this "to-be-looked-at-ness" become invisible: that is, why has the male gaze become normal?

Psychoanalysis and Sigmund Freud

As Peter Gay writes, "Freud is inescapable." So embedded has Freud and Freudian terminology become that "we all speak Freud whether we know it or not."[358] Slips of the tongue, repression, projection, neurosis, narcissism, fetish, and the uncanny, to name a few, have become part of the common lexicon. Perversely, though, such

Plate 40 Frahm, *No Time to Lose*, printed by the Joseph C. Hoover & Sons Calendar Company, 1950–60 (colour litho); Private Collection/DaTo Images/The Bridgeman Art Library.

recognition (conscious or not) has left Freud's work in a rather strange position: known but unknown. What I mean by this is simply that being aware of Freudian terminology—"repression," "projection," "sublimation," or "a slip of the tongue" (parapraxis)—is a long way from fully comprehending what they mean in a clinical

context, as envisaged by the Viennese doctor. In fact, everyday usage of Freudian words and phrases is "often imprecise in the extreme."[359] Now, I hardly have the time to summarize the vast library of Freud's thought (likewise the literature produced in response to Freud; good, bad, or indifferent) produced during his lifetime. Instead, the aim here is to concentrate attention on the following aspects of Freudian psychoanalysis most relevant to looking:

- "scopophilia" or "pleasure in looking";
- what Freud refers to as the "dream-work" with all its symbolism, latent and manifest content, wish-fulfillment and desire;
- Freud's work on sexuality, fetishism, and the fetish.

Initially devised as a medical therapy to be used in the treatment of "neurosis" and other psychic pain or disturbances, psychoanalysis has emerged as a particularly potent interpretative and critical tool in the humanities. The rising star of psychoanalysis in the humanities, though, has been matched by its declining status in science, where new discoveries in neurology especially have trumped the "talking cure."[360] Psychoanalysis's "other career" is no accident, either, as it helps form a crucial theoretical foundation in the wider "cultural turn" noted in the Introduction. As Michael Hatt and Charlotte Klonk note, "Freud and his acolytes wrote extensively on the significance of the theory for culture, history, social science and so on ..."[361] and as Gillian Rose argues, the reason for this is quite straightforward: psycho-analysis "argues that visuality is central to subjectivity."[362] In other words, who we are and how we recognize ourselves, and others, as individuals relies upon "certain moments of seeing," which are central to the formation of subjectivities and sexualities.[363] With this in mind, it makes perfect sense, then, that psychoanalysis has proved particularly effective for feminism's criticism of patriarchy and the male gaze, especially through the critical assessment of film.

To begin with we need to acquaint ourselves with the fundamental importance of the "unconscious" because, according to Gay, the theory of the unconscious is "truly indispensable" to Freud's psychoanalytical project. The theory of the unconscious allows Freud to "confidently assert that the mind, which appears so chaotic, contradictory, beyond causation, is ruled by inexorable laws."[364] For Freud, all the evidence suggests that understanding the complexity of conscious thought and mental life necessarily means that "[i]n psychoanalysis there is no choice for us but to assert that mental processes are in themselves unconscious ..."[365] In a neat analogy, Gay describes mental events as "pearls on an invisible chain, a chain that remains largely invisible precisely because many of the links are unconscious."[366] Freud adds that our understanding of the conscious mind is clearly inadequate because "the data of consciousness have a very large number of gaps in the them ... our most personal daily experience acquaints us with ideas that come into our head we do not know from where, and with intellectual conclusions arrived at we

do not know how."[367] As such, the theory of the unconscious as an active and crucial part of the human mind becomes both *necessary* and *legitimate* for Freud.[368] For further evidence of the existence of the unconscious—other than the not knowing where ideas and conclusions "come from"—Freud makes reference to his own clinical experience; meeting people who display all manner of tics, tremors, stammers, and slips of the tongue; and of course, those who suffer strange and bizarre dreams.

But what is the unconscious for; what functions does it perform? Briefly, the unconscious is a refuge for repressed memories of events going all the way back to childhood. For Freud, *"the essence of repression lies simply in turning away, and keeping it at a distance, from the conscious"*;[369] the suggestion here is that the function of repression is to protect the conscious mind, a system whose job is "burying" or "hiding" traumatic psychological events so as not to disturb the everyday performance of the conscious mind. Conversely, the unconscious mind is tasked with allowing what was repressed to break out and find a way into the conscious mind. The image here is of a continual battle between the conscious and unconscious, one that shows the unconscious to be anything other than "a mental dustbin" but rather an active and troubling presence.[370] What makes this whole process so alarming is the way in which the unconscious or the repressed makes itself known to the conscious mind; or, thinking back to Gay's analogy, the effort to make visible the invisible chain which hold the pearls of the necklace together.

The most recognizable moment where the unconscious breaks through into conscious thought is in slips of the tongue, or even "slips of the pen"—when we inadvertently say/write one thing when we meant to say/write another. For example, there is something telling when a student refers to Sigmund Fraud rather than Freud in an essay or dissertation; as a reader, it is obvious what the author wanted to write, "Freud," but by writing "Fraud" instead, one can conclude this writer feels either a deep ambivalence towards Freud's ideas ("Freud was a fraud but I can't express it here") and/or about having to complete a class assignment ("I feel a fraud writing about Freud"); or both (Freud is a fraud; I am a fraud). From these examples, we can see the beginnings of Holden Caulfield-like jaded cynicism as explored in *Catcher in the Rye* but more importantly that such slips do not necessarily lead to one connection but several, or to one repressed traumatic event but a combination of them. But which of these readings is correct?

A more complex example of the encroachment of the unconscious into conscious thought is dreaming and as a consequence the task of deciphering the exact meaning of a dream is that much more difficult to work out. Dispute their multivocal quality and the associated difficulty in identifying a single source to account for the intrusion of unconscious thought, Freud emphasizes the significance of the dream and what he calls the "dream-work," for several reasons. I should add two things, here; one, that the notion of the unconscious was hardly new in Freud's day and had been considered a quality of the human mind since antiquity, therefore Freud did not

discover the "unconscious," he reinterpreted the concept; and, two, historically dreams had often been discounted as nonsense and because of their fantastical nature (often divorced from the realities of the everyday) they were long regarded as unimportant.[371] Freud's work on the unconscious and on repression pushed him to completely revise this negative view of dreams and dreaming. On dreams, Freud says they are "brief, meagre and laconic in comparison with the range and wealth of dream-thoughts."[372] In other words, one can describe the events of a dream relatively succinctly, but the actual analysis of that dream defies such a reductive summary. In fact, Freud describes the dream and dream-thoughts as "two versions of the same subject-matter in two different languages."[373] Now most of us can describe what we remember from a dream—one version, one language—but the trouble is explaining what the dream means—this requires a different version in a different language. Added to this is something quite wonderful; namely, that the dream is the "modification" of the conflict between the unconscious and conscious mind "into a *pictorial* form."[374] Freud, in reference to his own "specimen dream," concludes a full analysis would lead him to "*alien*" and "*disagreeable*" thoughts that he would "dispute energetically."[375] This self-analysis highlights the distinction Freud draws out between the latent and manifest meaning of a dream, an approach that sounds remarkably similar to Roland Barthes' examination of the language of myth in culture, connotation and denotation, especially advertisements. The manifest content of the dream is the short summary; whereas the latent content of the dream is that which can only be discovered through careful analysis; and it is the latent content of the dream Freud finds so fascinating. The latent content of the dream is so disturbing that the "dream-work" disguises the repressed thoughts and alters them accordingly. The result: "A dream is a picture-puzzle of a sort... ."[376] Freud is thus able to conclude, "We are therefore justified in asserting that a dream is the (disguised) fulfilment of a wish. It will now be seen that dreams are constructed like a neurotic symptom; they are compromises between the demands of a repressed impulse and the resistance of a censoring in the ego."[377]

The wish fulfilled is, as ever in Freud, related to psychosexual urges and sexual fantasy. Psychoanalysis sets itself the task of interpreting the symbols of the dream in order to make manifest the disguised latent desires and wishes of the dreamer. For our own interests in this chapter, our aim is to consider the manifest visualization of the female body in American visual culture through an examination of the symbolic disguises used to hide the latent desires of patriarchal—meaning "male-dominated"—culture.

But what are these latent desires? Our reading of the unconscious so far lacks a piece of the Freud's theoretical puzzle: his theories on the development of sexuality. Central to psychoanalysis is the question of sexual difference, or more properly, "the process through which sexual difference is established and (often precariously) maintained," which Freud famously called the "castration complex."[378] According to Freud's theory, known as the Oedipus complex, all little boys believe that everyone

has a penis: boys, girls, their father, and, importantly, their mother. At some point, all boys recognize this to be untrue. What this realization awakens—that their mother does not have a penis—is the threat of castration by the father; if the mother does not have a penis, she must have done at some point, and that the father, as head of the household, *must* have removed the mother's penis. Now such a traumatic chain of events has several possible outcomes, all of which relate to repression and the unconscious. A successful transition through the castration complex sees the boy take develop a "normal," masculine, heterosexual sexuality; however, if this process falters in any way, other outcomes are possible. One is fetishism, which Freud describes as, the continuing desire in the male subject for his mother's "lost" penis; the fetish being "a substitute for the woman's (the mother's) penis that the little boy once believed in … "[379] Another possible outcome is homosexuality.

Freud's account of femininity and the development of female sexuality—the Electra complex—is far less convincing; girls see themselves as already lacking a penis, so do not fear castration, but see the power associated with those who have a penis—the father—which encourages the little girl to break her sole attachment with her mother and transfer it to the father. Rather than criticizing Freud's theories here, it is worth reminding ourselves of just how important looking and seeing are in the formation of the sexuality; as Rose notes, "it is this disciplining process, resolved by the Oedipus complex, that represses the child's profound drives an desires and thus produces the unconscious."[380] But what does this all mean for the representation of women in popular culture?

The Gibson Girl

Charles Dana Gibson was born in Roxbury, Massachusetts in 1867, studied at the Arts Student League of New York, in Manhattan and is best remembered for his illustrations of the so-called "Gibson Girl."[381] Although attributed to Gibson, the Gibson Girl emerged as part of the Progressive Era's invention of the "New Woman," and was depicted in the drawings and stories of Gibson, Howard Chandler Christy, and Harrison Fisher.[382] Appearing in magazines of the period, such as *The Century*, *Harper's Monthly*, *Weekly Bazaar*, and *Life*, the Gibson Girl epitomized the "beautiful, charming, and fashionable" "American Girl," praised for her "health, athletic abilities, and intelligence."[383] The Gibson Girl was, in the artist's own words, "The American Girl to all the world" and Gibson's image of the "American Girl" arguably set a standard for all subsequent illustrations and representations of American women throughout the twentieth century.

The success of the Gibson Girl can be judged against what we might imagine as a more contemporary phenomenon: the mass merchandising of modern popular culture. Gibson Girl products were consumed at levels that would make organizations such as Disney or the Star Wars franchise blush with envy. Any object with enough

surface area to carry the image of the Gibson Girl did so. Ellen Wiley Todd describes the phenomenon of the Gibson Girl in the following terms:

> the coolly elegant Gibson girl began her twenty-year reign as America's most popular visual type first in *Life* magazine, then in every imaginable artifact of American material culture. Doulton porcelain, commemorative spoons, umbrella stands, matchboxes and whisk-broom holders bore her figure. Thanks to pyrography, the decorative hobby of the day, enthusiasts burned her image into every available leather and wooden surface. For the male bachelor's apartment interior decorators marketed wallpaper with a repeat pattern of four Gibson girl faces. Commentators puzzled over her appeal, and in her heyday one of them named the types: the beauty, the athletic girl, the sentimental girl, the girl with a mind of her own, the ambitious girl, and—the universal favorite among men—the charmer.[384]

In terms of the wider representation of women in American visual culture, the Gibson Girl provides a kind of benchmark against which to trace the changing representation of women in the twentieth century.

The Gibson Girl offered a particularly feminized rather than feminist vision of the modern, educated young American woman at the turn of the twentieth century. Before 1890, many women who continued with a postgraduate education, for example, were considered "mannish" and the Gibson Girl was anything but.[385] Paraphrasing Lois W. Banner's observations in *American Beauty*, Gordon notes that for all the progressive rhetoric associated with women's education and the refined beauty of the "New Woman," the Gibson Girl was ultimately "a conservative image of American womanhood." In fact, "popular culture distorted both campus and postgraduate realities but quite accurately demonstrated the consternation with which most Americans regarded women's changing status."[386] Gordon and Banner rightly complain about the distortions of popular culture; after all, if society was to take seriously this dynamic and intelligent "New Woman," then why market her beauty first and her intelligence at best second? How do the products of popular culture—the "china plates and saucers, ashtrays, tablecloths, pillow covers, chair covers, souvenir spoons, screens, fans, [and] umbrella stands"—carrying the recognizable image of the Gibson Girl advance the progressive cause of woman at the turn of the twentieth century?

Moreover, what of Banner's accusation of the Gibson Girl's inherent conservatism? Let us consider Gibson's "All American Girl." With titles such as *Not Worrying About her Rights* (1909) and *No Time for Politics* (1909), one might assume Gibson's "girl" is hardly progressive in nature at all. If this "girl" (rather than woman) is not worrying about her rights, what is she worrying about? And why would a progressive, intelligent woman have no time for politics; and, if not, why not? In *Picturesque America, anywhere in the mountains* (Plate 41) these women appear self-confident and assertive—examine their body language—but equally

they mirror and therefore demand to be considered in much the same way as the epic beauty of the mountain. These women as much as anything else are picturesque. If these characters are representative of the "New Woman" then how does she differ from the old version: a mother, a housekeeper, a wife? We should also ask ourselves, how do these images evoke the "abilities and intelligence" that (supposedly) define the "New Woman"? And if the Gibson Girl, as Gibson claimed, was "The American Girl to all the world," what did/can the rest of the world make of her? And, what do Gibson's illustrations actually illustrate? By this I mean, has Gibson captured in pen and ink the essence of the type of woman who is part of a new intellectual movement, one whose focus is the empowerment of women across America? Or, has Gibson illustrated the fantasy of this new woman, intelligent *and* beautiful, able to discuss the finer things in life and yet still raise children while remaining in the home?

Plate 41 Charles Dana Gibson, *Picturesque America, anywhere in the mountains* (1900). Cabinet of American Illustration, Library of Congress Prints and Photographs Division, Digital ID: cai 2a12817.

In the examples above, the subject of the viewer's gaze is the slender feminine figure, at ease with the thought of being looked at or at being watched from afar; such self-composure and self-assuredness certainly sets the viewer at ease; we can stare at each of these women, examine carefully the definition of her cheeks, her fine clothes and beautifully dressed hat neatly balanced on her head. Gibson's girls are made available to the gaze, but whose gaze? If the viewer is male, then how reassuring it is that these beautiful, intelligent, and athletic women encourage our gaze and yet are unlikely to demand "rights" or employ "politics" in discussion? For the female viewer, could we argue that these women become models of virtue and conservative values blended with the more progressive notions of beauty and

fashion; all of which combine as of validating statement that reads: "you too can be beautiful *and* a mother!'"?

All of the above highlights a fundamental idea in visual culture studies: the male gaze. In *Ways of Seeing*, John Berger observed that, "Men look at women. Women watch themselves being looked at."[387] Berger goes on to say that in European art from the Renaissance onwards women were depicted as being "aware of being seen by a [male] spectator."[388] Thinking on the second half of Berger's assertion, he implies that women are well aware of this visual dynamic and act or perform for the benefit of the male gaze accordingly; women therefore learn that their place is to be looked at. The simple truth is that this kind of representation of women continued from the Renaissance right up until recent feminist challenges in art and criticism. And while emphasizing the ways in which the Gibson Girl replays this tradition, it does not begin to really address the question, why?

Looking and the Male Gaze

If men look at women, and women watch themselves being looked at, then the next step is to understand how this dynamic, named the male gaze, works. Laura Mulvey first outlined the theory of the "male gaze" in the essay, "Visual Pleasure and Narrative Cinema,"[389] a theory indebted to Freud's writings on sexuality and Lacan's "mirror stage."[390] For now, let me underscore the importance of "scopophilia" or "pleasure in looking"—the "visual pleasure" part of the essay's title—but Mulvey also describes the appropriation of psychoanalytic theory as a "political weapon" to demonstrate "the way the unconscious of patriarchal society has structured film."[391] Mulvey's feminist politics are worth highlighting because theories of sexuality developed in psychoanalysis are problematic—but more on this later. For now, let us look at Mulvey's use of Freud and the way in which the "male gaze" allows her to make links between cultural production—in this case, film—and the social, political, and economic discourses that structure American society and culture.

Mulvey's essay focuses on a pivotal twentieth-century form of cultural repres-entation: film or the movies. In essence, Mulvey alerts us to the fact that film, and by extension television, art, advertising, and all other forms of cultural representation can be "read" in much the same way as Freud reads the unconscious or the dream. Movies, in Mulvey's view, have a manifest and a latent content, just as, for Barthes, advertisements have a denotative and connotative meaning. Drawing on Freud's castration complex, Mulvey argues that visuality is structured in a gendered, that is, masculine way. Remember how Freud describes the importance of looking in the castration complex in terms of boys becoming aware of the mother's lack of a penis? Freud's emphasis or placing of the experience of the Oedipus complex *above* that of the Electra complex in turn creates a hierarchy; one in which the sexual development of the little boy is privileged over that of the little girl. However, as Gillian Rose

notes, "this assumption only works … if what Freud is talking about here is not simply vision, but *visuality*."[392] That is, the boy sees "through a visuality that asserts that the masculine position is to look, the feminine to be looked at, and that the feminine is to be seen as lacking."[393]

What strikes Mulvey though is the evident contradiction or "paradox of phallocentrism in all its manifestations is that it depends on the image of the castrated woman to give order and meaning to its world. An idea of woman stands as the lynch pin to the system; it is her lack that produces the phallus as a symbolic presence, it is her desire to make good the lack that the phallus signifies."[394] Sexual difference between men and women is therefore to be understood relationally; the feminine and masculine cannot exist without each other and are reinforced by the binaries of male/ active and female/passive, which Berger's commentary highlighted earlier. This is also reminiscent of the discussion on gendered landscape in Chapter 1 where Gast's *Progress* is feminine and yet the landscape is shaped by the activities of men; and also the regionalists whose work eroticizes the land, where the fecund undulations of the landscape mirror the hips, breasts, and bellies of women's bodies. From this, as Rose points out, Mulvey is able to conclude that the "castration complex mobilizes not only a set of ideas about sexual difference in relation to subjectivity, but also in relation to visuality."[395] Rather worryingly, women in cinema—on the screen—"exist only in relation to castration";[396] appearing as "castrated not-men."[397] I for one cannot see many Hollywood "starlets" allowing themselves to be described as such and fewer spectators waiting in line in the rain to watch a mainstream movie advertising its female lead actor as a beautiful "castrated not-man." Moving away from film, a consideration of Mulvey's argument in relation to post-Gibson Girl representations of women *and* men on the covers of the pulp fiction novels of the 1930s and later is informative.

Pulp Fiction, Dime Novels, and Men's Adventure Magazines

On the front cover of *Rugged Men*, December 1958 (Plate 42) we read: "We Fly Into Hell" "Strip Clubs—The housewife's new road to riches!" and "I Slit My Rival's Throat … for the right to mother a monster," all of which appear to belong to a contemporary genre of television talk show rather than a 1958 product of mass consumption. Overlooking the rather dubious text, what can we actually see on the cover? And, does "Rugged Man" reinforce or counter Mulvey's argument that the definition of masculinity requires femininity and vice versa?

The cover and content of *Rugged Men*, like so many other "men's adventure" publications,[398] suggest it is difficult to argue against Mulvey; after all, even though there are three people being rescued, of which only one is a woman, all the active characters are male.[399] Moreover, the rescue of the male sailors is distinct from the rescue of the woman in the torn, red dress; although their bodies are limp through

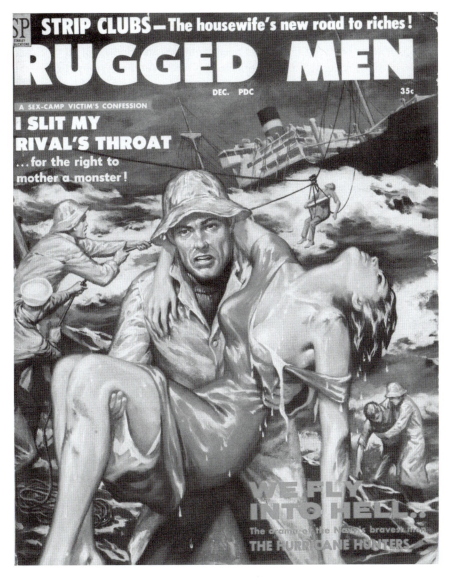

STRIP CLUBS — The housewife's new road to riches!

RUGGED MEN

DEC. PDC

35c

A SEX-CAMP VICTIM'S CONFESSION

I SLIT MY RIVAL'S THROAT

...for the right to mother a monster!

WE FLY INTO HELL...

The drama of the Navy's bravest in THE HURRICANE HUNTERS

Plate 42 *Rugged Men,* cover, December 1958.

exhaustion, their uniforms remain intact and because they are men (men equals masculinity) we might assume that they exhausted themselves saving others, perhaps. And why might we think this? The storm, the sinking ship, the wild crashing waves and violent sea, the black-gray storm-filled sky, the rescue of the crew all appear secondary, as mere background, to the main focus of the image: the rescue of the woman in the red dress. If you explore the world of pulp fiction covers, and I

recommend you do, the woman in the red dress is a repetitive trope. As is the state of undress many of these women find themselves in; whether as the result of a storm, a kidnap, or some other Art Frahm-like mishap, dresses and clothes (of all types and colors, in truth) never fall away completely to reveal full nudity or to expose the breasts, genitalia, or buttocks.

The cover imagery of *Rugged Men* is typical of the genre: the men are depicted as suitably rugged, while the woman is shown with long, smooth exposed legs, the suggestions of an underskirt, probably torn, the slippage from the shoulder of the dress to partially reveal a breast, here again the underwear valiantly preventing, against all odds, the woman's breast from breaking free, just as the trawlerman (?) holds the woman herself. Here masculinity reinforces itself for the male spectator; who else would buy *Rugged Men*? Moreover, the woman here hardly appears as a "castrated not-man," her presence does not to encourage the masculine fear of castration; instead, her near nudity and limpness, her passiveness, encourages a pleasurable rather than anxiety-inducing response: women need and moreover want to be rescued.

Although distinctly trashy in nature, produced and sold cheaply, publications such as *Rugged Men* and its ilk deserve our careful attention because of their ubiquitous presence in American popular culture. Sold in their millions, dime novels (in the mid to late nineteenth century) and then, later, pulp fiction novels were produced to be consumed and then discarded; they were a cheap and accessible form of popular cultural entertainment, in many ways, as we have discussed earlier in this book, and played on the public's appetite for salacious tales of crime (remember Weegee?), sex, and intrigue. Pulp fiction introduced the newsstands of America a variety of genres, including crime, war, horror, mystery, and science fiction, and an analysis of each would produce a fascinating insight into American culture of a given period. The emphasis here, though, is on another genre: the so-called "spicy" pulps. Like *Rugged Men*, the covers of spicy pulp novels employ a straightforward and some might say gratuitous amount of exposed female flesh to attract the reader's eye. Importantly, it is possible to identify consistencies in composition, subject matter, and style—a formula, if you will—in the cover illustrations of spicy and pulp novels.

For one thing, women are often shown in distress, imprisoned, or restrained in some way, whether in the arms of a captor, tied to a tree, or handcuffed to all manner of objects, even coffins. More than this, these women are subject to the gaze of a persecuting presence, many of whom might be described as "monsters": one can easily find examples of bizarre, many-limbed monsters, overtly aggressive, weapon-wielding, broad-chested men, and even sleeping, murderous devils (the variations seem endless). We could ask who and what is the monster and why has he kidnapped the young woman? Or, what has the woman tied to the tree done to make her captor so angry? And, finally, how has the woman found herself tied, for example, to the devil's coffin? Ignoring the obvious factual errors—does the devil even need to sleep?—we are confronted with near-naked women, paralyzed with

fear, situated and (un)dressed so that the viewer's gaze is practically uninterrupted. As noted earlier, the concept of the "male gaze" works on the active/passive binary but also sets up a masculine visuality, and what we have seen thus far seems to support Mulvey's argument. The question remains though: how are these images of "castrated not-men" pleasurable (to men)?

For Freud, seeing is derived from touching and is an indispensable part of normal sexual activity; "Visual impressions," says Freud, "remain the most frequent pathway along which libidinal excitation is aroused …" There is also the issue of civilization, which has progressively concealed the body, the effect of which has been to keep "sexual curiosity awake." The act of looking is therefore purposeful and driven by finding beauty in the sexual object, the ultimate aim of which is to "complete the sexual object by revealing its hidden parts." A problem here is that most of the time sexual curiosity cannot be consummated and has to be "sublimated": that is, the urge to "complete" the sexual object is redirected. Freud notes that art is an excellent example of sublimation, where the interest is "shifted away from the genitals on to the shape of the body as a whole."[400] On occasion, though, scopophilia—the pleasure derived from looking—becomes a perversion; Freud highlights three groups who respond in ways other than seeking to complete the sexual object or to sublimate: firstly, those whose pleasure derives purely from looking at the genitals; secondly, people for whom sexually motivated looking provokes disgust ("as in the case of *voyeurs* or people who look on at excretory functions"); and, finally, individuals, such as exhibitionists, for whom looking is not a preparatory to sex but supplants it.[401]

The aim here is to outline how the representation of the female body becomes a fetish object; or, as Freud puts it: "an unsuitable substitute for the sexual object."[402] The female body "bears a relation to a normal sexual object" but differs in that the "woman" being looked at is either a drawing, a painting, or a photograph: "we are looking at an object which lacks the tactile joys of fur or velvet, which possesses none of the olfactory charms of smelly feet, which lacks volume and rigidity (it can neither penetrate nor be penetrated)."[403] As we have discussed in relation to *Rugged Men* and the assorted covers from the spicy pulp novels, the female body is a fetish object and one located in specific fantasy scenarios, ones in which the masculine form of visuality reinforces its power over the "castrated not-men" by creating improbable scenarios in which they are presented as helpless and, due to their flimsy clothing choices, to be looked at (to be saved, to be rescued). Following Freud, the purpose of such imagery is masturbatory and nothing encapsulates this more than the pin-up girl images contemporaneous with the pulp novel covers.

Brief History of the Pin-up

Freud's work on sexuality and fetish has acute resonances with pin-up imagery of the 1930s onwards. Like the cover imagery of the spicy novels, pin-up art, especially

in the 1950s, presents the female body as fetish object. Unlike spicy novels, though, pin-up imagery alludes to the wider forms of representation of woman in art history. Historically, as Lynda Nead notes, the representation of the female body, quite often nude, "within the forms and frames of high art is a metaphor for the value and significance of art generally." Nead adds, "It symbolizes the transformation of the base matter of nature into the elevated forms of culture and the spirit. The female nude can thus be understood as a means of containing femininity and female sexuality."[404]

Nead does not mention Freud but her point echoes his work on sexuality and sublimation. "Anyone who examines the history of western art," Nead argues, "must be struck by the prevalence of images of the female body." Nead reasons with justification that the female nude hanging in the art gallery and the museum now connotes art with a capital "A": "it is an icon of western culture, a symbol of civilization and accomplishment." But how has the female body achieved this status? Nead goes further and asks, "how does the image of the female body displayed in the gallery relate to other images of the female body produced within mass culture?"[405] This distinction between the framed female nude found on the walls of the gallery and those images of women found in the various products of mass culture, in this case, the pin-up, which we should consider as "framed" (although somewhat differently), is pertinent to our discussion.

Bearing in mind the distinction Nead makes between the female body when represented in high art and mass culture, are we to believe that only high art images of the female nude "contain," that is demarcate, sanction, organize, and produce femininity and female sexuality? Remember the Gibson Girl and *Picturesque America, Not Worrying About her Rights* and *No Time for Politics*? Although not nude, in fact, decorously overdressed, the Gibson Girl is obviously an early form of American mass cultural containment enacted though the feminine. Of course, the Gibson Girl possesses intellectual wherewithal, athletic composure, and physical grace *but* Gibson merely transcribes these visual features onto a woman who must still conform to the image of woman as beautiful, as a mother, an educator to her child; one who partakes in rather than threatens phallocentric visuality: that is, she is aware that she is to be looked at and has learned to "perform" accordingly. The Gibson Girl is a formative, almost genteel depiction of femininity, but what of the representation of women in American popular culture after the Gibson Girl, those on the covers of pulp fiction novels and pin-up calendars and posters?

On the "definition and morphology" of the pin-up, André Bazin writes,

A wartime product created for the benefit of American soldiers swarming to a long exile at the four corners of the world, the pin-up girl soon became an industrial product, subject to well-fixed norms and as stable in quality as peanut butter or chewing gum. Rapidly perfected, like the jeep, among those things specifically stipulated for American military sociology, she is a perfectly harmonized product of given racial, geographic, social and religious influences.[406]

Bazin's observations on the reproducibility and continuity in form and content evident of wartime pin-up imagery are contextualized by Robert Westbrook, who notes that the pin-up helped consolidate the obligation to fight. As Westbrook highlights, in order to create the required sense obligation to fight, "representatives of the state and other American propagandists relied on two different moral arguments, neither of which constituted a claim of political obligation." The first appealed to those perceived universal moral values of "'freedom,' 'equality,' and 'democracy'"; the second, says Westbrook, is more interesting because "they implored Americans as individuals and as families to join the war effort in order to protect the state that protected them … an appeal to go to war to defend *private* interests and discharge *private* obligations."[407] Propaganda posters designed to encourage mass enlistment worked to situate the male population as natural and driven defenders of the nation's women; and as such, they "were articulating the moral obligations of the 'protector' to the 'protected,' a relationship ethically problematic in its own right but nonetheless different from that of a man to a woman viewed simply as sexual property."[408]

Despite concerns from religious groups, the pin-up became a ubiquitous presence on the walls of barracks and, famously, of course, on airplanes and tanks. In part, the American military were happy to encourage pin-ups because "officials linked the aggressiveness of the effective soldier with healthy, heterosexual desire and worried about sustaining such desire and thwarting homosexuality."[409] On saying this, Westbrook is quick to point out that pin-up images had to operate as something other than masturbatory aids if the obligation to protect was to be effectively leveraged, an observation that is difficult to apply to the pin-up images of the 1950s. Evidence suggests GIs on the whole found pin-ups far from "triggers of lust";[410] in fact, censorship meant most images were "relatively demure."[411] A deal struck between Hollywood and the War Department ensured a degree of censure, but Westbrook notes that most pin-up images rarely flirted with the limits of censure. The most popular pin-up was Betty Grable whose pin-up image was at one point requested 20,000 times per week and by the end of the war had been given to around five million servicemen. Westbrook hints that Grable and many of the other most popular pin-up models "were viewed not only as objects of sexual fantasy but also as representative women, standing in for wives and sweethearts on the homefront"; Grable in particular being seen as "a symbol of the kind of woman for whom American men—especially American working-class men—were fighting. She was the sort of girl a man could prize."[412] In other words, Grable became the GI's sister, his sweetheart or wife, or even his mother (see Plate 43).

By the end of World War II, according to Bazin, there was "the disintegration of the ideal pin-up girl": "A wartime product, a weapon of war," he says, "with the coming of peace, the pin-up has lost her *raison d'être*."[413] The pin-up does not disappear postwar, though; but undergoes a transition or, following Bazin, a division: "separated into its two components, eroticism and morality."[414] Bazin argues that:

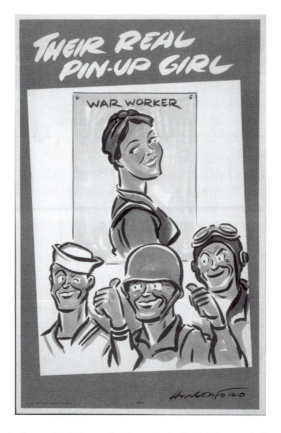

Plate 43 "Their real pin-up girl," Cyrus C. Hungerford, 1944. Library of Congress, Prints & Photographs Division, FSA-OWI Collection [LC-USZC4-5601].

> On the one hand, the pin-up tends to revert to the category of sex imagery and all its hypocritical vestiary complications; on the other to post-mobilization domestic virtues. Furthermore, in the United States there are even contests for "pin-up mothers" and "pin-up babies." And finally, the advertisers of tonic waters, chewing gum and cigarettes are trying to convert the various salvageable surpluses for peacetime purposes.[415]

What Bazin does not mention is that the wartime imagery was arguably an anomaly. If the postwar pin-up art separated into "eroticism and morality," this applied to prewar formative pin-up imagery.

The work of the artist Gil Elvgren (1914–80) offers a particularly enlightening perspective on this issue. According to Charles G. Martignette's short biography, Gil Elvgren was the foremost pin-up artist of the twentieth century, with a career beginning in the 1930s and spanning over four decades.[416] From early in his career, Elvgren worked for Coca-Cola, and his illustrations for the drinks company

portrayed the fundamentals of the American dream; and, during the 1940s and 1950s, he was commissioned by mainstream American magazines, including *McCall's*, *Cosmopolitan*, *Good Housekeeping*, and *Woman's Home Companion* to provide illustrations for magazine stories. Moreover, Elvgren was a creative force behind the pin-up calendars commissioned and produced by the promotional firm, Brown and Bigelow.[417]

Elvgren's work is typical of the pin-up genre (and widely available). In one example, cast against a yellow-orange backdrop, a female figure in a long, vaguely military-style three-quarter length coat with gloves, looks to be unraveling herself from the lead of the dog she is trying to walk; caught up in the lead, her coat is pulled back, exposing a long, sleek stockinged leg with suspender. One could argue that there is a distinct similarity between this figure's elegant stance and attire and the Gibson Girl. The hairstyle might have changed, but here is a well-dressed woman taking the dog for a walk. Then again, there is considerably more flesh on show here and there's a suggestion that—other than the gloves, stockings, and small hat—the coat is all she is wearing. Perhaps this is why the dog has turned tail to gaze up at his owner's semi-nudity. What would Freud say? Well, before he asks about Elvgren's image, he might ask about my description of it: for example, why do I presume the dog is male? I might answer, who else would make the effort to catch a glimpse of a woman's genitalia?

As if to prove my point (all men are dogs?), in another image, Elvgren replaces the dog with a television set. Again, there's a lack of environmental context, we see only a woman in a state of undress, a television set, and nothing else surrounding either—is this a bedroom? How many people in the 1950s had televisions in their bedrooms? But Elvgren sets up a series of gazes between the characters in the frame and then another between us and the characters in the frame. In both cases, the dog and the male face on the television set cannot see what we can see; in both cases, modesty prevents either pet or the guy on screen from catching sight of what they truly desire to see. We, on the other hand, are far more fortunate. As she stands in pink slippers, naked under her gown, the television voyeur (jut like the dog) works to distract the central female character and she "forgets" about us, thus revealing to the unseen (but acknowledged) audience exactly what she wants to conceal from those prying/spying figures in the frame. In both cases, femininity is clearly demarcated by those ideals of Puritanism—modesty, concealment—but also by the tacit acceptance that looking/gazing has an obvious and explicit sexual connotation; it is a gaze to which woman should accede, and to which men should legitimately aspire.

Similarly, pin-up artist George Petty, also producing images for promotional use, made a series of images over several years for RIDGID Tools in the 1950s. In a simple set up, Petty's "girls" appear alongside detailed drawings of RIDGID tools—wrenches, vices, and the like. Can we argue that they also partake in the containment of the female and feminine Nead describes and the sublimation of the sexual urge into art as Freud suggests? Petty's RIDGID tools images are capable of

sustaining a multitude of readings, most of which I cannot include here.[418] On the one hand, each of Petty's images was commissioned to advertise "RIDGID Tools" and did so by including an ingenious typographical logo, an actual RIDGID tool—a heavy duty pipe wrench—and through having a function: a calendar. The calendar hangs on the wall of a workshop, garage, locker room, or other gendered (masculine) space one presumes, and is hung and "framed" not unlike an artwork in a gallery. On the other hand, the "gallery" space of the locker room is, of course, of a different order to the museum or gallery and is, to a large degree, a private rather than public space. And though these pages have a function—as a calendar—this function seems secondary to the imagery: a voluptuous young woman, wearing little, with her impossibly long legs wrapped around a large, hard, red tool angled at approximately 45 degrees. In other words, a woman draped over an erect penis. In each case, the facial expressions and bodily contortions evoke pleasure and submission to the tool that is positioned between their legs; there is also the suggestion that a part of the wrench is about to penetrate each figure. The size and scale of the wrench makes it impossible to use for a practical purpose, it is an exaggeration; it is an outlandishly large tool. However, these young women do not appear interested in the practical use of the pipe wrench; these women are not professional tradespersons.

So, these women are not professionals recommending RIDGID Tools to a market of interested professionals; they are there to be looked at, their presence is one of allusion and sexual suggestion; here woman becomes decoration, adornment as well as fantasy and site of sexual excitement. Their femininity, their lack of a penis, is also matched by their lack of practical skills and inability to see tools as functioning objects, this in turn reinforces the masculine association with those skills and the more practical aspects of wrenches, vices, screwdrivers, etc. In an instant, these images perpetuate the active/passive undercurrent required of the "male gaze" and wider masculine visuality and culture.

Postwar Sexuality, the Kinsey Report, and the Pin-up

As noted earlier, these pin-ups are not real women; they cannot be "experienced" as part of a sexual union; they are fetish objects, objects to initiate masturbation. This impulse, according to Nead, is hardly a new development; a number of myths have "frequently recirculated, concerning the stimulating effects on male viewers of nude female statues and paintings."[419] Pliny, in *Natural History*, reports a young man who became so infatuated with the statue of Aphrodite of Cnidos that "he hid himself one night in the shrine and masturbated on the statue, leaving a stain on its thigh."[420] Myths and more contemporary anecdotes on this subject would not have caused any blushes in Alfred Kinsey, one of the authors of the Kinsey Report (published in 1948 as *Sexual Behavior in the Human Male*, and followed in 1953 by *Sexual Behavior in the Human Female*).[421]

Kinsey and his team surveyed a variety of men (and later, women) about their sexual habits. (I wonder if it is going too far to argue that, by publishing the volume on male sexual behavior first, Kinsey, like Freud, reinforces the primacy of male desire over female?) Kinsey's report helps contextualize the eroticized pin-up work of George Petty and Gil Elvgren, because this type of mass marketing of sex and sexuality coincides with a wider cultural, social, and scientific interest in sexuality and sexual behavior. Reading the contents page alone of *Sexual Behavior in the Human Male*—with explicit references to masturbation, same-sex intercourse, extra-marital sexual activity, animal intercourse, as well as frequency and varieties of sexual encounters—it is easy to imagine the negative reception such a shocking and controversial report received. The Kinsey Report was, and continues to be, controversial because it contradicted commonly held views regarding the sexual behavior of American men and women. [422] Kinsey's data did not support the wide-spread, conservative ideals presumed to structure American culture and society in the first half of the twentieth century; in fact, Kinsey's work showed a schism between the idea of proper and "normal" or regular sexual attitudes and the actuality of sexual activity among American men and women. Kinsey's subtitle frames it thus: "overt activities versus attitudes." Kinsey says,

> To a large degree the present study has been confined to securing a record of the individual's overt sexual experience. This has been because we feel that there is no better evidence of one's attitudes on sex. Specific questions have been asked about each subject's attitudes toward his parents, toward masturbation, pre-marital intercourse, sexual relations with prostitutes, and homosexual experience; but we do not have much confidence in verbalizations of attitudes which each subject thinks are his own, when they are, in actuality, little more than the reflections of the attitudes which prevail in the particular culture in which he was raised. *Often the expressed attitudes are in striking contradiction to the actual behavior*, and then they are significant because they indicate the existence of psychic conflict and they throw light on the extent to which community attitudes may influence the individual. [423] [emphasis added]

"Community attitudes" toward sex could be defined as a shared act between married men and women, with the idea of pleasure, particularly for women, secondary to procreation. But the Kinsey Report disassembled this puritanical viewpoint with a series of startling statistics, including this one: that 37 percent of the male population had achieved orgasm through homosexual sexual contact (if one considers the data was collected after a large number of men had been away at war, is this such a surprising statistic?).

Another shock for mid-century America was Kinsey's revelation that sex happened most when people were by themselves. The comic, writer, and filmmaker, Woody Allen, might have joked many years later, "Don't knock masturbation, it's sex with someone I love," but late 1940s' America appears less than in the collective mood

for laughing. Reactions to the Kinsey Report reveal unease in America surrounding issues of sex and sexuality, especially sex and sexuality that failed to comply and conform to the tight strictures of what is best described as a puritanical conception of the sexual relationship, sex act, and its "purposes."[424] I would argue this makes the RIDGID Tools calendars of George Petty and the work of other pin-up artists all the more intriguing because they at once seem squarely at odds with the prevailing puritanical attitudes towards sex and sexuality while also helping to define masculine and feminine sexuality, as well as (apparently) offering young men a healthy focus for any unrequited desires. When one considers that the majority of pin-up imagery was not for "private contemplation" but appeared widely as the "visual interest" in all sorts of promotional literature, sex and sexuality, like the color line, appears yet another troubling fault line in American culture.

Art Frahm and *No Time to Lose*

To conclude, and return to where we began, Art Frahm's *No Time to Lose*. Frahm's work, like Elvgren and Petty above, was often commissioned for use in promotional material for all kinds of products. In fact, I have seen examples of Frahm's work on salesman's sample calendars topped with one of his saucy pin-up images, and written underneath: "Your Advertisement in three or four lines will be printed in this space." Even to the unsophisticated eye, what these sample advertising calendars suggest is that Frahm's pin-up girl in, for example, *No Time to Lose* had next to nothing in common with the advertisers' products. But what kinds of images are we talking about? Frahm is intriguing because of a series of thematic images produced throughout the 1950s, each depicting young women in everyday situations—paying her fare on a bus, crossing the street, putting change in a parking meter—engaged in a variety of mundane activities—such as carrying groceries or gifts. Nothing but an ordinary day for this ordinary girl until, as you can see, not only does her underwear unexpectedly fall down around her ankles, but her embarrassment is doubled as an expected but fortuitous sharp gust of wind catches the hem of her skirt, revealing her legs to greater scrutiny. The fact that events such as this are thankfully rare—I wonder what exactly are the odds of this happening: the elastic breaking *and* the breeze—should not distract us from thinking carefully about how this image of a young woman is composed. For instance, who she is looking at? And what about her facial expression: is it shock, horror, surprise, all of the above?

James Lileks's "Art Frahm, a study of the effects of celery on loose elastic" is a suitably ironic and tongue-in-cheek account of Frahm's "ladies in distress"; all of which might encourage us to see Frahm's intent as not exactly wholesome but still a long way off offensive or obscene. This would be a miscalculation on our part though. According to Lileks, Frahm did not produce these images as a struggling illustrator "chafing against the dictates of some gnomish pervert who wanted a

year's worth of falling-panty pictures"; quite the opposite in fact, these images were produced by personal choice. The falling panty pictures are "a theme to which he returned again and again—and you have to wonder why," Lileks ponders.[425] There is something "creepy" for Lileks about Frahm's insistent and willing (rather than economically) dictated return to this form of imagery and image making. I would ask you to ignore "creepy" as a theoretical position, but Lileks is correct in his observation that the viewer is encouraged to eroticize rather than empathize with the figure within the frame. The deliberate appeal to a viewer and a certain type of response alerts us to a simple fact: that the presumed viewer is male. As such, Frahm's picture epitomizes Mulvey's male gaze.

Other than the activation of the male gaze, Frahm's works, like those of the spicy novels, and Petty and Elvgren, encourage an analysis using Freud. *No Time to Lose* cannot be described as pornographic—on first glance it even appears kitsch rather than erotic—but there is an undeniable erotic element; a flirtation with the sexual fetish and fetishism. More than this, Lileks's comedic subtitle, "a study of the effects of celery on loose elastic" neatly draws our attention to another key element: celery. Celery appears almost, but not quite, as frequently as the descending underwear of all Frahm's female protagonists. In many respects, celery is the equivalent of the wrenches in Petty's calendar images, a phallic substitute; but I want to concentrate on the intersection and manipulation of gazes I mentioned earlier in relation to Elvgren. *No Time to Lose* is quite exceptional because the gaze is shared between viewer and subject in the work, a little like Elvgren's dog-walker, especially in relation to the lack of background (there is nothing beyond the roof-lines of the cars), which only encourages us to stare.

The title, *No Time to Lose*, references the parking-meter whose red-flag exclaims "expires" and the woman in the spotted dress who has arrived back at her car late, so with "no time to lose" she attempts to put change in the meter. Just as she thinks things couldn't get worse, a traffic cop is there already, pen and ticket-book in hand, ready to hand out a fine. But things go from bad to worse as the elastic in her underwear snaps, they fall to the ground and then the wind blows, getting under her dress and blowing it upwards? What is she to do? Drop the coin and her bag of groceries? Pull up her pants or push down her billowing skirt? There is a joke in here, too; her knicker elastic "expires" as the meter does the same. But the joke allows Frahm to draw our eye from the meter to the woman's legs and then down those legs to her pink underwear, now warming her ankles. The traffic cop looks perplexed—he is scratching his head, probably puzzling over the woman's inability to return to her car in time, wondering how it is she cannot put a coin into a slot without her losing her shopping *or* her pants falling down. The shock on the woman's face as she stares into the "street" in which we, the viewers, are passers-by—stares at us—suggests she is in distress like the women waiting for "rugged men" to rescue them. Or is she?

Can we read the woman's reaction as one of sexual excitement, for her as well as the policeman (and us, the viewer)? As with Elvgren and Petty, this image presents a particular form of visuality in which masculinity is given permission to gaze—if a man of the law can stand and stare, so can we. Is there a higher power than the law to reinforce and validate our gaze? And the female willingly presents herself to be gazed upon; in fact, she is dressed to be looked at. Her hair carefully styled, her nails manicured and painted, her outfit carefully chosen; even her pants match her dress and shoes. What else do you notice? Are there aspects to this picture that might resist the idea that Frahm's picture is a prime example of the male gaze at work?

Conclusion

Laura Mulvey's essay is not without problems of course; a lot has happened in the world of visual culture studies since the early 1970s. Undoubtedly, Mulvey's identification of a particular visuality at work in Western culture underscored a seismic shift in the analysis of all forms of visual culture, not just film. In a later essay[426], Mulvey re-evaluates the impact of psychoanalytical criticism (in relation to film), pointing out that:

> Psychoanalytic film theory has argued that mass culture can be interpreted sympto-
> matically, and that it functions as a massive screen on which collective fantasy, anxiety,
> fear, and their effects can be projected. In this sense, it speaks to the blind spots of a
> culture and finds forms that make manifest socially traumatic material through distortion,
> defense, and disguise.[427]

In this chapter, the context for the introduction of basic psychoanalytic theories, in the main derived from Freud via Mulvey, has examined the ways in which aspects of patriarchal or phallocentric society can be analyzed. The representation of women in early forms of American mass culture reveals, as Lynda Nead highlighted, the very real effort to contain and control the feminine, to mark out the boundaries of femininity and then to police them. As much as the Gibson Girl or even the more wholesome pin-up images of a wartime Betty Grable define a new woman, strong, intelligent, and ambitious, all these qualities remain securely rooted in older, more traditional and patriarchal notions of the feminine: beauty, passivity, obedience, and, of course, motherhood.

Freudian psychoanalysis, in particular, enables us to consider the significance of certain objects (Frahm's celery; Petty's wrenches), events (the falling underwear, the instruction of children), places (street scenes, public transport), and, crucially, gazes (of figures within the frame and of the viewer and the figures in the frame). Consequently, rather than treating each image solely as an atomized object, psychoanalysis allows us to consider all examples in this chapter as Mulvey imagines,

"a massive screen on which collective fantasy, anxiety, fear, and their effects [are] be projected." The collective fantasies, fears, anxieties, and their effects run riot in the latent content of the images; that is, a picture of a woman on a calendar, smiling broadly, her limbs wrapped around the image of a wrench or of a flame-haired woman, in a shredded red dress which somehow manages to conceal her breasts and genitalia, shackled to a coffin clearly in mortal peril, reveal to us the unconscious desires and attitudes of American society and culture. To make this breakthrough, we have to find a way to get beyond this manifest or obvious content/subject-matter. As Mulvey notes, psychoanalytical theory is a potent way of doing so.

In the end, the ways in which women have been visualized in American culture tells us an awful lot about the core value, ideals, and attitudes of American culture. This is because psychoanalysis, when used a critical tool, examines such (moving or still) pictures as symptomatic of prevalent attitudes in American culture. The important conclusion to draw here is that forms of representation (illustrations, artworks, cartoons, films, etc.) actually *produce* as much as reflect a particular kind of subject as well as a particular kind of viewer. As each example has shown, a space is consistently opened out that conditions and allows men to stare at women, while simultaneously "instructing" women on how best to position themselves to be stared at.

−7−

The Trouble with Kitsch: Highs and Lows in American Art and Visual Culture

This final chapter brings us full-circle from Chapter 1 because here we find the return of manifest destiny and the discourse of American exceptionalism. As the end of twentieth century approached, so museums especially seized the opportunity to reconsider the historical achievements of the American nation. With this in mind, this chapter seizes an opportunity to reconsider a two-part millennial exhibition staged by the Whitney Museum of Art, New York: *The American Century: Art and Culture, 1900–2000*. One cannot fail to register the confidence bound up in the title, one that is more declarative statement than anything else. Before being swept away on a tide of national enthusiasm for the achievement in art of American artists, a point unlikely to be completely disproved, I think it prudent to consider such an exhibition in light of say Gast's *American Progress* from Chapter 1. A simple and crude image, as we saw, but with a simplicity and crudity that almost distracts from what it actually shows: the advance of the American ideal, the rightful pursuit of manifest destiny at any cost. Without overselling the connection, the point is: what does it mean when a society brings together all that it considers great, dynamic, experimental, *American*, about its culture and then names the century after *itself*? From this we move to other issues, relating to modernism and modern art, and the vision of art critic Clement Greenberg, a vision of art without the obvious connections to the brute forces of the everyday we find in Gast's picture. What is interesting about *The American Century* exhibition is that its definition of modernism is a broader church than Greenberg's. But why? And what does this say about the history of American art in the twentieth century? More importantly, the differences in these visions of modernism are built around very different attitudes to the value of low culture in relation to high culture. On the one hand, Greenberg, like Theodor Adorno and Max Horkheimer, is highly critical of mass-produced culture, calling it kitsch; and yet most other forms and schools of American art other than say abstract expressionism have consistently engaged with the products of low culture, like Jasper Johns's *Flag* (Plate 1) in the Introduction. There's a fault line here, and we will explore it by looking at Greenberg's notion of modernism and kitsch, the concept of the culture industry proposed by Adorno and Horkheimer, in relation to Stuart Davis's "Tobacco" paintings and the work of Richard Prince.

In April 1999, the Whitney Museum of Modern Art in Manhattan, New York opened Part 1 of a two-part exhibition entitled, *The American Century: Art and Culture, 1900–2000.*[428] Described by David Anfam as a "gargantuan extravaganza,"[429] the exhibition brought together over 1,200 objects including paintings, drawings, sculptures, prints, and photographs, "supplemented by related materials in architecture, music, dance, literature, film, and the decorative arts."[430] The scale and scope of the exhibition, with its obvious "millennial blockbuster" strategy, disappointed many critics because, as Anfam's review concedes, the curators set themselves an impossible task: to replay, across all floors of the Whitney Museum the dynamic shift in artistic production in America from its tentative beginnings to international dominance. The accompanying catalogues in which Barbara Haskell and Lisa Phillips lay out the intersecting histories of twentieth-century American art and culture underscore not only the sheer eclecticism of the period but, often indirectly, many of the tensions and issues inherent in the study of American modern art. Of these the most telling is the tempestuous relationship between high and low culture, here played out through the artistic production of twentieth-century American art. The second pressing issue relates to the insistence in the title of the exhibition that the twentieth century was the "American" century, a title which cannot help but be read as relying upon the discourse of exceptionalism.

Perhaps the most obvious place to start is with the title of the exhibition itself. As a knowing reference to Henry Luce's famous use of the phrase in *Life* magazine in 1941, "the American Century" reinforces the view of progress in twentieth-century American art as both extension and reflection of the progressive Americanization of an entire century. But on what grounds can it be said that the twentieth century was the American century? And who says so and why? Moreover, why make such a fuss about the art of America and why privilege a certain kind of cultural production— art? Staying with this theme, what kind of art, artworks, and artists are privileged over others? In fact, why is painting or sculpture often considered of greater cultural significance than an image on the cover of a magazine or the poster advertising the art exhibition itself, for example? In essence, the answer to these questions in relation to America appears to be "modernism."

Modernism means many things, as we shall see; but for the sake of clarity here, modernism defines a certain attitude towards art and culture. In the main modernism champions of "high" art and culture over "low" forms. This simple binary of high and low, however, is a good deal more complicated and nuanced, but we will get to this later. I would add, too, that criticism has for some time presented an equally rigid binary of inferior and superior forms of American art. Before 1945 early American modern art is considered *inferior* to the later post 1945 American modern art associated with the artists of abstract expressionism and the art critic, Clement Greenberg. To a large degree, Greenberg's work, in essays like "Avant-Garde and Kitsch" helped ground this bisection in the story of American art, with the subsequent creation of the "Greenberg Effect."[431] More importantly for this chapter, this brand of

modernism, with its emphasis on the purity of high art, has characterized—perhaps pathologized is a better description—low art as a contagion or impurity to be kept as far away from high, superior art as possible. The problem here, though, is that at no time has American art, even abstract expressionism, ever been hermetically sealed off from culture, especially low culture; the (for some) uncomfortable truth is that American art of the twentieth century engaged in continuing interaction with so-called low culture and was not necessarily resistant about embracing it.

With this in mind, we will look at the emergence of modernism in America and consider its resistance to low culture or, with Greenberg in mind, kitsch. In this sense, Greenberg is, as Caroline A. Jones describes him, a "customs inspector" type figure, securing the boundaries of avant-garde art against low-cultural invaders.[432] Against this anti-kitsch backdrop, we shall consider why so many distinguished and famous American artists across the twentieth century either worked within or alongside institutions associated with the production of low culture. For example, in the first part of the twentieth century, artists like Charles Sheeler, Georgia O'Keeffe, and Edward Steichen, all respected artists, at some point worked to produce commercial artwork; that is, it was used by the "culture industry" to advertise consumer goods. It is well known that Sheeler and Steichen worked as photographers for, among others, Condé Nast, and Sheeler produced a seminal series of images of the River Rouge Plant for the Ford Motor Company in 1927. O'Keeffe's advertising work is rather less well-known; commissioned by the A. J. Ayer agency, the same advertising agency who secured Sheeler for Ford, O'Keeffe was asked to visit Hawaii and produce a series of paintings of Hawaiian pineapples for Dole. As Michele Bogart says, O'Keeffe was "notoriously unwilling to take on commercial assignments" but on this occasion succumbed, "Attracted by the money and the all-expenses paid trip to Hawaii …"[433]

Post World War II, Andy Warhol is hard to avoid in this context; he worked in magazine illustration and advertising, but we should also mention another pop artist, James Rosenquist, who, considering the scale and content of his artistic production, worked as a billboard painter. But there is more to this than just individuals working commercially before becoming artists, and it is a theme we will return to towards the end of this chapter: namely, the appropriation of commercial imagery in the work of modern artists across the twentieth century. Most of us are familiar with the Brillo boxes, Campbell's soup cans, and Coca-Cola bottles of Warhol's work and as a consequence we might think that Warhol was the first American artist to appropriate everyday products in their work. Not so. In the 1920s, Stuart Davis and Gerald Murphy produced oil paintings of consumer products, Odol tooth powder and a razor, fountain pen and safety matches respectively. The consumable products of Davis's *Odol* (1924) (Plate 44) and Murphy's *Razor* (1924) are positioned centrally and do not appear as contemporary references in a wider genre or realistic scene.[434] They are the focus of the picture. Just like Warhol's soup cans.

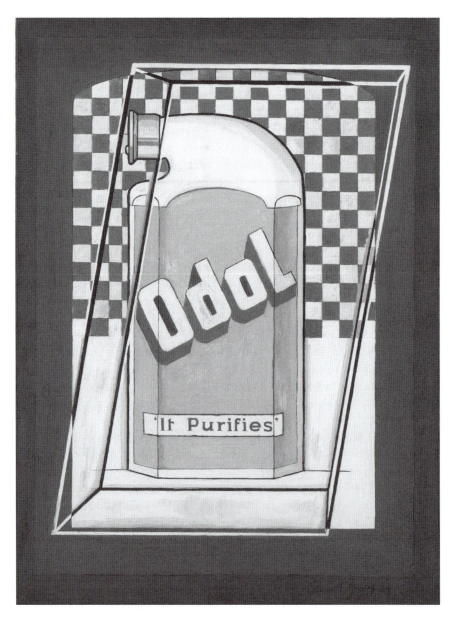

Plate 44 Stuart Davis (1892–1964), *Odol*, 1924. New York, Museum of Modern Art (MoMA). Oil on canvasboard, 24 × 18″ (60.9 × 45.6 cm). Mary Sisler Bequest (by exchange) and purchase. 645.1997. © 2008. Digital image, The Museum of Modern Art, New York/Scala, Florence.

Moreover, search through the history of early modern American art in the first decades of twentieth century and you will find many depictions of what might be called the lower end of the culture spectrum. Alongside the interest in tooth powder, razors, and the growing range of consumer products, artists found the garish pleasures of amusement fairs and music halls an attractive subject; for example, Reginald Marsh's images of the crowds and architecture at Coney Island. What "modernism"—Greenberg's vision for modernism or Greenbergian modernism, as it became known—put under erasure during the mid-century was the open engagement by artists with what for many defines—for good or for bad—American culture, and that is mass or popular culture. The advent of a cultural shift toward what is now called "postmodernism" cleared space in the first instance for pop artists like Warhol, Roy Lichtenstein, and Rosenquist and then later for the likes of Richard Prince and Barbara Kruger.[435] In each case, these artists engaged in a significant way with the visual imagery of mass culture and its products, in turn revealing the clash of high and low or, in other words, of culture and commerce.

As noted previously, naming the end of the century exhibition of American art at the Whitney, *The American Century: Art and Culture, 1900–2000*, was quite deliberate. Although it might appear so, it is not really a literal and descriptive title. On the contrary, the aim is to provoke, just like Henry Luce's comments in *Life*; and it is worth pausing to consider two things: (i) how such provocation elicits wider feelings of pride and/or prejudice within an audience; and (ii) the implicit connections that exist between two seemingly individual arguments, each constructed and then presented in turn by Luce in the 1940s and the exhibition's curators in the late 1990s. As critics of visual culture, we must question assertions of this nature—that the twentieth century was the American century—and to do so we have to examine the evidence employed to convince us.

Publishing magnate Luce's *Life* editorial called for a less isolationist America, arguing that America should face up to its responsibilities and "accept wholeheartedly our duty and our opportunity as the most powerful and vital nation in the world and in consequence to exert upon the world the full impact of our influence, for such purposes as we see fit and by such means as we see fit... ."[436] The legitimacy of Luce's argument relies upon two intersecting ideals: the shared belief in America as one nation, "speaking with one voice," a coherent if not precisely homogeneous notion of national identity; which in turn relies on yet another legitimizing story of national identity, manifest destiny.[437] As the basis for a highly influential and contentious *Weltanschauung* or worldview, it is exactly this sense of a coherent and shared American national identity which, as we have already seen, transnational American studies and many theories associated with visual culture studies seek to challenge. In effect, then, *The American Century: Art and Culture, 1900–2000*, despite its eclectic curatorial policy, appears merely to reinscribe a particularly inflexible and homogenizing narrative of national identity, one which favors Luce's mid twentieth-century rhetoric; a rhetoric infused with American exceptionalism.[438]

Following this idea, the exhibition can be seen as an active promotion of American art's dominance; equally, you could read the exhibition as a celebration of the diversity, originality, and growing quality of American art throughout the twentieth century. But lurking behind each of these apparently opposing propositions is a tacit acceptance that twentieth-century culture has by and large been shaped by an emergent American culture. As such, American artists and the American-ness of their art left an identifiable and indelible impression on *all* art.[439] It appears as though American art of the twentieth century should be considered as the perfect expression of Luce's rallying call, accepting wholeheartedly its duty and opportunity to produce the most powerful and vital art in the world and in consequence to exert upon the world the full impact of its influence, for such purposes and by such means as it sees fit. Here is the model of American art and American art criticism as a form of cultural imperialism.

Paraphrasing aside, I admit the above offers a somewhat negative perspective on the exhibition and the wider implications of the phrasing "the American century." I think what must be drawn more clearly into view is a reconsideration of the clash of commerce and culture in twentieth-century American art. Due to the Greenberg effect, our understanding of American modernism more broadly sides with Greenberg's vision of purity of form, the work of the work, etc.; the effect (a different kind of Greenberg effect) has been to obscure a more diverse lineage of modern American art in the twentieth century. Whether as a rejection of commercial interests and the culture industry as kitsch or as the deliberate absorption and appropriation of low cultural forms (the products of the culture industry) into the sphere of high art production, this is the real area of contestation in twentieth-century American art.[440]

Reference to kitsch and the culture industry directs us toward two figures who conceptualized what Nancy Jachec labels, "the modernist paradigm": "Frankfurt School theoretician Theodor Adorno and American intellectual and art critic, Clement Greenberg."[441] The modernist paradigm, according to Jachec, encompasses the period between the 1940s and 1960s where modernist art was considered "experimental, autonomous and innovative, and conducted by the subjective yet rational individual."[442] It is this particular formulation of modernism that remains the most potent and contentious interpretation of the modernist paradigm. As such, we cannot overlook its significance, especially when this particular version of modernism has been referred to as "*the* cultural movement of the twentieth century" in America.[443] By using words like "version" or "interpretation" it is clear that "modernism" has no singular definition; in fact, it is not even as simple as competing versions or interpretations, of which there are many, but also overlapping and interweaving interpretations, too. For the sake of clarity (and sanity), what follows is Charles Harrison's overview of three types of modernism.

Modernism

Harrison notes that "[t]here are few terms upon which the weight of implication, of innuendo, and of aspiration bears down so heavily as it does upon modernism."[444] For the sake of clarity, Harrison identifies three differing usages of "modernism" and it is useful to outline them here:

1. modernism as relating to the period in the history of Western culture from the mid nineteenth until at least the mid twentieth century known as "modernity";
2. modernism as an artistic tendency that makes a distinction between high or avant-garde art, which is self-critical and original, and popular and mass culture, which is kitsch; that is, "unself-critical and unoriginal";[445]
3. modernism as a critical tradition in which the "modernist" critic is able to make the distinction between high (or avant-garde) art and popular and mass culture (kitsch).

The first definition of modernism relates specifically to the processes of ind-ustrialization and urbanization that shaped Western culture from the mid nineteenth until at least the mid twentieth century. As Harrison notes, art during this period sought to modernize itself; hence "modernism may be vividly exemplified through stylistic and technical properties of works of art," which in turn engage with the "preoccupations and spectacles specific to the age." [446] The second and third senses of modernism are more specialized. Starting with the second definition: modernism is an evaluative concept, one that seeks to identify "truly modern art" from not only "classical, academic, and conservative types of art but also, crucially, from the forms of popular and mass culture."[447] This view has its origins in the work of the most influential critic of modernism, Clement Greenberg (Greenbergian modernism, as mentioned earlier). For Greenberg, "what establishes the modernism of a discipline or a medium is not that it reveals an engagement with the representative concerns of the age, but rather its development is governed by *self*-critical procedures addressed to the medium itself."[448] In short, the modernist work of art is more concerned with the aesthetic advancement of its own medium rather than the preoccupations and spectacles of its time; so, the modernism of Jackson Pollock's drip paintings lies not in their engagement with the concerns of post World War II American modernity but in their original and self-critical engagement with the history of painting and other advanced forms of art, like cubism, whereby painting draws attention to itself as painting rather than trying to "hide" its status as a made object. Abstract expressionism is, therefore, for Greenberg, the highest "critical achievement of an aesthetic standard *within* a given medium and *in face of* (though emphatically not in disregard of) the pervasive condition of modernity."[449] Crucially, neither the non-representational quality of abstract expressionism nor an emphasis on the flatness of the painterly surface are the rejection of previous aesthetic developments in painting

but a self-aware and original continuation of them. This is the work of the avant-garde as opposed to the work of kitsch. As Harrison notes, "what Greenberg called kitsch may be modern" but it is not modernist.[450]

Finally, Harrison's third description of modernism highlights a shared frame of reference with the second definition *but* rather than an equivocation between "modernism" and the artistic tendency it designates (modernism as a property common to certain avant-garde artworks), the critical tradition takes modernism to mean the *procedures* by which one is able single out the avant-garde or most advanced artwork (to distinguish between the two meanings, Harrison capitalizes the critical tradition of "Modernism." (N.B. I adopt Harrison's distinction below). What Harrison emphasizes here is that Greenberg would not consider how own critical writing on art as Modernism/modernism, because this was the work of the artwork as explained above. Therefore, naming the work of the critic who identifies the most modern work of art, in this case, Greenberg, is retrospective; Jachec's essay on Adorno and Greenberg with her assertion about their role in creating the modernist paradigm is a good example of this.

Greenberg/Adorno and Horkheimer: the Avant-Garde and the Autonomous Work of Art; Kitsch and the Culture Industry

Whatever your point of view, Greenberg remains as much a presence in the critical history of American modernism as the artist he championed and the art movement he wrote about with such passion: Jackson Pollock and abstract expressionism. Appearing in a 1939 edition of *Partisan Review*, Greenberg's first important essay, "Avant-Garde and Kitsch," was all for the avant-garde and all for the dispatch of kitsch. Getting right to the point, Greenberg says, "Kitsch is vicarious experience and faked experience … Kitsch is the epitome of all that it spurious in the life of our times. Kitsch pretends to demand nothing of its customers except their money—not even their time."[451] Kitsch is bad. Greenberg's point is explicit, and Trotskyist in emphasis, in privileging kitsch's opposite: the avant-garde. In contradistinction to the experience of kitsch (vicarious and faked) the avant-garde offers a truly personal and "authentic" experience; furthermore, unlike kitsch—the epitome of all that is spurious, that is, not what it claims to be—the avant-garde represents all that is innovative, forward-thinking and advanced, in culture. What Greenberg dislikes most about kitsch is that it is a lie; the kitsch object sells itself as possessing and offering the same qualities as an avant-garde object but in truth its products, and the experience of them, amount to nothing more than an empty promise. As Jones notes, "kitsch draws, parasitically, from the debased trappings of traditional 'high' art. Kitsch takes the place of a folk culture destroyed by industrialism, imitating the *effects* of art, where the avant-garde interrogates its *processes*."[452] Kitsch, then, is a form of deception.

Deception is also the watchword of Frankfurt School critical Theoreticians, Theodor Adorno (1903–69) and Max Horkheimer (1895–1973), who describe the function of the "culture industry," introduced in their groundbreaking work, *Dialectic of Enlightenment*, as deception. In many respects, the Greenbergian notion of "kitsch" shares many similarities with Adorno and Horkheimer's theorizing of the culture industry, hence it is worthwhile to consider in greater detail the wider cultural criticisms of the latter. Written while the two men were in exile in the U.S.A., fleeing Nazi persecution in Germany, and first published in 1947, *Dialectic of Enlightenment* contains the pivotal essay, "The Culture Industry: Enlightenment as Mass Deception." In short, the culture industry is what it says it is: the industrial production of culture; this is important because Adorno and Horkheimer suggest that the production of culture—music, art, dance, literature, etc.—is "created" by means more akin to the production line than the spontaneity of the artist. The idea of culture as the subjective expression of creativity has been inverted by the rationalizing principles of capitalism that instead make culture based upon consumer surveys. Therefore, the central tenet of "The Culture Industry" essay, for Adorno and Horkheimer is that the stamp of capitalism can be found on absolutely everything; that is, everything has been *commodified*. Crucially, even those aspects of culture which historically remained outside the purview of the rationalizing impulses of industry, for example, music, art, and theater, have seen their autonomy as well as spontaneity curtailed. Adorno and Horkheimer complain that, "Movies and radio no longer need to pretend to be art. The truth that they are just business is made into an ideology in order to justify the rubbish they deliberately produce."[453] The fact that those making movies refer to their work as belonging to "show business" is more than enough for Adorno and Horkheimer to condemn them.[454]

What Adorno and Horkheimer attempt to describe is the control of the products of culture through the use of technology; their work is to a large degree dealing with monopoly capitalism, so it comes as no surprise when they draw together mass production with mass culture (the industrial processes of Fordism and the scientific management processes of labor known as Taylorism). Accordingly, "the culture industry [is] no more than the achievement of standardisation and mass production"; therefore, "Marked differentiations such as those of A and B films, or of stories in magazines in different price ranges, depend not so much on subject matter as on classifying, organising and labelling consumers."[455] Here the notion of individual agency is stripped away and replaced by the model of a consumer who is predictable and thus remains in the thrall of the standardized products of the culture industry. Adorno and Horkheimer refer to this process as the "circle of manipulation and retroactive need," with the net result being that "the unity of the system grows ever stronger."[456] Following this logic, the culture industry is inescapable, and we are all trapped in the "rhythm of the iron system," one which has created its own "enthusiastic obedience."[457]

Just as the production line relentlessly pushes out one product after the next, Adorno and Horkheimer's repetitive polemical tone echoes the relentless rhythm of the machine: "The culture industry perpetually cheats its consumers of what it perpetually promises"; "The culture industry does not sublimate; it represses"; "The less the culture industry has to promise, the less it can offer a meaningful explanation of life, and the emptier is the ideology it disseminates"; "The culture industry tends to make itself the embodiment of authoritative pronouncements, and thus the irrefutable prophet of the prevailing order."[458] With these statements circling in our minds, it is not difficult to see why "The Culture Industry" essay has been widely criticized for its lack of specificity; Adorno and Horkheimer never draw on lengthy, detailed analyses of the products or the system they mercilessly criticize. Another contentious point is the way in which the culture industry is depicted as a brainwashing outfit; rather than offering freedom of choice to consumers, the culture industry offers only the ever-same repackaged as the new. Of course, this leads to another question altogether: if all the consumers in America are dupes to the advertising wiles of shifty executives in sharp suits, why are Adorno and Horkheimer immune from their manipulative charms? In fact, one could take the final quote above and offer the following: "Adorno and Horkheimer tend to make themselves the embodiment of authoritative pronouncements, and thus the irrefutable prophets against the prevailing order."

Why, you might be thinking, are we even considering the work of Adorno and Horkheimer when, with the best will in the world, they seem like elitist old curmudgeons, whose work relates to a defunct form of capitalism, who themselves appear unable to let themselves go and enjoy the vicarious thrills of American mass culture? Well, because this view, while remaining the dominant charge against Adorno and Horkheimer, is wide of the mark and ignorant of the true nature of the exiles' relationship with postwar American culture. As David Jenemann has recently written, Adorno, in particular, was deeply involved with and thus concerned about the evolution of mass culture in American society.[459] *Dialectic of Enlightenment* is, therefore, not written with disdain for America or American culture at all. The form of the culture industry essay is actually a mirroring of the culture industry's own form of address: repetition of the same but with a twist so as to appear new. Too little attention has been paid in the past to the fact that Adorno and Horkheimer's critique of the culture industry was written while both men were living and working in California; they were therefore very much aware of being caught up within the machinations of the culture industry. As the authors concede, "The triumph of advertising in the culture industry is that consumers feel compelled to buy and use its products even though they see right through them."[460]

If one aspect of culture is able to evade the confines of culture industry conformism, it is specific forms of art. Like Greenberg, Adorno in particular was convinced that autonomous art, the art of the avant-garde, was capable of remaining "outside" and therefore critical of the society out of which it was created. As Adorno notes in "The

Culture Industry Reconsidered," artworks like other goods have always been bought and sold, have always been subject to a market value, and artists like everybody else must take their place in economic exchanges of labor for wages.[461] However, "authentic" art manages to exist within this economic relationship, producing works close to those of a true culture, one minus the culture industry. What Adorno fears, and this is important for this chapter, is the instrumental collapse of the high and low spheres because such a collapse would mean that cultural entities become "commodities through and through."[462] Whereas in art, "technique is concerned with the internal organisation of the object itself, with its inner logic," the products of the culture industry are indifferent to this definition of artistic technique for good reason, namely: "The culture industry finds ideological support precisely insofar as it carefully shields itself from the full potential of techniques contained in its products." Adorno's argument here is that artworks, like any product of the culture industry, are themselves made objects, created at a certain time, in a certain place and in a certain society; and as such, the made object is imbued with a uniqueness relating to this context (the object is a product of its own society). The artwork embraces this uniqueness or aura, while the products of the culture industry do not. The reason for this is that art welcomes knowledge of its own contradictory moment and construction, whereas the culture industry with its emphasis on coherence and standardization cannot acknowledge this fact; to do so would dissolve the power of the culture industry. By the same token, Adorno's fear is that the opposite will occur: that art will deny its own uniqueness, its capacity to critique society, and acquiesce to the logic of the culture industry.[463]

To end this reading of Adorno (and Horkheimer), it is important firstly to reiterate a point to which Adorno is himself blind (in a manner similar to his criticism of the culture industry); by emphasizing the crisis facing the artwork, Adorno omits to consider that, as made objects themselves, the products of the culture industry might well be capable of critique; in other words, the unique qualities so crucial to the autonomous artwork might well exist in the objects of the culture industry (this is a criticism one could reasonably level at Greenberg, too). Secondly, and this is a further rejoinder to those who condemn Adorno as a cultural elitist: Adorno, unlike Greenberg for example, was one of the first major theoretical figures to take seriously mass culture and the culture industry, as evidenced throughout his career. To him the culture industry was not some minor aberration, to be sniffed at and then casually dismissed. Furthermore, when critics "read" the products of the culture industry—be it pop music, trashy novels, films, "agony" aunt and horoscope columns—as harmless social by-products, they also ignore the fact that these products are expressions of a democratic mass, free to express and believe in any way they choose. Of course, to Adorno, "the advice to be gained from manifestations of the culture industry is vacuous, banal or worse, and the behavior patterns are shamelessly conformist" but they are "real" and deserving of proper critical attention.[464] In other words, that so many people *believe* that particular alignments of distant planets

manifestly affect their everyday lives and personalities necessitates not derision but serious study.

The Art of the American Century and the Culture Industry

To reiterate, in the main modernism and its champions (Greenberg and Adorno) promote "high" art and culture—the avant-garde artist and artwork—over "low" forms—comic books, advertisements, magazine illustration—but, as this final section shows, the simple binary of high and low is a good deal more complicated and nuanced. Consequently, the history of twentieth-century American art is problematized. Regularly presented as an equally rigid binary of inferior and superior forms of American art, the pre-1945 in American modern art (normally called Early American modernism) is considered *inferior* to the later post 1945 American modern art associated with the artists of the New York School, the abstract expressionists, and the art critic, Clement Greenberg. To a large degree, Greenberg's essay, "Avant-Garde and Kitsch" helped bisect the story of twentieth-century American art. More importantly for this section, this brand of modernism, with its emphasis on the purity of high art, has characterized, or perhaps pathologized is a better description, low art as a contagion or impurity to be kept as far away from high, superior art as possible. The problem here, though, is at no time has American art, even abstract expressionism, ever been hermetically sealed off from other aspects of American or even non-American culture(s), especially low culture; the (for some) uncomfortable truth is that American art of the twentieth century engaged in a continual interaction with so-called low culture and was not necessarily resistant about embracing it.

With this in mind, we shall consider the significance of the ways in which several artists, working on either side of the 1945 dividing line, actively reject modernism's "purity" thesis while simultaneously working experimentally but with low cultural objects. What remains interesting is not the fact that a painting of a box of matches in the 1920s (Gerald Murphy) or a screen-print of a shaky newsprint image of an electric-chair (Andy Warhol) exist, but that their existence and to a degree worth (not monetary worth but their value as the successful working through of an idea) must still be determined against, funnily enough, Modernism's own "weight of implication, of innuendo, and of aspiration which bears down so heavily as it does upon modernism" itself.[465] In other words, modernism is weighed down but conversely Modernism weighs heavy on its subjects. Of course, I too am presenting too defined a binary; after all, there have been several notable defiant and deviant rejections of the hard-line Modernisms expounded by Greenberg and Adorno. In an American context, pop art most readily comes to mind. Post-Greenberg, Thomas Crow was able to write in 1996 that "it has to be conceded, low-cultural forms are time and again called upon to displace and estrange the deadening views of accepted practice, and some residuum of these forms is visible in many works of modernist art."[466]

Crow's observation is crucial because not only does it go some way to legitimize the use of low cultural forms (we will discuss what these might be later) in art but also that such a use is both productive and historical. The latter point is important because it helps us think about the ways in which American art has historically enjoyed a relationship with not only other forms of art but also a variety of subject matter. It suggests, too, the boundaries between high art and the culture industry are permeable and porous, and that this permeability and porosity works both ways, it is not just a one-way process; this, in turn, should prompt us to question what, then, constitutes the border between high and low art, who "puts" them there, why, and to what ends? In the end, this is about forms of looking, of course. High art tends to be found exclusively in museums, galleries, and private collections, and the reverence extended to the work of art hanging on a bare white wall by the audience can be witnessed the world over; the stuff of low culture, however, is rarely placed among the objects of high art, and finding an audience contemplating a box of washing powder *outside* of a gallery or museum is surely a rare occurrence. To be seen only in advertisements for that washing powder, perhaps? However, what happens when an artist places a box of washing powder, or a cigarette packet, or an image of a cowboy appropriated from an advertisement for cigarettes, at the center of their work? To explore these issues, we shall focus on the work of two artists, working at different points in the twentieth century: Stuart Davis and Richard Prince.

Stuart Davis

In Stuart Davis's *Odol* (Plate 44), we have a very early example of an artist's engagement with so-called low cultural ephemera. Nowadays, Davis is perhaps better known for his cubist/jazz-inspired works but our attention here will fix upon his "Tobacco-series" of 1921–4. In an essay commenting on recent and encouraging new interpretations of early twentieth-century American art, Judith Zilcer says of Davis's work:

> Whereas Stuart Davis's work was characterized as provincial in the immediate postwar period, more recent scholarship has recognized the originality of his "cubist realism." Davis's painting *Lucky Strike*—with its fusion of advertising imagery and the cartoons of popular culture is emblematic of the inter-disciplinary scholarship that modern American art invites. Apart from the formal invention of his composition, Davis's use of tobacco products as subjects of still life evokes questions about consumer culture, implied gender roles, and attitudes toward smoking in the Prohibition era. Equally intriguing is Davis's embrace of comic strip imagery that would appear to be at odds with the "high culture" of modern art.

In fairness, one might argue that modernism/Modernism's problem with early American modern art was the abiding interest in popular culture as a subject—advertising imagery, consumer culture, etc.—rather than with the more formal

aspects of painting identified by Harrison earlier. However, as Barbara Zabel notes, Davis's Tobacco paintings represent the artist's "increasing sensitivity to themes and motifs from American popular culture and represents part of an ongoing transgression of line between high and low culture."[467] These tobacco-related paintings are significant in terms of Davis's developing aesthetic and style because each image draws on "sources and references [that] are emphatically American ...," while deliberately foregrounding the influence of European modernism, especially cubism and collage.[468] On saying this, Zabel is mindful of previous criticism linking Davis's work with the nineteenth-century still life/*trompe l'oeil* paintings of William Hartnett (1848–92) and John Peto (1854–1907). Whereas Hartnett and Peto's work remains rooted in personal reflections on the fleeting nature of life ("smoking's connotations of passing pleasures"), Davis's work is "emphatically impersonal," engaged not with traditions but with the contemporary objects and media of his day, photography and advertisements.[469]

Zabel argues that, "in *Lucky Strike* Davis presented brilliantly colored, highly designed images whose allusions are to the new, to promises of a jazzy present and a bright future. Indeed, these are associations fostered by advertising itself."[470] In essence, then, he produced a work of art based upon the aesthetic principles of the advertising industry. Striking use of color, vivid and legible typography, and straightforward design all underpin Davis's *Lucky Strike* (Plate 45). So is this an advertisement or an artwork or both (recall the discussion of Jasper Johns's *Flag* in the Introduction)? On the grounds that Davis was not employed by the tobacco industry to create an image for the promotion of *Lucky Strike* cigarettes, this cannot be said to be an advertisement, although it is interesting to note that the painting, now at the Museum of Modern Art, New York, was donated to the museum by The American Tobacco Company, Inc. Davis's argument for appropriating the language of advertising is by virtue of its "current ness," its contemporaneity: it was "of the moment."

Also "of the moment" was Prohibition and in 1920 the prohibitionists revived the anti-tobacco movement, making Davis's choice of subject matter and form of address all the more interesting.[471] As Jackson Lears notes, "as rhetorical constructions, advertisements did more than stir up desire; they also sought to manage it—to stabilize the sorcery of the market place by containing dreams of personal transformation within a broader rhetoric of control."[472] Echoes of Adorno and Horkheimer's culture industry critique to one side, what is important about Davis's adoption, rather than appropriation, of the language of advertising is not only that it is a means of "naturalizing European modernism," as Zabel suggests. Of course, the presentation of a recognizable American brand of tobacco might well deflect criticism from Davis's European-influenced style but more than this Davis's engagement with tobacco advertising in a time of Prohibition reveals a hitherto unrecognized or unacknowledged depth to popular culture, especially the way in which advertising at once "stirs desire" while seeking also to control it.[473]

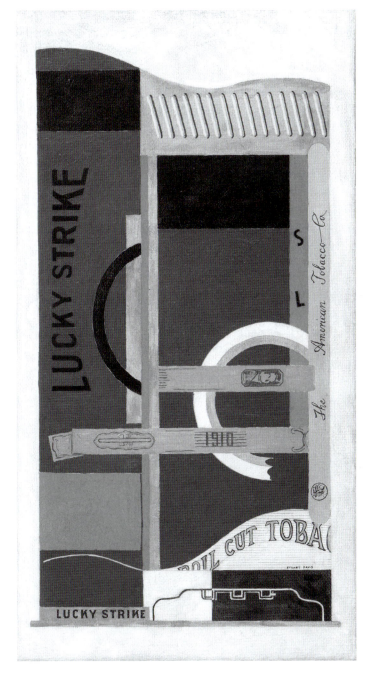

Plate 45 Stuart Davis (1892–1964), *Lucky Strike*, 1921. New York, Museum of Modern Art (MoMA). Oil on canvas, 33¼ × 18″ (84.5 × 45.7 cm). Gift of The American Tobacco Company, Inc. Acc. N.: 132.1951. © 2008. Digital image, The Museum of Modern Art, New York/Scala, Florence.

As such, Zabel is correct when she says Davis's tobacco-series is more "than a simple veneration of popular culture in America, these works document the nation's changing cultural environment and social habits during the postwar years while exposing the manipulative artistry of advertising."[474]

Richard Prince

Richard Prince is an artist/photographer whose work is synonymous with post-modernism, in particular the notion of "appropriation." During the 1970s, Prince, along with Sherrie Levine and Cindy Sherman, all made work that fundamentally challenged the veracity of the photograph, and the ideas of authenticity and originality in relation to both the work of the artist and to the art object itself.[475] Sherrie Levine took photographs of photographs by other highly regarded photographers, such as Walker Evans and Edward Weston; Sherman disguised and then photographed "herself" in a series of "film-stills," images which suggested narrative but were nothing more than staged moments; and Prince photographed, then cropped and enlarged advertising images from magazines, such as Marlboro cigarettes with their eponymous Marlboro men, to produce large-scale epic images like the one in Plate 46. Prince's technique of "appropriation" is as contentious as the term postmodernism itself, but more on that later.

Discussing his own early practice, Prince says:

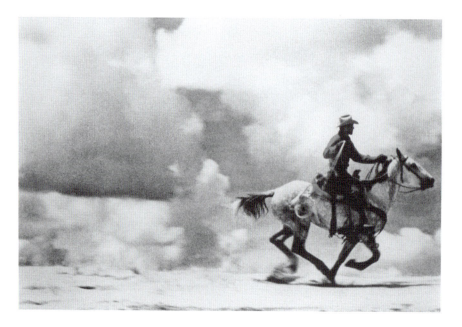

Plate 46 Richard Prince, *Untitled* (Cowboy), 1989, Ektacolor Photograph. Courtesy of the artist.

Advertising images aren't really associated with an author—more with a product/ company and for the most part put out or "art directed." They kind of end up having a life of their own. It's not like you're taking them from anyone. Pages in a magazine are more often thought of as "collage." When I re-photographed these pages they became "real" photographs. They "looked" like real photographs. They looked like real photographs because they were real photographs. Tearing a page out of a magazine and pasting it up on a board would have been a collage. Re-photographing a page out of a magazine was something else entirely. That "something else" was and is good revolution.[476]

Prince's point that advertising images are "art directed," they are in other words designed in advance by committee to meet a brief that will best serve the product to be advertised, is reminiscent of Adorno and Horkheimer's description of the workings of the culture industry; gone is the spontaneous form of cultural expression, replaced with a culture-by-committee. For Prince, the lack of an author, their anonymous status within the work, is almost an invitation to take on authorship of the image, to make it his own and do with it what he likes. Contrary to Prince's own rather benign point of view, Douglas Crimp argues instead that

Richard Prince *steals* the most frank and banal of these images, which register, in the context of photography-as-art, as a kind of shock. But ultimately their rather brutal familiarity gives way to strangeness, as an unintended and unwanted dimension of fiction reinvades them. By isolating, enlarging, and juxtaposing fragments of commercial images, Prince points to their invasion by these ghosts of fiction. Focusing directly on the commodity fetish, using the master tool of commodity fetishism of our time, Prince's rephotographed photographs take on a Hitchcockian dimension: the commodity becomes a clue. It has, we might say, acquired an aura, only now it is a function not of presence but of absence, severed from an origin, from an originator, from authenticity. [477]

Is Prince a thief, is he "stealing" the image? What, exactly, is stolen when you photograph another photograph, whether it is framed or in a magazine? Either way, Crimp articulates the way in which the image's status metamorphoses from the commercial into the art sphere.

The advertising image of the Marlboro man is not conceived of aesthetically or even artistically but from the perspective of how best to sell cigarettes; the creative processes employed by the image-maker are directed primarily to a specific end: commerce. The anonymity of the photographer—the photographer of the Marlboro advertisements, in fact, of most advertisements, is never credited—and allows Prince to "appropriate" the image, he is then able to insert or impress upon the work his own signature, which is both his name and the style—reminiscent of Brady and the photographs of the Civil War. Robert S. Nelson, using an appropriation strategy of his own (his text appropriates Roland Barthes' notion of myth) explains that "[a]ppropriation, like myth ... is a distortion, not a negation of the prior semiotic assemblage. When successful, it maintains but shifts the former connotations to create the new sign and accomplishes this covertly, making the process appear ordinary and

natural"; a point Barthes makes in his *Mythologies*.[478] Nelson notes, unsurprisingly, given his appropriation of Barthes' myth, that appropriation is "fundamental to modern advertising and to the abstracting and expropriating strategies of capitalism itself..."[479] But what does it mean when an artist, like Prince, appropriates an image that, in its own way, has already been appropriated?

What do I mean by already appropriated? If we focus upon the Marlboro Man/ Cowboy image, and recall Barthes' study of myth from Chapter 2, the "original" image would clearly seek to make a series of connections between product, cigarettes, and consumer; the way to do this of course is through connotation. This process relies upon a series of recognizable and known "truths" about cowboys, the way they act (as individuals), what they believe in (America!), what they represent (masculinity, control, rugged individualism, a historic connection to the past, a link to a simpler more straightforward life, control over one's own destiny, the instinct to survive, and many more). As we know by now, advertisements play with the truth somewhat and rely upon myth (here the myth of the American West) and so the employment of the Marlboro Man (rarely the same model but always the same man) bestows each of these qualities onto the cigarettes and by extension the smoker him/herself. So, the original advertising image is far from original but part of a much larger, now globalized bank of mythologized and mythologizing images.

So, we know the Marlboro Man is a myth, an invention of an advertising agency, reliant upon the mythologizing of the American West. But what is the significance of Prince's appropriation of this snippet of visual culture, which is really an appropriation of an appropriation?[480] Writing a review of Prince's retrospective at the Guggenheim, *New Yorker* art critic, Peter Schjeldahl argues that, Prince's "gorgeous prints of the cowboy photographs in Marlboro ads, a stock-in-trade since 1980, stick us with the fact that those pictures are beautiful. Any opinions we may have about advertising, cigarettes, and the West founder in our visual bliss."[481] Visual bliss? Schjeldahl suggests here that Prince somehow extracts from the most hackneyed advertising imagery, the most soulless, corrupt and manipulative form of image making, something approaching the sublime. In the earlier discussion of Adorno, in particular the "blind spot" identified in his writings on the products of the culture industry, we noted how the artwork embraces its uniqueness or aura, whereas the products of the culture industry do not, because to do so would undermine their emphasis on coherence and standardization. Here Prince's *Untitled* (Cowboy), as an appropriated image, a photograph of an advertisement torn from a magazine, has stripped away the slogans and health warnings, erased the page numbers and other signs of the image's lowly origins, in order to reproduce or, following Adorno, rediscover the uniqueness of the image. By doing so, Prince's photograph, a real photograph because it is a real photograph taken by a camera, emerges as both unique and appropriated, as with and without authorship. Moreover, one wonders whether, as Crimp notes above, the original advertising image was truly banal or had banality been foisted upon it?

Conclusion

Are the images of advertising or, more generally, popular culture banal? Is a painting of a box of cigarettes more or less banal than a doctored photograph of an advertisement torn from the pages of a magazine? Does it even make sense to ask such a question? The adoption or appropriation of mundane or banal imagery, sometimes referred to as "everyday" imagery, only ever reveals how wide of the mark and reductive descriptors like banal and mundane actually are. In Prohibition America with tobacco in the sights of the prohibitionists, painting a packet of *Lucky Strike* cigarettes cannot be seen as just an idle reproduction of the mundane or the banal; likewise, when contemporary media imagery is so pervasive that it is almost invisible—just "out there"—then the act of stripping away the advertisement's corporate identity and message reminds us to look again, and reconsider more carefully what it is we overlook every day. Of course, this suggests that, in the case of the tobacco-related examples discussed above that advertising helps create and then perpetuate a particular form of perception.

For Jackson Lears, advertisements mean "Many things. They urge people to buy goods, but they also signify a certain vision of the good life; they validate a way of being in the world. They focus private fantasy; they sanction or subvert structures of economic and political power. Their significance depends on their cultural setting."[482] When that cultural setting is disturbed or reframed, as in the work of Davis and Prince, there is a profound effect on the ideas of "American-ness" so important to the meaning of *Lucky Strike* cigarettes and the Marlboro Man. In both cases the artist's engagement with kitsch and the culture industry does not carry with it the dire consequences Greenberg and Adorno seem so concerned about. In fact, as we have seen, Adorno's work is more forgiving than perhaps even he realized. Rather, Prince's photographs of photographs of cowboys—who are more likely models than "real" cowboys—are illustrative of the complex and nuanced relationship between high and low art, if such a distinction can still be made. Davis's tobacco-series of works, too, exhibits a similar, multifaceted relationship with advertising and the promotional image.

What distinguishes Davis from Prince, other than the historical span between them, is their understanding of the work of an artist. For Davis the artist is a stable entity, sure to some degree of his critical and political intentions, and convinced that the work of art is able reflect and project these intentions to a presumed viewer, who is also a stable and predictable individual: he is a modernist, although Greenberg would surely argue otherwise. Prince, if considered a thief, is far more suspicious of the artist as a stable category, therefore his intentions, if he even has any, are diffuse, contradictory, even playful: this makes Prince a postmodernist, reveling in the knowledge that there are no stable subjectivities to fall back on, let alone stable national identities, identity is like the advertising image, constructed.

In the end, Davis's work despite best intentions approached the American-ness of his subject matter as though it were unproblematic; Prince's work is far more attuned to the problems inherent in such a belief. The "American century" appears as one in which artists through dialogue with, rather than ignoring or discounting, the popular culture of the American nation came to see American-ness not as an innate property of the American people but as a series of contested meanings, constantly in flux, always being renegotiated. But, then again, I do think Mark Twain is right about the national devotion to ice water.

Notes

1. It should be pointed out that the phrase "visual culture" appeared long before the 1990s. For an excellent discussion of the genealogy and objects of visual studies, see Margaret Dikovitskaya, *Visual Culture: The Study of the Visual after the Cultural Turn*, Cambridge, MA: MIT Press, 2005, pp. 47–64. The same is true of the self-reflexive turn in American studies, which can be traced back to Gene Wise's, "Paradigm Dramas" in "American Studies: A Cultural and Institutional History of the Movement," *American Quarterly*, Vol. 31, No. 3 (1979), pp. 293–337, which was part of a special section in the journal, called "The American Studies Movement: A Thirty-Year Retrospective." Other important essays from this edition of *American Quarterly* include: Robert F. Berkhofer, "The Americanness of American Studies" (pp. 340–5) and Leo Marx, "Thoughts on the Origin and the Character of the American Studies Movement" (pp. 398–401).

2. See the special edition of *Cultural Critique* (No. 40, Autumn, 1998), called "The Futures of American Studies." Edited and with an introduction by Robyn Wiegman, it also contains two cornerstone essays for what has become known as the "New American studies": John Carlos Rowe, "Post-Nationalism, Globalism and the New American Studies" (pp. 11–28) and George Lipsitz, "'Sent for You Yesterday, Here You Come Today': American Studies Scholarship and the New Social Movements" (pp. 203–25). See also Donald E. Pease and Robyn Wiegman (eds.), *The Futures of American Studies*, Durham, NC and London: Duke University Press, 2002. Along with the essays mentioned above, this edited collection has a more detailed introductory essay that highlights the significance of Gene Wise's "Paradigm Dramas" (see Note 1 above) and includes several other essays not originally included in *Cultural Critique* (No.40, Autumn, 1998). Of these, it is worth highlighting the inclusion of Janice Radway's "What's in a Name?", originally published in *American Quarterly*, Vol. 51, No. 1 (1999), pp. 1–32. I discuss the importance of this essay later in this introduction.

3. As Donald Pease notes, "Both globalization and postcolonialism begin with the assumption that while the nation-state may not be dead exactly, it has undergone a drastic change in role. The world economy requires socially and territorially more complex organizations than nation-states, which have subsequently become splintered rather than developmental in form. The time bound and enclosed nation-state whose institutional form once foreclosed other possibilities has given way to more complex patterns of interdependence grounded in the belief that the local and international are inextricably intertwined. Global tribes with widespread

diaspora networks, epistemic communities with transnational allegiances, migrant labor forces, and radically pluralist groups now construe nation-building as a provisional and highly unreliable linkage between universalism and territorial exclusion." Donald Pease, "National Narratives, Postnational Narration," *Modern Fiction Studies*, Vol. 43, No. 1 (1997), p. 1.

4. Quoted in Shelley Fisher Fishkin, "Crossroads of Cultures: The Transnational Turn in American Studies": Presidential Address to the American Studies Association, November 12, 2004, *American Quarterly*, Vol. 57, No. 1 (2005), pp. 17–57 from Mark Twain, "What Paul Bourget Thinks of Us," in *How to Tell a Story and Other Essays*, 1897, in *The Oxford Mark Twain*, 29 vols., ed. Shelley Fisher Fishkin (New York: Oxford University Press, 1996), pp. 196–7.

5. Rowe, "Post-Nationalism, Globalism, and the New American Studies," p. 11.

6. Lipsitz, "Sent for You Yesterday, Here You Come Today," p. 211.

7. There is considerable debate about the impact on those communities/societies/cultures subject to forms of cultural imperialism; how does one accurately measure the effects of cultural imperialism and what about appropriation and resistance? For an early and still relevant discussion of these issues, see John Tomlinson, *Cultural Imperialism: A Critical Introduction*, Johns Hopkins University Press, 1991.

8. Janice Radway, "What's in a Name?," pp. 1–2.

9. Radway begins with a critique of Carl Bode's essay, "The Start of the ASA," as a means of reinvigorating, even recalibrating the organizations aims and goals for the new millennium See Carl Bode, "The Start of the ASA," *American Quarterly,* Vol. 31 (1979), pp. 345–54. As Radway highlights in her own footnotes, the headnote to the essay clearly shows that Bode's essay was originally written in 1960.

10. Radway's Address was followed by the presidential addresses of Amy Kaplan (2003) and Shelley Fisher Fishkin (2005) and both share to some degree the concerns expressed in "What's in a Name?" See Amy Kaplan, "Violent Belongings and the Question of Empire Today; Presidential Address to the American Studies Association 2003," *American Quarterly*, Vol. 56 (2004), pp. 1–18; Shelley Fisher Fishkin, "Crossroads of Cultures: The Transnational Turn in American Studies—Presidential Address to the American Studies Association, November 12, 2004," *American Quarterly*, Vol. 57 No. 1 (2005), pp. 17–57.

11. See Shelley Fisher Fishkin, "Crossroads of Cultures," p. 36.

12. George W. Bush, "Address to a Joint Session of Congress and the American People," September 20, 2001, http://www.whitehouse.gov/news/releases/2001/09/20010920–8.html [accessed May 28, 2008].

13. Fishkin, "Crossroads of Cultures," p. 36. See also Ali Fisher, "The Janus-faced development of 2New American Studies'," *49th Parallel*, Conference Special Edition, Autumn 2006, p. 5.

14. Fisher, "Janus-faced development," pp. 2–3.

15. Paul Giles, "Transnationalism in Practice," *49th Parallel*, Special Edition: *Dislocations: Transatlantic Perspectives on Postnational American Studies*, Issue 8, 2001. http://www.49thparallel.bham.ac.uk/back/issue8/index.htm [accessed May 28, 08].
16. Giles, "Transnationalism in Practice," no pagination.
17. Giles, "Transnationalism in Practice," no pagination.
18. Kaplan, "Violent Belongings," pp. 15–16.
19. Nicholas Mizoeff, *An Introduction to Visual Culture*, London and New York: Routledge, 1999, p. 1 [emphasis added].
20. See Joanne Morra and Marquard Smith (eds.), *Visual Culture: Critical Concepts in Media and Cultural Studies*, 4 volumes, London and New York: Routledge, 2006. Still, a preference for brevity does not preclude some background, so I advise readers with limited knowledge about the emergence of visual culture studies to undertake some background research. Once again I find it easy to direct readers to Morra and Smith, *Visual Culture*. Volume 1 offers one of the best collections of essays on visual culture studies from central figures, including: Mieke Bal, Norman Bryson, Lisa Cartwright, Douglas Crimp, James Elkins, Hal Foster, David Freedberg, Michael Ann Holly, Martin Jay, Rosalind Krauss, Nicholas Mirzoeff, W. J. T. Mitchell, Keith Moxey, and Irit Rogoff. Further volumes present works from a wide array of disciplines, including: Plato, G. W. F. Hegel, Ferdinand de Saussure, Jacques Lacan, Frantz Fanon, George Bataille, Theodor Adorno, Carol Duncan, Guy Debord, and Jacqueline Rose, to name a few. Other texts of interest are: M. Barnard, *Art, Design and Visual Culture*, London: MacMillan, 1998; Norman Bryson et al. (eds.), *Visual Culture: Images and Interpretations*, University Press of New England [for] Wesleyan University Press, 1994; Jonathan Crary, *Techniques of the Observer*, MIT Press, 1990; James Elkins, *Visual Studies: A Skeptical Introduction*, London: Routledge, 2003; J. Evans and S. Hall, *Visual Culture: The Reader*, London: Sage, 1999; Holloway and Beck (eds.) *American Visual Cultures*, London: Continuum, 2005; Richard Howells, *Visual Culture*, Oxford: Blackwell, 2003; N. Mirzoeff, *Introduction to Visual Culture*, London: Routledge, 1999; N. Mirzoeff, *The Visual Culture Reader* (2nd ed.), London: Routledge, (1998) 2002; W. J. T. Mitchell, *Picture Theory : Essays on Verbal and Visual Representation*, Chicago: University of Chicago Press, 1994; G. Rose, *Visual Methodologies*, London: Sage, 2001; Barbara Stafford, *Good looking: Essays on the Virtue of Images*, Cambridge, MA: MIT Press, 1996; Sturken & Cartwright, *Practices of Looking*, Oxford: Oxford University Press, 2001; John A. Walker and Sarah Chaplin, *Visual Culture: An Introduction*, Manchester and New York: Manchester University Press, 1997. For those with an interest in the, occasionally fractious, debate regarding art history versus visual culture, read the "Questionnaire on Visual Culture" (see *October* 77, 1996, pp. 3–4; 25–70) organized, distributed, and published by the editors of the journal *October* in 1996. Respondents include

Svetlana Alpers, Susan Buck-Morss, Jonathan Crary, Thomas Crow, and Martin Jay, and the "Questionnaire" stands as an interesting document regarding the reception of and attitudes toward "visual culture."

21. W. J. T. Mitchell, "Interdisciplinarity and Visual Culture," *The Art Bulletin*, Vol. 77, No. 4 (December, 1995), p. 542.
22. Mitchell, "Interdisciplinarity," p. 542.
23. Mitchell, "Interdisciplinarity," p. 542.
24. Mitchell, "Interdisciplinarity," p. 542.
25. Mirzoeff, *Visual Culture*, p. 5. Mirzoeff's examples here include X-Rays and the Hubble telescope [emphasis added].
26. See Jonathan Crary, *Techniques of the Observer: on Vision and Modernity in the Nineteenth Century*, Cambridge, MA: MIT Press, 1990 (an extract is also reproduced in Morra and Smith, *Visual Culture,* Vol 4, pp. 88–113); Jonathan Crary, *Suspensions of Perception: Attention, Spectacle, and Modern Culture*, Cambridge, MA and London: MIT Press, 2001; Martin Jay, *Downcast Eyes: The Denigration of Vision in Twentieth-Century French Thought*, Berkeley, Los Angeles, London: University of California Press, 1994; James Elkins, *Visual Studies: A Skeptical Introduction*, New York and London: Routledge, 2003; Barbara Stafford, *Devices of Wonder: from the World in a Box to Images on a Screen*, Los Angeles: Getty Research Institute, 2001.
27. Morra and Smith, *Visual Culture*, Vol. 1, p. 7.
28. For more on visual culture and proprioception in particular, see James Elkins, *Visual Studies: A Skeptical Introduction*.
29. W. J. T. Mitchell, "Cloning Terror: The War of Images 2001–04" in Diarmuid Costello and Dominic Willsdon (eds.), *The Life and Death of Images*, Ithaca, NY: Cornell University Press, 2008, p. 180. For more on the "pictorial turn," see W. J. T. Mitchell, *Picture Theory: Essays on Verbal and Visual Representation*, Chicago: University of Chicago Press, 1994.
30. To read extracts from these texts and others, including Aristotle, John of Damascus, Rene Descartes, and Thomas Hobbes, see Sunil Manhani, Arthur Piper, and Jon Simons, *Images: A Reader*, London, Thousand Oaks, New Delhi: Sage Publications, 2006, pp. 20–40.
31. See Richard Rorty (ed.), *The Linguistic Turn: Essays in Philosophical Method* Chicago; London: University of Chicago Press, 1970.
32. Dikovitskaya, Margaret, *Visual Culture: The Study of Visual Culture after the Cultural Turn*, Cambridge, MA, London: MIT Press, 2006, p. 48.
33. Dikovitskaya, *Visual Culture*, p. 48.
34. Dikovitskaya, *Visual Culture*, p. 48.
35. Dikovitskaya, *Visual Culture*, p. 48.
36. Mitchell, "Interdisciplinarity," p. 541.
37. See Karal Ann Marling's *Old Glory: Unfurling History*, Boston, London: Bunker Hill Publishing in association with the Library of Congress, 2004.

38. Marling, *Old Glory*, p. 8.
39. Marling's *Old Glory*, p. 7.
40. Marling's *Old Glory*, pp. 10–11.
41. Fred Orton, *Figuring Jasper Johns*, Cambridge, MA: Harvard University Press, 1994. Orton adds, "The statement that 'he dreamed one night of painting a large flag' is not a representation of a dream. There is little or no secondary revision, and without it and Johns' free association there is nothing that would make the dream the 'royal road' to the desires and fears that might have motivated it and so in part may have determined the decision to paint a large flag," p. 98. *Flag*, Johns claims is also his first work of art, so like America, it is exceptional.
42. Andrew Benjamin, *What is Abstraction?* London: Academy Editions, 1996, p. 30.
43. Benjamin, *What is Abstraction?* p. 32.
44. Fred Orton, in *Figuring Jasper Johns*, p. 90, describes the conventional manner for constructing the Stars and Stripes.
45. Orton, *Figuring Jasper Johns*, p.110.
46. Orton, *Figuring Jasper Johns*, p. 97.
47. Orton, *Figuring Jasper Johns*, p. 114–15.
48. Orton, *Figuring Jasper Johns*, p.118.
49. Walt Whitman, Preface to the first issue of *Leaves of Grass* (1855), Brookyln, NY, at http://www.bartleby.com/229/2004.html#2 [accessed February 11, 2008].
50. Whitman, Preface to first issue of *Leaves of Grass*.
51. Walt Whitman, "On to Denver—A Frontier Incident" from *Specimen Days* in Graham Clarke (ed.), *The American Landscape: Literary Sources and Documents*, Volume 2, *The American Image: Landscape as Symbol and Myth in the Nineteenth Century*, The Banks, Mountfield: Helm Information Ltd., 1993. For full text, see also http://www.bartleby.com/people/WhitmnW.html [accessed February 11, 08).
52. Rachel Ziady DeLue, "Elusive Landscapes and Shifting Grounds" in Rachel Ziadt DeLue and James Elkins (eds.), *Landscape Theory*, New York and London: Routledge, 2008, p.11.
53. DeLue and Elkin's edited text, *Landscape Theory*, published at the beginning of 2008, is itself evidence of the continuing interest in landscape across academic disciplines.
54. Jay Appleton, *The Experience of Landscape* (1975) quoted in DeLue and Elkins, *Landscape Theory*, p. 11.
55. DeLue in DeLue and Elkins, *Landscape Theory*, p. 11.
56. DeLue in DeLue and Elkins, *Landscape Theory*, p. 11.
57. W. J. T. Mitchell, "Imperial Landscape" in *Landscape and Power*, p. 5.
58. Stephen F. Mills, *The American Landscape*, Keele: Keele University Press, 1997, p. 3. The roundtable discussion, "The Art Seminar" in DeLue and Elkins, *Landscape Theory* (pp. 87–156) is worth reading with this in mind.

59. Mills, *American Landscape*, p. 3.

60. Mitchell, "Imperial Landscape" in *Landscape and Power*.

61. Mitchell, Preface to 2nd edition of *Landscape and Power*, p. vii.

62. Mitchell, Preface to 2nd edition of *Landscape and Power*, vii.

63. Mitchell, Preface to 2nd edition of *Landscape and Power*, vii.

64. D. W. Meinig (ed.), *The Interpretation of Ordinary Landscapes*, New York, Oxford: Oxford University Press, 1979, p. 1.

65. Meinig, *Ordinary Landscapes*, pp. 1–2.

66. Meinig, *Ordinary Landscapes*, p. 2.

67. Meinig, *Ordinary Landscapes*, pp. 2–3.

68. Meinig, *Ordinary Landscapes*, p. 3.

69. Meinig, *Ordinary Landscapes*, p. 3.

70. Meinig, *Ordinary Landscapes*, pp. 3–5.

71. Martin Heidegger, "The Age of the World Picture," in *The Question Concerning Technology and Other Essays*, translation and introduction by William Lovitt. New York: Garland Publishing, Inc., 1977.

72. Heidegger, "World Picture."

73. Heidegger, "World Picture," my emphasis.

74. Gary Sauer-Thompson, http://sauer-thompson.com/conversations/archives/002569.html [accessed August 9, 2007].

75. Edward S. Casey, *Representing Place: Landscape Painting & Maps*, Minneapolis, London: University of Minnesota Press, 2002, p. 7.

76. Casey, *Representing Place*, p. 3.

77. Kenneth Clark in Casey, *Representing Place*, p. 5. The full quote reads: "In the West, landscape painting has had a short and fitful history. In the greatest ages of European art, the age of the Parthenon and the age of Chartres Cathedral, landscape did not and could not exist; to Giotto and Michelangelo it was an impertinence. It is only in the seventeenth century that great artists take up landscape painting for its own sake, and try to systematize the rules. Only in the nineteenth century does it become the dominant art, and create a new aesthetic of its own." Kenneth Clark, *Landscape into Art*, New York: Harper & Row, 1976, p. 229. See Casey, *Representing Place*, fn. 2, p. 278, for commentary on this quotation.

78. Martha A. Sandweiss, *Print the Legend: Photography and the American West*, New Haven: Yale University Press, 2002, p.3.

79. Sandweiss, *Print the Legend*, p. 3.

80. Sandweiss, *Print the Legend*, p. 3.

81. Sandweiss refers the reader to Frederick Turner Jackson, "The Significance of the Frontier in American History," *Annual Report of the American Historical Association for the Year 1893*. Washington: Government Printing Office, 1894).

82. Frederick Turner Jackson, "The Significance of the Frontier in American History" in Frederick Turner Jackson, *The Frontier in American History*, New York: Dover Publications, 1996, p. 3. All quotations are taken from this edition.

83. Jackson, "Significance of the Frontier," p. 22.

84. The text accompanying this image reads: "Northern Arizona and the Grand Canyon are captured in this pair of Multi-angle Imaging Spectroradiometer (MISR) images from December 31, 2000. The above image is a true color view from the nadir (vertical) camera. A stereo composite image was generated using data from MISR's vertical and 46-degree-forward cameras. Viewing the stereo image in 3-D requires the use of red/blue glasses with the red filter placed over your left eye. To facilitate stereo viewing, the images have been oriented with north at the left." Available at http://earthobservatory.nasa.gov/IOTD/view.php?id=1366 [accessed October 25, 2008].In addition to the Grand Canyon itself, which is visible in the western (lower) half of the images, other landmarks include Lake Powell, on the left, and Humphreys Peak and Sunset Crater National Monument on the right. Meteor Crater appears as a small dark depression with a brighter rim, and is just visible along the upper right-hand edge. Can you find it?

85. David Harvey, *Spaces of Capital: Towards a Critical Geography*, Edinburgh: Edinburgh University Press, 2001, pp. 219–29 [in Morra and Smith, p. 235].

86. Harvey, *Spaces of Capital* [in Morra and Smith, p. 235].

87. Harvey, *Spaces of Capital* [in Morra and Smith, p. 236].

88. Harvey, *Spaces of Capital* [in Morra and Smith, p. 236].

89. Harvey, *Spaces of Capital* [in Morra and Smith, p. 236].

90. Harvey, *Spaces of Capital* [in Morra and Smith, p. 240].

91. D. W. Meinig, *The Shaping of America: The Geographical Perspective on 500 Years of History*, Volume 2, *Continental America, 1800–1867*, New Haven and London: Yale University Press, 1993, p. 3.

92. Meinig, *Shaping of America*, p. 78. Meinig outlines the way in which the Louisiana Purchase (announced by Thomas Jefferson on July 4, 1803) offered for the first time in the republic's history an opportunity to solve, once and for all, the "Indian problem." The purchase would allow whites and "Indians" to coexist because, in a manner echoing George Washington's dictat to the Native Americans, "the Country, is large enough to contain us all …" (Quoted in Meinig, *Shaping of America*, p. 78).

93. Meinig, *Shaping of America*, p. 78.

94. Meinig, *Shaping of America*, p. 78.

95. See Jennifer A. Watts and Claudia Bohn-Spector, *The Great Wide Open: Panoramic Photographs of the American West*, Henry E. Huntington Library and Art Gallery, London: Merrell Publishers Limited, 2001, fn. 8, p. 73.

96. Quoted by Julius W. Pratt in "The Origin of "Manifest Destiny,"" *The American Historical Review*, Vol. 32, No. 4. (July, 1927), p. 795.
97. See Angela Miller, "Everywhere and Nowhere: The Making of the National Landscape" *American Literary History*, Vol. 4, No. 2 (Summer, 1992), pp. 207–29.
98. Miller, "Everywhere and Nowhere," p. 207.
99. Miller, "Everywhere and Nowhere, p. 208.
100. Barbara Groseclose, *Nineteenth Century American Art*, Oxford and New York: Oxford University Press, 2000, p. 158.
101. Groseclose, *Nineteenth Century American Art*, p. 158.
102. Amy S. Greenberg, *Manifest Manhood and the Antebellum American Empire*, Cambridge: Cambridge University Press, 2005, p. 2.
103. Greenberg, *Manifest Manhood*, p. 2. Greenberg also references the following texts, which saves me the job! See also, Henry Nash Smith, *Virgin Land: the American West as Symbol and Myth*, Cambridge, MA: Harvard University Press, 1950, pp. 81–111; Richard Slotkin, *Regeneration Through Violence: The Mythology of the American Frontier, 1600–1860*, Middletown, CT: Wesleyan University Press, 1973.
104. Wanda Corn, *Grant Wood: The Regionalist Vision*, New Haven; London: Yale University Press, 1983, p. xiii.
105. Corn, *Grant Wood*, p. xiii.
106. One could equally examine social realism's responses to the Depression, and I would encourage students to do so.
107. Grant Wood (1892–1942) from *Revolt Against the City* (pp. 435–6) in Charles Harrison and Paul Wood (eds.), *Art in Theory, 1900–2000: An Anthology of Changing Ideas*, Oxford: Blackwell Publishing, 1999, p. 436.
108. Thomas Hart Benton quoted in Robert Hughes, *American Visions: The Epic History of Art in America*, London: The Harvill Press, 1997, p. 443; Benton quoted in Ann Dempsey, *Styles, Schools and Movements*, London: Thames and Hudson, 2002, p. 165.
109. Meyer Schapiro quoted in James M. Dennis, *Renegade Regionalists: The Modern Independence of Grant Wood, Thomas Hart Benton, and John Steuart Curry*, Madison, Wisconsin: University of Wisconsin Press, 1998, p. 80.
110. Dennis, *Renegade Regionalists*, p. 47.
111. Sandweiss, *Print the Legend*, p. 205.
112. See also Grant Wood's *Spring Turning* (1936), *Arbor Day* (1932), *Fall Plowing* (1931), and *Young Corn* (1931). In all these images, lush greens, soft undulating hills and people working in harmony with each other and the land dominate.
113. Corn, *Grant Wood*, p. 90.
114. See Corn, *Grant Wood*, p. 90.
115. *America's Wonderlands: The National Parks and Monuments of the United States*, Washington: National Geographic Society, (1959) 1966.

116. Melville Bell Grosvenor, "Foreword" in *America's Wonderlands*, p. 5.

117. Grosvenor, *America's Wonderlands*, pp. 5/7.

118. George B. Hartzog, Jr., "Introduction" in *America's Wonderlands*, p. 12.

119. *America's Wonderlands*, pp. 32–3.

120. *America's Wonderlands*, p. 39.

121. *America's Wonderlands*, p. 391.

122. Horror films, too, reflected exactly the same anxieties. See Mark Jancovich, *Rational Fears: American Horror in the 1950s*, Manchester: Manchester University Press, 1996.

123. Margaret Marsh, "(Ms) Reading the Suburbs," *American Quarterly*, Vol. 46, No. 1. (Mar., 1994), p. 40.

124. Karal Ann Marling, *As Seen on TV: The Visual Culture of Everyday Life in the 1950s*, Cambridge, MA, London: Harvard University Press, 1994, p. 243.

125. Marling, *As Seen on TV*, p. 245.

126. Marling, *As Seen on TV*, p. 250.

127. See also J. Howard Miller's "Just Do it!" a poster based upon a photograph of Geraldine Doyle taken at a Michigan pressing plant in 1942. Available at http://www.archives.gov/exhibits/powers_of_persuasion/its_a_womans_war_too/its_a_womans_war_too.html [accessed September 2, 2008].

128. Images at Library of Congress. http://www.loc.gov/rr/print/list/126_rosi.html#color [accessed September 2, 2008].

129. Elaine Tyler May, *Homeward Bound: American Families in the Cold War Era*, New York: Basic Books, 1988, p. 13.

130. May, *Homeward Bound*, pp. 13–14.

131. May, *Homeward Bound*, p. 14.

132. May, *Homeward Bound*, p. 164.

133. Beatriz Colomina, "Introduction" in Beatriz Colomina, Annmarie Brennan and Jeannie Kim (eds.), *Cold War Hothouses: Inventing Postwar Culture, from Cockpit to Playboy*, New York: Princeton Architectural Press, 2004, p. 12.

134. David Snyder cited in Colomina, "Introduction," *Cold War Hothouses*, p. 12.

135. Colomina, "Introduction," *Cold War Hothouses*, p. 12. For more on national parks as domestic spaces, see Jeannie Kim, "Mission 66" in *Cold War Hothouses*, pp. 168–89.

136. Thorstein Veblen, *The Theory of the Leisure Class: An Economic Study of Institutions*, London: George Allen and Unwin, [1899] 1924, p. 69.

137. Theodor Adorno, "Veblen's Attack on Culture" in *Prisms*, tr. Samuel & Shierry Weber. Cambridge, MA: The MIT Press, [1967] 1981, p. 76.

138. Adorno, "Veblen's Attack," p. 83. On the roots of Veblen's "puritanical work ethos," see John D. Diggins, *The Bard of Savagery: Thorstein Veblen and Modern Social Theory*, Great Britain: Harvester Press, 1978.

139. John D. Diggins, *The Bard of Savagery*, p. 6.

140. Terry Smith, *Making the Modern: Industry, Art, and Design in America*, Chicago and London: The University of Chicago Press, 1993, p. 6.
141. Smith, *Making the Modern*, p. 6.
142. Smith, *Making the Modern*, p. 7.
143. Smith, *Making the Modern*, p. 99.
144. Smith, *Making the Modern*, p. 99.
145. Stuart Ewen, *Captains of Consciousness: Advertising and the Social Roots of Consumer Culture*, New York: Basic Books, 2001, p. 1.
146. Roland Barthes, "The New Citroën" in *Mythologies*, [1957] trans. Annette Lavers, London: Vintage, 1983, p. 88.
147. Ewen, *Captains of Consciousness*, p. 107.
148. Roland Barthes, "The Rhetoric of the Image" in *Image, Music, Text,* trans Steven Heath, London: Fontana Press, 1977, p. 32.
149. Jessica Evans in Jessica Evans and Stuart Hall (eds.), *Visual Culture: the Reader*, London, Thousand Oaks, New Delhi: Sage, 2003, p. 12.
150. Chris Barker, *Cultural Studies: Theory and Practice* [3rd edition], London, Thousand Oaks, New Delhi: Sage, 2008, p. 77.
151. Daniel Chandler, *Semiotics for Beginners*, http://www.aber.ac.uk/media/Documents/S4B/sem03.html [accessed February 26, 2008].
152. Michael Moriarty, *Roland Barthes*, Stanford, CA: Stanford University Press, 1991, p. 19.
153. Moriarty, *Barthes*, p. 19.
154. Moriarty, *Barthes*, p. 88.
155. Barthes, *Mythologies*, p. 109.
156. Annette Lavers, *Roland Barthes: Structuralism and After*, London: Methuen & Co., 1982, p. 108.
157. Barthes, *Mythologies*, p. 154 Barthes explains that "Here the statement is no longer directed towards a world to be made; it must overlay one which is already made, bury the traces of this production under a self-evident appearance of eternity: it is a counter-explanation, the decorous equivalent of tautology."
158. Barthes, *Mythologies*, p. 118.
159. Barthes, *Mythologies*, pp. 123–4.
160. Barthes, *Mythologies*, p. 150.
161. Barker, *Cultural Studies*, p. 62.
162. David Hawkes, *Ideology*, London and New York: Routledge, 1996, p. 12.
163. Andres Duany, Elizabeth Plater-Zyberk, and Jeff Speck, *Suburban Nation: The Rise of Sprawl and the Decline of the American Dream*, New York: North Point Press, 2000, p. 8.
164. Duany et al., *Suburban Nation*, p. 8.
165. Angela G. Dorenkamp, John E. McClymer, Mary M. Moynihan, and Arlene C. Vadum (eds.), *Images of Women in Popular Culture*, San Diego, New York,

Chicago, Atlanta, Washington, D.C., London, Sydney, Toronto: Harcourt Brace Jovanovich, Inc., 1985, p. 88.

166. Betty Friedan, "The Problem that has no Name," from *The Feminine Mystique* (1963) in Dorenkamp et al., *Images of Women in Popular Culture*, p. 88.

167. Friedan, "The Problem that has no Name," p. 90.

168. Friedan, "The Problem that has no Name," p. 90.

169. Friedan, "The Problem that has no Name," p. 90.

170. Cecelia Tichi, *Shifting Gears: Technology, Literature, Culture in Modernist America*, Chapel Hill & London: The University of North Carolina Press, 1987, p. 58.

171. For example, in "Ornament and Crime," Adolf Loos states that "I have discovered the following truth and present it to the world: cultural evolution is equivalent to the removal of ornament from articles in daily use" ("Ornament and Crime" in Ludwig Münz and Gustav Künstler, *Adolf Loos: Pioneer of Modern Architecture*, London: Thames & Hudson, 1966, pp. 226–7). Louis H. Sullivan was far less bombastic. For Sullivan, ornament is not a crime; ornament has a place, but there are good or bad types of ornament. Ornament should not appear "stuck on" to a structure but emerge organically from the structure itself; or, as Sullivan says: "a certain kind of ornament should appear on a certain kind of structure, just as certain kind of leaf must appear on a certain kind of tree" ("Ornament in Architecture" in Louis H. Sullivan, *Kindergarten Chats and Other Writings*, New York: The Gallery Press, 1965, p. 189). Finally, Frank Lloyd Wright, who describes ornament as "primarily a spiritual matter, a proof of culture, an expression of the quality of soul within us, easily read and enjoyed by the enlightened when it is a real expression of ourselves." He also notes that, "*True* ornament is not a matter of prettifying externals. It is organic with the structure it adorns, whether a person, a building, or a park" ('Ornamentation" in Patrick J. Meehan (ed.), *Truth Against the World: Frank Lloyd Wright Speaks for an Organic Architecture*, New York: Wiley, 1987, pp. 71–2).

172. Friedan, "The Problem that has no Name," p. 90–1.

173. Friedan, "The Problem that has no Name," p. 88.

174. Rachel Bowlby, "'The Problem with No Name': Rereading Friedan's *The Feminist Mystique*," *Feminist Review*, No. 27 (Autumn 1987), p. 66.

175. Bowlby's revisionist piece addresses the outdatedness of Friedan thus: "In academic circles, Friedan's humanist premises and triumphalist rhetoric of emancipation do now seem rather old-fashioned. The current emphasis on sexual difference as the starting point for questions, rather than as an ideological confusion masking women's full humanity, has the effect of relegating a perspective such as Friedan's to the status of being theoretically unsophisticated as well as historically outdated. But to fail to consider her on these grounds is to accept precisely those assumptions about concepts of

progressive liberation and enlightenment, collective and individual, which the later models have put into question. The point is not to reject Friedan from some point of advanced knowledge either as simply "of her time"—an argument for the early sixties of no interest now, or as benightedly prejudiced—good liberal as she was, we've come a long way since then. Rather, the very twists of her argument, with all the oddity of its details and contradictions, as seen from more than two decades later, may themselves suggest a different perspective on current feminist preoccupations and assumptions and current versions of feminist history and feminism's destination (Bowlby, "Rereading Friedan," pp. 71–2). Admittedly, the same can now be said of Bowlby's piece, written as it was over twenty years ago.

176. Jessamyn Neuhaus, "The Way to a Man's Heart: Gender Roles, Domestic Ideology, and Cookbooks in the 1950s," *Journal of Social History*, Vol. 32, No. 3 (Spring 1999), pp. 529.

177. Neuhaus, "The Way to a Man's Heart," p. 530.

178. Irving S. White, "The Functions of Advertising in Our Culture," *Journal of Marketing*, Vol. 24, No. 1 (July 1959), p. 8.

179. There exists a wide literature, both fiction and non-fiction, on the subject of racial passing, from black to white, and of course, white to black. In literature, examples include: Charles Chesnutt, *The House Behind the Cedars* (1900); James Weldon Johnson, *Autobiography of an Ex-Coloured Man* (1912); and, Nella Larsen, *Passing* (1929) and in film, *Imitation of Life* (1939). White to black passing is most famously related to minstrelsy, best exemplified by films such as *The Jazz Singer* (1927) and *Soul Man* (1986). Novels on white to black passing include, *The White Negro* (1956) by Norman Mailer and John Howerd Griffin's *Black Like Me* (1960). Critical texts include: Henry Louis Gates, Jr. "The Passing of Anatole Broyard" (from *Thirteen Ways of Looking at a Black Man*); Eric Lott, *Love & Theft: Blackface Minstrelsy and the American Working Class*; Susan Gubar, *Race Changes: White Skin, Black Face in American Culture*; and Richard Dyer's, *White*.

180. Randall Kennedy, "Racial Passing," *Ohio State Law Journal*, Vol. 62, No. 3 (2001), p. 1145.

181. "Look at these people—old, young, black and white—I've never seen anything like it, " said Vernita Gray, 59 surveying the crowd of up to 240,000 people after Obama's acceptance speech. http://www.cnn.com/2008/POLITICS/11/05/chicago.reax/index.html [accessed November 12, 2008].

182. http://www.barackobama.com/2008/11/04/remarks_of_presidentelect_bara.php [accessed November 12, 2008].

183. For example, see George W. Bush's speech at National Defense University, Fort Lesley J. McNair, on the "War on Terror" from March 2005. Although Bush emphasizes that true democracies require free elections and freedom of speech, in other words, fairness, commentators on the election of President

Bush himself to his second term in office have raised serious doubts in the minds of those his administration is at pains to convince. For the Bush speech, see http://www.whitehouse.gov/news/releases/2005/03/20050308-3.html [accessed November 12, 2008]. For examples of criticism, the Web offers an endless variety. Be wary though—many authors/sites have specific agendas. The large news networks have editorial control and offer fairer coverage. See "Bill Press: More evidence Bush stole the election" at http://edition. cnn.com/2001/ALLPOLITICS/07/23/billpress.column/index.html [accessed November 12, 2008].

184. http://www.barackobama.com/2008/11/04/remarks_of_presidentelect_bara. php [accessed November 12, 2008].
185. Amy Helene Kirschke, *Art in Crisis: W. E. B. Du Bois and the Struggle for African American Identity and Memory*, Bloomington, Indiana: Indiana University Press, 2007, p. 1.
186. Kirschke, *Art in Crisis*, pp. 1–2.
187. Richard Dyer, *White*, London and New York: Routledge, 1997, p. 3.
188. Dyer, *White*, p. 45.
189. Cited in Dyer, *White*, p. 8. See Peggy McIntosh, "White Privilege and Male Privilege: A Personal Account of Coming to See Correspondences through Work in Women's Studies," *Wellesley College Centre for Research on Women Working Papers Series* 189 (reprinted in Margaret Anderson and Patricia Hill Collins (eds.), *Race, Class, and Gender: An Anthology*, Belmont, CA: Wadsworth, 1992, pp. 70–81.
190. W. E. B. Du Bois, *The Souls of Black Folk*, Whitefish, MT: Kessinger Publishing, 2004, p. 3.
191. Shawn Michelle Smith, *Photography on the Color Line: W. E. B. Du Bois, Race, and Visual Culture*, Durham, NC and London: Duke University Press, 2004, p. 25.
192. http://www.ferris.edu/jimcrow/what.htm [accessed: March 12, 2008].
193. Smith, *Photography on the Color Line*, p. 25 [emphasis in original].
194. Smith, *Photography on the Color Line*, p. 25.
195. Smith, *Photography on the Color Line*, p. 25.
196. Dyer, *White*, p. 14 [emphasis in original].
197. See Brian Wallis, "Black Bodies, White Science: The Slave Daguerreotypes of Louis Agassiz," *The Journal of Blacks in Higher Education*, No. 12 (Summer 1996), pp. 102–6.
198. Dyer, *White*, p. 15.
199. Smith, *Photography on the Color Line*, p. 32.
200. Smith, *Photography on the Color Line*, p. 32.
201. W. E. B. Du Bois, *The Souls of Black Folks*, p. 3.
202. Smith, *Photography on the Color Line*, p. 29.
203. Smith, *Photography on the Color Line*, p. 29.

204. Smith, *Photography on the Color Line*, p. 40.

205. Smith, *Photography on the Color Line*, p. 40.

206. Du Bois, *The Souls of Black Folks*, p. 3.

207. Smith, *Photography on the Color Line*, p. 41.

208. Kirschke, *Art in Crisis*, p. 52.

209. Kirschke, *Art in Crisis*, p. 52.

210. Kirschke, *Art in Crisis*, p. 49.

211. Leon F. Litwack, "Hellhounds" in James Allen, Hilton Als, Congressman John Lewis, and Leon F. Litwack, *Without Sanctuary: Lynching Photography in America*, Santa Fe, NM: Twin Palms Publishers, 2000, p. 9.

212. Litwack, "Hellhounds," p. 9.

213. Kirschke, *Art in Crisis*, p. 49.

214. Litwack, "Hellhounds," p. 10.

215. Smith, *Photography on the Color Line*, p. 40.

216. Litwack, "Hellhounds," p. 11.

217. Quoted in Litwack, "Hellhounds," p. 11.

218. Dora Apel, "Lynching Photographs and the Politics of Public Shaming" in Dora Apel and Shawn Michelle Smith, *Lynching Photographs*, Berkeley, Los Angeles, and London: University of California Press, 2007, p. 55.

219. Dora Apel, "Lynching Photographs," p. 55. Stacy is described by Apel as a "homeless tenant farmer" who approached the house of Mrs. Marion Jones, a 30-year-old mother of three, to ask for food. She became frightened and screamed at the sight of Stacy on her property (p. 55).

220. Dora Apel, "Lynching Photographs," p. 55.

221. Kirschke, *Art in Crisis*, p. 96. Kirschke also notes that this photograph is probably the inspiration for Abel Meeropol's poem, "Strange Fruit" written later that decade and made famous by Billie Holiday (p. 97).

222. Kirschke, *Art in Crisis*, p. 96.

223. Shawn Michelle Smith, "The Evidence of Lynching Photographs" in Dora Apel and Shawn Michelle Smith, *Lynching Photographs*, p. 16.

224. Smith, "The Evidence of Lynching Photographs," p. 16.

225. This image can be found in James Allen et al., *Without Sanctuary*, plate 32.

226. James Allen et al., *Without Sanctuary*, p. 177. There is also a lengthy description of the original photograph and the fuller account of the events of the lynching of Shipp and Smith (see Plate 31, pp. 175–6).

227. See fn. 13, p. 81 in Smith, "The Evidence of Lynching Photographs." Smith cites Cynthia Carr, *Our Town: A Heartland Lynching, a Haunted Town, and a Hidden History of White America*, New York: Crown, 2006.

228. Smith, "The Evidence of Lynching Photographs," p. 18.

229. Grace Elizabeth Hale quoted in Smith, "The Evidence of Lynching Photographs," p. 18.

230. Theodore Dreiser, "Speech on the Scottsboro Case" in Nancy Cunard (ed.), *Negro: An Anthology*, New York and London: Continuum, [1934; 1970], 2002, p. 177.
231. Gordon Parks quoted in Eamonn McCabe, "American Beauty," *The Guardian*, G2 Magazine, March 10, 2006, p. 9.
232. Cited in Eamonn McCabe, "American Beauty," p. 9.
233. John Sinclair, "The Genius of Emory Douglas" in Sam Durant (ed.), *Black Panther: The Revolutionary Art of Emory Douglas*, New York: Rizzoli, 2007, p. 4.
234. Will Herberg "Marxism and the American Negro" in Cunard, *Negro*, p. 131.
235. Eugene Gordon, "Blacks Turn Red" in Cunard, *Negro*, pp. 142–3. On the present Negro leadership, Gordon adds, "Dubois calls himself a socialist and tries valiantly to love the masses, is incurably snobbish" (p. 140).
236. "James W. Ford Accepts" in Cunard, *Negro*, p. 144.
237. "Sketch of the Life of James W. Ford, Negro Worker Nominated for Vice-President of the U.S." in Cunard, *Negro*, p. 144. See Ford's, "Communism and the Negro" (1932) also in Cunard, pp. 146–52.
238. Colette Gaiter, *Visualizing a Revolution: Emory Douglas and The Black Panther Newspaper,* http://www.aiga.org/content.cfm/visualizing-a-revolution-emory-douglas-and-the-black-panther-new [accessed March 12, 2008].
239. Amiri Baraka, "Emory Douglas, A 'Good Brother,' a 'Bad' Artist" in Sam Durant (ed.), *Black Panther: The Revolutionary Art of Emory Douglas*, New York: Rizzoli, 2007, p. 18.
240. Amiri Baraka, "Emory Douglas," p. 180.
241. Amiri Baraka, "Emory Douglas," p. 181.
242. Kent Courtney's, *Are These Cats Red? The Black Panthers* (1969), http://archive.lib.msu.edu/DMC/AmRad/thesecatsred.pdf [accessed March 12, 2008].
243. Kent Courtney's, *Are These Cats Red? The Black Panthers* (1969), no page number.
244. "What is the War on Terror?" http://www.whitehouse.gov/infocus/nationalsecurity/faq-what.html [accessed March 10, 2008]. President Bush added that it was a war in defense of "freedom and democracy" and is described in terms of it being the only logical and sensible response open to "freedom-loving people" not just in America but across the globe.
245. Mitchell, "Cloning Terror: The War of Images 2001–04," pp. 179–207. Mitchell argues that the "terrorist and the clone … are the mutually constitutive figures of the pictorial turn in or time (p. 182). The result is what he refers to as "cloning terror"; which Mitchell describes as "1. the paradoxical process by which the war on terror has the effect of producing more terror, 'cloning' more terrorists in the very act of trying to destroy them, and 2. the horror of terror

of cloning itself, which presents a spectacle of unleashed forces of biological reproduction and simulation that activates some of our most archaic phobias about image-making" (p. 182).

246. As an interesting companion thought to this book's emphasis on the visual, we must not forget the power of written and spoken language, especially in relation to war. The recent "war on terror" has seen a change in the language of government in the U.S.A., one which now deploys words rarely, if ever uttered in the past; these include "Empire" and "Homeland." The introduction to this book discussed the call from American studies scholars to embrace a transnational perspective with regard to the U.S.A., especially its foreign policy. Amy Kaplan's, "Violent Belongings and the Question of Empire Today," *American Quarterly*, Vol. 56 (2004), pp. 1–18, explores precisely the rhetoric of the government, its new found fondness for referring to its Empire and the U.S.A. as a homeland (Homeland Security) in this regard. Kaplan argues, "In this fantasy of global desire for all things American, those whose dreams are different are often labeled terrorists who must hate our way of life and thus hate humanity itself. As one of the authors of the Patriot Act wrote, 'when you adopt a way of terror you've excused yourself from the community of human beings'" (p. 7, see fn. 16, p. 17: Viet D. Dinh, quoted in Daphne Eviatar, "Foreigners' Rights in the Post-9/11 Era: A Matter of Justice," *New York Times*, October 4, 2003).

247. Derrick Price, "Surveyors and the Surveyed: Photography Out and About" in Liz Wells (ed.), *Photography: A Critical Introduction* [3rd edition], London and New York: Routledge, [1996] 2004, p. 69.

248. See Abigail Solomon-Godeau, "Who is Speaking Thus?" in *Photography at the Dock: Essays on Photographic History, Institutions and Practices*, Minneapolis: University of Minnesota Press, [1991] 1995, pp. 169–83; and, Martha Rosler, "In, Around, and Afterthoughts (on Documentary Photography)" in Richard Bolton (ed.), *The Contest of Meaning: Critical Histories of Photography*, Cambridge, MA and London: The MIT Press, [1989], 1996, pp. 303–42. This is a revised version of Rosler's essay, which was originally published in *Martha Rosler: 3 Works*, Halifax: The Press of Nova Scotia College of Art and Design, 1981.

249. Abigail Solomon-Godeau, "Who is Speaking Thus?" p. 169.

250. Solomon-Godeau, "Who is Speaking Thus?" p. 169.

251. Quoted in Price, "'Surveyors and Surveyed," p. 69; Solomon-Godeau, "Who is Speaking Thus?" fn. 1, p. 299.

252. Solomon-Godeau, "Who is Speaking Thus?" p. 170.

253. Solomon-Godeau, "Who is Speaking Thus?" p. 170.

254. Solomon-Godeau, "Who is Speaking Thus?" p. 170.

255. Solomon-Godeau, "Who is Speaking Thus?" p. 170.

256. Rosler, "Afterthoughts," p. 303.

257. Rosler, "Afterthoughts," p. 303 [emphasis in original].
258. Solomon-Godeau, "Who is Speaking Thus?" p. 171.
259. Solomon-Godeau, "Who is Speaking Thus?" p. 173.
260. Edward T O'Donnell, "Pictures vs. Words? Public History, Tolerance, and the Challenge of Jacob Riis," *The Public Historian*, Vol. 26, No. 3. (Summer 2004), p. 7.
261. Jacob Riis, *How the Other Half Lives* http://www.cis.yale.edu/amstud/ inforev/riis/introduction.html [accessed March 12, 2008].
262. Cited in Solomon-Godeau, p. 175.
263. Solomon-Godeau, "Who is Speaking Thus?" p. 175.
264. Rosler, "Afterthoughts," p. 306.
265. Solomon-Godeau, "Who is Speaking Thus?" p. 176.
266. Solomon-Godeau, "Who is Speaking Thus?" p. 176.
267. Walter Benjamin, "The Author as Producer" (1934) in Andrew Arato and Eike Gebhardt, *The Essential Frankfurt School Reader*, London: Continuum, 1982, p. 264.
268. Benjamin, "The Author as Producer," p. 262.
269. Solomon-Godeau, "Who is Speaking Thus?" p. 176.
270. Solomon-Godeau, "Who is Speaking Thus?" p. 176.
271. Solomon-Godeau, "Who is Speaking Thus?" pp. 177–8.
272. Solomon-Godeau, "Who is Speaking Thus?" p. 178.
273. Solomon-Godeau, "Who is Speaking Thus?" pp. 177–8.
274. Solomon-Godeau, "Who is Speaking Thus?" pp. 179.
275. Roy Stryker quoted in Rosler, "Afterthoughts," p. 315.
276. Rosler, "Afterthoughts," p. 315.
277. Rosler, "Afterthoughts," p. 321.
278. Rosler, "Afterthoughts," p. 306.
279. Rosler, "Afterthoughts," p. 304.
280. Rosler, "Afterthoughts," p. 308.
281. Joel Snyder, "Photographers and Photographs of the Civil War" in Joel Snyder and Doug Munson, *The Documentary Photograph as a Work of Art: American Photographs, 1860–1876*, Exhibition Catalogue, The David and Alfred Smart Gallery, The University of Chicago, 1976, p. 17. To view over 1,000 photographs from the Civil War, visit the Library of Congress at http:// memory.loc.gov/ammem/cwphtml/cwphome.html.
282. Snyder, "Photographers and Photographs of the Civil War," p. 19.
283. Snyder, "Photographers and Photographs of the Civil War," p. 19. This point is not strictly true. Matthew B. Brady exhibited scenes from the Battle of Antietam showing the dead, leading the *New York Times* (October 1862) to comment on the photographs, "If he [Brady] has not brought bodies and laid them in our door-yards and along our streets, he has done something very like it."

284. Snyder, "Photographers and Photographs of the Civil War," p. 21 [emphasis added].

285. Snyder, "Photographers and Photographs of the Civil War," p. 21.

286. Brady assembled a group of excellent photographers, including Alexander Gardner, James Gardner, Timothy H. O'Sullivan, William Pywell, George N. Barnard, and Thomas C. Roche.

287. Trachtenberg, "Albums of War: On Reading Civil War Photographs," *Representations*, No. 9, Special Issue: American Culture Between the Civil War and World War I (Winter 1985), p. 3.

288. Trachtenberg, "Albums of War," p. 3.

289. Trachtenberg, "Albums of War," p. 3.

290. Trachtenberg, "Albums of War," p. 5.

291. Snyder, "Photographers and Photographs of the Civil War," p. 20.

292. Karal Ann Marling and John Wetenhall, *Iwo Jima: Monuments, Memories and the America Hero*, Cambridge: Harvard University Press, 1991, p. 64.

293. Marling notes that the first flag was only visible from the landing zone and it was decided a larger and therefore more visible flag would motivate Marines still fighting elsewhere on the island. It is not mentioned but I suppose for the Japanese army to see the Stars and Stripes atop Mt. Suribachi would certainly hit their morale. Marling and Wetenhall, *Iwo Jima*, p. 64.

294. Marling and Wetenhall, *Iwo Jima*, p. 72.

295. See James Bradley (with Ron Powers), *Flags of Our Fathers*, USA: Bantam, 2000.

296. Karal Ann Marling and John Wetenhall, "Patriotic Fever and the truth About Iwo Jima," *History News Network*, March 4, 2002. http://hnn.us/articles/599.html [accessed March 12, 2008]. Marling and Wetenhall's short piece is a rebuttal to the criticism their book *Iwo Jima* received in the national press. All efforts on their part to engage in a debate about criticism leveled at the book, that it called into question the heroism of American soldiers who fought and died for their country, were themselves rebutted, while editors of newspapers allowed detractors plenty of column inches. A book whose aim was to overturn popular misconceptions, to stir people from a fuzzy haze of nostalgia and half-truth was itself subject to misconception.

297. Marling and Wetenhall, *Iwo Jima*.

298. Marling and Wetenhall, "Patriotic Fever and the truth About Iwo Jima."

299. A transcript of "Executive Order 9066" can be found at http://www.ourdocuments.gov/doc.php?flash=true&doc=74&page=transcript [accessed March 12, 2008]. The document is listed in "100 Milestone Documents." The list has been compiled by the National Archives and Records Administration, and is drawn primarily from its holdings. The documents chronicle United States history from 1776 to 1965.

300. http://www.archives.gov/research/japanese-americans/index.html [accessed March 12, 2008].

301. Site locations included: Tule Lake, California; Minidoka, Idaho; Manzanar, California; Topaz, Utah; Jerome, Arkansas; Heart Mountain, Wyoming; Poston, Arizona; Granada, Colorado; and Rohwer, Arkansas.

302. The War Relocation Authority (WRA) was also initiated by a Roosevelt Executive Order, 9102.

303. Roderick Conway Morris, "Don McCullin's Harrowing Images of War," *International Herald Tribune*, October 30, 1997 http://www.iht.com/articles/1997/10/30/don.t.php?page=2 [accessed March 2, 2008].

304. Besides McCullin, Rosler lists: "W. Eugene Smith, David Douglas Duncan, Larry Burrows, Diane Arbus, Larry Clark, Danny Lyon, Bruce Davidsonm Dorothea Lange, Russell Lee, Walker Evans, Robert Capa, …, and Sally Meiselas." Rosler, "Afterthoughts," p. 308.

305. Susan Sontag, "Witnessing" in *Don McCullin*, London: Jonathan Cape, 2003, p. 16.

306. "McCullin is still visibly grieving about being prevented by the British authorities from covering the Falklands War. 'I'd been with just about every army in the world, and I felt that to be there with the British Army, my own people, was what my whole career had been a preparation for. I'd earned it with my blood and sweat.' Even the Imperial War Museum's attempts to dispatch him as its official photographer were thwarted. 'The government wanted a cosmeticized image of the war, a Hollywood version in which people didn't really bleed and there was no pain.' His eventual sacking by the Sunday Times was inevitable, McCullin said, 'because they wanted to kill off photojournalism, and promote style pieces and garden furniture instead.'" Morris, "Don McCullin's Harrowing Images of War," *International Herald Tribune*, October 30, 1997.

307. Rosler, "Afterthoughts," p. 306.

308. Sontag, "Witnessing," p. 17.

309. Tom Lea Papers, MS476, Univerity of Texas at El Paso, http://libraryweb.utep.edu/special/findingaids/tomlea.cfm [accessed March 2, 2008].

310. Solomon-Godeau, "Who is Speaking Thus?" p. 178.

311. Rosler, "Afterthoughts," p. 308.

312. See "The Abu Ghraib Files" at http://www.salon.com/news/abu_ghraib/2006/03/14/introduction/ [accessed November 11, 2008].

313. Bob Nickas, "Introduction" in Mark Michaelson, Steven Kasher, and Bob Nickas (eds.), *Least Wanted: A Century of American Mugshots*, New York: Steidl/Steven Kasher Gallery, 2006, p. 18.

314. "1. a mugshot does not mean that the person is guilty or innocent of any crime; 2. the fact that a mugshot was taken does not establish that a crime

was committed or that the subject of the photograph is guilty or innocent of any wrongdoing." Michaelson et al., *Least Wanted*, p. 11. (Also repeated on p. 304 as a disclaimer: "The editors wish to emphasise their strong feeling that a mugshot does not mean that the person is guilty or innocent of any crime. Furthermore, the fact that a mugshot was taken does not establish that a crime was committed or that the subject of the photograph is guilty or innocent of any wrongdoing.")

315. Nickas in Michaelson et al., *Least Wanted*, p. 18.

316. Many of the images found in *Least Wanted* are to be found with additional material at http://www.leastwanted.com. From here one can leave "comments" or remarks about specific images.

317. Susan Sontag, *On Photography*, London: Penguin Books, p. 161.

318. I should stress that a similar attitude toward photography was also crucial in Europe during the same era. In fact, as we shall see, many of the key figures and theorists to whom this chapter will refer are European.

319. It is interesting to debate this distinction in greater detail. Besides *The Wire*, I could also highlight *Homicide: Life on the Street* (also set in Baltimore), *The Shield*, and *Boomtown*, as well as older shows such as *NYPD Blue* and *Hill Street Blues*. It is possible to argue that the CSI franchise is more an example of a procedural program, like another contemporary franchise, *Law and Order*, but the former in particular dispenses with any notion of presenting time realistically. In the world of CSI, complicated DNA tests or partial fingerprints—"partials"—are manipulated via super-futuristic interfaces heralding results in seconds rather than in weeks or even months. And all the while the staff in white coats speak to each other as though they need to explain in the simplest terms how and why they are performing the tasks at hand. Clearly an effort to inform the viewer but one which reminds me so much of the theater of Bertolt Brecht and the "estrangement effect."

320. Wikipedia helpfully lists the following shows: *10–8: Officers on Duty* (USA, 2002–3); *21 Jump Street* (USA, 1987–91); *24* (USA, 2001–present); *77 Sunset Strip* (USA, 1958–64); *Adam-12* (USA, 1968–75); *Alias* (USA, 2001–6); *America's Most Wanted* (reality) (USA, 1988–present); *B.J. and the Bear* (USA, 1979–81); *Bakersfield P.D.* (USA, 1993–4); *Banacek* (USA, 1972–74); *Baretta* (USA, 1975–8); *Bones* (USA, 2005–present); *Boomtown* (USA, 2002–3); *Bourbon Street Beat* (USA, 1959–60); *Brooklyn South* (USA, 1997–8); *Cagney & Lacey* (USA, 1982–8); *Cannon* (USA, 1971–6); *Car 54, Where Are You?* (USA, 1961–3); *Charlie's Angels* (USA, 1976–81); *CHiPs* (USA, 1977–83); *Close to Home* (USA, 2005–7); *The Closer* (USA, 2005–present); *Cold Case* (CBS, 2003–present); *Columbo* (USA, 1971–94); *COPS* (reality) (USA, 1989–present); *Cracker* (USA, 1997–9); *Criminal Minds* (USA/Canada, 2005–present); *CSI: Crime Scene Investigation* (USA/Canada, 2000–present); *CSI: Miami* (USA/Canada, 2002–present); *CSI: NY* (USA/

Canada, 2004–present); *David Cassidy: Man Under Cover* (USA, 1978–9); *The Defenders* (USA, 1961–5); *Diagnosis: Murder* (USA, 1993–2001); *Disorderly Conduct* (reality); *Dragnet* (USA, 1951–9, 1967–70, 1989–1991 and 2003–4); *Due South* (Canada/USA, 1994–9); *Ellery Queen* (USA, 1975–6); *The F.B.I.* (USA, 1965–74); *Father Dowling Mysteries* (USA, 1987–91); *The Fugitive* (USA, 1963–7 and 2000–1); *Get Smart* (comedy) (USA, 1965–70); *Hawaii Five-O* (USA, 1968–80); *Highway Patrol* (USA, 1955–9); *Hill Street Blues* (USA, 1981–7); *Homicide: Life on the Street* (USA, 1993–9); *Hot Pursuit* (reality) (USA, 2006–present); *In the Heat of the Night* (USA, 1988–94); *Ironside* (USA, 1967–75); *JAG* (USA, 1995–2005); *Jake and the Fatman* (USA, 1987–92); *Judd, for the Defense* (USA, 1967–9); *Kojak* (USA, 1973–8 and 2005); *LAPD: Life On the Beat* (reality; USA, 1995–9); *Law & Order* (USA, 1990–present); *Law & Order: Criminal Intent* (USA, 2001–present); *Law & Order: Special Victims Unit* (USA, 1999–present); *Life* (US TV series) (USA, 2007–present); *Magnum, P.I.* (USA, 1980–8); *Manhunt* (USA, 1959–61); *Matlock* (USA, 1986–95); *Matt Houston* (USA, 1982–5); *McCloud* (USA, 1970–7); *McMillan and Wife* (USA, 1971–7); *Miami Vice* (USA, 1984–90); *Mickey Spillane's Mike Hammer* (USA, 1958–60 and 1984–5); *Midnight Caller* (USA, 1988–91); *Millennium* (USA, 1996–9); *The Mod Squad* (USA, 1968–73); *Moonlighting* (USA, 1985–9); *Most Wanted* (USA, 1976–7); *Murder, She Wrote* (USA, 1984–96); *Naked City* (USA, 1958–63); *NCIS* (USA, 2003–present); *Night Court* (comedy) (USA, 1984–92); *N.Y.P.D.* (USA, 1967–9); *NYPD Blue* (USA, 1993–2005); *Numb3rs* (USA, 2005–present); *Owen Marshall: Counselor at Law* (USA, 1971–4); *Ohara* (USA, 1987–8); *Pacific Blue* (USA, 1996–2000); *The People's Court* (reality); *Perry Mason*; *Police Squad!* (comedy) (USA, 1982); *Police Story* (USA, 1973–7); *Police Woman* (USA, 1974–8); *Quincy, M.E.* (USA, 1976–83); *Raines* (USA, 2007); *Reno 911!* (comedy) (USA, 2003–present); *Richard Diamond, Private Detective* (USA, 1957–60); *The Rockford Files* (USA, 1974–80); *The Rookies* (USA, 1972–6); *Sergeant Preston of the Yukon* (USA, 1955–8); *The Shield* (FX, 2002–present); *Special Unit 2* (comedy/horror); (USA, 2001–2); *Spenser: For Hire* (USA, 1985–8); *Starsky and Hutch* (USA, 1975–9); *The Streets of San Francisco* (USA, 1972–7); *Sue Thomas: F.B.Eye* (USA/Canada, 2002–5); *S.W.A.T.* (USA, 1975–6); *Third Watch* (USA, 1999–2005); *T.J. Hooker* (USA, 1982–6); *Twin Peaks* (USA, 1990–1); *The Untouchables* (1959 TV series) (USA, 1959–63); *The Untouchables* (1993 TV series) (USA, 1993–4); *Vega$* (USA, 1978–81); *Veronica Mars* (USA, 2004–7); *Walker, Texas Ranger* (USA, 1993–2001); *The Wire* (USA, 2002–present); *Without a Trace* (USA, 2002–present); *The X-Files* (USA/Canada, 1993–2002).

321. Sandra S. Phillips, Mark Haworth-Booth, and Carol Squiers, *Police Pictures: The Photograph as Evidence*, San Francisco Museum of Modern Art, San Francisco: Chronicle Books, 1997, p. 11.

322. Even Private Investigators, who exist in shadowy recesses of the no-mans land between the police and criminal fraternity, possess an identifiable set of visual conventions: the office with a partial glass door, the PI's name painted on it (to be smashed at regular intervals by those the PI annoys in some way—women, the police, fellow PIs, criminals, or those who feel under threat of exposure from the ongoing private investigation); the bottle of whiskey in the office filing cabinet but no files; the evidence of physical violence (black eye, broken nose, etc.). From Marlowe to J. J. "Jake" Gittes (even Rick Deckard in *Bladerunner*), it is worth compiling a list of conventions and then finding movies that invert them.

323. David Gauntlett, "What's interesting about Michel Foucault" at http://theory.org.uk/ctr-fou2.htm [accessed December 5, 2007].

324. Michel Foucault, *Power/Knowledge, Selected Interviews and Other Writings 1972–1977*, edited by Colin Gordon, London: Harvester, p. 97.

325. Original French version: Michel Foucault, *Surveiller et punir*, Paris: Gallimard, 1975.

326. The term or periodization "feudal" has long been considered somewhat problematic. For the sake of clarity, I am defining this shift in terms of economics; namely, the shift from a particular economic system to another.

327. Central to the Enlightenment project, in no particular order and with significant omissions, are: Jeremy Bentham; Edmund Burke; Étienne Bonnot De Condillac; Condorcet; Denis Diderot; Fontenelle; Johann Wolfgang Von Goethe; Thomas Hobbes; David Hume; Immanuel Kant; Gotthold Ephraim Lessing; John Locke; Wilhelm Von Leibniz; Montesquieu; Isaac Newton; Thomas Paine; François Quesnay; Marquis De Sade; J. C. F. Von Schiller; Adam Smith; Baruch Spinoza; Voltaire; Adam Weishaupt; and, Mary Wollstonecraft.

328. Foucault, *Power/Knowledge*, p. 98.

329. One can make a strong argument for parallels in Foucault's philosophy of the subject and Martin Heidegger's philosophy of Being. As Herbert Dreyfuss argues: "At the heart of Heidegger's thought is the notion of being, and the same could be said of power in the works of Foucault. The history of being gives Heidegger a perspective from which to understand how in our modern world *things* have been turned into *objects*. Foucault transforms Heidegger's focus on *things* to a focus on *selves* and how they became *subjects*. And, just as Heidegger offers a history of being, culminating in the technological understanding of being, in order to help us understand and overcome our current way of dealing with things as objects and resources, Foucault analyzes several regimes of power, culminating in modern bio-power, in order to help us free ourselves from understanding ourselves as subjects." http://socrates.berkeley.edu/~hdreyfus/html/paper_being.html [accessed January 2, 2008].

330. Foucault, *Power/Knowledge*, p. 17.

331. Foucault, *Power/Knowledge*, p. 147.
332. Foucault, *Power/Knowledge*, p. 148.
333. Lois McNay, *Foucault: A Critical Introduction*, Cambridge: Polity Press, 1994, p. 94.
334. Foucault, *Power/Knowledge*, p. 148.
335. Michel Foucault, *Discipline & Punish: The Birth of the Prison*, trans. Alan Sheridan, New York: Vintage Books, 1995, p. 228.
336. Although many prisons since have been influenced by Bentham's design.
337. Allan Sekula, "The Body and the Archive," *October*, Vol. 39. (Winter 1986), p. 5.
338. Sekula, "The Body and the Archive," p. 6.
339. Sekula, "The Body and the Archive," p. 6.
340. Sekula, "The Body and the Archive," p. 7.
341. Sekula, "The Body and the Archive," p. 8.
342. Sekula, "The Body and the Archive," pp. 8–10.
343. Sekula, "The Body and the Archive," p. 10.
344. With regards to race, see Brian Wallis, "Black Bodies, White Science: Louis Agassiz's Slave Daguerrotypes," *American Art*, Vol. 9, No. 2 (1995), pp. 36–61.
345. Phillips et al., *Police Picture*, p. 12. By camera-based images Phillips appeals to moving as well as still-images.
346. For example, During December 2007 (in the UK), movies showing were *American Gangster* (Ridley Scott); *The Assassination of Jesse James by the Coward Robert Ford*; on DVD release was another Ridley Scott film, *Bladerunner*; and, on television in the week ending December 7 across all channels it was possible to watch: *NCIS, the CSI* franchise; the *Law and Order* franchise; *Criminal Minds* and many more.
347. See http://mafiahouse.bravehost.com/Lucky.html; http://paulandkaja.com/intersection/anecdote2.html; http://www.bugsysclub.com/club/community/info_luciano.htm. I admit that these Web sites are not academic but they are another example of how difficult it can be to divorce fact from fiction, and truth from myth. Among the dates, facts, and anecdotes one rarely finds moral or ethical questions or judgments. Just like mug shot photographs, there seems to be a belief in the reporting of "fact" equals truth, overlooking, of course, accounts of the effects of drug trafficking, prostitution rings, protection rackets, wide-scale bribery, control of the unions, the fall out from "Family" wars, etc.
348. Tim B. Wride, "The Art of the Archive" in *Scene of the Crime*, New York: Harry N. Abrams, 2004, pp. 18–19.
349. Wride, "Art of the Archive," p. 19; p. 21.
350. Wride, "Art of the Archive," p. 21.
351. Wride, "Art of the Archive," p. 21.

352. Wride, *Scene of the Crime*, pp. 210–11.
353. Wride, "Art of the Archive," p. 18.
354. See http://www.getty.edu/art/gettyguide/artObjectDetails?artobj=61129 [accessed February 2, 2008].
355. http://www.getty.edu/art/gettyguide/artObjectDetails?artobj=61129 [accessed February 2, 2008].
356. A request to reprint the cover from *Time Magazine*, June 27, 1994, was declined.
357. Phillips, *Police Pictures*, p. 12.
358. Peter Gay (ed.), *The Freud Reader*, London: Vintage, 1995, p. xiii.
359. Gay, *Freud Reader*, p. xiii. Arguably, the same might be said of the ways in which these terms are now used professionally after the endless revisions and reimaginings of Freud's theories.
360. Michael Hatt and Charlotte Klonk, *Art History: A Critical Introduction to its Methods*, Manchester: Manchester University Press, 2006, p. 174.
361. Hatt and Klonk, *Art History*, p. 174.
362. Gillian Rose, *Visual Methodologies: An Introduction to the Interpretation of Visual Materials* [2nd edition], London, Thousand Oaks, New Delhi: Sage Publications, 2007, p. 109.
363. Rose, *Visual Methodologies*, p. 107.
364. Gay, *Freud Reader*, p. 572.
365. Sigmund Freud, "The Unconscious" in Gay, *Freud Reader*, p. 574.
366. Gay, *Freud Reader*, p. 572.
367. Sigmund Freud, "The Unconscious" in Gay, *Freud Reader*, p. 573.
368. See Freud, "The Unconscious" in Gay, *Freud Reader*, pp. 573–77.
369. Freud, "Repression" in Gay, *Freud Reader*, p. 569 [emphasis in original]. Freud makes a distinction between "primal repression" and "repression proper."
370. Hatt and Klonk, *Art History*, p. 176.
371. Sigmund Freud, *The Interpretation of Dreams*, The Penguin Freud Library Volume 4, translated James Strachey, edited Angela Richards, London: Penguin Books, p. 382. Freud notes that "our predecessors in the field of dream interpretation have made a mistake of treating the rebus (the dream) as a pictorial composition: and as such it has seemed to them nonsensical and worthless" (p. 382).
372. Freud, *The Interpretation of Dreams*, p. 383.
373. Freud, *The Interpretation of Dreams*, p. 381.
374. Freud, "On Dreams" in Gay, *Freud Reader*, p. 163.
375. Freud, "On Dreams" in Gay, *Freud Reader*, p. 164.
376. Freud, *The Interpretation of Dreams*, p. 383.
377. Freud, "Overture: An Autobiographical Study" in Gay, *Freud Reader*, p. 28.
378. Rose, *Visual Methodologies*, p. 113.

379. Sigmund Freud, "Fetishism" in *On Sexuality: Three Essays on Sexuality and Other Works*, Translated James Strachey, London: Penguin, p. 352.

380. Rose, *Visual Methodologies*, p. 113.

381. Early instructors at the Arts Students League of New York included: William Merritt Chase, J. Alden Weir, Walter Shirlaw, Frederick Dielman, John H. Twachtman, Kenyon Cox, Augustus Saint-Gaudens, Daniel Chester French, Thomas Eakins, Childe Hassam, Frank Duveneck, Thomas W. Dewing, and Arthur Wesley Dow. See http://www.theartstudentsleague.org/history.html [accessed March 3, 2008].

382. Lynn D. Gordon, "The Gibson Girl Goes to College: Popular Culture and Women's Higher Education in the Progressive Era, 1890—1920," *American Quarterly*, Vol. 39, No. 2 (Summer 1987), p. 211.

383. Gordon, "Gibson Girl Goes to College," p. 211.

384. Elle Wiley Todd, *The "New Woman" Revised: Painting and Gender Politics on Fourteenth Street*, Berkeley; Los Angeles; Oxford: The University of California Press, 1993, p. 5. Also available at http://ark.cdlib.org/ark:/13030/ft9k4009m7/ [accessed October 23, 2008].

385. Gordon, "Gibson Girl Goes to College," p. 211.

386. Gordon, "Gibson Girl Goes to College," p. 211. See Lois W. Banner, *American Beauty*, Chicago: University of Chicago Press, 1984.

387. John Berger, *Ways of Seeing*, London: Penguin, 1972, p. 47.

388. Berger, *Ways of Seeing*, p. 49.

389. Laura Mulvey, "Visual Pleasure and Narrative Cinema," *Screen*, Vol. 16, No. 3 (1975), pp. 6–18. All references to Mulvey's essay relate to the version in: Philip Simpson, Andrew Utterson, and K. J. Shepherdson (eds.), *Film Theory: Critical Concepts in Media and Cultural Studies: Volume III*, London & New York: Routledge, 2004, pp. 56–67. It is worth adding this volume also contains Mulvey's essay, "Afterthoughts on 'Visual Pleasure and Narrative Cinema' Inspired by *Duel in the Sun* (King Vidor, 1946)," pp. 68–77.

390. Sigmund Freud, *On Sexuality: Three Essays on the Theory of Sexuality and Other Works*, trans. James Strachey; edited by Angela Richards. London: Penguin Books, 1991.

391. Mulvey, "Visual Pleasure and Narrative Cinema" p. 56.

392. Rose, *Visual Methodologies*, p. 115 [emphasis added].

393. Rose, *Visual Methodologies*, p. 115.

394. Mulvey, "Visual Pleasure and Narrative Cinema" p. 56.

395. Rose, *Visual Methodologies*, p. 108.

396. Mulvey, "Visual Pleasure and Narrative Cinema" p. 57.

397. Rose, *Visual Methodologies*, p. 117.

398. Researching these publications will introduce you to magazines with titles like: *Man's Combat*, *Man's Life*, *Male*, *World of Men*, *True Adventure*, *Man to Man*, *Wildcat Adventures*, *Stag*, *Men in Conflict*, *Man's Story*, *Man's Exploits*, and *For Men Only*.

399. See Max Allan Collins, George Hagenauer, Richard Oberg, and Steven Heller, *Men's Adventure Magazines in Postwar America,* Taschen GmbH, 2004; Adam Parfrey (ed.), *It's a Man's World: Men's Adventure Magazines—The Postwar Pulps*, US: Feral House, 2003.

400. Sigmund Freud, *On Sexuality*, p. 69. In a footnote, Freud adds that he believes the "concept of the beautiful has its roots in sexual excitation and that its original meaning was "sexually stimulating" (see fn. 2, p. 69).

401. Freud, *On Sexuality*, p. 70.

402. Freud, *On Sexuality*, p. 65.

403. Roger Cranshaw, "The Object of the Centrefold," *Block 9*, East Barnet, 1983, p. 28.

404. Lynda Nead, *The Female Nude: Art, Obscenity and Sexuality*. Florence, KY: Routledge, 1992, p. 2.

405. Nead, *The Female Nude*, p. 1.

406. André Bazin, *What is Cinema, Vol. 2*, edited and translated by Hugh Gray, Berkeley, Los Angeles, London: University of California Press, p. 158.

407. Robert B. Westbrook, "'I Want a Girl, Just Like the Girl that Married Harry James': American Women and the Problem of Political Obligation in World War II," *American Quarterly*, Vol. 42, No. 4 (December 1990), p. 588.

408. Westbrook, "American Women," p. 592.

409. Westbrook, "American Women," p. 595. That is, the military was more than happy to encourage heterosexual desire and fantasy, that is "autoeroticism" or masturbation, as long as it did not become "habit forming" (see pp. 595–6).

410. Paul Fussell quoted in Westbrook, "American Women," p. 596.

411. Westbrook, "American Women," p. 596.

412. Westbrook, "American Women," p. 596.

413. Bazin, *What is Cinema, Vol. 2*, p. 160.

414. Bazin, *What is Cinema, Vol. 2*, p. 160.

415. Bazin, *What is Cinema, Vol. 2*, p. 160.

416. See Charles G. Martignette, "The Art & Life of Gil Elvgren" at http://www.gilelvgren.com/GE/bio.php. This biography is part of a larger Web site (http://www.gilelvgren.com/GE/index.php), which lists all Elvgren's works, with a selection of images of key works produced at various stages of his career. Much of the detail here is taken from Martignette's biography of Elvgren [accessed February 2, 2008].

417. As Martignette notes, Elvgreen worked for many major American companies, including *Orange Crush, Schlitz Beer, Sealy Mattress, General Electric, Sylvania*, and *Napa Auto Parts*. See http://www.gilelvgren.com/GE/bio.php [accessed February 2, 2008]. I have contacted Brown and Bigelow several times to arrange for reproduction of Elvgren images without success.

418. Just like the images I intended to use in the text. The company who own the copyright politely declined my request for permission to reproduce several of the Petty images in this book.

419. Nead, *The Female Nude*, p. 6.
420. Nead, *The Female Nude*, p. 87. Nead continues: "Of course, the physical dimensions of the freestanding statue might be seen to enhance the potential for sexual arousal. The statue cannot only be touched, but it can also, in fantasy at least, be held and embraced. The inevitable extension of this kinetic experience is the myth of Pygmalion, in which the female statue is not only embraced but also responds to that embrace. In another permutation of this fantasy of male arousal there is the case from sixteenth-century Italy, of Aretino, who so admired the exceptional realism of a painted nude Venus by Sansorino that he claimed 'it will fill the thoughts of all who look at it with lust.' Over two centuries later, there is the example of the bibliophile Henry George Quin, who crept into the Uffizi in Florence when no one was there, in order to admire the Medici Venus and who confessed to having fervently kissed several parts of her divine body. All three of these instances deserve to be fully examined in the light of their specific historical circumstances; but in the context of this discussion of the formation of cultural distinctions, some different kind of observations can be made" (p. 87).
421. Although most often referred to as the "Kinsey Report," *Sexual Behavior in the Human Male* (1948) and *Sexual Behavior in the Human Female* (1953) were co-authored by Alfred C. Kinsey, Wardell B. Pomeroy, and Clyde E. Martin (with Paul H. Gebhard contributing to the latter); the research (for *Sexual Behavior in the Human Male*) was initiated by Kinsey in 1938 and he undertook the substantial bulk of the interviewing process. All references to the "Kinsey Report" and "Kinsey" traditionally refer to all contributors and the same applies here. See * note in W. Allen Wallis, "Statistics of the Kinsey Report," *Journal of the American Statistical Association*, Vol. 44, No. 248 (December 1949), p. 463.
422. Searching the Internet for information on the Kinsey Report, it is not surprising to find its methods and conclusions questioned but rather shocking to see it judged by the conservative movement, Human Events, as the fourth most "harmful book" of the nineteenth and twentieth century after Marx and Engels, *Communist Manifesto*, Hitler's *Mein Kampf*, and Mao Zedong's *Quotations from Chairman Mao*. Fifth is John Dewey's *Democracy and Education*, then Marx's *Das Kapital*; seventh, Betty Friedan's *The Feminist Mystique*; August Comte's *The Course of Positive Philosophy* is eighth and ninth is Nietzsche's *Beyond Good and Evil*; finally, number ten: John Maynard Keynes's *General Theory of Employment, Interest and Money*. See http://www.humanevents. com/article.php?id=7591 [accessed February 12, 2008].
423. Alfred C. Kinsey et al., *Sexual Behavior in the Human Male* [1948], Bloomington: Indiana University Press, 1975, pp. 57–8 [emphasis added].
424. A similar controversy emerged in the 1970s when Shere Hite released the *Hite Report: A Nationwide Study of Female Sexuality*, in which she, like Kinsey,

outraged the so-called "moral majority" with her assertion that most American women did not achieve orgasm through heterosexual intercourse.

425. James Lileks, "Art Frahm, a study of the effects of celery on loose elastic." Available at http://www.lileks.com/institute/frahm/indexmain.html [accessed February 28, 2008].

426. Laura Mulvey, "Some Thoughts on the Theory of Fetishism in the Context of Contemporary Culture," *October*, The MIT Press, Vol. 65 (Summer 1993), pp. 3–20.

427. Mulvey, "Some Thoughts on the Theory of Fetishism," p. 6.

428. *The American Century: Art and Culture, 1900–2000*, Part 1 was on view from April 23, 1999 to August 22, 1999; Part 2, September 26, 1999 to February 13, 2000, at the Whitney Museum of Modern Art. Accompanying each exhibition was a large-scale catalogue: Barbara Haskell, *The American Century: Art & Culture, 1900–1950*, New York: Whitney Museum of American Art in association with W.W. Norton, 1999; and Lisa Phillips, *The American Century: Art & Culture, 1950–2000*, New York: Whitney Museum of American Art in association with W.W. Norton, 1999.

429. David Anfam, "Review: The American Century: Part One. New York, *The Burlington Magazine*, Vol. 141, No. 1160 (November 1999) p. 707.

430. See http://www.whitney.org/www/exhibition/past.jsp [accessed January 23, 2008].

431. Caroline A. Jones, *Eyesight Alone: Clement Greenberg's Modernism and the Bureaucratization of the Senses*, Chicago and London: The University of Chicago Press, 2005, p. xix.

432. Jones, *Eyesight Alone*, p. 208.

433. Michelle H. Bogart, *Advertising, Artists, and the Borders of Art*, Chicago and London: The University of Chicago Press, 1995, p. 165. Bogart adds that O'Keeffe requested she stay among the workers but was informed that this was not allowed (a white woman among peasants was not the done thing); in protest, O'Keeffe refused to paint a single pineapple on her whole trip: "Instead she painted papaya trees and ginger flowers, and Ayer had to make do with one of these." In the end, the Dole company demanded a pineapple, so one was shipped to O'Keeffe's penthouse at the Shelton Hotel, which she then painted to fulfill her end of the bargain; a task she dutifully (and allegedly) completed in a single day (p. 166).

434. Stuart Davis's earlier work, *Lucky Strike* (1921), references the cigarette and tobacco brand but in a manner more reminiscent of cubist still life and collage.

435. Barbara Kruger also worked initially on magazines as a designer.

436. Henry Luce, *Life* magazine, February 7, 1941.

437. Douglas Tallack, "Seeing Out the Century," *Journal of American Studies*, Vol. 35, No. 1 (2001), pp. 127–31. It is also possible to draw out the connections

between Luce's rhetoric of 1941 and the nineteenth-century notions of "manifest destiny" discussed earlier in this book.

438. The exhibition catalogues for each half of the show explore in even greater variety the artifacts of wider visual culture. See Barbara Haskell, *The American Century: Art & Culture, 1900–1950* and Lisa Phillips, *The American Century: Art & Culture, 1950–2000* respectively.

439. A debatable point, I admit. But even if a non-American artist or photographer, for example, denies the influence of an American origin in their work, it is hard to deny that their work will at some point be compared with the dominant force in a globalized art market and culture, namely America and American art/photography.

440. A battle traced to some degree in each of the exhibitions but with greater clarity in the exhibition catalogues.

441. Nancy Jachec, "Modernism, Enlightenment Values, and Clement Greenberg," *Oxford Art Journal*, Vol. 21, No. 2 (1998), p. 123.

442. Jachec, "Modernism," p. 123. Jachec's accompanying footnote cites the older translation into English by C. Lendhardt of Theodor Adorno's *Aesthetic Theory*. I would recommend instead Robert Hullot-Kentor's translation, published in 1997 by University of Minnesota Press, Minneapolis. Jachec's essay sets out to re-politicize Greenberg's work, highlighting his long-term editorial connections with *Partisan Review* and *Commentary*; crucially, the political outlook of these publications shifted while Greenberg was an active contributor (*Partisan Review* moved away from its interest in Trotskyism in the early 1940s; *Commentary*'s focus was always political and sociological, never art-related, and was founded by the American Jewish Committee to study the political/sociological origins of the Holocaust). As such, Jachec highlights a connection between shifts in Greenberg's modernist art criticism and the shift in left-liberal thinking and politics post-World War II, a shift that successive critiques have overlooked (pp. 123–4).

443. Tallack, "Seeing out the Century," p. 128.

444. Charles Harrison, "Modernism" in Robert S. Nelson and Richard Schiff, *Critical Terms for Art History*, Chicago and London: The University of Chicago Press, 1996, p. 142.

445. Harrison, "Modernism," p. 145.

446. Harrison, "Modernism," p. 143.

447. Harrison, "Modernism," pp. 144–5.

448. Harrison, "Modernism," p. 145.

449. Harrison, "Modernism," p. 145.

450. Harrison, "Modernism," p. 145.

451. Clement Greenberg, "Avant-Garde and Kitsch" (1939) in *Art and Culture: Critical Essays*, Boston: Beacon Press, (1989), p. 10.

452. Jones, *Eyesight Alone*, p. 37.

453. Theodor Adorno, and Max Horkheimer, *Dialectic of Enlightenment*, trans. John Cumming, London: Verso, 1997, p. 121.

454. In Adorno's reflections on his exile in America, published as *Minima Moralia: Reflections from Damaged Life* (tr. E. F. N. Jephcott. London: Verso, 1997), he says: "Every visit to the cinema leaves me, against my vigilance, stupider and worse" p. 25. On saying this, Adorno was fond of Charlie Chaplin; see Theodor Adorno, "Chaplin Times Two," translated John MacKay, *The Yale Journal of Criticism*, Vol. 9, No. 1 (1996), pp. 57–61.

455. Adorno and Horkheimer, *Dialectic of Enlightenment*, pp. 121, 123.

456. Adorno and Horkheimer, *Dialectic of Enlightenment*, p. 121.

457. Adorno and Horkheimer, *Dialectic of Enlightenment*, p. 120.

458. Adorno and Horkheimer, *Dialectic of Enlightenment*, pp. 139, 140, 147, 147.

459. See David Jenemann, *Adorno in America*, Minneapolis: University of Minnesota Press, 2007.

460. Adorno and Horkheimer, *Dialectic of Enlightenment*, p. 167.

461. Theodor Adorno, "The Culture Industry Reconsidered" in *The Culture Industry: Selected Essays on Mass Culture*, edited J. M. Bernstein, London: Routledge, 1991, p. 86; see also Theodor Adorno, *Aesthetic Theory*, trans. Robert Hullot-Kentor, Minneapolis: University of Minnesota Press, 1997.

462. Adorno, "The Culture Industry Reconsidered," p. 86.

463. Adorno, "The Culture Industry Reconsidered," p. 87.

464. Adorno, "The Culture Industry Reconsidered," p. 89.

465. I have appropriated Harrison's words, quoted earlier. See footnote 11.

466. Thomas Crow, *Modern Art in the Common Culture*, New Haven and London: Yale University Press, 1996, p. 4.

467. Barbara Zabel, "Stuart Davis's Appropriation of Advertising: The Tobacco Series, 1921–1924," *American Art*, Vol. 5, No. 4 (Autumn 1991), p. 56.

468. Zabel, "Stuart Davis," p. 58. On saying this, Zabel has to fend off previous criticism linking Davis's work with the still life/*trompe l'oeil* paintings of William Hartnett (1848–92) and John Peto (1854–1907).

469. Zabel, "Stuart Davis," p. 60.

470. Zabel, "Stuart Davis," p. 60.

471. Zabel, "Stuart Davis," p. 61. Moreover, as Zabel argues, Davis's works also address the wider social changes in attitudes towards the way tobacco was actually smoked. Traditionally, tobacco was smoked with a pipe or chewed; in fact, smoking cigarettes up until World War I was considered "a debasement of manhood" (quoted in Zabel, p. 61).

472. Jackson Lears, *Fables of Abundance: A Cultural History of Advertising in America*, New York: Basic Books, 1994, p. 10.

473. Zabel, "Stuart Davis," p. 63. Briefly, if the period in American art history most often referred to as Early American modernism has one major concern it was how could American art absorb the newest ideas and theories of art

developed in Europe, while not being subsumed by them. Artists like Stuart Davis and Charles Sheeler, for example, both of whom were greatly influenced by cubism, were charged with the rather difficult task of being both modern *and* American.

474. Zabel, "Stuart Davis," p. 6.
475. See Douglas Crimp, "Pictures," *October* Vol. 18 (Spring 1979), pp. 75–88, and the follow-up essay, "The Photographic Activity of Postmodernism," *October*, Vol. 15 (Winter 1980), pp. 99–101.
476. Richard Prince. Interview by Brian Appel, available at http://www.rovetv. net/pr-interview.html [accessed May 29, 2008].
477. Crimp, "The Photographic Activity of Postmodernism," p. 100 [my emphasis].
478. Robert S. Nelson, "Appropriation" in Robert S. Nelson and Richard Shiff (eds.), *Critical Terms for Art History*, Chicago and London: University of Chicago Press, 1996, p. 119.
479. Nelson, "Appropriation," p. 119.
480. The Marlboro cowboy images are part of a much wider nexus of mythologizing the "look" of the cowboy. There is nothing original about the Marlboro man. He is in fact a cliché.
481. Peter Schjeldahl, "The Joker: Richard Prince at the Guggenheim," *The New Yorker*, October 15, 2007.
482. Lears, *Fables*, p. 1.

Index